Painting Women

Painting Women

Cosmetics, Canvases,
and Early Modern Culture

Patricia Phillippy

The Johns Hopkins University Press
Baltimore

© 2006 The Johns Hopkins University Press
All rights reserved. Published 2006
Printed in the United States of America on acid-free paper
9 8 7 6 5 4 3 2 1

The Johns Hopkins University Press
2715 North Charles Street
Baltimore, Maryland 21218-4363
www.press.jhu.edu

Library of Congress Cataloging-in-Publication Data

Phillippy, Patricia Berrahou, 1960–
 Painting women : cosmetics, canvases, and early modern culture /
Patricia Phillippy.
 p. cm.
 Includes bibliographical references and index.
 ISBN 0-8018-8225-7 (hardcover : alk. paper)
 1. Women in art. 2. Gender identity in art. 3. Feminine beauty
(Aesthetics)—Europe. 4. Cosmetics—Social aspects—Europe. 5. Arts,
European—16th century. 6. Arts, European—17th century. I. Title.
 NX652.W6P48 2006
 700'.4522'09031—dc22 2005005202

A catalog record for this book is available from the British Library.

The first thing
that strikes the reader
of his careful face is its dazzling
craft, but by then
it's already too late.
—"THE POET DOWNSTAIRS"

Contents

Illustrations

Acknowledgments

As is always true, this book has been influenced by conversations, events, ideas, and interactions too numerous to name, some of which took place many years—decades—before I began writing, others that punctuated my daily life while the book, in various stages of completion, simmered in the background. The contributions of several colleagues have been direct; those of others more subtle. I thank those who have read portions of the book and provided invaluable criticism, particularly Babette Bohn, Anthony Colantuano, Randall Dodgen, Susan Egenolf, Marian Eide, Margaret J. M. Ezell, Katherine E. Kelly, Julia Reinhard Lupton, and Howard Marchitello. Marshall Grossman was good enough to identify himself as the initial reader for the Johns Hopkins University Press, and his commentary at a moment early in the project was of great value. Others have contributed in various ways to the development and completion of this book. Among them I must thank Elaine Beilin, Margaret Burri, Liana De Girolamo Cheney, Giovanna Del Negro, Richard J. Golsan, Ruth Larson, Anne Lake Prescott, Mihoko Suzuki, and Abby Zanger. Fouad Berrahou patiently helped with the translation of the more intractable phrases in Marguerite's *Miroirs*. Lael Parish offered helpful insight into some Italian passages and inspired me to explore Bologna and its riches, continuing to prove herself to be an infallible source of insight and good company, as she has been for the past twenty-five years. The assistance of my multitalented daughter, Iman Berrahou, was crucial to the completion of the book and is much appreciated.

Grant support from the Program to Enhance Scholarly and Creative Activities at Texas A&M University allowed me to conduct research in England, France, and Italy in 2000–2001 and 2001–2. Funding from the Women's Studies Program and from the Melbern G. Glasscock Center for Humanities Research, both at Texas A&M, provided important and much-needed assistance, as did a Faculty Fellowship from the College of Liberal Arts, Texas A&M University, from 2002 to 2004. The Department of English supported my travel to galleries and exhibits, which was invaluable in the completion of the book. I thank

in particular Larry Mitchell for his encouragement and support in his capacity as head of the Department of English. A Teacher/Scholar Award from the University Honors Program, Texas A&M, supported me during the writing phase. Finally, support from the Department of English and College of Liberal Arts covered the expenses associated with rights and reproductions.

In undertaking the art historical dimension of this project, I was reminded continually of the value of my interdisciplinary training in the Renaissance Studies program at Yale University. Without that foundation and the desire it instilled in me and in my colleagues to bridge the gaps between the sometimes too-discrete disciplines of history, art history, literary criticism, and religious studies, this project would not have been conceived, let alone realized. I would be remiss if I did not mention my lasting gratitude to Phoebe Stanton, whose remarkable lectures in Art History 101 at the Johns Hopkins University many years ago impressed me and prompted many excursions, both physical and intellectual, into the world's galleries since then.

During the composition of this book, my former advisor and friend Thomas M. Greene died. I remain grateful for his guidance and for his model of exacting scholarship and sensitive reading. His works and his example continue to be rich and suggestive, and they permeate this project.

Finally, throughout the writing of this book, I remembered my father's characteristic response to my teenage forays into the cosmetic culture: "Only old houses need paint." That phrase launched the discussion in the pages that follow, and so the book, like its author, is a (sometimes unruly) child of Gordon Phillippy's paternal wisdom and wit.

Painting Women

Introduction

In his *Treatise Against Painting and Tincturing of Men and Women* (1616), Thomas
Tuke calls a woman's painted face "the *idoll*, she doth so much adore." "Her love
of painting," he insists, "hath transformed her into a *picture*."[1] Drawing a strik-
ing parallel between Protestant iconoclasm and condemnations of cosmetics, he
pleads, "for very shame, let not these heathenish images be brought into the
houses of God. They do ill become the *bodies of Saints*, which are the *Temples of
the holy Ghost*."[2] For Tuke, face painting corrupts the material bodies of Christ-
ian women and the collective spiritual body of the church into which these
painted images, objectified as idols, intrude. His argument bespeaks a faith in a
direct correspondence between internal vices or virtues and their outward man-
ifestations and the troubled career of that belief in its applications.[3] Thus, he
cites Saint Ambrose to show that "the condition of the mind is discerned in the
state and behavior of the body. Without a doubt then a deceitfull and effeminate
face, is the ensigne of a deceitfull and effeminate heart."[4] Although during this
period men as well as women were likely to paint, Tuke (despite the title of his
work) and his fellow polemicists overwhelmingly described the practice as a par-
ticularly feminine infraction, one product of women's inborn pride.[5] Painting

women embody the assumed alliance between internal and external states, including gender, the threat posed by women's manipulations of that alliance, and the processes by which men's interpretations of a woman's cosmetic self-creation translate her from subject to object: "Her love of painting hath transformed her into a *picture*."

Painting Women: Cosmetics, Canvases, and Early Modern Culture studies the intersection of painting and femininity in sixteenth- and seventeenth-century Europe as a site for exploring abstract ideas of gender construction and subjectivity in specific, historically grounded models. The term *painting* suggests the plural aspects of my approach. First, I address representations of women by men in the early modern period, in works by artists as familiar as Shakespeare and Vasari and in those by lesser-known figures such as Giovanni Luigi Picinardi and Jean Liébault. Second, the term refers to women's use of cosmetics during the period, a subject the book engages through readings of didactic works, material objects, and artworks that comment on women's painting, often through the conflation of ideals of artistic beauty with those of feminine beauty.[6] Finally, I examine women's self-representations, as characters and creators, in literary texts and visual arts, in works such as Elizabeth Cary's *Tragedy of Mariam*, Aemilia Lanyer's *Salve Deus Rex Judeaorum*, Marguerite de Navarre's poetic *Miroirs*, and paintings by Lavinia Fontana, Artemisia Gentileschi, and Elisabetta Sirani. I argue that early modern discussions of women's face painting, despite the commitment of their (almost exclusively) male authors to an essentialist view of femininity, display clear evidence of the constructed quality of gender as performed in the practice of painting. This evidence, in turn, permits women writers and painters to legitimize their entries into print and the visual arts by challenging the essentialist grounds on which the conflation of painting and femininity is advanced. This book reads the material practice of face painting and the polemical writings attending it in relation to literary and visual works by women and shows how painting, in its various senses, served as a point of focus for the period's castings of femininity.

These chapters assume and demonstrate that constructions of gendered subjects in early modern culture, and in the arts that reflect it, depend upon interactions with generic and discursive choices that are themselves coded in demonstrably gendered ways. Focusing on painting allows one to consider in concrete terms and examples the theoretical relationship between psychological or physiological "interiority" and the body's physical exterior—in other words, to en-

gage the vexing question of the relationship between biological sex and cultural gender as manifested in encounters with the conventions of cosmetic adornment and of literary and artistic production. Ubiquitous complaints about women's deceptive use of cosmetics, for example, are often echoed in condemnations of literary works and visual icons that threaten to deceive readers or viewers. Thus, Tommaso Buoni surmises that men disallow women's painting, "perche gli Amanti da cotal falsità argomentino alla falsità & doppiezza dell'animo; che chi non teme falsar le cose esteriori, agevuolmente studia à farsar i beni interiori" ("because men from those outward deceipts gather the inward untruth and deceipt of the minde: For she that feareth not to falsifie these exteriour parts, may with more ease, and lesse feare adulterate the inward Beautyes of the minde").[7] Philip Stubbes applies similar terms to the illusory, feminized practices of the stage when he compares "masking Players" to "painted sepulchres,"[8] and John Downame makes this twin suspicion of cosmetic and theatrical disguise explicit: "like Players, they [painting women] come disguised in the similitude of other persons, for want of a better, they act their part in the habit of an harlot."[9]

Painting Women undertakes a comparative study of English, French, and Italian writers and visual artists to examine how men's and women's different approaches to painting contribute to early modern constructions of gender and to demonstrate the need to interpret gender in specific relationships to historical periods, cultures, and genres. In the past three decades feminist literary critics and art historians have uncovered and documented formerly neglected works by women artists and writers of early modern Europe, attempting to locate these works within the established, predominantly masculine literary and visual canons and to script a feminine history of the arts emergent within women's works themselves.[10] In their inception these critical efforts struggled with the difficulties attending assertions of literary or artistic value on the basis of sex, often assuming that early modern women's works are inherently valuable because they appeared in a period that largely suppressed female public expression.[11] This appeal to biographical and biological fact (that is, to an essential femininity) was troubled on several fronts. For example, attributions of anonymous or dubious works confronted the challenge of identifying critical criteria beyond gender, usually ascribed to a work's feminist or gendered expression, to support arguments for and establish the significance of female authorship.[12] Perhaps more urgently, the association of women's artistic representations with their gendered bodies could serve to negate the artistic value of their works: thus, women artists and writers

were often portrayed as motivated by a need for direct self-expression rather than by a desire to master the media in which they work.[13] Recent work in art history and literary studies has moved beyond the essentialism of its critical legacy,[14] and I hope to contribute to this project by arguing that early modern women's works can provide a template for contemporary constructionist approaches to femininity insofar as they self-consciously engage gender within the specific discourses of painting. Taking genre—literary, artistic, or cultural—as the starting point for comparisons between early modern men's and women's works, I examine performances of gender in relation to painting, rather than seeing literary and visual works as revelatory of their authors' essential selves.[15] Insofar as the gendered subject is a product of his or her manipulations of convention, women's works must be read in relation to the overwhelmingly masculine literary, artistic, and cultural traditions from which they emerge.[16] I survey the development of the early modern "beauty industry" and relate that phenomenon to other aspects of the culture (to pre- and post-Reformation views of the body and its adornment, for instance) and to the major artistic and literary currents and concerns of the period. My reading of the painting woman takes its cue from early modern women's works, which establish their authors' rights to self-creation and self-authorship by exposing and challenging the essentialist underpinnings of the conventions governing painting, in both of its senses.[17]

"Femininity," Sabine Melchoir-Bonnet writes, "is the creation of the mirror." She explains, "the authority of the reflection is imposed primarily upon women who . . . construct themselves under the gaze of the other."[18] As the following chapters show, the cosmetic culture of early modern Europe places women before literal, visual, and textual mirrors that reflect masculine standards for feminine beauty, virtue, and vice. This cosmetic culture, as Saundra L. Bartky's writes of the contemporary American beauty industry, constitutes "a disciplinary practice [that] produces a body which in gesture and appearance is recognizably feminine." Through a gradual process of internalization, women comply with the means "by which the ideal body of femininity—and hence the feminine body-subject—is constructed; in doing this, they produce a 'practiced and subjected' body, that is, a body on which an inferior status has been inscribed."[19] The result of this beauty industry, for the twenty-first-century woman as for her ancestors, is to insist that she "connive," as John Berger puts it, "in treating herself as, first and foremost, a sight."[20] As "self-policing subjects," painting women engage in a "self-surveillance [that] is a form of obedience to patriarchy."[21]

In applying this argument to the cosmetic culture of sixteenth- and seventeenth-century Europe, certain qualifications must be noted. Two separate textual traditions, derived respectively from classical medical discourses and from the writings of the church fathers, sent competing and apparently contradictory messages to women concerning cosmetic self-creation. The first group of texts is composed of instructional manuals on the preparation of cosmetics, offering women recipes for ointments, lotions, soaps, bleaches, and powders to cleanse the body and to dye the hair and skin.[22] These texts set forth a wide range of recipes, some involving harmless (if unsavory) organic ingredients, others casting women as amateur apothecaries handling dangerous substances in their homes, often with toxic outcomes. Mary Evelyn's recipe for "Puppidog Water for the Face," in *Mundus Muliebris* (1690), exemplifies organic treatments:

> Take a Fat Pig, or a Fat Puppidog, of nine days old, and kill it, order it as to Roast; save the Blood, and fling away nothing but the Guts; then take the Blood, and Pig, or the Puppidog, and break the Legs and Head, with all the Liver and the rest of the Inwards . . . to that, take two Quarts of old Canary, a pound of unwash'd Butter not salted; a Quart of snails-Shells, and also two Lemmons . . . Still all these together in a Rose Water Still . . . Let it drop slowly into a Glass-Bottle, in which let there be a lump of Loaf-Sugar, and a little Leaf-Gold.[23]

Giovanni Battista della Porta's advice for the preparation of *sollimato*, or mercury sublimate, meanwhile, details the more toxic treatments common in the period. "Havemo detto già, che niuna cosa val tanto a far bella la faccia alle donne, cioè a polirla, e farla lucida, quanto l'argento vivo" ("I said, that there was nothing better than quick-silver for womens paints, and to cleanse their faces, and make them shine"), he writes, and he recommends the following recipe:

> Piglia meza oncia di argento vivo purgato, e non falsificato co'l piombo . . . quesi mischia con una meza libra di sollimato, e ponilo in mortaio di marmo, e con un pistello di legno nuovo lo pesterai volgendo sempre in rotondo, primo diverrà nero, poi fra sei hore diverrà bianco se non lascierai di volgere in giro sempre.

> [Take one ounce of pure quick-silver, not falsified with lead . . . Mingle this with a half a pound of Mercury sublimate, and put it into a marble mortar, and with a new wooden pestle, stir it well, turning it round about. First, it will be black, in six hours it will grow white, if you cease not to beat it.]

After the addition of salt, the mixture is ground, washed, and let set until the solids sink to the bottom. When "onely powder remain without dregs" ("lapolvere nudo senza bruttezze"), Porta writes, "make little cakes of it, and dry it in the sun" ("ne farai pitole, e sa seccare al sole").[24]

Underlying the advice of instructional manuals is a consensus on ideals of feminine beauty—blonde hair, black eyes, white skin, red cheeks and lips—culled from and promulgated by the Petrarchan tradition and its transmission across Europe.[25] Giovanni Marinello's influential *Gli ornamenti delle donne* (1562) offers the following wisdom on the beauty of women's complexions, citing the origins of these standards:

> le guancie saranno bianche, & vermiglie, & appresso tenere, & morbide, la bianchezza somigli latte, gigli, rose bianche, & neve: & il colore vermiglio paia rose incarnate, & iancinti porpurei, tali le scrisse il Petrarca nel Sonnetto Io canterei d'amore: ove dice.
>> E le rose vermiglie infra la neve
>> Mover da'l ora. . . .
> Et l'Ariosto nel Settimo Canto.
>> Spargeasi per la guancia delicata
>> Misto color di rose, e di ligustri.
> Dalle quali cose cogliamo, che quattro qualità si richiedono alle guancie, oltre alla loro positura; che siano bianche, vermiglie, tenere, & morbide.

> [the cheeks will be white and red, and nearly tender and delicate, the whitest resembling milk, lilies, white roses, and snow and the vermilion colors a pair of flesh-pink roses, and purple hyacinths, as Petrarch writes in the Sonnet, "I will sing of love," where he says:
>> and the vermilion roses among the snow
>> moved by the breeze . . .
> And Aristo in the Seventh Canto:
>> The mixed color of roses and lilies
>> Spread across her delicate cheek.
> From which things we gather that four qualities are required of the cheeks, other than their position; that they be white, red, tender and delicate.][26]

While regulating and standardizing ideals of feminine beauty, instructional manuals, moreover, suggest the considerable labor and expense that women were willing to invest in the self-consuming effort to achieve those ideals. Thus,

Porta concludes his recipe for *sollimato* by confessing, "son molte donne, che non sostengono l'argento vivo sollimato, perche, è molto nosevole alli denti" ("some will not away with quick-silver, by reason of the hurt it commonly doth to the teeth"). But the benefits of the treatment, he insists, outweigh its costs: "Ma veramente di niun modo meglio si cava acqua di argento vivo, che quella, che vien chiara, e humida, perche bagnandosi la faccia con quello, splende . . . ne ho visto in mia vita cosa piu eccellente" ("Yet there is no better water, then that which is extracted from quick-silver; it is so clear and transparent, and the face anointed with it, shines like silver . . . and I never saw a better").[27] When Margaret Cavendish disapproves of painting's "Sluttishness," her complaint is not against the immorality of the practice but against its unladylike labor, "especially in the Preparatives . . . which are very uneasy to lye in, wet and greasy, and very unsavoury." As for cosmetics themselves, "most Paintings are mixed with Mercury, wherein is much Quicksilver, which is of so subtil a malignant nature, as it will fall from the Head to the Lungs, and cause Consumptions . . . rot the Teeth, dim the Eyes, and take away both the Life and Youth of a Face."[28]

The toxicity of early modern cosmetics was a common theme in the second group of early modern texts of the cosmetic debate: invectives against painting.[29] Juan Luis Vives's commentary on the practice in *De institutione feminae Christiane* (1523) is typical. "I should like to know," Vives asks, "for what reason a young woman smears herself with white lead and purple pigment. If it is to please herself, she is mad . . . But if you are looking for a husband . . . [i]t seems to me that wishing to attract a man with makeup is the same as trying to do so with a mask. Just as you attracted him in this disguise, so will you drive him away when you are unmasked" ("in quo equidem audire pervelim quid spectet virgo, cum cerussa et purpurisso se illinit. Si sic placere sibi, demens est . . . At sponsum quaeris virum et ei conciliari studes fuco . . . perinde mihi videtur esse cupere te fuco pellicere virum aliquem ac persona; quem tantum avertes renudata quantum attrixisti contecta").[30] The invective catalogues the horrifying physical effects of cosmetics:

> Quid quod et tenella cutis citius rugatur et totus faciei habitus in senilem deformatur modum? Foetet spiritus, scabrescunt dentes, toto denique corpore taeter hailtus spiratur, tum ex cerussa et argento vivo, tum vel maxime ex dropacibus, sapunculis et smegmatis quis cutem velut tabellam in postridianam picturam parant.
>
> [Young skin becomes wrinkled more quickly, the whole appearance of the face begins to look old, the breath reeks, the teeth become rotten, and a foul odor is

emitted by the whole body, from white lead, mercury, and especially from depila-
tories, soaps, and ointments with which they prepare their face like a wooden
tablet for the next day's painting.][31]

Vives calls forth classical and early Christian authorities to argue that painting
adulterates God's workmanship, erects a false idol in the place of God's image,
is a temptation to lust, exemplifies feminine dissembling, and was introduced to
women by the apostate angels after their fall to earth.[32] Leon Battista Alberti's
treatise on home economics, *Della famiglia* (1434), agrees with Vives and under-
scores the fact that the addressees of anti-cosmetic invectives (as opposed to
cosmetic recipe books) are often men rather than women. Alberti's patriarchal
speaker, Giannozzo, instructs his younger male family members on how to
"persuade women . . . never to paint with white powder, brazilnut dye, or other
makeup" ("come e' persuadevano alle donne per questo non si dipignessono il
viso con cerusa, brasile o simile liscio alcuno"), a rhetorical feat that "few hus-
bands can manage" ("niuno pare sappia distornela").[33] Having informed his wife
that "the woman's character is the jewel of her family" ("la onestà nella donna
sempre fu ornamento della famiglia")[34] and that wearing makeup invariably com-
promises her chastity, Gionnozzo illustrates his point:

> Ivi era il Sancto, una ornatissima statua d'argento, solo a cui il capo et le mani
> erano d'avorio candissimo: era pulita, lustrava, posta nel mezo del tabernaculo
> come s'usa: dissili: "Donna mia, se alla mattina tu con gessi et calcine, et simili
> impiastri imbiutassi il viso a questa imagine . . . dimi, dopo molti giorni volendola
> vendere cosi lisciata, quanti danari n'aresti tu? Più che mai avendola lisciata?"

> [There was a saint in the room, a very lovely statue of silver, whose head and hands
> were of purest ivory. "My dear wife," I said to her, "suppose you besmirched the
> face of this image in the morning with chalk and calcium and other ointments . . .
> Tell me, after many days of this, if you wanted to sell it, all polished and painted,
> how much money do you think you would get for it? More than if you hand never
> begun painting it?"]

When his wife admits that its value would be much less, Gionnozzo moralizes
his tale: "the buyer of the image does not buy it for a coating of paint . . . but
because he appreciates the excellence of the statue and the skill of the artist"
("che chi compera l'imagine non compera quello impiastro . . . ma appregia la
bontà della statua et la gratia del magisterio"). Moreover, "if those poultices could
have that [ill] effect on ivory, which is hard stuff by nature . . . they can do your

own brow and cheeks still greater harm" ("se queste adunque pultiglie tanto possono in una cosa durissima, in uno avolio . . . quelle molto più potranno nel fronte et nelle guance tue").[35]

Three points, shared by most anti-cosmetic invectives, become clear in Vives's and Alberti's comments and reveal unexpected affinities between texts of this tradition and the cosmetic recipe books whose existence and contents seem to contradict them. First, Alberti's address to male householders casts *anti*-cosmetic discourses as a disciplinary practice through which ideal femininity is constructed and in which masculinity is deeply invested. If masculine ideals of feminine beauty are enforced in instructional manuals, in which women learn to connive in conforming their appearances to an acceptable pattern, masculine ethical standards are imposed upon women in anti-cosmetic invectives. Although espousing contradictory aims, these two genres undertake identical means. As Amy Richlin writes of the classical Roman forerunners of these early modern types, "moralizing texts coexisted in tension with contemporary technology," each striving toward the same disciplinary goal: "Thus in Roman culture as today, real women can be said both to implicate themselves in a system by which they beautify themselves, and to be implicated in a system that conceals, disguises, derides and silences them . . . The term 'beauty culture' incorporates the paradox whereby a cultural practice simultaneously constructs and erases its practitioners."[36] When Tuke claims that, "because governement is granted unto men by nature," husbands must "reform" painting wives, he affirms that men's restraint of women's painting, like the cosmetic culture that mandates their decoration, is itself a regulatory practice—a form of painting—constitutive of femininity. He advises:

> take away her painting, and do not that with terror and threats, but with a gentle and sweet perswasion. Let her ever and non heare thee say, that the painted faces of women doe displease thee . . . Be not slacke to discourse of these things . . . sometimes speaking faire, and sometimes turning away thine eyes with dislike, and sometimes againe making much of her. Dost thou not see that painters, when they goe about to make a faire picture, doe now apply these colours, and then others, wiping out the former? Be not thou more unskilfull then painters. They being to paint the shape of the bodie on tables, do use so great paines and care; and is it not meet that wee should trie all conclusions, use all meanes, when we desire to make soules better?[37]

Tuke's appropriation of feminine painting as a masculine rhetorical strategy devoted to adorning not the body but the soul is typical of the period's gendering of rival versions of painting, in both of its senses. In treatises on the art of painting, as in cosmetic texts, masculine creativity appears as a function of the mind, women's creative and self-creative acts as belonging to the body. While a man before the mirror reflects upon the status of his soul, the woman engaged in her toilette is "essentially a bodily being."[38]

Second, invectives such as Vives's and Alberti's assert a relationship between the often unwholesome materials constituting early modern cosmetics and the frailties of femininity. Whereas cosmetic manuals proceed on the presuppositions that "the female body is something that needs to be fixed" and that "a woman's face, unpainted, is defective,"[39] anti-cosmetic invectives interpret makeup as simultaneously an index and a literalization of women's "deformities," physical and, most important, moral.[40] Although at first glance concerns about the toxicity of early modern cosmetics may strike one as "a feminist point, [an] argument in the main interest of women,"[41] the formulaic insistence that painting women "teach their faces to lye . . . getting deformity instead of beauty" confirms that the argument does not aim to promote women's welfare but to promulgate a view of femininity as flawed, corrupt, and corrupting.[42] Women's cosmetics are considered to be, in Richlin's phrase, "something icky put over something icky."[43] When John Bulwer, in *Anthropometamorphosis* (1653), notes that "Roman Dames had infinite little boxes filled with loathsome trash of sundry kinds of colours and compositions, for the hiding of their deformities, the very sight and smell whereof was able to turne a mans stomack,"[44] he transmits the misogynistic classical discourses (in this instance, Ovid's *Remedia amoris*) equating the female body with the makeup box, or *pyxides:* beautiful on the outside but polluted on the inside, both are versions of the painted sepulchre.[45] Yet early modern makeup boxes also embody the twin aspects of the cosmetic debate itself. Decorated with scenes from mythology or literature, from the Rape of Lucretia to the Judgment of Paris to Petrarchan *trionfi* (fig. 1),[46] their exteriors, like cosmetic manuals, celebrate the benefits of women's adornment, while their toxic contents prefigure and promote the fatal outcomes of painting rehearsed by invectives.

Finally, Vives and Alberti both imagine and construct the painting woman as an object—of decoration, display, and scrutiny—in much the same way that cosmetic recipe books posit a (primarily male) audience for whom makeup is applied. Thus, Vives casts the woman's painted face as a mask or a wooden tablet, and

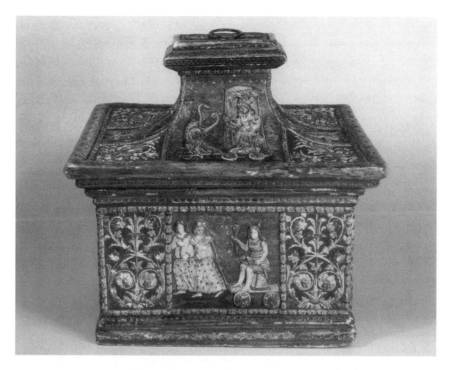

Fig. 1. Makeup box (Cassetta) (Italian, c. 1500). Victoria and Albert Museum, no. W.21.-1953.

Alberti sees both wives and statues as objects acquired by the male connoisseur with the acuity to value the skill of the artificer in embodying his Idea in debased matter. The painting woman is an object, moreover, that calls forth masculine interpretation and fashioning. Tuke's paterfamilias must become a painter to create the ideal wife, while Alexander Niccholes notes the need (which he does not satisfy) for exegetical expertise when confronting the inscrutable feminine text: "There is a Text in woman, that I would faine have women to expound, or man either: to what end is the laying out of the embrodred haire, embared breasts, virmillioned cheekes, alluring lookes, fashion gates, and Artfull countenances, effeminate, intangling, and insnaring gestures."[47] By staging and exploring "the dichotomies of surface and depth, mind and body, particularly as applied to women,"[48] the early modern cosmetic debate revolves around the objectified figure of the painting woman poised precariously before her polysemous mirror. Unraveling her meanings and mysteries is a case study in early modern gender construction. Buoni's explanation of women's motives for painting illustrates one

strategy by which this construction proceeds. Wondering "why doe women which are not borne fayre attempte with artificiall Beauty to seeme fayre?" ("perche le Donne non nate belle con artificiosi belletti tentano apparir belle?"), he speculates:

> ò forse perche essendo le Donne assai sottoposte al rossore, che suol nascere da vergogna . . . & già sapendo che la bellezza è commune ornamento di tutte le Dorine; appare grave nota d'infamia à gl'intelletti loro l'esser prive di quello; onde per schifare una tanta macchia non temono con mille inventioni & con mille artificii ornat i corpi suoi.

> [*Perhaps* because women being for the moste parte subject unto that pleasing redness, which ariseth of shamefastnesse . . . and knowing that this Beautifull bashfullnesse, giveth splendour and ornament to all women, it seemeth to their understandings a great note of infamy to be deprived thereof; and therefore to avoyde so great a blotte, they feare not with a thousand artes and inventions to give the like Beauty to their faces.][49]

Such interpretations blame feminine duplicity (imagined as inherent in women's natures) for behaviors prompted by aesthetic and ethical standards imposed upon women by men. Modest women blush, women are told, and so they paint, perhaps not primarily to feign blushing (and thereby mask immodesty) but to conform to male expectations for feminine appearance and behavior. Yet, by attempting to prove themselves modest, to avoid "infamy," they indict themselves as immodest. If Buoni suggests the double bind attending women's decisions to paint or not to paint, Roy Porter summarizes the semiotic double bind in which painting places male interpreters. "She who couldn't blush," he writes, "was a woman without shame. But the woman who wore rouge . . . wore an artificial blush, which (men feared) all too readily . . . hid the bare-faced cheek of the shameless woman."[50]

Women's objectification by the cosmetic culture of early modern Europe and the seemingly unnavigable sea of contradictions confronting them, caught between the mandates of the beauty culture, on the one hand, and the moral indictments of anti-cosmetic polemicists, on the other, present bleak prospects for readers hoping to see these women as self-conscious, self-governing subjects. Viewing the practice of making up as "self-deconstructing, since this focus on the surface calls into question the existence of any underlying self,"[51] a number of contemporary feminist critics have compared cosmetics to decapitation; an

"eroticization" of the female head that silences women and robs them of identity. As Howard Eilberg-Schwartz writes, "it is precisely the desire to be looked at rather than the desire to look which is signaled by cosmetics."[52] Yet, as Buoni's discussion of the feminine blush illustrates, early modern women may have found themselves as effectively silenced and objectified by injunctions against cosmetics as by cultural expectations for feminine beauty. To illustrate the similar regulatory outcomes of the cosmetic debate's twin genres, we might recall Vives's warning to women that painting alienates husbands, who suspect feminine deception and are repelled by the ravages of cosmetics. Despite Shirley Garner's suggestion that early modern "women's pleasure in making up may have been heightened by its linking them with the forbidden, sinful, and sexually illicit,"[53] we must note that a common *defense* of face painting in the period insisted that wives embellish themselves to please their husbands. Porta explains the essentialist underpinnings of this defense:

> ma, che Idio autor dell'universo, ha dato alla natura delle cose, che tutte in se havessero perpetuità, creò il maschio, e la femina . . . e che il maschio fusse chiamato all'atto della generatione, allettato da questa bellezza, e creò la donna molle, delicate, e bella, accioche allettato da questa, quasi costretto fusse sollicitato. Noi dunque accioche la moglie piacesse al suo marito, ne offe si dalla loro bruttezza andassero ad infestare, e macchiare gli altrui letti, habbiamo havuto pensiero di provedere alle donne, come con il ruffanesmo della bellezza, & allettamento de' colori, se fussero nere, ruvide, macchaite, e brutte, e se vergognassero della loro bruttezza, diventassero bianche, liscie, bionde, & bellissime.

> [But when God, the Author of all things, would have the Natures of all things to continue, he created Male and Female . . . and to make Man in love with his Wife, he made her soft, delicate and fair, to entice man to embrace her. We therefore, that Women might be pleasing to their Husbands, and that their Husbands might not be offended at their deformities, and turn not to other Womens chambers, have taught Women how, by the Art of Decking themselves and Painting, if they be ashamed of their foul and swart Complexions, they may make themselves Fair and Beautiful.][54]

In light of the "violent implications of the patriarchal politics of painting,"[55] which seek to silence women either through the eroticization or castigation of their physical forms, the notion that early modern women could assert a "right to paint" may amount merely to admitting their inevitable complicity in a sys-

tem in which they could only please (or displease) their male governors, rather than pleasing, or governing, themselves.

What possibilities existed for women implicated in the early modern cosmetic culture for negotiation, self-authorship, and autonomy? Is it always true that women painted only to be viewed, thereby denying their identities as viewing, discriminating subjects? If it is true that "integral to the fashioning of a personal identity is the construction of a physical body,"[56] this study asks: How can painting help to construct the feminist body of early modern women?

With Gionnozzo's wife, the quiet recipient of her husband's stern advice in Alberti's *Della famiglia,* we can begin to answer these questions. When asked whether his wife obeyed his injunction against painting, Gionnozzo admits:

> Pur tale ora alle nozze, o che ella si vergognasse tra le genti, o che ella fosse riscaldata pel danzare, la mi pareva alquanto più che l'usato tincta: ma in casa non mai; salvo il vero una sola volta quando doveano venire gli amici et le loro donne la pasqua convitati a cena in casa mia; allora la moglie mia col nome d'Idio tutta impomiciata, troppa lieta s'afrontata a quelunque venia, et così a chi andava si porgeva, a tutti motteggiava. Io me n'avidi.

> [It is true that at weddings sometimes, whether because she was embarrassed at being among so many people or heated with dancing, she sometimes appeared to have more than her normal color. In the house, however, there was only one time, when friends and their wives were invited to dinner at Easter. My wife, on this occasion, had covered her face with pumice, in God's name, and she talked all too animatedly with each guest on his arrival or departure. She was showing off and being merry with everyone, as I observed.]

To remedy the situation, Gionnozzo pulled his wife aside and said: "Oh dear, how did your face get dirty? Did you by any chance bump into a pan? Go wash yourself, quick, before these people begin to make fun of you" ("Tristo a me, et come t'imbrattasti così il viso? forse t'abbattesti a qualche padella? Laverati, che questi altri non ti dilegino"). He concludes triumphantly: "She understood me at once, and began to cry. I let her go wash off both tears and makeup. After that I never had to tell her again" ("Ella me intese, lagrimò; io gli die' luogo ch'ella si lavasse le lacrime et il liscio. Dipoi ebbi mai di questo che dirgliene").[57]

To assert that the early modern cosmetic debate serves as a case study in the period's constructions of gender requires one to show how anti-cosmetic invec-

tives and instructional manuals support an essentialist view of femininity while implicitly acknowledging that cosmetics are troublesome specifically because they *expose* the constructed qualities of masculinity and femininity.[58] Gionnozzo's anecdote illustrates both the essentialist underpinnings of the cosmetic debate and their troubled applications as they move beyond polemics toward the material objects of their concern, women's bodies. He censures not only his wife's painting but also her garrulousness, emphasizing multiple feminine vices that together compromise her modesty. Her "showing off" is imagined as a product of women's natural shortcomings as descendants of Eve,[59] and Alberti's goal is to curb women's natures through the controlling wisdom of male governors. Yet the story also demonstrates the pragmatic and semiotic limitations of this masculine rule: as Gionnozzo admits, he is unable to determine at social gatherings whether his wife *is* painting or is simply flushed from dancing or (in accordance with the masculine dream of feminine modesty) might, in fact, be blushing with embarrassment. The inference of women's essential characters is profoundly shaken by the practice of painting. If the empirical evidence is inconclusive or, worse yet, deceptive, what can one affirm about women's natures? Barnaby Rich, in *My Ladies Looking-Glasse* (1616), makes explicit the dilemma implicit in Gionnozzo's narrative when he admits that external evidence of women's characters can be misleading and easily manipulated: "But let us enter a little into consideration, how we might distinguish between a good woman and a bad; we cannot do it by the outward show; for if we should ayme our judgements but according to their lookes, we might sometimes thinke the old painted face of *Proserpina* to be the same that is was, when she first became to be *Plutoes* wife."[60] Not only does makeup sever the link between women's internal characters and external shows, it also marks the borders of gender. If "the surface of the body is a site for the display of difference,"[61] the early modern cosmetic culture acknowledges with anxiety the possibility that men, through painting, might become feminized, even as painting women might assume a creative and self-creative authority ordinarily reserved for men. Gionnozzo's report implies that his unassuming wife may have dared to assume this right of self-creation and that her husband may have remained entirely unaware.

Women's painting, then, threatens not only men's control over women but the very terms on which that control is established—that is, men's superiority as demonstrated by the equation of women's internal weaknesses with the frailties of the female body. A central assumption of Alberti's project of wife taming, one employed repeatedly throughout the cosmetic debate, is that women must be

molded and given shape by the creative intellect of men. Women are, in essence, matter upon which men impose form. Rich suggests this when he argues that women, rather than men, must beware the hazards of painting "because as women are more flexible, and therefore more apt to be seduced to ill, so they are more tractable againe, and therefore more easie to be induced to vertue." He concludes optimistically, "There is more possibility to reclaime ten ill living women, to a conformitie of a better life, then to reforme one misliving man."[62] The more pessimistic, and more common, view was that the painting woman dared to usurp the privileges of masculinity by molding and fashioning herself. While clearly a debased version of masculine rule, devoted only to the body rather than the soul—a material painting rather than the spiritual art imagined by Tuke—women's self-fashioning threatened, chiefly by *impersonating*, masculine creative sovereignty and natural superiority.

This image of malleable woman imprinted by man informs both the cosmetic debate and discussions of the art of painting, in which it guides theories of the relative merits of *disegno* and *colore*. Derived from the Aristotelian precept that, as Patricia Reilly summarizes it, "form, or the idea in its ideal state, is equated with the male . . . [while] matter is subservient to form, merely fleshing out the divine world of ideas,"[63] the dichotomy posed challenges for women artists during the period.[64] As Fredrika Jacobs has shown, thanks to the gendered division of form and matter, theorists commonly assign to women the ability merely to copy, rather than to improve upon, nature. Thus, portraiture was considered the genre at which women painters, lacking the creative *ingegno* of male artists, might excel. As Giovanni Battista Armenini put it in *De veri precetti della pittura* (1586), "poiche da mediocre ingegno può esser posseduto à bastanza, tutta volta ch'egli sia prattico ne' colori" ("even an artist of mediocre talent can master this art as long as he is experienced in colors").[65] Moreover, given that "la Pittura esser femmina et il Disegnio maschio" (Painting is feminine and Design is masculine), as Pietro Testa claims,[66] color requires the restraint and order provided by the masculine creativity embodied in design.[67] Thus, it is the male painter's task to subdue the seductive qualities of *colore*. As a result of these concepts, the works of women artists, who were deemed incapable of exercising the intellectual control of *disegno*, were subject to interpretations that emphasized the unmediated imitation of nature and direct expression of women's essential natures and passions.[68] Vasari presents Bolognese sculptor Properzia de' Rossi, the only woman to appear in the first edition of the *Vite* in 1550,[69] first and foremost as a woman in

love whose unrequited passion reveals itself in her major work, *Joseph and Potiphar's Wife*. Vasari reports:

> Nel quale ella finì, con grandissima maraviglia di tutta Bologna, un leggiadrissimo quadro, dove perciochè in quel tempo la misera donna era innamoratissima d'un bel giovane (il quale pareva che poco de lei si curasse), fece la moglie del maestro di casa di Faraone che, innamoratosi di Josep, quasi disperata del tanto pregarlo, a l'ultimo gli toglie la veste d'attorno con una donnesca grazia e più che mirabile. Fu questa opera da tutti reiputata bellissima et a llei de gran sodifazzione, parendole con questa figura del vecchio Testamento avere isfogato in parte l'ardentissima sua passione.

> [She completed a most graceful panel, to the great amazement of all Bologna— since at the time the poor woman was very much in love with a handsome young man who, it seemed, cared little for her—in which she carved Potiphar's wife, who, having fallen in love with Joseph and almost desperate after so many entreaties, finally takes off her clothes before him with a womanly grace that is more than admirable. This sculpture was deemed most beautiful by everyone, and it gave her great satisfaction, since with this figure from the Old Testament she felt she had expressed in part her own most burning passion.][70]

Imagining the woman artist to be incapable of crafting a work of pure invention, Vasari refers the panel to De' Rossi's personal experience, conflating artist and subject and interpreting Potiphar's wife as a self-portrait of the desperate sculptor.[71] As Jacobs has argued, moreover, Vasari portrays De' Rossi as a victim of "erotomania," a specifically feminine form of melancholia understood to be devoid of the creative genius associated with male melancholia during this period.[72] Even in her despair, the female artist could only remain on the surface of things, copying the debased images that reflected her own inferior nature.

Following critics such as Jacqueline Lichtenstein, Patricia Reilly, and Philip Sohm, who align attitudes about feminine self-creation in the early modern cosmetic debate with those attending discussions of the art of painting proper,[73] these chapters describe a feminist intervention by women artists that foregrounds the constructed quality of gender when viewed through the lens of painting. My contributions to art historical criticism are to demonstrate how the dynamics of the cosmetic debate illuminate women artists' self-representations and, beyond this, to align these visual works with texts by women writers that engage the cosmetic debate in similar ways and deploy similar strategies for authorial self-

fashioning.[74] Although Bartky argues that "painting the face is not like painting a picture,"[75] for the woman artist, negotiating restrictions on feminine creativity advanced by the cosmetic culture and in theoretical discussions of the arts, the two acts may be more similar than they appear. Because the judgments and mandates of the early modern cosmetic culture and those of connoisseurs and consumers of women's writing and painting during the period rest upon shared assumptions about women's nature and their creative capabilities, "gross imbalances in the social power of the sexes,"[76] integral to the cosmetic culture, also attend the creation and the reception of women's works. Through various approaches to the subject these chapters assert that painting, in both of its senses, can constitute a gesture of feminine control over the mirror and its reflection.

This study locates the intersection of painting and femininity in a number of works by men and women, in different media and from different countries of origin. I employ comparative, interdisciplinary principles to approach the cultures of early modern Europe as they are reflected in disparate texts and visual arts emerging from a wide-ranging temporal period (roughly two centuries) and a far-reaching geographic area (from Catholic Italy to Protestant England).[77] In doing so, I share the comparative perspective delineated by Clayton Koelb and Susan Noakes that sees literary (and, I would add, artistic) activity "as involved in a complex web of cultural relations," and I concentrate on the figure of painting to negotiate and describe this network.[78]

The juxtapositions of works, authors, and national cultures undertaken in these chapters may strike some readers as going beyond what is generally deemed advisable for historically based criticism, daring imprudently "at one slight bound [to] o'erleap . . . all bound."[79] I maintain, however, that moving freely, although far from arbitrarily, from Italy to France to England, and from literary to visual works, can remind critics of the early modern period (myself included) of the extensive, dynamic culture of the Renaissance: an international cultural movement whose documentation—or, perhaps more correctly, celebration—occupied nineteenth- and early-twentieth-century critics and admirers of the period.[80] The primacy of this concept has been eclipsed by more recent critical approaches, chiefly new historicist, that view individual texts and artworks within limited temporal (usually synchronic) and geographic (occasionally national but most often more narrow regional, civic, or local) contexts. Rather than advocating a return to an antiquated, laudatory approach to the period, I utilize painting to trace the outline of a body of works, attitudes, and practices that, consid-

ered in its entirety, constitutes a background against which local gestures take on new meaning and novel relationships among discrete texts, discourses, and artworks are revealed. This involves shifting my primary focus away from issues of geographic, chronological, or intertextual influence in order to delineate a coherent, sustained conversation on gender, performed by different voices in different tongues and registers, as they construct masculinity and femininity in relation to painting.[81] Remaining mindful of the diverse and dialogic qualities of early modern cultures, and of the unfinished, progressive natures of identity and subjectivity in the period,[82] I seek connections across national and disciplinary borders that illustrate diverse commentaries on and performances of gender. Conversely, these connections underscore the consistency and frequency of some constructions of identity through men's and women's relationships with the material practices of painting. Such an interdisciplinary approach, which encompasses a wide range of texts, objects, and practices, can augment partial views of early modern subjectivity resulting from highly specific approaches to literary, artistic, and cultural texts.[83]

In moving across national borders, this book revisits the remains (if not necessarily resurrecting the spirit) of an earlier scholarly project devoted to describing the progress of the *translatio studii* across Renaissance Europe. In some measure both the early modern cosmetic debate and theories of the art of painting, as they unfolded across the Continent and in England, offer textbook examples of the translation of classical studies. Derived from a small core of classical and patristic works, pro- and anti-cosmetic texts appeared first in Latin before being translated into the vernacular languages, with many Italian works receiving translation into French and English in turn. Classical sources on the art of painting followed a similar line of transmission, their commonplaces reiterated by Italian, French, and English authors over the course of several centuries.[84] Indeed, the repetitions of anti-cosmetic invectives could be seen, by the seventeenth century, as grounds on which to reject these works: John Gauden's *Discourse of Artificial Beauty* (1656) challenges the authority of invectives by pointing out that "the number of mens names" in the chorus condemning painting far surpasses "the weight of their reasons."[85] Although the body of texts constituting the early modern cosmetic debate and the related corpus on the art of painting rely upon basic ideas of representation and self-representation gleaned from a small number of classical core texts, their transmission invariably bears the traces of the political and cultural climates in which they were received. Such cultural distinctions, in fact, illustrate the multinational character of Renaissance

culture and support my assertion that the meanings of early modern texts, art-works, and material practices cannot be fully understood when interpreted only on the parochial level, without reference to aspects of the more general culture, in all of its diversity, informing them. The works themselves reflect their authors' recognitions of the cultural conditions of reception—conditions that, in turn, bespeak material and practical differences in women's relationships to painting in early modern Italy, France, and England. Thus, for instance, Tuke at once relies heavily upon an English translation of an anti-cosmetic invective by Span-iard Andres de Laguna and distinguishes between Englishwomen's unacceptable but manageable painting and the ungovernable "Italianate" practices of Catholic women, whose disguises transform them into "Romish *Jesabel*[*s*]."[86] Rather than eliding these distinctions, I respect and utilize differences among representations of painting in order to describe early modern cultures' shared and disparate per-ceptions of how women come into being through their manipulations of the materials of cosmetic self-creation.

This book argues, then, that comparison and interdisciplinarity are funda-mental to understanding local instances of the gendering of early modern paint-ing and to connecting the concerns of the cosmetic debate to more general attitudes about femininity and women's capacities for self-expression and self-creation during the period. Interpreting women's works in relation to one an-other and to the dominant, male-authored discourses from which they emerge, I hope to return the Renaissance to the early modern, remaining mindful that "'the Renaissance' as a nineteenth-century, retrospectively painted portrait,"[87] like any painted face, reflects both likeness and difference.

Chapter 1 examines William Shakespeare's "Rape of Lucrece" and Elisabetta Sirani's *Portia Wounding Her Thigh* through their engagements with the gen-dered arts of painting, rhetoric, and cosmetics. Against the backdrop of Sirani's funeral, with its display of an extraordinary effigy of the artist that carries the trace of her culture's complex negotiations with women's painting, I argue that Sirani's painting and Shakespeare's poem respond to the commonplaces of the early modern cosmetic culture and, in varying degrees, challenge its disciplinary mandates. Whereas this challenge is only partially realized in "The Rape of Lucrece," which ultimately contains its heroine within Shakespeare's "rhetoric of display,"[88] Sirani's *Portia* advances the painting woman's right to self-create by emphasizing the heroine's self-mutilation as a cosmetic wound. Sirani's image is an exemplary work for the concerns of this book because it demonstrates one

means by which the feminist artist could establish the female subject by negotiating and exposing the essentialism of the early modern cosmetic culture.

Chapter 2 studies the transcript of Agostino Tassi's 1612 trial for the rape of Artemisia Gentileschi in relation to constructions of femininity in Gentileschi's paintings of Judith and in Shakespeare's juridical tragicomedy, *Measure for Measure*. Although the transcript has most often been used to infer a psychological drama enacted in Gentileschi's paintings, I read it as a documentary history of gender relations and assumptions informing both the female painter's and the male playwright's works. A brief discussion of two domestic portraits of women, by Prospero Fontana and his daughter, Lavinia, illuminates the shared concerns of the rape trial and *Measure for Measure* with women's places within and beyond the troubled household. I argue that the trial, Artemisia's Judith paintings, and Shakespeare's play all explore the intersection of painting and justice and expose the dependence of men's judgments on women's agency. Shakespeare and Artemisia both envision a newly empowered female subject, created through her control over her own specular image. Augmenting the simple, binary formula for determining women's characters, Artemisia and Shakespeare complicate conventional images of women's duplicitous characters and repair the female friendships threatened by the polarizing approach to gender current in the legal and aesthetic assumptions of early modern culture.

Together, chapters 3 and 4 consider the interplay between representations of women's painting in the cosmetic culture and Reformation discussions of idolatry and iconoclasm. Chapter 3 considers Marguerite de Navarre's two textual mirrors, *Le Miroir de l'âme pécheresse* and *Le Miroir de Jhesus Christe crucifié* in the context of Continental discussions of idolatry, on the one hand, and the cosmetic culture's gendering of vision and contemplation, on the other. I show how the frequent deployment of the image of Socrates' mirror in cosmetic texts (specifically, in Jean Liébault's *Trois livres de l'embellishment et ornement du corps humain*) renders the painting woman at once an idol, in her objectification, and an idolater, in her illicit power of self-creation. By emphasizing women's intimacy with Christ, grounded upon his relationships with women during his Incarnation, Marguerite and Lavinia Fontana both describe the female subject as discriminating and self-aware.

Chapter 4 traces Marguerite's influence in Elizabethan and Jacobean England, where John Bale's publication of Elizabeth's youthful translation of *Le Miroir de l'âme pécheresse* uses Marguerite's imagery to advance Elizabeth's legitimacy as heir to the throne and to defend Anglican iconoclasm against Catholic

idolatry. Bale's redeployment of the themes of Marguerite's first *Miroir* informs Elizabeth's iconography throughout her reign. Eight years after Elizabeth's death, Lanyer's *Salve Deus Rex Judeaorum* comments on the difficult legacy of Elizabethan imagery, tainted by its associations with idolatry and debased women's painting. Attributing to women an interpretive acuity and spiritual self-awareness approximating Marguerite's, Lanyer imagines an immaculate female subject whose intimacy with Christ repairs the troubling division between her inward state and outward show.

Finally, chapter 5 studies the vicissitudes of concepts of custom and conscience as they permeate post-Reformation and Counter-Reformation approaches to women's cosmetic self-creation. A prefatory discussion of two visual mirrors for women, by Giovanni Bellini and Titian, illustrates the legacy of the cosmetic debate's two literary genres in representations of painting women and shows how both genres rob women of interiority while enabling their male creators to engage in various cultural dialogues through the display of the objectified female form. Next, I concentrate on two English works written in moments at which the nature and sovereignty of individual conscience were particularly pressing concerns. Elizabeth Cary's *Tragedy of Mariam* embodies the commonplaces of anti-cosmetic invectives in Salome while exploring the possibility of women's self-determination and self-creation, grounded in her inviolable conscience, in the figure of Mariam. In John Gauden's *Discourse of Artificial Beauty* the conscientious defense of women's rights to cosmetic self-creation enables the construction of the female subject. Finally, I consider the interplay of custom and conscience in images of Mary Magdalen's conversion by Orazio and Artemisia Gentileschi, illustrating that the strategies for constructing female subjectivity in Gauden's work parallel those employed by women writers and artists during the period. Defending a woman's right of self-creation, these works illustrate the birth of the female subject through her negotiations with the rival demands of the countenance and the conscience.

Painting Women

Spectacle and Subjectivity

What lies in the space between a woman's makeup and her face? Implied by this question are various assumptions attending the material practice of face painting in early modern Europe and informing its meaning in sixteenth- and seventeenth-century culture. Despite the fact that some men also used cosmetics, increasingly as the seventeenth century progressed,[1] invectives overwhelmingly target only women's adornment, associating it with feminine vanity. As Nathaniel Richards writes in *The Celestiall Publican* (1630),

> A painted Face sleekt o're by cunning Art,
> Is but the Pride of a luxurious Heart
> . . . Lust, Pride, and Envie, all the sinnes that are,
> Wait on the painted Beautie falsely faire.[2]

Because early modern invectives against painting were culled from those of the church fathers (who also aggressively represented face painting as women's diabolical work), these texts contribute to the period's pervasive and multifaceted misogyny, marking its discursive and ideological foundations. Giovanni Battista della Porta offers a scathing example of the misogyny guiding both invectives

against cosmetics and instructional manuals prescribing their use when he concludes his list of recipes for *cerussa, acqua di argento vivo,* and other cosmetics with "alcune burle, che si fanno alle donne" ("Some Sports against Women"). "E cosi portremo conoscere le faccie imbelletate," he advises, "faccisi cosi: Mastica con i denti un poco di zaffarano, & accosta la sua bocca alla loro faccia ragionando, che 'l siato farà impallidire il belletto, a al farà giallicia, ma se non sarà imbellettata, non ricerverà alcune nocumento" ("If you would know a painted Face, do thus: Chew Saffron between your Teeth, and stand neer to a woman with your mouth: when you talk to her, your breath will foul her Face, and make it yellowish; but if she be not painted, the natural colour will continue").[3]

Closely associated with the painting woman's assumed vanity is the question's implication of fraud—the concern that cosmetics might disguise the face to deceive onlookers. Because the practice of face painting was feminized in early modern culture, as well as the polemics that sought to police it, the lie of makeup—the troublesome product of women's illicit self-creation—reflected women's inherent doubleness. The painting woman "had need to be *twice defined,*" Tuke moralizes, "for she is not what she seemes. And though she bee a *creature* of God, as she is a woman, yet is she her own *creatrisse.*"[4] In the distinction between the body and its ornament, feminine duplicity is literalized and defined.

Finally, the question and its multiple answers in early modern culture assert a confidence in the identifiable borders of the physical body, assuming that it is possible to determine the limits of the flesh and, accordingly, to distinguish between what belongs to the body and what is beyond it.[5] In fact, such faith is continually challenged by cosmetic practices and their interpretations. This challenge is issued on two fronts. First, the highly toxic ingredients of early modern cosmetics led critics of face painting to condemn the practice on the evidence of its damaging physical effects. Thus, Tuke quotes Andres de Laguna's *Annotationes in Discordiem*—"translated out of the Spanish," he notes, "by Mist. Elizabeth Arnold"[6]—in likening the effects of mercury sublimate to "originall sinne," passing "from generation to generation, when the child borne of them, before it be able to goe, doth shed his teeth one after another, as being corrupted and rotten, not through his fault but by reason of the vitiousnesse and taint of the mother that painted her selfe."[7] The comment indicates the second means by which perceptions of face painting blur the imagined limits of the physical body. Even as early modern cosmetics were able to penetrate the skin and corrupt the body from within, so the notion of the painting woman's "vitiousnesse" aligns

her cosmetic practices with an internal, spiritual corruption, a kind of "original sinne." Thus, Tuke explains, "as the exteriour Author of these devices is evill, even no other then the divell: so the interior grounds thereof are also evill, as pride, wantonnesse, and lacke of judgement, or else rebellion of affections against judgement."[8] What is applied to the surface of the body, then, what is "exteriour" to it, makes manifest a legion of feminine weaknesses lying within. In this respect face painting serves as a clear and compelling case study of early modern constructions of gender: women paint, the argument goes, and, *because* they paint, they reveal themselves to *be*, essentially, women.

For the female *artist* in the period invectives against women's face painting provided the terms by which her creative endeavors could be viewed as alternatively prodigious and transgressive. To the woman who moved from the privacy of her closet to the public forum of the artist's studio, who shifted her gaze from her looking glass to subjects and objects beyond it, and who applied the pigments of her trade (the same materials used in cosmetics) to the canvas rather than the body, treatises on cosmetics defined the contours of the period's resistance to the idea of feminine creativity and virtuosity. As Frances E. Dolan has shown, early modern discussions of the art of poetry and of face painting both associate female creativity with the physical and the artificial (that is, with cosmetics) in order to "reinforce the perception of its self-absorption, transience, and decadence."[9] "If the male poet can be described, however optimistically and provisionally, as creating a golden world," she explains, "his female counterpart, the '*creatrisse*,' can be depicted as brazen, both counterfeit (brass rather than gold) and shameless, presumptuous, and bold."[10] Thus, George Puttenham denigrates poetry's excessive "colours" by comparing them to "the crimson tainte, which should be laid upon a Ladies lips, or right in the center of her cheekes" but "by some oversight or mishap [is] applied to her forhead or chinne," resulting in "a very ridiculous bewtie,"[11] and Roland Fréart de Chambray's *Idée de la perfection de la peintre* (1662) personifies modern painting, "l'Idole du temps present" ("this *Idol* of the present *Age*"), as "une nouvelle Maistresse, coquette & badine, qui ne leur demande que du fard & des coleurs, pour agreer à la premiere rencontre, sans se soucier si elle plaira long-temps" ("a new *Mistress*, trifling, and full of tattle, who requires nothing of them but *Fard* and *Colour* to take at first sight, without being at all concern'd whether she pleas'd long or not").[12] Whereas these theorists on the arts deploy images of painting women figuratively, polemicists in multiple genres condemn face painting as an illicit form of imitation. Martin Cognet observes that, "as a man would judge one to be yll at ease, which weareth a plaster on his

face, or one that hath been scourged to have been punished by lawe, so doeth painting betoken a diseased soule marked with adulterie."[13] Similarly, Philip Stubbes imagines face painting as simultaneously an adulterous corruption of God's creation and an idolatrous self-love: "And thinkest thou (oh Woman) to escape the Judgement of God, who hath fashioned thee, to his glory, when thy great and more then presumptious audacicitie dareth to alter, & chaunge his workmanship in thee?"[14] Women's face painting is viewed as impersonating, and thus debasing, men's creativity in treatises on the arts and as presumptuously usurping God's creative license in invectives against cosmetics. Giorgio Vasari's *Lives of the Artists* spells out the implications of these arguments for the woman artist herself. Whereas Michelangelo stands at the pinnacle of Vasari's teleology of the arts because his "divinissimo ingegno" (most divine genius) and "sì maravigliosa perfezzione" (such marvellous perfection) surpass the slavish imitation of nature, his female contemporary Sofonisba Anguissola is praised as a faithful portraitist, because women, incapable of creating a golden world, can only hope to copy fallen nature.[15] Thus, the trait most frequently attributed to her—five times in the three-page biography—is not *ingegno* (genius) but *diligenza* (diligence). Vasari's life of the female artist ends with a (nervous) quip that deflates Anguissola's creativity by associating it with the female body's reproductive capacity: "Ma se le donne sì bene sanno fare gl'uomini vivi, che maravaglia che quelle che vogliono sappiano anco fargli sì bene dipinti?" (But if women know so well how to make living men, what marvel is it that those who want to do so are also so able to create them in painting?)[16]

This chapter follows these difficult negotiations with the painting woman into three works—the spectacle of Elisabetta Sirani's funeral in Bologna in 1665, Shakespeare's narrative poem "The Rape of Lucrece," and Sirani's painting *Portia Wounding Her Thigh*—each engaging early modern discourses on cosmetics, rhetoric, and painting that commonly "construct the display or spectacle as feminine and the spectator as masculine."[17] Each, accordingly, casts gender as a function of subjects' engagements with artistic and/or linguistic conventions and explores the alliances between inward and outward states and between private experience and public performance implicit in and troubled by women's painting in both of its senses. Each uses the painting woman to guarantee the author's creative sovereignty in his or her medium. The memorials following Sirani's death both celebrate the female artist's virtuosity and contain her exceptional powers of self-authorship within masculine rhetorical virtuosity. "The Rape of Lucrece" also explores this masculine "rhetoric of display" as mani-

fested in men's and women's encounters with pictorial and rhetorical conventions.[18] Like Sirani's eulogists, Shakespeare complicates the terms of anti-cosmetic invectives, but he goes beyond them by demonizing masculine colors and establishing feminine self-representation as a model for the male poet's work. Finally, in Sirani's *Portia Wounding Her Thigh* both the heroine and her female *creatrisse* claim a virtuosity that defends the painting woman's authority to create and self-create using the pigments of her trade.

My point in seeking characteristically masculine and feminine approaches to painting in these works is not to argue that Sirani's sex definitively alters her treatment of her subject or that Shakespeare and Sirani's eulogists, as men, inevitably place their female subjects in predictable gender categories current in early modern culture. Instead of linking their positions to essentially male or female points of view, I offer a spectrum of responses to the figure of the painting woman based upon their authors' encounters with the conventions of painting. The works of Sirani's eulogists mark one extreme on this spectrum, Sirani's *Portia* occupies the opposite extreme, and Shakespeare's poem stakes out a middle ground between the poles at which feminine self-authorship is alternatively denied and affirmed. I plot the coordinates of early modern culture's more or less feminist treatments of the image in response to these encounters with generic and discursive models, rather than in connection with the sexes of their authors. In its self-conscious manipulation of the commonplaces attending painting, Sirani's *Portia* provides an emblem of the strategies for self-authorship undertaken by the painting women studied throughout this book. The image exposes the fiction of an essential femininity on which the early modern cosmetic debate proceeds and, in doing so, stages Sirani's performance of femininity and her assertion of the female painter's powers of self-creation.

When Elisabetta Sirani died at the age of twenty-seven, Giovanni Luigi Picinardi, prior of lawyers of the University of Bologna, lamented her in terms that objectify her as an icon of Bolognese identity and self-praise: "Piange il Reno di Felsina, e sul di lui nobil margo deploro ancor'io lo scorno della Natura, il prodigio dell'arte, la gloria el Sesto Donesco, la Gemma d'Italia, il Sole della Europa, ELISABETTA SIRANI" (The Reno of Felsina weeps, and on its noble banks I too deplore the shame of Nature, the prodigy of art, the glory of the Female Sex, the Gem of Italy, the Sun of Europe, Elisabetta Sirani).[19] The daughter of painter Giovanni Andrea Sirani, Elisabetta was an extraordinarily prodigious painter, producing nearly two hundred works in a career that spanned only a decade, sup-

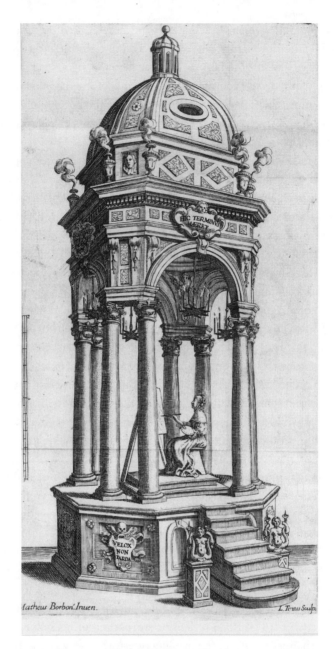

Fig. 2. Catafalque of Elisabetta Sirani from Giovanni Luigi Picinardi, *Il Pennello Lagri-mato* (Bologna: Giacomo Monti, 1665). By permission of the British Library, shelf mark 72.i.16.

porting her family when her father succumbed to gout, and opening a success-
ful school to train women painters, including her two sisters, Barbara and Anna
Maria.[20] Although Sirani was buried on August 28, 1665, next to Guido Reni in
the Church of San Domenico in Bologna, an elaborate funeral took place six
weeks later, on November 14. For the occasion the church was hung in black
and decorated with wreaths and shields bearing emblems and devices: one, for
instance, showed "un'arbore carco di frutti, con una acetta che lo tronca" (a tree
laden with fruit, with an axe cutting it off), with the motto *Invidia Manus*.[21] In
the middle of the nave a catafalque of imitation marble representing the Tem-
ple of Fame was erected ("alta, e nobile Machina fabricata di finti marmi, rapp-
resentante il Tempio dell'Honore") (fig. 2).[22] There "si mirava la Statua al Nat-
urale di detta Signora Sirani maestosamente sedente nel mezzo di detto Tempio
in atto di dipingere" (one observed the lifelike statue of the said Signora Sirani
majestically seated in the middle of the said Temple, in the act of painting).[23]
The publication of Picinardi's funeral oration, *Il Pennello Lagrimato* (*The Lamented
Paintbrush*), shortly after the event ensured the immortality of the spectacle and
its participants as well as that of its dedicatee.

Some of the celebrity surrounding Sirani's death was due to its mysterious cir-
cumstances. Following a series of complaints of stomach pains for which she was
treated throughout the summer of 1665, Sirani fell ill and died in August. An
autopsy revealed the apparent cause of death to be "materia velenosa e corro-
siva" (poisonous and corrosive matter) and led to the arrest of the family's maid-
servant, Lucia Tolomelli.[24] Despite the lack of clear motive (which gave rise to
the theory that Tolomelli was employed by an *invidia manus*, a jealous painter),
a trial ensued, resulting in Tolomelli's banishment from Bologna.[25] Although the
maidservant was subsequently pardoned, Sirani's "fine oscura e tragica" (obscure
and tragic end),[26] following her extraordinary career, won her a place in the city's
pantheon: when Sirani's contemporary and mentor, Carlo Cesare Malvasia, pub-
lished his *Felsina pittrice* in 1678, the survey of Bolognese painters culminated
with the brief life of this "Pittrice Eroina," a literal counterpart to the feminine
Felsina pittrice (*Bologna-as-Painter*) of the volume's title.[27]

In Sirani's apotheosis following her death, one can detect resonances of her
culture's conflicted relationships with the female artist and with women engaged
in the more mundane practice of face painting. At the center of the ceremony,
literally and figuratively, is the effigy of the painting woman: a life-size likeness
of Sirani, probably made of wax (much like the effigies that surmounted the cas-
kets of royalty during heraldic funerals in the period), painted to resemble the

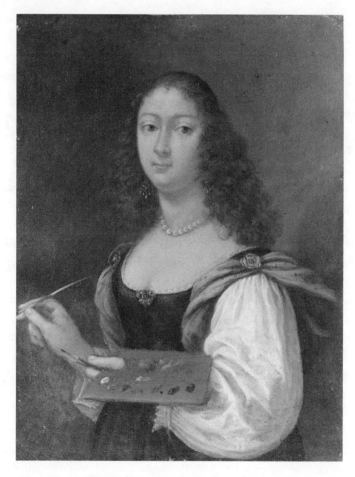

Fig. 3. Elisabetta Sirani (?), *Self-Portrait* (1660), or Barbara Sirani (?), *Portrait of Elisabetta Sirani* (1665). Pinacoteca Nazionale, Bologna, inventory no. 368.

artist in life, and eternally engaged in the act of painting. We can imagine the effigy as resembling Sirani's portrait (fig. 3), now in Bologna, probably the posthumous portrait of the artist by her sister, Barbara, praised by Picinardi in *Il Pennello Lagrimato*.[28] Here Sirani appears as a calm allegory of the art itself.[29] Painting is imagined as a gentile pursuit for the well-bred woman of which the female painter is both practitioner and personification (that is, *Felsina pittrice*). As a posthumous representation, memorializing in paint the art of painting embodied by the subject, the portrait foregrounds the material practices by which the image, the art, and the female artist are constructed.

The painted (made-up) face of the subject is the immediate product of the female painter's applications of pigments to create her sister's image, literally an image of the sister art. Thus, the subject's face makes manifest painting in both of its senses. The white skin and red cheeks and lips seem to be the products of cosmetics: the subject, Elisabetta Sirani, would have applied ceruse (white lead mixed with vinegar) to lighten her skin and fucus (red crystalline mercuric sulphide) to dye her cheeks and lips.[30] Beyond the canvas, meanwhile, the female artist, Barbara Sirani, creates and colors the image with "*Ceruse, or white lead*" ("*la biaca [o] il bianco*"), which, as Richard Haydocke reports in his translation of Lomazzo's *Trattato dell'arte de la pittura* (1584), is the chief means by which the painter manufactures white pigments *and* by which the painting woman whitens her skin. To color the cheeks and lips, they both employ "i due cenapri, cioè di Minera, & artificiale" ("*reddes* made of the 2 *cynnabars called Vermilions* Natural and Artificiall").[31] When Haydocke adds to Lomazzo's treatise two chapters based on Leonard Fioravanti's *Dello specchio di scientia universale* (1564) that, "debating the matter partly like a Physician, and partly like a Painter," explicate the ill effects of women's cosmetics,[32] he suggests the perceived equivalence between the two arts based on their shared ingredients. Physicians such as Haydocke were often involved in discussions of, and activities surrounding, the creation of artist's pigments and women's cosmetics; during this period the Latin word *pigmentum* referred to both a pigment and a drug, and colors for both arts of painting were sold at apothecaries' shops.[33] Odoardo Fialetti's description of the painter's process for making ceruse, for example, is a mirror image of Porta's recipe for the cosmetic of the same name. Fialetti instructs the painter, "To make white Lead . . . Take a Gallypot, whereinto put several small plates of clean Lead, cover them with white Wine Vinegar, cover the Pot, and dig an hole in a Cellar, where let it abide for the space of six Weeks; take it up, and scrape off the White Lead from the plates."[34] And Porta similarly advises the painting woman:

ponila in vase overe crucivolo di creta di bocca larga, e spargerà sopra aceto fortissimo . . . dopo firma sopra la bocca lamine di piombo . . . [P]er ogni quindici giorni si toglie quel coverchio, e si vede se il piombo sia anchora rissoluto, e radine sopra quello, che vi stà come fuliggine, e raso torra a coverchiare, & a ferrar le commissure, e lascia per altro tanto tempo, e fa il medesimo come habbiamo insegnato ai sovra, finche tutto il piombo sia dissoluta in cerussa.

[into a pot, or earthen vessel, with a broad mouth; pouring in the sharpest vinegar . . . then fasten a plate of lead on the mouth of the pot . . . Every fifteen days take

off the cover, and see how it is, if the lead be dissolved, and scrape the cover of all that hangs upon it, and put in the cover, anoint it all about, and let it stand so long, till all the rest be performed, as I said before, and the whole lead be turned to cerus.][35]

Considered in light of the material and metaphoric associations between the two arts of painting, Barbara Sirani's portrait presents her sister as an allegory of self-authorship in which the painting woman is the lord and owner of her face. Sirani establishes her sister's femininity, and her own artistic identity, through her self-conscious embodiment and display of the conventions of beauty, realized through the painting woman's artistry. In the specular canvas, as Picinardi suggests, Barbara sees her own creative and self-creative skills reflected in her sister's image:

E poi, che avrai la sua sembianza espressa,
Se d'esprimere ancor brami l'Idea
Del Germano valor, pingi te stessa.

[And then, since you will have expressed her likeness,
If you still desire to express the Idea
Of sisterly valor, paint yourself as well.]

Barbara's performance and self-representation, like those of her sister, valorize and authorize female creativity and virtuosity.[36]

These two posthumous portraits of the artist, the funeral effigy and Barbara Sirani's allegory of the art of painting, stand in different relationships to the problem of women's creative sovereignty addressed by the early modern cosmetic debate. This difference can be illuminated by considering two letters written by the Venetian courtesan and poet Veronica Franco and published in Venice in 1580. Together the letters explicate the positive and negative connections between the two arts of painting and women's conflicted relationships to them. In letter 21 Franco addresses the painter Tintoretto in response to his portrait of Franco, now in Worcester, Massachusetts (fig. 4):[37]

Vi prometto che quando ho veduto il mio ritratto, opera della vostra divina mano, io sono stata un pezzo in forse se ei fosse pittura o pur fantasima innanzi a me comparita per diabolico ingagno, non mica per farmi innamorare di me stessa, come avvenne a Narcisso, perchè, Iddio grazia, non mi tengo sì bella che io tem a di avere a smaniare delle proprie bellezze, ma per alcun altro fine, che so io.

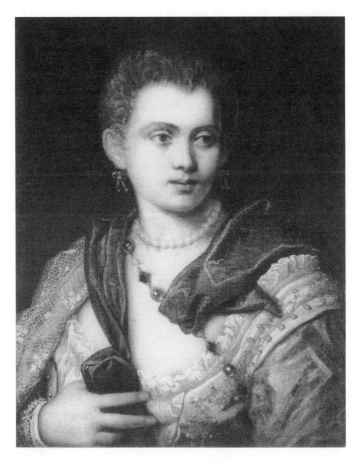

Fig. 4. Jacopo Tintoretto (attrib.), *Portrait of a Lady* (1575?). Worcester Art Museum, Worcester, Massachusetts, Austin S. and Sarah C. Garver Fund.

[I swear to you that when I saw my portrait, the work of your divine hand, I wondered for a while whether it was a painting or an apparition set before me by some trickery of the devil, not to make me fall in love with myself, as happened to Narcissus (because, thank God, I don't consider myself so beautiful that I am afraid to go mad over my own charms), but for some other reason unknown to me.]

In the letter immediately following, Franco admonishes a mother who is forcing her daughter to become a courtesan:

Dove prima la facevate andar schietta d'abito e d'acconciamenti nella maniera che conviene ad onesta donzella . . . a un tratto l'avete messa su le vanità del biondeg-

giarsi e del lisciarsi, e d'improviso l'avete fatta comparer . . . con tutti quegl'altri abbellimenti che s'usano di fare perche la merzanzia trovi concorrenza nello spedirsi.

[Where once you made her appear simply clothed and with her hair arranged in a style suitable for a chaste girl . . . suddenly you encouraged her to be vain, to bleach her hair and paint her face. And all at once, you let her show up with . . . every other embellishment people use to make their merchandise measure up to the competition.]

She concludes the letter, "Nostro Signor vi guardi col rimanervi dalla mala intenzione che mostrate avere di guastare e corrompere la fattura del vostro proprio sangue e delle vostre proprie carni" ("May Our Lord save you from your obvious intention to ruin and corrupt what you have created from your own flesh and blood").[38]

The two letters are arguably juxtaposed in the collection in order to explore the distinction and similarities between the two arts of painting, and Franco selfconsciously notes that the *diabolico ingagno* of the art of painting is one version of the courtesan's diabolical painting. Like Sirani's two posthumous images, the letters alternately celebrate the painting woman's virtuosity and register the corruption and objectification attending her illicit self-creation. Tintoretto's portrait is itself a portrait of a painting woman, displaying Franco's use of the *abbellimenti* that she condemns in her letter to the nefarious mother.[39] As such, Tintoretto's image celebrates his own artistry and Franco's mastery of her art as well; her self-mastery, which, deployed in her publications and her professional persona, enables her to perform her femininity on the public stage of Venetian society. Moreover, as Elisabetta Sirani's portrait provides a mirror for her sister Barbara, Tintoretto erects a mirror for Franco: when Franco describes herself as a self-effacing Narcissus—as a modest, feminine correction of this infamous male example of vanity and self-love—she suggests the merger of her own and Tintoretto's arts of painting. Alberti's *Della Pittura*, after all, had advanced Narcissus as a symbol of the art of painting, arguing that his specular self-knowledge symbolizes the art's concern with "representing only what can be seen" ("solo studia il pictore fingiere quello se vede"). "What else can you call painting" ("che dirai tu essere dipigniere"), Alberti asks, "but a similar embracing with art of what is presented on the surface of the water in the fountain?" ("atra cose che simile abracciare con arte quella ivi superficie del fonte?").[40] In invoking the figure,

Franco may have had in mind Tintoretto's *Bathing Susanna* (Kunsthistorisches Museum, Vienna) and *Narcissus* (Galleria Colonna, Rome), a pair of images dating from about twenty years before her portrait, which illustrates the affinities between women's face painting and the art of painting.[41] Both works represent their protagonists admiring their reflections: Narcissus gestures toward his own image in the pond, while Susanna, with the accoutrements of the painting woman before her, engages in her toilette unaware of the elders lurking nearby. In their unusual depiction of Susanna as a painting woman and their juxtaposition of her art with that of Alberti's original painter, Tintoretto's twin canvases note, as do Franco's letters, that the two arts are implicated by each other.

If Tintoretto's celebration of the painting woman's virtuosity parallels those undertaken by Barbara Sirani and by her sister's eulogists, Franco's letters make it clear that this optimistic vision of women's painting can never be wholly divorced from the debased art of cosmetics. Her address to the mother in letter 22 emphasizes the physical and moral corruption precipitated by face painting and the dehumanizing effects of the mercantile culture of courtesanship that reduces a woman to dead *merzanzia*. Franco's complaint is against the Pygmalion-like construction of the courtesan proposed by her addressee, an undertaking that, as she suggests elsewhere, is unlikely to succeed, given the girl's *mediocrità*, her limited talents and unremarkable looks.[42] Incapable of Franco's own self-creative virtuosity, the daughter will be rendered a mere object offered for sale by her mother. This objectification, of course, is an unavoidable product of the beauty culture, which, like the profession of courtesanship, displays the spectacle of the woman's body for men's estimation, pleasure, and use. Smith's *Wonder of Wonders*, for example, exempts "the Venetian Curtizans (the most impudent Harllots of all other)" from his castigation of cosmetics, since among them "the art or craft of painting or tincturing of womens faces is ordinarily used, without any sense of evil in it . . . and so by long continuance [they] may ignorantly take up and practice that fashion with impunity."[43] Unaware of the immorality of the practice, these courtesans can neither be held accountable for their sin nor be reformed. For Smith the Venetian courtesans are emblems of the most venal of feminine vices and practices, face painting included. As Franco's letter demonstrates, the objectification of women in the sexual marketplace approximates the calcifying effects of the beauty culture itself. Only the true virtuosa, she argues, can control the vagaries of the market, turning the spectacle to her own advantage. Thus, letter 21 unites Tintoretto and Franco as artists engaged in pro-

ductive self-creation, an empathetic Narcissus and his responsive Susanna, while letter 22 personifies the dehumanizing effects of the cosmetic culture in the perverse, exploitative mother.

Although the effigy central to Sirani's funeral resembles Barbara Sirani's empathetic portrait of her sister, the object inevitably associates women's painting with corruption and death. Presented to an audience that replaces the female artist before her specular canvas, the effigy forecloses on the female painter's creative sovereignty. Like the extremes of Petrarchan praise realized in the poetic blazon, the effigy literally praises Sirani to death, in Laura A. Finke's words, "killing her into art."[44] A common theme in anti-cosmetic invectives is that cosmetics both belie a woman's internal, moral corruption and hasten the corruption of her flesh. As Stubbes puts it, painting women "think their beautie is greatly decored: but who seeth not that their soules are thereby deformed."[45] The falsehood of the painted exterior is an index of "a wanton, lying hart." Thus, Tuke moralizes,

> Fucus is paint, and fucus is deceit,
> And fucus they use, that doe meane to cheat
> . . . If truth the inwards held, and governed,
> Falshood could not so shine in white and red.[46]

The moral corruption associated with women's painting figures the very real, very detrimental effects of cosmetics themselves. Fioravanti lists among the ill effects of ceruse, fucus, and other cosmetics, "i denti neri e scanati come una mula, il fiato pupzzolente, & la faccia mezza abbrugiata . . . offusca la vista, impedice l'udito, & disconcia lo stomaco" ("black teeth, standing far out of their gums like a Spanish mule; an offensive breath, with a face halfe scorched . . . dimming the complexion, dulling the hearing, and offending the stomack").[47] Tuke's image of the "vizard newly varnished ore . . . with ceruses" as besmeared with "poisons one would loathe to kiss" resonates tellingly with his subtitle: "A Treatise Against Painting and Tincturing of Men and Women: Against Murther and Poysoning, Pride and Ambition; Adulterie and Witchcraft."[48] Clearly, the poison included in Tuke's litany of moral sins and imagined as the product of painting recalls the literal poisons contained in early modern cosmetics.[49]

Interpreting these descriptions of the material and moral corruption attending face painting, Finke has persuasively argued that the painting woman implies "all the horrors, both visual and olfactory, of the putrefying corpse." By representing the futility of efforts to stave off age and decay, she becomes "a power-

ful *memento mori.*[50] The effigy of Elisabetta Sirani—the painted, memorial image of a woman painter purportedly killed by corrosive poison—functions as such a memento mori. A contemporary observer's comment that Sirani was "mourned by all . . . [T]he women especially, because she made their portraits beautiful, cannot hold their peace" ("È pianta da tutti: e le donne ancora [perche faceva belli i loro ritratti] no se ne possono dar pace") cites the artist's skill in embellishing women's faces with false colors as the essence of her artistic identity.[51] Like Vasari's biography of Anguissola, the comment relegates Sirani, as a female painter, to the relatively debased task of portraiture,[52] and it shares the notion that women's painting reflects and depicts only the physical rather than the spiritual or intellectual, the body rather than the soul. The association of Sirani's femininity with that of her subjects emphasizes not the female portraitist's accuracy (as Vasari claims for Anguissola) but her willingness, like her subjects', to employ colors to improve upon nature with counterfeit faces. Thus, Sirani is not a guarantor of her subjects' immortality through faithful reproductions of their likenesses but a coconspirator with them in the effort to defy age and physical imperfection. According to this view, such an attempt, in Sirani's painting and in that of her subjects, can only confirm the inevitable triumph of moral deformity, physical decay, and death.

Sirani's posthumous image in wax, moreover, is a material embodiment of the idea of femininity as pliable matter upon which masculine creativity impresses its defining form. From treatises on the art of painting to entries in the cosmetic debate, the gendering of form and matter aligns men with substance and women with surface. Alberti's advice to painters to "circumscribe the plane with their lines" ("agiugnimenti delle superficie") before "fill[ing] the circumscribed places with colors" ("tingono superficie") reveals, in Reilly's words, "the ornamental and supplementary role he believed [feminine] color plays in its relation to [masculine] *disegno.*"[53] Thomas Overbury's satirical portrait of *The Wife,* too, casts procreation and *cosmesis* in similar terms when he claims, "*God* to *each man a private woman* gave / . . that on her *his like* he might *imprint,*" and later applies the vocabulary of early modern art criticism to women's bodies: "Beauty in decent shape, and Colours lies, / Colours the matter are, and shape the Soule."[54] If Sirani's effigy offers a synecdoche of her culture's gendered approaches to the painting woman, it also reveals her eulogists' constructions of a difficult femininity in terms of the female painter's relationship to her masculine art. Picinardi's figurative description of Sirani as "il Sole della Europa" and his praise of "l'eccellenza del suo Pennello" (the excellence of her Paintbrush) associate her

with masculinity, particularly in the conflation of *il pene* and *il pennello*, a sala-cious pun exploited most famously by Aretino.[55] Similarly, Malvasia's post-humous praise of Sirani claims for the female painter a "manly" (*virile*) style: unlike her female precursors, Sirani "non lascio mai una certa timidità e lecca-tura propria del debil sesso" (never left in her work a certain timidity and flat-tery that is proper to the weaker sex).[56] Her posthumous association with women's portraiture in particular, then, suggests that Sirani misused her talent—perhaps as a function of her popularity among her female clientele in Bologna[57]—by por-traying merely her subjects' bodies rather than their souls. While the notion of Sirani's masculine-feminine style elevates problematic feminine painting by association with the superiority of masculine *ingegno*, her eulogists also depict Sirani as the exception rather than the rule, a "prodigio dell'arte" not to be rivaled by living female artists. As Picinardi and Malvasia enhance the stature of the deceased artist, and consequently increase the value of their own encomia, they implicitly acknowledge that "the gender of style, like that of *virtù*, is not neces-sarily determined by sex."[58]

In the city's mourning for Sirani the represented body of the painting woman—the *creatrisse* who also self-creates—becomes a cipher of the troublesome self-authorship implicit in women's painting itself. In the comfortable wake of her death, Sirani's power is appropriated by her male eulogists, while the image of the living-dead artist renders her an objet d'art, in Finke's terms.[59] The effigy underwrites the male-authored narratives predicated on its malleable form, from Picinardi's civic "pride in ownership" to Malvasia's teleological myth of *Bologna-as-Painter*.[60] For the purpose of the funeral, above all, was to celebrate Bolognese culture and its accomplishments. Picinardi's opening words thus define the sym-bolic meaning of Sirani's life story to the grieving but approving body politic:

> Chè la Citta di Bologna sia mai sempre stata, e sia Madre, e Prodottrice a 'Ingegni cospicui, & Illustri tanto del Maschile, quanto del Femineo sesso, in ogni genere di scienze, & Arte . . . fra quali nell' Eta corrente a guise di Sole, la Virtue della Si-gnora Elisabetta Sirani, risplendente a gli Occhi universali apparvia, a benche per dura sorte prima di giongere all' Auge del Meriggio, e tramontata all' Occaso nello, anno vigesimo sesto di sua Eta, nulladimeno ha ella accresciuto non piccolo raggio di gloria a questa sua Patria con l'eccellenza del suo Pennello.[61]

> [Since the City of Bologna has ever and always been either the state, or the Mother, or Producer of eminent and Illustrious Geniuses both of the Masculine and the Feminine sex, in every kind of science and Art . . . among whom in the current

Age, like the Sun, the Virtue of Signora Elisabetta Sirani appeared, resplendent to the universal Eyes, and although it was her fate to last only from daybreak to the Zenith of Midday, and to decline into the Sunset in her twenty-seventh year, nonetheless she has increased not by a little the ray of glory of this her Fatherland with the excellence of her Paintbrush.]

Although Picinardi, like Malvasia, acknowledges Sirani's possession of a masculine-feminine *ingegno*, he praises her virtue rather than her talent, describes her as a spectacle evaluated by male onlookers, and turns her legacy to the *patria*'s glory rather than her own. He subsumes Sirani's *virile* power of self-authorship within a patriarchal vision of civic ownership, while the effigy reduces her to an object; the "idoll" of face painting, in Tuke's phrase.[62] Recreating malleable femininity in his own image, Picinardi advances his, and his city's, creativity on the material, moribund power of the painting woman.

While the female painter is both exalted and controlled by the spectacle's display of her objectified form, the effigy also carries the material traces of the ideological and discursive affinities between face painting and the more orthodox coloring involved in the art of painting. The male artist engaged in coloring Sirani's effigy[63]—that is, painting the face of the painting-woman-turned-object—practices an art that is admittedly counterfeit but which nonetheless employs artifice to offer "il medesimo aspetto che rende la natura istessa" ("a true and naturall resemblence of *Life*").[64] As Jacqueline Lichtenstein has shown, the early modern debate concerning the relative merits of *colore* and *disegno* participates in a philosophical tradition "that had never separated the problematic of ornament from that of femininity." She explains: "used in excess, ornament becomes makeup, which conceals rather than elucidates truth. This distinction . . . was applied in the same manner to language and to the image."[65] Thus, theorists of both the arts of painting and of rhetoric condemn or defend colors in terms that associate artifice with women's cosmetic practices. For proponents of design-based painting, such as Franciscus Junius, the preoccupation with color constitutes "an effeminate kinde of polling and painting" ("vulsa atque fucata muliebriter comat"). He explains, "Lawfull and stately ornament ad a certaine kind of authoritie to the bodies of men, whereas a womanish and luxurious trimming doth not so much decke the body, as it discovereth the mind" ("foedissima sint ipso formae labore. & cultus concessus atque magnificus addit hominibus . . . autoritem; at mulierbris & luxuriousus, non corpus exornat, sed detegit mentem"). The overuse of "strumpet-like ornaments" ("ornamentis mereticiis"),

which he compares to "fucus and ceruse" ("fuco & cerussa"), weakens "the whole strength of our invention and designe, with the unseasonable care of garnishing the worke too much" ("Neque tamen haec eo pertinuerunt, ut in pictura nullus fit ornatus; sed ut pressior & servior, atque eo minus confessus").[66] Within the corrective context of masculine virtuosity, whether rhetorical or artistic,[67] color "ne solamente esprime nelle figure le cose come sono; mà mostra ancora alcuni moti interiori . . . ponendo sotto gl'occhi l'affettione de gl'animi; & i loro effetti" ("not onely expresses the outward formes of thinges; but also discovereth certain inward passions . . . laying before our eies, the affections of the mind, with their effect").[68] As such, the work of the male artist coloring the effigy mirrors that of the rhetorician, Picinardi, as he embellishes the memory of his female subject. The masculine re-creation of Sirani as effigy redirects the conflicted art of women's painting toward productive imitation and civic panegyric. Similarly, Picinardi's rhetoric is itself offered as the orthodox alternative to the feminine artistry both eulogized and definitively curtailed in Sirani's memorial effigy. In the spectacle of Sirani's funeral, the painting woman, objectified and displayed, ensures and enables the masculine rhetorical and artistic virtuosities that kill her into art.

If Picinardi's *Il Pennello Lagrimato* turns its epideitic prowess toward adorning and advancing the painting woman as its chief metaphor and motive, Shakespeare's "Rape of Lucrece" anatomizes and genders this rhetorical and representational strategy through a protracted meditation on painting in both of its senses. As Nancy J. Vickers has shown, the poem captures Lucrece within a masculine "rhetoric of display" grounded upon "the woman's body raped at the poem's center."[69] Collatine opens the poem by "blazoning" his wife ("to blazon, to describe in proper heraldic language, to paint or depict in colors")[70] before a male audience that includes her future rapist. His performance—motivated, as Vicker's notes, by a pride in ownership much like Picinardi's toward Sirani—initiates a descriptive poetics of which Tarquin's crime is the result: "rape is the price Lucrece pays for having been described."[71] In creating the poem as a "rhetorical display of virtuosity," moreover, Shakespeare both problematizes and masters the descriptive mode in which he engages. Shakespeare's encomium of Lucrece, like Collatine's and like Picinardi's of Sirani, is "an artfully constructed sign of identity, a proof of excellence," underwritten by the artfully constructed body of the female heroine.[72]

Lucrece is the painted effigy central to the poem that memorializes her, as Elisabetta Sirani's effigy both decorates and enables the funeral in her honor. Shakespeare, however, complicates the objectification of women common in both the early modern cosmetic culture and the Petrarchan rhetoric of praise, foregrounding each genre's reliance on masculine spectatorship to focus and define the feminine object. The result is to illustrate and eulogize the complicity of women in masculine standards of beauty and to expose the constructed quality of those objectifying standards (and, therefore, of the femininity predicated upon them). He does so, first, by treating *female* spectatorship in Lucrece's lengthy contemplation of a "skillful painting, made of Priam's Troy,"[73] as a model of feminine self-representation that guides the male poet's eye and, second, by diverting the demonized practice of face painting from Lucrece, "the picture of pure piety" to Tarquin (542). Whereas Lucrece's "true eyes have never practic'd how / To cloak offenses with a cunning brow" (748–49), the poem insists, Tarquin "doth so far proceed / That what is vile shows like a virtuous deed" (251–52).

"The Rape of Lucrece" anatomizes and explores good and bad painting and the use and abuse of colors. From its first moments the poem is obsessively concerned with colors, a term ubiquitously employed to signify the emblazoned body of Lucrece and the false motives of her attacker:[74]

> But she with vehement prayers urgeth still
> Under what color he commits this ill.

> Thus he replies: "The color in thy face,
> That even for anger makes the lily pale,
> And the red rose blush at her own disgrace." (475–79)

Six times Shakespeare synecdochically describes Lucrece through the red and white of her face, and he repeatedly imagines her "stained," "tainted," and "poisoned" body following the rape (1655, 1746, 1707). Clearly, the poem borrows its reds and whites from Petrarch but does so within a critical consideration of Petrarchism's legacy in the early modern cosmetic culture, in which these vernacular commonplaces enforce women's compliance with masculine standards of beauty. In the narrative poem and in Shakespeare's own Petrarchan exercise, *The Sonnets*, this "chiastic color scheme," as Fineman has called it, merges creation and self-creation in terms of masculine and feminine painting. Thus, sonnet 20 praises the "woman's face with Nature's own hand painted" of the poet's

"master-mistress," opposing this untainted image to "false women's fashion."[75] "The Rape of Lucrece," meanwhile, deploys these colors to join the protagonists, Lucrece and Tarquin, as "inverse versions of each other . . . [who] *together* make the rape of Lucrece."[76] Whereas Sirani's eulogists expend posthumous praise on her masculine-feminine style, Shakespeare imagines a masculine-feminine painting that challenges the cosmetic culture's casting of femininity by arguing that masculinity, too, is implicated in and defined by that culture.

By constructing Lucrece's femininity as a product of painting, Shakespeare troubles the presumed correspondence between internal state and external appearance on which moralizations of face painting rely. At the same time, he associates rival perceptions of the visible proof of inward vice or virtue with male and female spectators, presenting the resulting differences in objective or subjective responses. Thus, Lucrece, incapable of false painting, is nonetheless viewed by her maid with "fair cheeks over-washed with woe" (1225), a perception that leads the maid, Lucrece's "poor counterfeit" (1269), to weep in sympathy with her mistress. The scene illustrates women's empathetic union based upon an artless art of painting—that is, upon an "over-washing" that, in Lomazzo's terms, "mostra le passioni dell'animo, è quasi la voce istessa" ("expresses all the passions of [the] mind and almost the very voyce itself").[77] While this will be the model for women's painting throughout the poem, Shakespeare further observes and displays this scene within painting's artificial, objectifying terms when his male narrator reports, "A pretty while these pretty creatures stand, / Like ivory conduits coral cesterns filling" (1233–34). Finally, he revises the notion of woman as malleable matter, man as defining form, to claim for women a guilelessness that shames men's falsehood:

> For men have marble, women waxen minds,
> And therefore are they form'd as marble will;
> The weak oppress'd, th'impression of strange kinds
> Is form'd in them by force, by fraud, or skill.
> Then call them not the authors of their ill,
> No more than wax shall be accounted evil,
> Wherein is stamp'd the semblance of a devil.
>
> Their smoothness, like a goodly champaign plain,
> Lays open all the little worms that creep;
> In men, as in a rough-grown grove, remain
> Cave-keeping evils that obscurely sleep.

Through crystal walls each little mote will peep;
 Though men can cover crimes with bold stern looks,
 Poor women's faces are their own faults' books. (1240–53)

This insistence on women's malleable characters and the transparency of their faces exonerates Lucretia, and women in general, from the suspicion of veiling "a lying, wanton hart" with a painted face. Rather, feminine painting in the poem is an exercise in empathy, mirroring, and imagining the self as other. The poem describes the creation of the female subject in a specular relationship with other women—a subjectivity that male observers, in the poem and beyond, inevitably objectify.

Shakespeare's exploration of feminine subjectivity in connection with painting also occurs in cosmetic recipe books, in which it defends not the women's innate honesty but their right to employ cosmetic artifice. In other words, the gesture ultimately *displaces* the female subject with the objectifying standards of feminine beauty. Thomas Jeamson's *Artificiall Embellishments* (1665), for example, argues that "the *Soule* that better part of Man, when it becomes Tenant to the Body, should have it not a *Prison* but a *Palace*, a *Lodging*, whose structure and superficiall Ornaments might make its Pilgrimage pleasant, and invite its stay."[78] Jeamson's departure from the moralized interpretations of women's face painting common in anti-cosmetic invectives is clear in this audacious rewriting of the spiritual commonplace of the soul's imprisonment in the flesh. To prove that the fleshly palace, adorned by women with the superficial ornaments of painting, is to be preferred to the prison, the author offers "Roman *Lucretia*, whose braver Spirit, had for its lodging a *White-hall*, sutable to its *Grandure*, I mean her body." He favorably compares her to "*Socrates* whose *Royall Soule* was condemn'd to the *Prison* of a crooked or mishapen body."[79] And, to explain his appeal to female readers in particular, Jeamson claims: "all Bodies not being equally capacitated for its impressions, it [Art] usually imploys its skill about the Female Sex; whose soft and pliant earth, Nature works with a more carefull hand, to make it a thriving soile for the tender plant of Beauty; so that it slights Men, and casts them by, as Canvace too course and rough to draw thereon the taking lineaments of a cleare and smooth-fac'd *Venus*."[80] Although cosmetic recipe books, like Jeamson's, remove cosmetic practices from the moral turpitude with which they are associated by anti-cosmetic polemicists, their assertions of women's agency in crafting their appearances are vexed by their coetaneous mandates that women conform to prescribed standards of beauty. Ostensibly empowering women to

self-create, *Artificiall Embellishments* actually contains and objectifies them within an understanding of feminine beauty as valuable only insofar as it pleases male onlookers. Thus, Jeamson adapts the imagery of women as pliable matter to literalize their value according to their conformity with cultural standards of beauty: "those whose bodyes are dismist natures *press* with some *errata's*, and have not the *royall stamp* of Beauty to make them *currant coyne* for humane society, make choice of obscurity."[81]

Shakespeare releases Lucrece from the suspicion of fraudulent self-display according to terms borrowed from discussions of painting current in his culture. His adaptation of the works of the cosmetic debate exposes their regulatory goals, equating them with the sexual and oratorical violations of Lucrece enacted by and within his poem. Recognizing that the painting woman necessarily connives in the disciplinary practice that renders her a spectacle for men's perusal, Shakespeare stops short of granting creative sovereignty to his heroine. Instead, he emphasizes Lucrece's fatal complicity in the standards of beauty permeating his poem and his culture. Moreover, he qualifies the poem's rhetoric of display by imagining Lucrece's self-display before painted mirror images, alternative versions of painting women similar to Barbara Sirani before the image of her sister and Veronica Franco before Tintoretto's portrait. "The Rape of Lucrece," therefore, employs the discourses of painting, on the one hand, to contain its female protagonist within the poem's objectifying rhetoric and, on the other, to explore the potential of feminine painting, understood as self-authorship accomplished through Lucrece's empathetic encounter with the art of painting, as a model for poetic creation. An artful blazon of Lucrece as Tarquin gazes upon her accomplishes the former (386–413), while the *ekphrasis* of the Trojan scene undertakes the latter (1366–1582).

By staging masculine spectatorship of the objectified female form—rendering woman a smooth, compliant "canvace"—the blazon presents a gendered counterpart to the *ekphrasis* later in the poem. The blazon casts Lucrece as a painted effigy while relentlessly foregrounding its self-conscious artistry. Shakespeare vividly emblazons Lucrece's "lily hand" resting beneath her "rosy cheek" (386); the other hand, "perfect white" upon a "green coverlet," "showed like an April daisy on the grass" (393–95); her eyes are "marigolds" (397); her hair is "golden threads" (400); and her breasts are "like ivory globes circled with blue,/ A pair of maiden worlds unconquered" (407–8). Perusing this objet d'art, Tarquin is filled with desire: "With more than admiration he admired/Her azure veins, her alabaster skin,/Her coral lips, her snow-white dimpled chin" (418–20).

The experience of reading this passage is reminiscent of that of numerous passages in early modern treatises on coloring, in which the pigments' enumerations visually displace the sense of the language itself in accidental contests between the sister arts, painting and poetry:

Ad oglio si consano, per bianco, la biacca, per giallo, tutti i gialdolini . . . per turchino tutti gl'azzuri, & alcuna sorte di smalti; per verde, il verde rame, il verde santo; per morello, quel di ferro, di cilestro, & l'endico, per rosso quanti cene sono; de' sanguinei, tutte le lacche; de' ranzati il minio, è l'oropimento arso, di color d'ombra tutti i narrati d'essa; & di nero, tutte le sorti.

[These colours are to be used in *Oyles*; of *whites white lead*; of *yeallows* al sorts . . . Of *Blewes* all the *azures*, & some kind of *smalts*. Of *Greene, Verdigrease*, & *pinke*: of *Murries*, that of iron, *skiecolour*, & *Indico*. Of *Reds* all sorts; of *Sanguin*, all *lakes*. Of *Orange-tawny red lead*, and *burnt orpigment*. Of *shaddowes* all that are named. And of *Blackes* all sortes.][82]

Shakespeare's poetic colors, applied to and creating the body of Lucrece, exploit the traditional strategies of *ekphrasis* that advance poetic virtuosity by augmenting and surpassing the merely visual experience of painting with the semiotic nuances available in language. The blazon, like Picinardi's enumeration of Elisabetta Sirani's virtues, translates Lucrece from animate being to inanimate object,[83] gendering the viewer of this highly crafted spectacle as male and, not incidentally, as threatening both ocular and sexual violence. In doing so, Shakespeare implicates masculine spectatorship, including its Petrarchan and rhetorical legacies, and opens a space in his poem for describing a feminine alternative.

The rivalry between the sister arts is most apparent in "The Rape of Lucrece" when Shakespeare and his heroine digress to blazon the "skillful painting" of Troy."[84] While clearly an exercise in poetic virtuosity for Shakespeare himself, the *ekphrasis* also places the female observer before the work of art, where she is further observed by the male narrator in order to explore and expose the "regime of vision" governing the poem throughout.[85] If Tarquin's, and Shakespeare's, invasive anatomy of Lucrece renders her an object, a painted effigy, Lucrece's engagement with the scene of Troy sets off a series of affective, empathetic correspondences between women—Lucrece, Hecuba, and Helen—that resonate with the early modern literatures of painting. Lucrece's meditation upon the Trojan scene is prompted by her initial identification with Helen as a victim of rape (1369): "To this well-painted piece is Lucrece come," we're told, "To find a face

where all distress is stell'd" (1443–44). Yet Shakespeare and his heroine are both quick to distinguish between Lucrece, "the picture of pure piety," and the painting woman, Helen. "Show me the strumpet who began this stir," Lucrece exclaims, "That with my nails her beauty I may tear" (1471–72). It is, rather, the figure of "despairing Hecuba" with whom Lucrece identifies and in whom she finds her sorrow mirrored (1447). In opposing Helen to Hecuba, the poem echoes early modern treatises on the art of painting, which frequently recommend such binary pairs to create "copiousness and variety" ("copia et varietà"), as Alberti puts it, in painted *istorie*.[86] Moreover, the passage adopts the language and imagery current in various discourses of painting by returning to the original painting woman: as the Greek story went, Helen was the first mortal to use the cosmetic arts, the knowledge of which Paris had purloined from Venus.[87] Bartas's *La Judit* (1574), for instance, complains against the fraudulent craft that transforms a Hecuba to a Helen: "Vous dont l'art et le fard, dont les perles d'or / De la femme à Priam font la soeur de Castor" ("Ye who with riches art, and painted face, / For Priam's wife put Castor's sister in place").[88] While Hecuba is the matronly correction of the strumpet Helen in Shakespeare's *ekphrasis*, Jeamson deploys the familiar pair to encourage women's self-creation through painting: "Though you may look so *pallidly* sad, that you would be though to be dropping in your *Graves*; and though your skins be so devoid of colour, that they might be taken for your winding sheets; yet these *Recipe's* will give you such a rosie cheerfulnes, as if you had new begun your resurrection. They are the handsome Ladies *Panacaea*, of such efficacy that they will teach you creatures of mortality to retrace the steps of youth, and transforme the wrinkled hide of *Hecuba* into the tender skin of a tempting *Helena*."[89] Through the judicious use of cometics, he assures his female readers, "There is none of you but might equallize a *Hellen*."[90]

As she is described by Shakespeare, however, Hecuba embodies the painting woman as memento mori, her own emblazoned effigy:

> In her the painter had anatomiz'd
> Time's ruin, beauty's wrack, and grim care's reign;
> Her cheeks with chops and wrinkles were diguis'd,
> Of what she was, no semblance did remain.
> Her blue blood changed to black in every vein,
> Wanting the spring that those shrunk pipes had fed,
> Show'd life imprison'd in a body dead. (1450–56)

The image resonates with the language of anti-cosmetic polemicists as they describe the living death of the painting woman: "To what may I a painted wench compare?" asks Thomas Draiton, "She's one disguized, when her face is bare. / She is a sickly woman alwaies dying. / Her color's gone, but more she is a buying."[91] In her age and brutal sorrow Hecuba appears in the *ekphrasis* as the painting woman unveiled, her physical deformity depicted by the imagined author of the scene and further emblazoned in Shakespeare's verse. Ironically, however, this external deformity reverses the assumptions of anti-cosmetic invectives by indexing Hecuba's moral virtue rather than her apparent viciousness. Thus, Bartas's description of the painting woman unveiled, translated by Tuke, shows affinities with Shakespeare's portrait of Hecuba:

> With hollow yellow teeth, or none perhaps,
> With stinking breath, swart cheeks, & hanging chaps,
> With wrinkled neck, and stooping as she goes,
> With driveling mouth, and with a sniveling nose.[92]

"This sad shadow," Hecuba, is the mirror image of Lucrece (1457); her "counterfeit," as Edward Tylman calls the painting woman, "A shadow of [her] selfe."[93] She is, like Helen, the painting woman observed in Lucrece's looking glass, the *ekphrasis*. But Shakespeare adopts the imagery of anti-cosmetic invectives only to undermine their assumptions. By canceling Lucrece's initial identification with Helen and replacing it with her empathetic self-representation as a second Hecuba, and by doing so within a meditation upon painting and its observation, "The Rape of Lucrece" severs the reliable link between the mask of the painting woman and the character hidden beneath.

Lucrece's identification with Hecuba exposes face painting's fraudulent surface, as does Shakespeare's proto-feminist thesis, "Poor women's faces are their own faults' books," but the falsehood that is exposed is the misogynistic interpretation of women's cosmetic practices as proof of their moral corruption and deformity. Moreover, the *ekphrasis* deploys early modern condemnations of women's painting to characterize male, rather than female, manipulations of appearance in the service of fraud. Tuke's claim that "If truth the inwards held, and governed, / Falshood could not so shine in white and red" resonates with the description of "perjur'd Sinon" in the *ekphrasis* (1521). The figure of Sinon revises and reclaims the red and white "heraldry in Lucrece's face" (64), offering a masculine, demonized, example of painting to mirror Tarquin's false colors, "Whose inward ills no outward harm express'd" (91):

In him the painter labor'd with his skill
To hide deceit, and give him the harmless show
An humble gait, calm looks, eyes wailing still,
A brow unbent, that seem'd to welcome woe,
Cheeks neither red nor pale, but mingled so
 That blushing red not guilty instance gave,
 Nor ashy pale the fear that false hearts have. (1506–12)

Gazing upon this "constant and confirmed devil" (1513), Lucrece quickly makes the connection between Sinon's guile and Tarquin's, figuring masculinity as a function of men's diabolical deployment of painting's false shows:

"It cannot be," quoth she, "that so much guile"—
She would have said, "could lurk in such a look";
But Tarquin's shape came in her mind the while,
And from her tongue "can lurk" from "cannot" took:
"It cannot be," she in that sense forsook,
And turn'd it thus, "It cannot be, I find,
But such a face should bear a wicked mind.

"For even as subtile Sinon here is painted
So sober-sad, so weary, and so mild,
(As if with grief or travail he had fainted),
To me came Tarquin armed to beguild
With outward honesty, but yet defil'd
 With inward vice: as Priam did cherish,
 So I did Tarquin, so my Troy did Perish." (1534–47)

Shakespeare's brilliant staging of Lucrece's thought processes in the choreographed exchange between the male poet's interpretations and her reported speech exemplifies the poem's masculine-feminine painting and constructs feminine subjectivity as a product of the heroine's specular interactions with the painted scene.

In the fluid currencies of painting as they traverse the *ekphrasis*, Lucrece shifts from identification with Helen to Hecuba, two versions of the painting woman, and finally to Priam, the *male* observer beguiled by painted show. Throughout the episode Lucrece explicitly acts as a figure for Shakespeare the poet, augmenting the "pencilled pensiveness and color'd sorrow" of the *ekphrasis* with the virtuosity of the poet's words (1497). "The painter was no god," Shakespeare insists

(1461), to give Hecuba a voice, a deficiency of painting that its sister art repairs in Lucrece's empathetic complaints: "Poor instrument," quoth she, "without a sound, / I'll tune thy woes to my lamenting tongue" (1464–65). While Shakespeare performs his own rhetoric of display in the ekphrastic spectacle of Lucrece, the bifurcated impulses of early modern cosmetic discourses split between the poem's twin protagonists, Lucrece and Tarquin. As Lucrece becomes Hecuba, embodying the painting woman as a memento mori blazoned into art, Tarquin, as a second Helen, carries the traces of face painting's diabolical rupture between inward state and outward show. Although Stubbes argues that cosmetics are "the Devils inventions to intangle poore soules in the nets of perdition,"[94] the devil stamped on the waxen mind of Lucrece is the impress of the fraudulent *male* painter, Tarquin. "Such devils steal effects from lightless hell," Lucrece insists of "subtile Sinon" (1555). This white devil and his "sad shadow," Tarquin, perform masculinity by vividly embodying the commonplace of invectives against women's painting, "'tis hard to find / A painted face sort with a single mind."[95]

Shakespeare's preoccupation in "The Rape of Lucrece" with the incongruity between "inward ills" and painting's outward show parallels the poem's alternative versions of masculine and feminine spectatorship. These gendered relationships to display, in turn, appear in the poem as a tension between public performance and private subjectivity. While masculine scrutiny—the rhetoric of display practiced by Collatine, Tarquin, and the narrator himself—reduces Lucrece to an objet d'art, female subjectivity is constructed in the privacy of Lucrece's meditation upon the "painted images" of the *ekphrasis* (1578), a privacy itself observed by Shakespeare and displayed to the reader of the poem. Thus, the lesson that Lucrece draws from the Trojan scene is voiced in her question, "Why should the private pleasure of some one / Become the public plague of so many moe?" (1478–79). It is a question that reverberates throughout Lucrece's own story as her rape and its consequences violently usher her from private domesticity (itself penetrated by the rapist's desire) to public display: "They did conclude to bear dead Lucrece thence," the poem ends, "To show her bleeding body thorough Rome, / And so to publish Tarquin's foul offense" (1850–52). This tense intersection of spectacle and subjectivity is addressed, moreover, in the poem's opening scene, in which the narrator interjects to condemn Collatine's foolhardy showcasing of his wife's charms, the rhetoric of display that propels Tarquin toward rape: "Or why is Collatine the publisher / Of that rich jewel he should keep unknown / From thievish ears because it is his own?" (33–

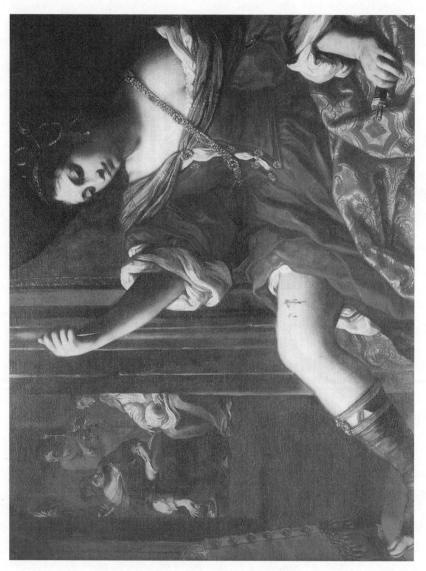

Fig. 5. Elisabetta Sirani, *Portia Wounding Her Thigh* (1664). Stephen Warren Miles/Marilyn Ross Miles Foundation, Houston.

35). Again, it is the threat of publicity with which Tarquin subdues Lucrece before the rape ("But if thou yield, I rest thy secret friend:/The fault unknown is as a thought unacted" [526–27]) and with which Lucrece, in turn, attempts to save herself from violation: "Think thou how vile a spectacle it were/To view thy present trespass in another" (631–32). Lucrece's description of her violated body as a "poisoned closet" underscores the conflation of the woman's body with private domestic space, both penetrated—thus rendered public—by the rapist (1659).[96] Whereas the scopic economy of Lucrece's male governors aggressively displays and objectifies her, Shakespeare gives us Lucrece's (qualified) privacy within which the female observer rewrites her relationship to her own objectification in the work of art and thereby underwrites the male poet's virtuosity. Lucrece's corpse, appropriated by Brutus in the poem's closing movement from rape to republic,[97] parallels Sirani's effigy as deployed in Picinardi's civic panegyric. Like Barbara Sirani poised before the sisterly and specular portrait of Elisabetta Sirani (see fig. 3), Lucrece positioned before the skillful painting of Troy demonstrates and valorizes feminine creativity and subjectivity as an affective union of self and reflected other—an unadulterated image lying behind the mask of the painting woman.

Shakespeare's quiet alignment of his own poetic project with the painting woman's self-authoring power anticipates Elisabetta Sirani's virtuoso display of this power in *Portia Wounding Her Thigh* (fig. 5). Like the ceremony surrounding Sirani's death, and like Shakespeare's poem, the painting overtly meditates upon the possibility of women's creative self-authorship and makes use of the painting woman to underwrite its author's performance of artistic virtuosity. Unlike these male-authored examples, however, Sirani's *Portia* energizes the difficult alliance between the painting woman's internal state and external appearance to challenge the divisions between public performance and private subjectivity and between masculine and feminine forms of creativity. In "The Rape of Lucrece" Shakespeare reveals the multiple genderings implicit in cosmetic and rhetorical colors and undermines the misogynistic assumptions of anti-cosmetic invectives by describing a feminine self-representation grounded in painting and its observation. But he ultimately contains this power in Lucrece's emblazoned corpse, publicly displayed at the poem's close. Sirani engages the question of women's creative sovereignty on similar terms. She, however, exploits the generic and discursive choices available in her culture's approaches to painting to imagine a feminine, and feminist, point of view on the art. She does so by exposing

and challenging the essentialism governing her culture's constructions of the painting woman.

In 1664, the year before her death, Elisabetta Sirani recorded in her "Nota" her creation of "una Porzia in atta di ferisi una coscia quando desiderava saper la conguira che tramav il marito" (a Portia in the act of wounding herself in the thigh when she desired to know the plot her husband was devising).[98] Commissioned for the private apartments of Signore Simone Tassi, "the subject belongs to a group of themes including the Rape of Lucretia which explores the relationship between public and private, often sexual, behavior."[99] According to the life of Brutus in Plutarch's *Vite* (a copy of which was included in Giovanni Andrea Sirani's library in an inventory of 1666),[100] Portia undertakes the act of self-wounding in order to prove her masculine self-restraint:

> non prima hebbe ardimento domandare al marito i segreti del suo cuore, ch'ella havesse fatta questa esperienze di se stessa. Perche pigliando un piccolo coltello, colquale i barbieri sogliono tagliar l'unghie, e cacciando di camera tutte le sue cameriere, si fece una gran ferita in una coscia, onde n'uscì di molto sangue: e di là poco quella ferita le mise addosso un grave dolore, & una terribil febre.

> [Because she would not aske her husband what he ayled before she had made some proofe by her selfe, she tooke a little rasour such as barbers occupie to pare men nayles, and causing her maydes and women to go out of her chamber, gave her selfe a great gash withal in her thigh, that she was straight all of a goare bloud, and incontinently after, as vehement fever tooke her, by reason of the payne of her wounde.][101]

Insisting that she ought "not to be [Brutus's] bedfellow and companion in bed and at borde onelie, like a harlot, but to be partaker also with [him of] good and evill fortune" ("perche io partecipassi solamente teco del letto, e della tavola, ma accioche io havessi parte teco della coseiete, e delle triste anchora"), Portia denounces womanly weakness and offers her wound as evidence of her trustworthiness and fidelity:

> Io sò, che la natura della donne è fragile a ritenere i segreti, ma io, o Bruto mio, hò in me una certa forza e di buona creanza, e d'ottima consuetudine oltra lo ingegno naturale; e mi conosco essere figliuola di Catone, e moglie di Bruto. Nelle quai cose fidandomi io prima poco, hora hò conosciuto per pruova, ch'io non mi lascierei vincere dal dolore. Dette queste parole gli mostrò la ferita, e gli scoperse la pruova, ch'ella haveva fatta di se medesima. Allora Bruto spaventato, & alzando

te mani al cielo, pregò gli Dei, che riuscendogli valorosamente i suoi disegni, lo facissero riputare marito degno di Porcia: e poi amorevolmente confortò la moglie.

[I confesse, that a womans wit commonly is too weake to keepe a secret safely: but yet, Brutus, good education, and the company of vertuous men, have some power to reform the defect of nature. And for my selfe, I have this benefit moreover: that I am the daughter of Cato and wife of Brutus. This notwithstanding, I did not trust to any of these things before: until that now I have found by experience, that no paine nor griefe whatsoever can overcome me. With those wordes she shewed him her wounde on her thigh, and told him what she had done to prove her selfe. Brutus was amazed to heare what she sayd unto him, and lifting up his handes to heaven, he besought the goddes to give him the grace he might bring his enterprise to so good passe, that he might be founde a husband, worthie of so noble a wife as Porcia: so he then did comfort her the best he could.][102]

In displaying the moment of Portia's self-wounding, Sirani focuses on the act itself as simultaneously one of self-mutilation and self-definition. Beautifully dressed, coiffed, and ornamented, her Portia is set in the well-lit foreground of the domestic scene, a space uncomfortably shared by the viewer.[103] The light emphasizes the white flesh of her face, shoulders, and the thigh exposed from the folds of her scarlet skirt. Although Sirani exploits the conventional markers of feminine beauty to stress the figure's sexuality, she also reflects Portia's self-proclaimed status as an exceptional woman, a virago, in the quasi-military sandal encircling the leg that she rests boldly on a foreshortened chair, the gold chain, a usual element of the noblewoman's *donora*, here slung like a holster across Portia's torso, and of course the small blade with which she has just penetrated her thigh.[104] Evidence that the image was originally intended as a companion piece to Giovanni Andrea Sirani's *Semiramis* further underscores, in Babette Bohn's words, "the remarkable coexistence of Portia's femininity and fortitude" in Elisabetta Sirani's hands.[105] The calm with which Portia undertakes her wounding, too, alludes to her father's and husband's philosophy of Stoicism, which she, despite her femininity, intends to adopt. Sirani thus presents Portia's attempt to overcome feminine weakness ("How weak a thing," says Shakespeare's Portia, "The heart of woman is!")[106] through self-mutilation. Furthermore, she emphasizes the heroine's self-exile from ordinary femininity by including her maidservants in the bifurcated space of the domestic scene. Set beyond the privacy of Portia's chamber, they are separated from her not only by the physical threshold through which they are seen but also by their identification with the

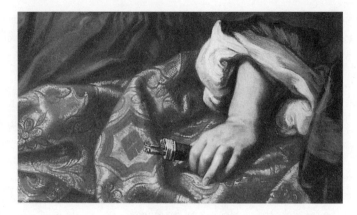

Fig. 6. Elisabetta Sirani, *Portia Wounding Her Thigh* (detail). Stephen Warren Miles / Marilyn Ross Miles Foundation, Houston.

quintessential tools of femininity, the materials of spinning. Engaged in women's work, gossiping, and oblivious to the heroic action being undertaken by their mistress, the servants, as Chadwick writes, "betray their sex by talk . . . Removed from the private world of women to the public world of men, Portia must assert her control over speech."[107] Unlike Lucrece, who, as Shakespeare's "Argument" tells us, proves her chastity when "Collatinus finds his wife (though it were late at night) spinning amongst her maids" (p. 1816), Sirani's Portia turns away from feminine pastimes toward masculine Stoicism and secrecy. She attempts to substitute one privacy for another, one subjectivity for another, in the act of self-wounding, which is also a virtuoso performance of exceptional femininity.

As Portia's maidservants deploy the emblematic objects of femininity, the tools of spinning, their mistress marks her distance from them by taking in hand a masculine tool, "un piccolo coltello, colquale i barbieri sogliono tagliar l'unghie"—in effect, a nail file. In depicting this object, Sirani turns to the material culture of cosmetics surrounding her, illustrating a typical accoutrement of the early modern *men's* toilette (fig. 6). In her left hand Portia holds a compact toilet set, from which the *coltello* has been removed and which still holds two other grooming aids. The toilet set is a smaller version of one now owned by the Victoria and Albert Museum (fig. 7). An English example coetaneous with Sirani's *Portia* (possibly a gift from Charles II to Thomas Campland), the wood and tortoiseshell case contained silver, tortoiseshell, and ivory instruments necessary for the gentleman's toilette: scissors, nail files, razors, combs, and a mirror. From mid-century women's toilet sets ("including pots for creams, glue,

patches and powder, pin cushions, brushes, snuffers, candlesticks and perhaps a silver-framed mirror") were customary gifts for wealthy brides, while their masculine equivalents were purchased, inherited, or acquired as gifts.[108] Borrowed from her husband, Portia's toilet set displaces the material objects of feminine painting with those of masculine self-definition and self-fashioning. As such, Sirani explicitly engages the cosmetic culture on gendered terms, exposing the degree to which men as well as women are implicated in its mandates and exploring the contours of its gendered form in creating her masculine-feminine heroine.

Acknowledging the gaze traditionally imposed upon women by the cosmetic culture, Sirani's Portia carries the traces of the regime of vision established by male spectatorship, which renders the female form an aestheticized object of display. Indeed, Rosika Parker and Griselda Pollock discount interpretations of the painting as "a feminist image in its portrayal of a strong woman," stressing instead Sirani's acquiescence to Reni's aesthetics, in which "women caught in . . . acts of

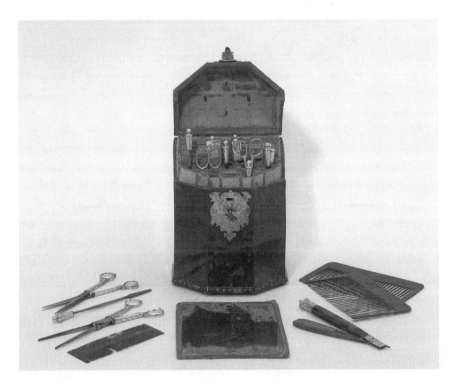

Fig. 7. Traveling toilet set (English, 1640–50).Victoria and Albert Museum, no. 720-1877.

heroism or courage, are shown to the viewer for the enjoyment of the sight of woman." They argue, "Sirani's participation in the dominant stylistic and iconographic modes of her period and city led her to represent female figures in a way which confirmed rather than disrupted the sexual ideology which the Reni mode of representation served."[109] The visually seductive qualities of Sirani's image, however, and her illustration of "the necessity for [feminine] self-mutilation,"[110] when read through the lens of painting, challenge women's mandated complicity in the self-mutilating standards of the cosmetic culture and of Baroque aesthetics. Sirani displays Portia's self-mutilation to demystify and deconstruct early modern constructions of femininity advanced according to their relationships to painting. She gives visual form to the debilitating practices of the cosmetic culture and supplements the feminine, seductive qualities of painting, in both of its senses, with the self-defining tools of masculine adornment in order to challenge this culture's assumptions. Her insistence on the centrality of the material female body—a prolepsis of her own funereal effigy—enables a feminist intervention that disrupts the transhistorical dimensions of Portia's story, turning them toward the specific, physical gestures with which her heroine negotiates masculine prescriptions for women's beauty and virtue and co-opts masculine tools of self-creation.[111] Moreover, Sirani's depiction of Portia's *masculine* virtues, focused in the heroine's manipulation of the material objects of the masculine toilette, complicates and undermines cultural prescriptions for feminine beauty, which, in turn, inform the aesthetic tenets of Renist representation.[112]

As her heroine distinguishes herself from mundane femininity through her act of self-wounding, so Sirani, too, complicates this construction of femininity by mirroring her own creativity in Portia's self-authoring act. Portia's claim to possess characteristics of both sexes and Sirani's visual allusions to those characteristics reflect the exceptional femininity of the female artist herself, a woman set apart from her sex through her mastery of the art that translates her from the privacy of the household into the public world of the artistic marketplace. Like Portia, Sirani establishes her femininity by manipulating the tools of traditionally masculine arts: the "barbers rasour" (*un piccolo coltello*) wielded by Portia is the visual and functional equivalent of the paintbrush (*il pennello*) that occupies Elisabetta Sirani's hand in her portrait as the art of painting (see fig. 3). Both tools are employed by the female virtuoso, performing a masculine-feminine subjectivity in the privacy of her chamber. Sirani's handling of her heroine further aligns Portia with Sirani's self-authorship as memorialized by her sister:

rather than portraying the "goare bloud" (*molto sangue*) that Plutarch describes as the near-lethal results of Portia's wound, Sirani depicts the gash with a delicacy that reduces it to mere decoration, a superficial wound at best. The pale red paint that constitutes the wound mirrors the sumptuous coloring of Portia's dress and the rosy shading of her cheeks and lips. In displacing the sexual wound of Lucrece's rape with Portia's highly erotic self-wounding with the tools of the masculine toilette, Sirani calls attention to the constructive, rather than destructive, power of female creativity in her story. Whereas Shakespeare's Lucrece refuses agency in her fatal wounding, insisting "'tis he [Tarquin],/That guides this hand to give this wound to me" (1722), Sirani's Portia is eager to define her own sexuality and subjectivity by marking the body's surface, inscribing her identity upon her skin, in order both to articulate and to alter the sex hidden within. *Portia Wounding Her Thigh* is, in this respect, a looking glass for the painting woman. Like the woman who employs makeup to alter and define her physical appearance, Portia and Sirani explore a woman's power and potential to self-create, self-define, and eradicate the feminine "defect of nature" ("ingegno naturale") by manipulating her own flesh. Although she practices an art of painting in which the accretion of surfaces is also a self-decapitation,[113] Sirani's decision to represent the wound in and as painting exposes the violence implicit in feminine self-adornment and supplants it with masculine-feminine self-control. Portia's wound marks the distance she travels from domestic submission to public performance and figures the early modern woman painter's journey from privacy to publicity as a self-mutilation much like that enacted by women's cosmetic practices themselves.

Sirani's *Portia* offers an allegory of women's painting, in both of its senses, that foregrounds the problematic correspondences between spectacle and subjectivity. Portia's story is one of an attempt much like that undertaken by the artistic technique of coloring, which promises, in Lomazzo's terms, "mostra . . . alcuni moti interiori . . . ponendo sotto gl'occhi l'affettione de gl'animi" (to "discover [. . .] certain inward passions . . . laying before our eies, the affections of the mind"). Portia attempts to signify her exceptional femininity, her hidden identity as a virago, by altering the material surface of the body. Sirani's painting responds to and registers Portia's subsequent career in Plutarch's history in order to anatomize the difficult alliance between internal state and outward form as it is imagined both in the art of painting and in discussions of women's cosmetic practices. For, as Plutarch reports, Portia's attempted cross-gendering is ulti-

mately unsuccessful: "she did what she could to dissemble the griefe and sorrow she felt in her heart" ("tentò di nascondere al marito i dolori, che per ciò laffligevano"), he writes:

> ma la magnanima, e generosa donna fu scoperta da una certa pittura. Il suggetto di questa scrittura era una historia Greca, cioè Hettore, che usciva di Troia, accompagnato da Andromacha; laquale haveva preso il figliuolo dal marito, e gli teneva gli occhi addosso. Veggendo Porcia questa pittura, per la somiglianza della passion si diede a piangere, e molte molte appressandosi quivi, sospirò, e pianse amarissimamente.

> [But a certaine painted table bewrayed her in the end, although untill that time she alwaies shewed a constant and patient minde. The devise of the table was taken out of the Greeke stories, how Andromache accompanied her husband Hector, when he went out of the citie of Troy to goe to the warres, and how Hector delivered her his litle sonne, and how her eyes were never off him. Porcia seeing this picture, and likening her selfe to be in the same case, she fell weeping: and comming thither oftentimes in a day to see it, she wept still.][114]

Like Lucrece, Portia identifies with a painted image of Troy and is both associated with and distinguished from her mirror image in the representation. When Brutus is informed of his wife's sorrowful self-identification with Andromache, he insists:

> Sorridendo Bruto, & io, disse, posso dire hora i versi d'Hettore a Porcia.
> A te convien pensare à tuoi filati,
> A le tue lane, e commandar le serve.
> Percioche la natura del corpo è in colpa, ch'ella non può fare attioni equali alle nostre: man con animo non merita minor lode in servigio della patria; che facciano noi.

> [I cannot for my part say unto Porcia, as Hector aunswered Andromache in the same place of the Poet:
> Tush, meddle thou with weying dewly out
> Thy maydes their taske, and pricking on a clout.
> For in deede the weake constitution of her bodie doth not suffer her to perform in shewe, the valiant acts that we are able to do: but for courage and constant mind, she shewed her selfe as stout in the defence of her country as any of us.][115]

For Plutarch, Portia's experience of the painting of Troy and her identification with the painted heroine, Andromache, reveal her inability to alter her feminine *essence:* as Shakespeare's Portia complains, "I have a man's mind, but a woman's might. / How hard it is for women to keep counsel!"[116] Brutus acknowledges Portia's movement from femininity to masculinity in leaving behind the feminine occupation and companionship of the loom, but hers is an imperfect translation. Through her spectatorship of the Trojan scene, Portia's hidden interior is indeed laid forth, and what is revealed is femininity *as* a deformity, the "weake constitution" of the female body itself ("la natura del corpo"), which prevents Portia from performing "in shewe" the valiant acts ("attioni equali alle nostre") for which men are created (the story argues) by nature. Painting is the means by which Portia's attempt to establish an autonomous feminine subjectivity in the act of self-wounding is revealed as an impossible dream: betrayed by *pittura* (the "painted table"), Portia's veneer of masculinity collapses, and her indelible essence emerges from behind the body's torn veil.

Portia's wound, in fact, is a cosmetic wound. Her story plays out the imagined moral deformity of the painting woman. Thinking to decorate the surface, Tuke and his companions insist, the painting woman corrupts the soul. Portia's story of attempted self-definition through a masculine wounding of the female flesh reveals the essentialist underpinnings of the antifeminist invectives against women's painting. The painting woman, like Portia, not only corrupts the flesh but also reveals the *essential* deformity that is femininity itself. As Sirani understood, Portia's self-inflicted wound not only parallels the physical self-mutilation enacted in women's use of cosmetics but also lays forth and exposes the internal, moral deformity of the painting woman that prompts her irreverent and idolatrous self-creation.

In Sirani's handling, however, the calm beauty of Portia's face—the product of the painting woman's colors—belies neither the "goare bloud" of the external wound nor the deformed femininity hidden below the surface. Masculine stoicism and feminine beauty both appear as false shows. Like her *creatrisse,* Sirani's Portia is poised between spectacle and spectatorship, between masculinity and femininity, to assert her right to self-definition and her sovereignty over her flesh. Sirani, like Jeamson, confirms that "deformity . . . is a *single* name, yet a *complicated* misery,"[117] but she calls attention to the constructed character of this misery, imposed upon women by men, and thereby exposes and defies the essentialist reading of femininity at the heart of her culture's discourses on painting. She imagines and illustrates in Portia the legitimate power of the painting woman

not only to counter this construction but to create herself in her own image. While Jeamson promises to free his female readers "from the loathsome embraces of this hideous Hagge [Deformity],"[118] Sirani uses her skill as a female painter to challenge the objectifying tenets of early modern anti-cosmetic invectives *and* the nascent beauty industry promulgated by cosmetic manuals such as *Artificiall Embellishments*. In *Portia Wounding Her Thigh* the painting woman— Sirani as well as her mirror image, Portia—occupies a middle ground between an objectified femininity, fixed by the male gaze beyond an impassable threshold, and a transgressive subjectivity that defines and decorates the female painter's specular image. As the painting woman inscribes her identity on the female body, she undertakes an act of self-authorship that re-creates the world in her own image.

Public Women

Female Friendship on Trial

During his trial in 1612 for the rape of Artemisia Gentileschi, the painter Agostino Tassi based his defense on offense: he denied the initial rape and the year-long sexual relationship that followed it, claiming instead that Artemisia was "a whore" ("una puttana").[1] "Three or four times, I saw [men] coming out of Orazio Gentileschi's house" ("tre o quattro volte con occasione ch'io m'imbattevo a vedere qualch'uno uscire di casa di Horatio Gentileschi"), he testified, and "once while I was passing by, I raised my eyes toward the window and saw Artemisia with her arm on the shoulder of a man" ("una volta mentre ch'io passavo di lì alzando gli occhi alla finestra viddi ch'Artimitia haveva un braccio su la spalla a quel [uomo]") (449–50; *Atti* 95–96). Tassi produced a string of witnesses from Artemisia's Roman neighborhood, traditionally the red-light district that, by papal legislation, housed most of the city's prostitutes,[2] to impugn her character: Luca Penti, a tailor, testified "that he had seen Artemisia at the window many times" ("Detta Artimitia io l'ho vista a una finestra"); Mario, a painter's apprentice, reported that "Carlo Veneziano said that he had seen her shamelessly at the window" ("il signor disse l'aveva vista alla finestra molto sfacciatamente"); and Marcantonio Coppino, "whose job it was to mix ultramarine

color" ("di fare il colore azzurro oltremarino"), affirmed that Artemisia had been deflowered many years ago, having heard so "in Antinoro Bertucci's shop" ("nel corso in bottega di Antinoro Bertucci"), where a group of painters had gathered and talked of her as "a public woman" ("[una] madonna pubblica del bordello") (480; "Appendix" 434).

Accusations such as these exploit the early modern assumption that the professional woman—in this case, a painting woman—willingly abandons feminine modesty and (most likely) chastity as she crosses the threshold from privacy to publicity. In much the same way that texts of the early modern cosmetic debate obsessively display the painting woman before male onlookers, Tassi's witnesses return repeatedly to the image of Artemisia at the window to prove her a public woman.[3] The judgments of both rely upon the evidence of a woman's immodest appearance before a censorious, but captive, male audience. An informal apprentice in the studio of her father, Orazio, Artemisia reached maturity in a porous domestic space where living and working quarters were intimately connected and to which clients, models, and Orazio's colleagues (including Artemisia's future rapist) were frequent visitors.[4] Associating Artemisia with the local prostitutes, who "attracted customers by preening in [their] window[s],"[5] Tassi and his witnesses respond to the spatial porosity of her father's house by charging her with an immorality based upon the imagined permeability of her female body, its availability to masculine observation and penetration. The charge, aided by the legacy of the trial itself, informs the oscillations between fame and infamy that attend Artemisia's career throughout her life and in her critical afterlife. Despite her illustrious career,[6] an epitaph published upon her death in 1653 chides:

> Co 'l dipinger la faccia a questo, e a quello
> Nel mondo m'acquistai merito infinito;
> Ne l'intagliar le corna a mio marito
> Lasciai il pennello, e presi lo scalpello.

> [By painting this and that likeness, I earned infinite merit in the world; but to carve horns upon my husband's head, I set aside the brush and took up the chisel.][7]

Clearly, this satire of feminine inconstancy responds to and devalues Artemisia's incongruous *merito:* her currency in the world of public accomplishment, as effectively as the misfortune of her rape, makes her vulnerable to the charge of sexual promiscuity.

This chapter argues that the transcript of Tassi's trial, Artemisia Gentileschi's painted images of a notoriously duplicitous woman, Judith, and William Shakespeare's juridical tragicomedy, *Measure for Measure*, share a common structural principle that doubles the female figure—polarizing feminine virtue and vice in terms that also underwrite the feminine duplicity assumed by the cosmetic culture—and further empowers the female witness of this specular scene.[8] Each suggests a redirection of the disciplinary gaze that fixes the painting woman before her mirror, a static emblem of feminine duplicity and guile, toward a renewed perspective in which the female subject might come into being in relation to a woman's control over her own image. Judith is an apt figure for this strategy because her story foregrounds the interaction between painting and justice that is also central to the trial and to *Measure for Measure*. Shakespeare's chief addition to the plot he inherited from his sources, the bed trick, requires the proliferation of the story's female protagonists from two to three. This addition disrupts the binary casting of the play's heroines and energizes a series of affective alliances between the triple heroines, established beyond the threshold of the play's troubled patriarchal households. It parallels Artemisia's treatment of Judith, whom she doubles in the maidservant, Abra, and further observes from her unique perspective as a female painter. By adding this third, gendered, term, Artemisia and Shakespeare revise conventional images of women's duplicitous characters and repair feminine alliances dissolved by the logic that defines women through their opposites.

Feminist criticism has long been dissatisfied with *Measure for Measure*'s apparent objectification and containment of women by and within the male point of view, rendering it a dramatic equivalent to the aggressive displays of the controlling male gaze common in Renaissance portraiture of women and in the cosmetic culture. Kathleen McKluskie's complaint against the "patriarchal bard" famously argues that "feminist criticism of this play is restricted to exposing its own exclusion from the text,"[9] while more recent critics have seen Isabella as a "sexualized, silenced woman in a scopic economy of male desire."[10] I counter this view by showing how Artemisia's triple perspective as female spectacle, spectator, and self-author parallels that of the women of *Measure for Measure*, who evade, at least temporarily, their male governors' efforts to contain them within the play's, and the period's, predictable categories of maid, widow, and wife.[11] In response to Angelo's charge in act 2, scene 4, of *Measure for Measure*, that "women are frail, too," Isabella agrees:

Ay, as the glasses where they view themselves,
Which are as easy broke as they make forms.
 . . . Nay, call us ten times frail,
For we are soft as our complexions are,
And credulous to false prints.[12]

The lines portray women as easily broken and vulnerable, like Shakespeare's
Lucrece, to false impressions but as self-defining as well—as viewing themselves
rather than being viewed and, like Judith, as capable of self-fashioning through
their manipulations of appearances, their deployment of the dyes of makeup to
imprint new faces. It is an image that pervades the play's stagings of women's
self-governing, empathetic networks and affiliations, culminating in the final
scene's tableau of female solidarity as Mariana and Isabella kneel together to
plead for Angelo's life. Like "The Rape of Lucrece," *Measure for Measure* ulti-
mately contains this power of feminine self-creation, but its rich female subjects
remain vital at the play's close, and beyond, despite their subordination.[13] *Mea-
sure for Measure* provisionally allows, and perennially resuscitates, the dream of
repairing the female alliances severed by its patriarchal law and, thereby, enables
the fragile self-definitions of its triple heroines.

I begin with a pair of portraits by the Bolognese painter Prospero Fontana and
his daughter, Lavinia, which together comment upon the cultural commonplaces
manipulated by Tassi and his accomplices in constructing their portrait of Arte-
misia Gentileschi. They also suggest one possible response by the painting woman
to these conventions, a response that, for reasons that will become clear, could
provide only a partial model for Artemisia. Prospero's *Portrait of a Lady*, in the
Museo Davia Bargellini, Bologna, depicts the private rather than public woman
(fig. 8).[14] The subject appears in three-quarter pose but modestly averts her gaze
to the right, acquiescing to the "regime of vision" that governs both Renaissance
portraits of women and the period's cosmetic culture.[15] Probably intended to
commemorate the subject's marriage, the portrait records the details of her per-
sonal adornment, the influences of fashion interjected into household space. These
details—her elegant dress, her jewelry (including a gold brooch and chain and a
pearl and ruby necklace, usual elements in the bride's *donora*), her hair, restrained
in the style proper to married women, and her red and white complexion, con-
forming to cosmetic mandates for feminine beauty—emphasize her status as a
virtuous wife. The flowers on the table, too, symbolically reflect her virtues.[16]

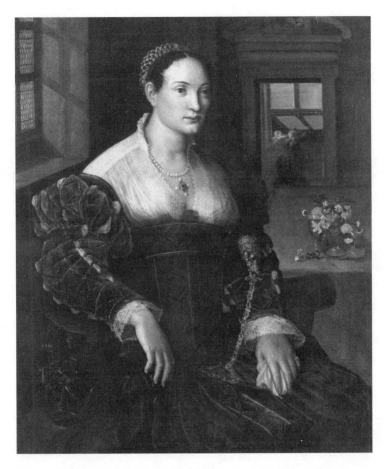

Fig. 8. Prospero Fontana, *Portrait of a Lady* (1565–70). Museo Davia Bargellini, Bologna, inventory no. 387.

The lady's placement within the household enlists the elements of domestic architecture to articulate her character. In a background vignette two female servants open or close a large window, while on the extreme left, a second window—rectangular, leaded, composed of opaque glass[17]—illuminates the subject from behind. Exploiting "the analogy between the house and the body,"[18] Prospero equates feminine chastity with household honor. To display this equation he deploys the symbolism of the window, current in both sixteenth-century Bolognese culture, which "explicitly forbade the lady from appearing at or near a window,"[19] and Renaissance artistic theory. Prospero doubles his subject in the female servants, vulnerable to observation at the open window, while the lady

herself appears at a safe distance and turned away from a window that admits light but not sight. Unlike Artemisia, branded a public woman by her reported performances in the proscenium of the domestic window, Prospero's lady is defined by and defines the impenetrable household. If visual accessibility implies sexual accessibility for Artemisia's accusers, the window symbolizing the open body of the public woman, Prospero guarantees his lady's chastity with her represented and devalued opposites, her objectification as an emblem of domestic and marital enclosure, and the portrait's foreclosure on the illicit gaze of the viewer or the lady herself. At the same time, as Joanna Woods-Marsden has suggested of Quattrocento portraits of women, the Albertian equation of the picture plane with "an open window" ("una finestra aperta") may help to explain Prospero's "inclusion of this charged motif in . . . [the] female likeness."[20] The window as an image of the art of painting may register Prospero's self-conscious awareness of the potentially intrusive gaze of the male painter and observer of this domestic scene. To display a woman as an emblem of household honor is necessarily to render her, in some measure, public.

Prospero's portrait, like the testimony of the rape trial, with its recurring image of Artemisia "shamelessly at the window" ("alla finestra molto sfacciatamente"), foregrounds the intensely scopic quality of life in the early modern neighborhood—the intricate, informal networks of voyeurism and gossip that worked to regulate the behavior of men and especially of women prior to, and often as an alternative to, the formal interventions of ecclesiastical and criminal courts. This culture of surveillance is embodied and objectified in his multiplication of the lady in her twin maidservants. While Prospero's division of the lady into more and less virtuous halves reflects his culture's pervasive bifurcation of the female form—expressed, for instance, in the imagined doubleness of the painting woman who is, as Tuke claims, "*twice defined*"[21]—his depiction of the supplementary *third* figure provides an occasion for reflecting on the specular logic governing the portrait itself. The twin maidservants are not only more accessible (and therefore less chaste) versions of the enclosed housewife; they are also witnesses to the lady's chastity—potentially hostile ones, should she fall.[22] They literalize the gendered webs of surveillance circumscribing and constructing the lady, including the viewer's suddenly self-conscious relationship to her, and they underscore her own self-policing conformity to cultural standards of feminine beauty and conduct. They make visible, through negation, her invisible virtues.[23]

Influenced by her father's example,[24] Lavinia Fontana addresses similar issues

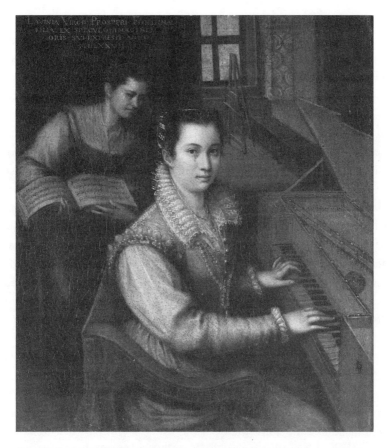

Fig. 9. Lavinia Fontana, *Self-Portrait with a Spinet* (1577). Accademia Nazionale di San Luca, Rome, inventory no. 743.

in her *Self-Portrait with a Spinet*, now in the Accademia di San Luca, Rome (fig. 9). Painted in 1577, before Lavinia's marriage to the painter Gian Paolo Zappi and intended for her future father-in-law,[25] the self-portrait meditates upon Lavinia's relationship to her father's house, as a daughter and a painter, and gestures reassuringly toward the Zappi as it comments upon both aspects of her identity. Seated at the spinet, dressed, as Woods-Marsden puts it, "in the Petrarchan colors of love: red brocade robe, white lace ruff open at the neck, wide white sleeves, and two coral necklaces,"[26] Lavinia presents herself as an ideal gentlewoman whose amateur accomplishment in music symbolizes, elevates, and sanctions her professional engagement in the art of painting.[27] An inscription on the painting asserts her chastity and her identity as her father's daugh-

ter: "Lavinia Virgo Prosperi Fontanae/Filia Ex Speculo Imaginem/Oris Sui Expresit Anno/MDLXXVII" (Lavinia, the virgin daughter of Prospero Fontana, with a mirror created this image in 1577). The presence of the maidservant also ensures the subject's virtue by guaranteeing her supervision and chaste accompaniment within the paternal household. Unlike the problematically placed servants in Prospero's *Portrait of a Lady*, whose menial task further distances them from their mistress's leisure, Lavinia's maidservant is placed firmly within the protection of the domestic space, assisting her lady in the pursuit of a ladylike pastime. In the painting's background, emphasized by the foreshortened spinet and *cassone*, Lavinia, like her father, depicts a window and places before it a revolutionary element in the painting's construction of femininity, an empty easel.[28]

Clearly, Lavinia's self-portrait responds to the same culture of surveillance by which Prospero's lady is created and contained. Through a series of intimations of her creative sovereignty, however, Lavinia scripts her engagement with this culture and her control over its conventions in constructing her own image. The portrait depicts the painter in a pose borrowed from her illustrious and, significantly, noble precursor Sofonisba Anguissola in her *Self-Portrait at the Keyboard with a Maidservant*, painted in the 1550s.[29] The imitation asserts Lavinia's self-avowed identity as a painter and affirms, as she contemplates marriage, that her professional activities will continue.[30] The allusion to Anguissola's productive model is echoed in the inscription's reference to the *specchio* as the artist's aid to self-creation: several of Anguissola's self-portraits similarly invoke the mirror, in part to guarantee the authenticity of the likeness,[31] in part to emphasize the artistry involved in the self-portrait by recalling the centrality of the mirror to early Renaissance theories of artistic imitation.[32] For the woman painter, moreover, this adoption of the common aid to women's self-adornment constructs the female subject within the canvas as the reflection of her culture's prescriptions for feminine beauty.

The *Self-Portrait* illustrates Lavinia's self-fashioning according to these prescriptions and her command over them. She dresses *herself* in the colors of Petrarchism, both in her wedding garments and in the colors with which she creates her face.[33] As if marking her willing compliance with the cosmetic and aesthetic mandates in which she resides, the subject of Lavinia's self-portrait meets the gaze of the spectator. Unlike Prospero's *Portrait*, which insists upon its subject's modestly averted glance, Lavinia's self-portrait acknowledges the approved eye of the male spectator (Severo Zappi) and supplements it with that of the female painter herself, engaged in the act of self-creation. As such, La-

vinia's allusion to her father's problematic window elaborates Prospero's implicit invocation of the Albertian window within a commentary on women's painting in particular. By juxtaposing the easel and the window, Lavinia scripts an allegory of the viewer's relationship to her image, framed in the proscenium of the picture plane. The canvas removed from the empty easel, we might surmise, is the self-portrait itself, now displayed in the threshold of the patriarch's home. Unlike the leaded pane that protects Prospero's lady, Lavinia's window is clear. The opened shutter admits the light that falls across the background, illuminating the easel—light that, in the controlling hand of the painter, is an essential component of the art of coloring.[34] Yet the window is placed well behind the female subject, arguing the impenetrability of the household and of her virginal body. Despite her intimacy as a painter with the window, figured in the painting's visual triad of the window, the easel, and the subject's head and associating Lavinia's artistic products with her *ingegno*, the self-portrait assures the viewer that this public woman willingly submits herself to the rules of deportment, adornment, and conduct that guarantee her integrity and that of her household.

If Lavinia's *Self-Portrait* scripts her willingness to trade her father's house for her husband's—to change hands, as it were—this exchange depends upon the stability and unassailable reputation of Prospero's household, guaranteed by the imagery of the *Self-Portrait* and ratified in the virginity of his daughter. Thus, a second symbolic trinity, produced in the painting by the aligned forms of the spinet (or virginal), the *cassone* (symbolizing marriage), and the easel, revises Prospero's objectified feminine trinity in his *Portrait of a Lady* and articulates Lavinia's willing transition from virginity to marriage and the projected persistence of her professional activities after this exchange.[35] In undertaking this trade, both father and daughter ensured Lavinia's continued success and productivity: the newlywed couple lived in Prospero's house, with Gian Paolo's inferior talent supporting that of his wife. In Bologna, and later in Rome, Zappi assisted Lavinia in the studio and acted as her agent beyond. When Lavinia enrolled in the Roman Accademia di San Luca in 1604, Zappi "was also signed into the [academy] on behalf of his wife."[36] The *Self-Portrait*, then, registers the liminality of the bride, temporarily caught between two households, and casts this transitional moment in artistic terms, as the translation of the woman painter from private enclosure to public exposure. Accordingly, Lavinia made two copies of the betrothal picture. If the original affirms the licit penetration of the patriarchal household by the groom, the later versions are conceived as public works, intended to spread Lavinia's fame as a female painter.[37] By investing Lavinia's rep-

utation as a virtuous woman in the stability of Prospero's household, and vice versa, the Fontanas trace the movement from privacy to publicity as an orthodox marriage of the female painter's talent with the demands and desires of her clients.

What was, for Lavinia Fontana, a comfortable liminality was, for Artemisia Gentileschi, a brutal rupture. Violently jettisoned from the protective walls of domesticity, betrayed from within by the dangerous permeability of her father's artisanal household, Artemisia negotiates a different course through the troubled waters threatening to overwhelm the public woman.[38] As Elizabeth Cohen writes, Artemisia "had to rely on herself because those responsible for her had defaulted."[39] During her testimony, however, Artemisia adapts strategies for feminine self-fashioning in relation to the contested space of the artist's studio— at once a space of creative license and sexual violation, of public domesticity and private intimacies—that recall Lavinia Fontana's in her self-portrait and look forward to Artemisia's own depictions of the extra-domestic painting woman, Judith.

Orazio Gentileschi's complaint against Agostino Tassi for the rape of his daughter responds to the same code of family honor that underwrites the Fontanas' representations of women. The fact that Artemisia's father rather than she—who was in 1612 nearly nineteen years old—brought the suit reflects the dual meaning of *raptus* in European civil and canon law as referring both to rape and theft of property.[40] Early modern rape is a crime against the father's property because a woman's chastity constitutes, and therefore can compromise, family honor. Orazio's petition, in fact, conflates the rape with the theft by Tassi and an accomplice of a painting described as "a *Judith* large in size" ("una Iuditta di capace grandezza") (410; *Atti* 39).[41] The transcript makes clear that the crime under investigation was *stupro violente*, more narrowly defined in the period as forcible defloration. By threatening the marriageability of a virgin, violent defloration also threatened to rob her father of valuable property.[42] The remedy was, most often, marriage.[43] Following the rape, then, "Agostino continued with Artemisia and enjoyed her as if she were his own possession, having promised to marry her at the time he deflowered her" ("Agostino di poi ha sempre seguitato Artimitia e godutola come cosa sua havendoli dato nel atto dello sverginamento la fede di sposarla") (411; *Atti* 41).

In a sexual economy in which women are property exchanged between men, as Guido Ruggiero writes, "it was not atypical to begin a relationship with rape, move on to a promise of marriage, and continue with an affair."[44] When these

promises proved false and cases ended up in court, judgments commonly sought resolution in marriage.[45] This outcome was at first the goal of the Gentileschi prosecution, initiated over a year after the rape. Under cross-examination by Tassi himself, Artemisia explains that "we didn't bring suit earlier because something else had been arranged so that this disgrace would not become known" ("non se n'è dato querela prima perchè s'era ordinato di fare qualche altra cosa acciò non si divolgasse questo vittuperio"). When Tassi follows up by asking whether she hoped to marry him, she admits, "I was hoping to have you as a husband, but now I don't, because I know that you have a wife" ("Io speravo di havevi per marito ma adesso non lo spero perchè so che havete moglie") (464; *Atti* 124–25). Uncertainty about what constituted marriage in seventeenth-century Italy may have complicated the question of Tassi's bigamy. Despite the Council of Trent's condemnation of private vows as establishing marriage, couples might reasonably have believed that a marriage promise followed by sexual consummation were sufficient in themselves to cement the bond: in a recent study of the issue in early modern Piedmont, Saundra Cavallo and Simona Cerutti found that, "sex, sometimes cohabitation, nearly always followed . . . a promise [of marriage]," which had the "social impact of legitimating the couple before the community."[46] Evidence showing that up to 44 percent of Elizabethan brides were pregnant at the time of their wedding implies that in Anglican England, too, the promise of marriage was commonly held to license sexual relations.[47] Up to two weeks before the end of Tassi's trial, intermediaries were still trying "to bring off this business of Artemisia, so that this story could be ended and [we] could find a way to get her married" ("io riducevo a perfettione questo negotio d'Artimitia accioche si levasse via questa historia et si trovasse modo di sposarla") (466; *Atti* 130). Accompanied by an Augustinian friar, Artemisia visited Tassi in prison, where he renewed his promise of marriage on the condition that she retract her charge of rape, which she refused to do. Adding ecclesiastical formality to the testimony, the friar reports that "Agostino told him that she was his dear Artemisia and his wife, that they had contracted matrimony, and that he had given his pledge to marry her" ("[Agostino] disse che era la sua cara Artemisia e moglie e . . . che havevano concluso il parentado e che lui gli haveva dato le fede di sposarla") (481; "Appendix" 435).

Cases such as Gentileschi versus Tassi wound up in court because of a disruption of the informal processes by which courtship and marriage proceeded in the period. They attest to the presence and power of community networks of control over women's honor—what Cavello and Cerutti describe as "alliances among

women . . . expressed in secret but effective forms of solidarity."[48] Often, too, such cases describe the severing of these bonds.[49] As vigorously as the trial debates the virtue of Artemisia, it scrutinizes the behavior and motives of her neighbor, Tuzia Medaglia. Counter to Lavinia Fontana's responsible maidservant, Orazio's petition complains that, "through [Donna] Tuzia his tenant and as a result of her complicity, a daughter of the plaintiff has been deflowered by force and carnally known many, many times by Agostino Tassi" ("per mezzo e a persuasione di Donna Tutia sua pigionante una figliola dell'oratore è stata forzamente sverginata e carnalmente conosciuta più e più volte da Agostino Tasso") (410; *Atti* 39). Artemisia's first words in her testimony also complain that Tuzia "plotted to betray me by taking part in having me disgraced" ("ha trattato contra di me un tradimento tenendo mano a farmi vittuperare") (414; *Atti* 45). Artemisia's mother had died in 1605, and Orazio enlisted Tuzia's help to provide his only daughter with a female companion and chaperone: Tuzia claims that "whenever Signor Orazio left, he always entrusted his daughter to me" ("Il signor Horatio quando si partiva sempre mi raccomandava questa figliola") (421; *Atti* 59).[50] On the day of the rape Tassi entered the home through Tuzia's adjacent apartment and ordered Tuzia to leave. Despite Artemisia's pleas, Tuzia withdrew, thereby enabling the rape. Tuzia is a major character in the drama of the trial: Tassi is questioned at length about her complicity, and she describes her "affection" ("l'amore") for Artemisia and her role in facilitating what she clearly sees as a courtship, not a rape (419; *Atti* 57).[51]

Artemisia's vulnerability to Tuzia's betrayal speaks to the power of women's networks in early modern Europe, their potential for collapse, and the lasting damage these failures could cause. Throughout the case female friendship and its power to safeguard or violate a woman's honor are on trial. Bound together by the memory of shared affection and betrayal, Tuzia and Artemisia are both objects of scrutiny in the trial and are both subjected to tests of their complicity with men, set against a fragile ideal of women's solidarity. Rendered neither maid, wife, nor widow by Tassi's rape and false promise of marriage, Artemisia is perhaps more deeply victimized by Tuzia's betrayal, which further robs her of a self-governing female alliance, protected from men's invasive gaze.[52]

Confronted with this violent surveillance, Artemisia crafts her identity in the testimony, much as Lavinia Fontana had done in her *Self-Portrait with a Spinet*, but she testifies to the disastrous dissolution of household protection and honor that the trial seeks to repair. When Prospero's *Portrait of a Lady* reproduces its subject as female triplets, it provides an opportunity for a feminist intervention

that would reunite the dissolved alliances between or within women and for a regendering of the gaze that would replace masculine speculation with feminine interaction. Such an intervention occurs in his daughter's *Self-Portrait*, in which her command over the culture of surveillance defines the threshold between the household and the world. Lavinia replaces Prospero's difficult female trinity with the productive alliances of symbolic triples (easel, *cassone*, and virginal, on the one hand; easel, window, and head of the subject, on the other) that support her claim to creative control over her own image and foregrounds the harmony between the maidservant and her lady, united in the project of making music. Unable, as yet,[53] to reconstruct and redeem her shattered household through the art of painting, Artemisia becomes in her testimony both an actor performing her femininity and a director orchestrating the performance.[54] In a revisionist trinity that parallels Lavinia's. Artemisia, doubled in Tuzia, is further observed by Artemisia the witness, a resistant female subject who occupies a position in the testimony analogous to Lavinia's before her self-portrait. As Artemisia moves into the apex of this "visual triangle" ("triangolo visivo"),[55] she, like Lavinia, replaces the censorious male gaze with her own creative and controlling vision. This is the position she occupies quite literally, of course, as a painter before the specular images of women in her canvases.[56]

Mirrored in Tuzia, Artemisia as a witness in the trial is both object and subject, both observer and observed. Her doubling in Tuzia becomes triple when she recounts her own turbulent experience of the culture of surveillance that polarizes the two women. Her description of the rape, including graphic details of its violence, makes present a crime rendered invisible by her subsequent compliance with Tassi's seduction, the evidence of which is hidden in Artemisia's own flesh. Accordingly, she is subjected to scrutiny by midwives who verify the loss of her virginity (412–13; *Atti* 53–54), and later in the trial, in the presence of her attacker, she undergoes torture by having *sibille* applied to her hands "in order *to remove any mark of infamy* and any doubt that might arise against the person of the said summoned woman . . . from which she could appear to be *a partner in the crime*" ("ad tollendam omnem maculam infamiae omnemque dubietatem quae oriri posset contra personam dictae . . . ex eo qua socia criminis videatur") (461 [my emph.]; *Atti* 120). The idea that a woman's body might be made to reveal her complicity in the rape (that Artemisia, like Tuzia, may have been a partner in the crime) or, conversely, that torture might repair her damaged reputation (by removing the mark of infamy) reenacts the rape by presenting feminine suffering for the male spectator, her rapist included. Her torture

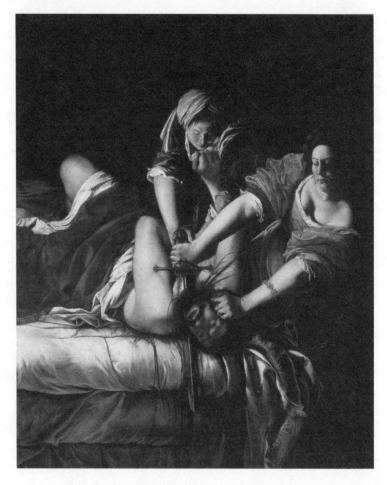

Fig. 10. Artemisia Gentileschi, *Judith Slaying Holofernes* (1620). Galleria Uffizi, Florence, inventory no. 1567. Alinari/Art Resource, New York.

also follows the reasoning that casts Artemisia as simultaneously plaintiff and defendant: it hopes to externalize and thereby represent her inscrutable will.[57]

Based on the documentation of the trial, contemporary discussions of Artemisia's work, as Elizabeth Cohen writes, "often continue to put sexual experience, specifically the rape, at the center of her identity and achievements. Blaming the victim becomes celebrating the victim."[58] Novels, plays, and films that retell the story of the rape have spread that interpretation to the public at large.[59] Mary Garrard's 1989 monograph remains the chief proponent of this approach: for instance, interpreting Artemisia's *Judith Slaying Holofernes* (1620), now in the

Uffizi (fig. 10), Garrard argues that "Judith's decapitation of Holofernes provides a shockingly exact pictorial equivalent for the punishment of Agostino Tassi." "Given the artist's unusual biography," she continues, "it is surely justifiable to interpret the painting, at least on one level, as a cathartic expression of the artist's private, and perhaps repressed, rage."[60] Garrard's thesis has been targeted for scarifying by conservative critics, on the one hand, who wish to salvage Artemisia's works from what they consider to be the extremes of feminist interpretation, and by feminists, on the other, who have seen this emphasis on biography as mitigating the serious appreciation and evaluation of women's works by referring them to standards grounded not in virtuosity but in expectations of the artist's direct, gendered expression.[61] Keith Christiansen and Judith W. Mann's catalogue for the 2002 exhibition at the Metropolitan Museum of Art showcasing works by Orazio and his daughter attempts to debunk the biographical approach to Artemisia's canvases (which they regularly associate with Garrard), while the show itself posed in vivid terms questions of the intersection of an artist's sex with conventional genres and the demands of patronage.[62] My reading of Artemisia's testimony at the Tassi trial argues that her skill at manipulating cultural and discursive conventions enabled her successful performance of femininity, despite the assault on her reputation and identity enacted by the rape. In the following pages I elaborate this proposition by taking genre (literary, artistic, and cultural) as the starting point for interpretations of women's self-creative acts and self-defining representations. Artemisia's Judith paintings and Shakespeare's play transform the generic options available to their authors in similar ways, each taking into account the specific conventions attending women's painting, in both of its senses. In other words, the visual architecture that I describe as feminine, and feminist, in Artemisia's hands informs *Measure for Measure* as well, allowing both works to challenge the period's objectified portraits of ideal femininity.

Artemisia returned to the figure of Judith several times in her forty-year career, a fact that may reflect her patrons' desires rather than her preoccupation with the apocryphal heroine. The story of Judith's beheading of the Assyrian tyrant, Holofernes, was popular in the period, appearing in images whose functions were as likely to be political as didactic as erotic.[63] The Uffizi *Judith Slaying Holofernes* is unique in several ways (see. fig. 10).[64] Crowded into its frame, the scene is presented, as it were, in extreme close-up: the viewer is placed by Holofernes's anguished stare uncomfortably near the end of the bed, which is converted from

a site of seduction to one of violence.[65] The painting's depth is created by the foreshortened body of Judith's maidservant, Abra, as she subdues the drunken Holofernes, pressing him down to a position of surrender and fading resistance. His fist extended toward Abra's chin may just have made contact or may not yet have done so. His arm is about to fall limp.

Artemisia's painting makes the story one of women's cooperative and collective experience. Despite Holofernes's unavoidable gaze, our attention is drawn to the centrally placed Abra and the thick limbs of the maidservant and her mistress. Artemisia's painting doubles Judith in Abra. Poised above Holofernes, Abra is an overpowering female figure who consigns the general to a passive position on the bed ordinarily assigned to women. By shifting the dominant gender, by placing woman on top, the painting renders visible the invisible crime of rape, now embodied in the male victim. Thus, Holofernes's arms resemble thighs, spread before Judith's phallic sword. Like Artemisia's testimony, the canvas speaks at once to the objectification of the woman's body in the sexual economy of early modern rape, courtship, and marriage and resists that objectification by empowering female agency—significantly cast as plural, a product of women's solidarity—both within the painting and beyond, in the female painter's creativity. *Judith* refers to the trial from which it emerges not in its psychological dream of revenge and castration but in the visual architecture containing and controlling its gendered bodies: thus, it learns from the trial not only the structural doubling of the female form but also the demands of judgment, of justice, that necessitate this doubling to externalize and evaluate a woman's hidden will.

To say that Artemisia's Judith is doubled in Abra, however, is to elide the duplicity implicit in the figure of Judith herself. The heroine's traditional doubleness embodies the central assumption of the trial's gendering of Artemisia, which divides the female into more and less guilty halves in order to display her inner nature. This renders Judith, in Artemisia's hands, both a productive emblem of the overly determined public woman and a means by which to examine and control the relentless bifurcation of women imposed by men. As Pollock argues, Artemisia "borrows the heroic mould of the political conspirator Judith to define, within a world of public representation, a figure of identification for woman as self-creating artist."[66] Commentaries on the apocryphal Book of Judith, from the church fathers forward, have remarked that Judith's victory over Holofernes, while ordained by God, nonetheless depends upon a deceptive manipulation of her physical appearance, her self-transformation from modest widow to seductress. In preparation for her departure to the Assyrian camp: "she

laid aside her sackcloth which she had put on, and divested herself of her widow's garb, and washed her body all over with water, and anointed herself with costly ointment, and vamped up the hair of her head, and put it on a tire, and clad herself in her gayest attire, with which she had been wont to be garbed in the days while Manasseh her husband was alive, and she took sandals for her feet, and put on anklets and bracelets and rings and her earrings and all her finery, and adorned herself gayly so as to beguile the eyes of as many as should behold her."[67] As Amy-Jill Levine writes, "The private widow becomes a public woman; she undergoes a total inversion from ascetic chastity to (the guise of) lavish promiscuity."[68]

Exiled by widowhood from the patriarchal household, Judith leaves behind the protection of Bethulia for the Assyrian camp, charting the public woman's dangerous course. The quintessential painting woman, Judith exploits costume, makeup, and jewelry—the dangerous ornaments that, as early modern polemicists frequently remind women, are indices of feminine pride. Inevitably, too, her story poses an intractable exegetical problem by requiring a transvaluation of women's adornment, a practice ordinarily castigated as superfluous and vain at least, adulterous and deceptive at most. In the service of liberating her people, Judith's adornment must be understood as a chaste and obedient act, the incongruous means by which God exacts punishment in accordance with the demands of divine justice. The story showcases women's cosmetic transformation as the means by which justice is served while complicating the usual interpretation of the practice itself. Germaine Greer's observation that the female subjects of Artemisia's *Judith Slaying Holofernes* "could be two female cut-throats, a prostitute and her maid slaughtering her client,"[69] indicates the troublesome duplicity that forces the viewer of Judith's example to pass judgment on two levels at once—one that exonerates her actions as the scourge of God, one that condemns her lethal deception.

Early modern interpretations of Judith reflect this difficult duplicity, concentrating particularly on the challenge it poses to the notion of an easy and identifiable correspondence between women's inward states and outward shows. One argument brought forth by Florentine officials in 1503, for instance, explaining the decision to replace Donatello's *Judith and Holofernes* with Michelangelo's *David* in the Piazza Vecchio was that, despite the heroine's usefulness as an emblem of the city-state's divinely ordained liberty, "it is not proper for a woman to kill a male."[70] Guillaume du Bartas's *La Judit* (1574) presents the heroine's toilette as the feminine equivalent of the epic hero's preparation for

battle, recounting her prayer that feminine wiles may lead Holofernes to his doom:

> Fay, fay donc, ô bon Dieu, que ses charmès espris
> Dan les tours annèles de mes cheveux soyent pris
> . . . Fay que de mes propos le flatteur artifice
> Suprenne dans ses laz sa renarde malice.

> [Grant gracious God that his bewitched wit
> May with my crisped hair be captive knit
> . . . Grant that my artificiall tong may move
> His subtill craft & snare his hart in love.][71]

As Bartas casts his Judith in Petrarchan colors, he worries about the potential idolatry contained in the heroine's painted face:

> A pour ses riches bords deux couraux qui, riant,
> Decouvrent deux beaux rangs de perles d'Orient.
> Ce beau pillier d'ivoire & ce beau sein d'alabastre,
> Font l'idolastre camp de Judith idolastre.

> [Her *Corall* lips discov'red, as it were,
> Two ranks of *Orient* pearle with smyling cheer.
> Her yv'ry neck, and brest of *Alabastre*,
> Made Heathen men, of her more *Idolastre*.][72]

Once transformed, Judith is compared to the overweening Semiramis, an uncomfortable parallel that associates the heroine with "l'art et la fard" ("riches art and painted face") of "infames femmes" ("defamed dames")[73] and with the Assyrian enemy against whom she fights: "et le reste / De ses habits pompeux est digne du beau corps / De celle qui d'Euphrate entourela les bords" ("What els she weare, might well bene seene upon, / That Queene who built the tours of *Babylon*").[74] Less high-minded treatments of the heroine's story than Bartas's exploit the ambiguity between Judith's double identity as sacred heroine and femme fatale to render her the object of salacious and prurient display in the numerous examples of what Margarita Stocker calls "Judith erotica" or to present her as an exemplum of *vanitas* and a memento mori.[75] By focusing on Judith's diabolical crime (in the former genre) and on her diabolical painting (in the latter), these works express the early modern perception of a subversive message lying behind even the most orthodox version of Judith's story,[76] and they reflect the heroine's

function as, in Jacqueline Lichtenstein's words, "an allegory of makeup, an allegory of painting in its essence and in its effects."[77]

As an allegory of feminine painting, in both of its senses, Judith offers to Artemisia a means to complicate and control traditional assertions of women's duplicity. She does so by emphasizing the cooperation between women inherent in the story, implying, as Stocker puts it, "a female conspiracy against the male," and by emphasizing the heroine's exploitation of ornament, "underscor[ing] Judith's ambiguity precisely in order to suggest female subversion."[78] In both of these strategies Artemisia uses Judith's difficult painting to destabilize the usual, gendered, relationship between female spectacle and male spectator. If the cosmetic culture enacts a figurative decapitation of its female subject, Artemisia's images of Judith's beheading of Holofernes vividly portray the reversal of this violent objectification in the painting woman's hands. In Artemisia's *Judith and Her Maid Carrying the Head of Holofernes*, now in the Pitti Palace (fig. 11),[79] the feminine alliance staged in the Uffizi *Judith Slaying Holofernes* is at once more obvious and more difficult. In a hurried moment after the beheading, Judith and Abra anxiously glance beyond the frame, fearful of being seen with the grisly evidence of their crime. Judith's hand rests on Abra's shoulder, binding the women together in this forbidden enterprise and offering them as an emblem of female solidarity that prompts Garrard to comment, "at this moment, Abra is not her servant, but her sister."[80] While Judith's face is given in profile, a position that tends to objectify the subject,[81] she evades objectification through her empathetic bond with Abra and the contrast between Judith's flushed face and the truly objectified profile of Holofernes, now literally a dead object carried in Abra's basket. The female subject is thus constructed as a matter of color, through her blush. Judith is protected by Abra's substantial form, which turns away from the viewer in a gesture of privacy and enclosure. The women are both displayed for our inspection and powerfully resist display. This insistence on privacy forestalls traditionally licit points of view and demands complicity: the viewer must at once become a partner in crime with the women and maintain a critical distance from a scene that will not admit him. By releasing the action from its narrative and concentrating on this moment of feminine complicity, Artemisia thematizes the contradictions implicit in her culture's common gendering of the spectator as exclusively male. She gives voice to the woman who sees herself being seen. As the painting stages and critiques the illicit gaze and as Artemisia takes control of the visual architecture of the scene, the eye of the male viewer, objectified in the dead eye of Holofernes, is effectively closed.

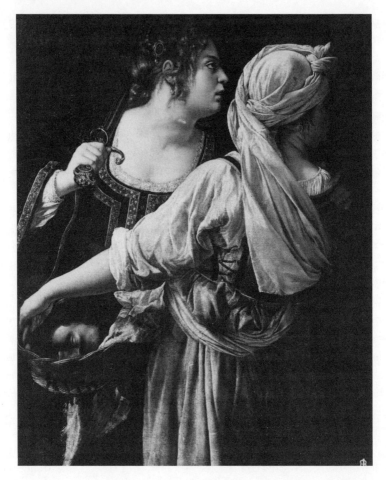

Fig. 11. Artemisia Gentileschi, *Judith and Her Maid Carrying the Head of Holofernes* (1618–19). Galleria Palatina, Palazzo Pitti, Florence, inventory no. 398. Alinari/Art Resource, New York.

Artemisia's challenge to the male gaze is clear when one considers similar treatments of Judith and Abra and her interactions with these generic options. As a model for the Pitti *Judith and her Maid*, Artemisia relied on her father's rendering of the scene, now in Oslo (fig. 12).[82] Although these works portray Judith and Abra in very similar terms, the differences between them are telling. Both Orazio and Artemisia carefully represent Judith's ornament. In Orazio's painting the heroine's dress, jewelry, and hairstyle contribute to what Christiansen and Mann describe as an "aestheticization of the dramatic moment": richly decorated, lovingly detailed, Judith and Abra offer the painter the opportunity to

display his mastery of visual rhythm in which "formal devices are employed as narrative strategies."[83] Compared to his daughter's rendition, Orazio's scene is relatively uncomplicated in its treatment of the female subjects and placement of the viewer. Well-lit and brightly clothed, placed before a tent that is also the curtain of the proscenium, Judith and Abra appear in poses that emphasize Orazio's orchestration of repeated patterns and visual leitmotifs. Theatrically displayed to the (male) viewer, they resist observation within the frame but invite it from beyond. Artemisia revises her father's treatment of the scene simply by depicting Judith's hand placed on Abra's right shoulder rather than her left, drawing their forms more tightly and tensely together, a collusive and conspiratorial pair. Moreover, she once again exploits the troublesome duplicity inherent in Judith's self-transformation from chaste widow to femme fatale by encoding Judith's jewelry with conflicted, cross-gendered associations. As Garrard points out, on the pommel of Judith's sword is the Gorgon's head, an allusion to

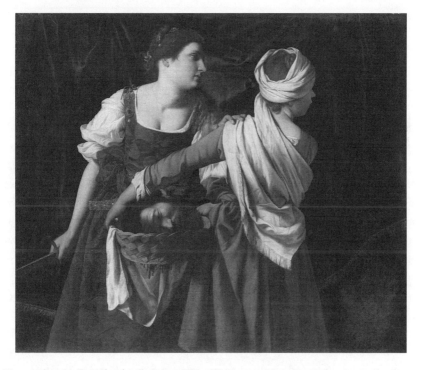

Fig. 12. Orazio Gentileschi, *Judith and Her Maidservant* (1608). National Gallery, Norway, inventory no. NG.M. 02073. Photo: J. Lathion © Nasjongalleriet 2004.

the frightening specter of castration that Judith's story shares with the Medusa's.[84] By exploiting this emblem of Judith's deceptive self-fashioning, Artemisia capitalizes on the contradictions inherent in the apocryphal text—that is, the incongruous redemption of feminine painting in the service of divine justice—and poses the problem specifically in terms of spectatorship. In other words, Artemisia's presentation of the painting woman self-consciously cross-genders color and ornament (in Judith's decoration of her body and in Artemisia's depiction of the scene), exchanging Orazio's aestheticized portrayal for the intense drama of women's private, and furtive, complicity.

In depicting Judith and Abra as partners in crime, Artemisia augments Orazio's generic innovations with a self-consciousness about the feminine duplicity traditionally inferred by male spectatorship. Accordingly, she embellishes the creative and re-creative power of her female subject as a painting woman. Her final rendition of the scene (c. 1625), now in Detroit (fig. 13), as Stocker writes, "most explicitly invokes Judith's sacred/sinister ambiguity."[85] Judith's clearly made-up face and the unexpected military shoe emerging from beneath her gown give her the appearance of "an actress dressed up for a part."[86] The daring chiaroscuro with which Artemisia creates the face of her heroine foregrounds the art of coloring as a defining feature of the painting woman's virtuosity. Judith's lethal control of appearances, the ease with which she adopts a costume in order "to beguile the eyes of as many as should behold her," here clearly serves as an allegory and defense of specifically feminine painting. The woman's eye beholding this deceptive figure, the painting argues, is not beguiled but empowered to challenge the roles and robes by which femininity is defined and described.[87]

The images of female solidarity and self-definition in Artemisia's *Judith* paintings do not work to repair Tuzia's betrayal on a simple biographical level. Rather, they thematize, as the rape trial does, the bifurcation of the female form implied and required by male observation, be it the illicit gaze of the rapist, the scrutiny of the law, or the display of the cosmetic culture. The Artemisia/Tuzia split "becomes" Judith/Abra as Artemisia the painter energizes the powers of the painting woman, Judith, to act as both observer and observed. She creates the female spectacle for the masculine taste of the patron but inscribes the trace of her subjective presence in the work of art. In doing so, she exposes the essentialist bases of the construction of women's painting—and, by extension, the construction of femininity itself—as fraudulent and debased to give visual form to, and thereby control, the culture of surveillance from which her paintings and her testimony emerge. It is a culture that insists upon a woman's doubling as

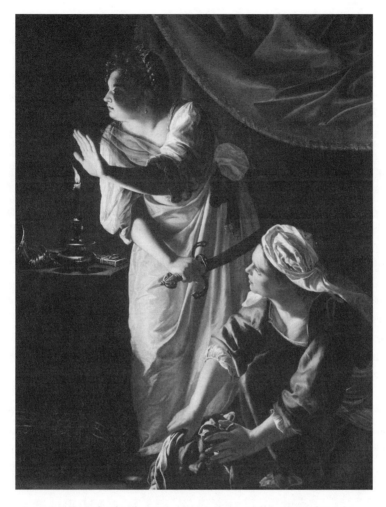

Fig. 13. Artemisia Gentileschi, *Judith and Maidservant with the Head of Holofernes* (c. 1625). Gift of Mr. Leslie H. Green. Photograph © The Detroit Institute of Arts.

moral opposites to give external form to her inscrutable internal character; that relies upon her complicity with male governors in policing her neighbors, sisters, mothers, and daughters; and that demands her compliance, as a self-policing subject, with its defining standards. Judith and Abra reflect Artemisia's interactions with this culture's scopic economy and reclaim women's self-defining power in terms anticipated by Shakespeare's play.

<center>CRⅉⅉ</center>

In *Measure for Measure* the scrutiny of the law is also the illicit gaze of the rapist. Angelo speaks the polarized extremes of women's characters resulting from this collusion of true and false witness, voicing a duality that extends as easily to Judith as to Isabella:

> Never could the strumpet
> With all her double vigour, art and nature,
> Once stir my temper, but this virtuous maid
> Subdues me quite. (2.2.183–86)

The apocryphal story of *Susanna and the Elders* gives concrete form to the sexual violation enacted by Angelo's abusive juridical gaze. As a tale "fundamentally about the legal versus the illicit uses of a woman's body by men,"[88] the narrative bears an uncanny resemblance to Tassi's trial, which replicates the rape in Artemisia's public shaming. It offers a template, too, for Angelo's coercion of Isabella's chastity in exchange for her brother's life. As the story goes, the elders (or judges, as they are sometimes called), prompted by lust, threaten to accuse Susanna publicly of adultery—a crime punishable by death—to force her surrender to their desires. Susanna refuses and submits herself to the stern judgment of the law, only to be saved when the elders are exposed as perjurers and put to death for the crime of bearing false witness. Artemisia's version of the story (fig. 14), painted around 1610 (a year before her rape), poses the problem that the Uffizi *Judith Slaying Holofernes* solves:[89] stripped of Judith's productive ornament, Susanna is tragically isolated, violently exposed to the voyeurism of the elders and the viewer as well. She is poised unnaturally near the hovering elders and excessively close to the viewer who, as Griselda Pollock notes, is oddly placed in Susanna's bath and thus deprived of a rational relationship to the scene. Reversing the image's conventional use as an occasion for voyeuristic pleasure,[90] Artemisia offers a Susanna whose purpose is to coerce viewing in the *absence* of pleasure. By spatially collapsing the narrative, Artemisia is able "to reveal in tableau form the oppositions that underlie and structure the tale":[91] feminine shame imposed by masculine ocular intrusion. In exchange for the painting's radically fragmented visual and narrative space and its isolated female form, Artemisia's *Judith* constructs a visual triangle that replicates and inscribes the elders' double vision of Susanna (as chaste wife and "fornicatress") in Judith but repairs this division in the twin heroines Judith and Abra as observed, con-

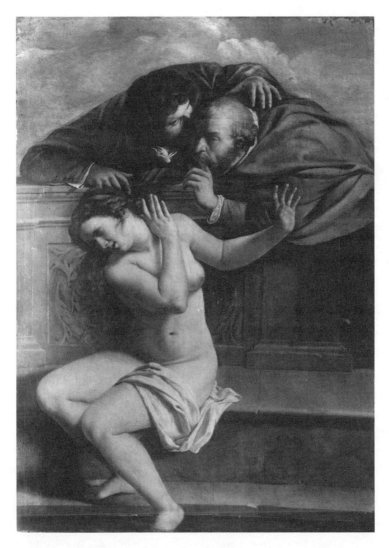

Fig. 14. Artemisia Gentileschi, *Susanna and the Elders* (c. 1610). Schloss Weissenstein, Pommersfelden, Germany, inventory no. 191. Foto Marburg/Art Resource, New York.

trolled, and completed by the defining, and self-defining, femininity of the painter herself.

This reparative triad is also the structure within which the triple heroines of *Measure for Measure*—Juliet, Mariana, and Isabella—are observed, controlled, and completed by women's networks that defy the reductive categories of maid, widow, and wife. The play's frequently noted formal imperfections and contrived

happy ending are the dramatic equivalents of Artemisia's distilled narrative in *Susanna and the Elders* and similarly expose the suppressed antecedents—rape, public shame, and death—explicit in Shakespeare's sources.[92] Shakespeare's innovation in *Measure for Measure* adds the plot device of the bed trick, the play's structural embodiment of the polarization of virgin and whore, maid and wife. As the bed trick substitutes a willing sexual partner (Mariana) for an unwilling victim (Isabella), it also supplements the sources' twin heroines by one. This addition, like Artemisia's visual architecture, allows each heroine to define herself within the play's female alliances. Each heroine assumes the power to evade the defining gaze of male governors and to witness their crimes.[93] Moreover, the bed trick focuses Shakespeare's concern with disguise (which culminates in the discovery of no less than three characters in the final scene) in terms that engage the self-defining craft of the painting woman. As the Duke describes the bed trick, "Craft against vice I must apply / . . . So disguise shall by th' disguised / Pay with falsehood false exacting" (3.2.277 and 3.2.280–81).

George Whetstone's *Promos and Cassandra*, Shakespeare's immediate source, allows us to consider what is at stake in Shakespeare's proliferation of heroines, from two to three, in *Measure for Measure*. "In the cyttie of Julio," the argument tells us, "there was a law, that what man so ever committed Adultery should lose his head, & the woman offender should weare some diguised apparrel, during her life, to make her infamouslye noted."[94] When Andrugio and his "minion" Polina are sentenced under this severe law, Promos forces Andrugio's sister Cassandra to sleep with him to save her brother's life, promising to marry her to restore her "wasted" honor. Cassandra acquiesces, but, when Promos reneges on both promises, she appeals to the king, who orders Promos to "marrye Cassandra to repaire her crased Honour; which done, for his hanious offence [that is, the murder of Andrugio] he should lose his head" (A4). The play ends with Cassandra, now married to Promos and persuaded that "dutie commands mee / To preferre before kyn or friend, my Husbands safetie" (2.4.2, L2v), pleading for his life. As in *Measure for Measure*, her suit is unsuccessful until, through a substitution of heads copied by Shakespeare, Andrugio is saved and, consequently, so is Promos.

Whetstone's drama shares the assumptions of the Tassi trial, particularly the sentiment that "marriage wipes out [the] stayne" of both consensual sex during betrothal and rape (1.2.3, C1),[95] as the play frequently and unequivocally terms Promos's sexual violation of Cassandra.[96] It also shares with the trial the desire to scrutinize women's hidden characters by externalizing them in the polarized

extremes of virtue and vice: thus, the guilty Polina and the chaste Cassandra (whose honor is only superficially stained, since her "forced fault, was free from evil intent" [1.3.2, K2]) are joined in rituals of self-shaming and communal lament presented for the viewing pleasure of male spectators. Like Judiths in reverse, who surrender their gowns "de couleur celeste, / Couverte haut et bas d'un ret d'or" ("[of] coulour blew Coelest, / Benetted all with twist of perfite golde"),[97] Polina appears "in a blew gowne," the "shamefull weedes" signifying her fault, to warn women to "keepe aloofe though love your harts do arme" (1.5.3, F2), while the innocent Cassandra "condemn[s her]self to wear these weedes of shame" (2.2.3, K2). Identically clad, the two women mourn Andrugio's presumed death and, in the last act, appear accompanied by Cassandra's female servant to perform a ritual lamentation for the impending death of Cassandra's rapist-turned-husband, Promos (2.5.5, M1–M1v).

I suggested at the beginning of this chapter that Prospero Fontana's paradoxical representation of three rather than only two alternative femininities in his *Portrait of a Lady* offered an opening for feminist interventions realized in Artemisia's and Lavinia's regenderings of the gaze. Whetstone's display of this triad of female mourners provides a similar opportunity for Shakespeare's revisionist intervention in *Measure for Measure*. Whetstone's scene supplements by one the play's twin heroines in a secularized, eroticized imitation of the lament of the Three Maries for Christ, an affective moment frequently displayed in pre-Reformation liturgical drama and incorporated into Shakespeare's *Richard III*.[98] Whetstone recalls this spectacle of feminine solidarity to support his drama's conventional definitions of women by men's controlling gaze: it offers an emblematic tableau, the song of mourning, to externalize and confirm Cassandra's submission to the wifely duty that erases her rape. This suggestive feminine trinity predicts Shakespeare's more complex deployment of the visual triangle containing and defining his heroines in *Measure for Measure*, in which Whetstone's Polina "becomes" both her dramatic counterpart, Juliet, and the fallen Mariana, whose pining for Angelo leads her to mournful self-confinement in the moated grange. Whetstone's tamed Cassandra, meanwhile, is doubled in the bed trick in Shakespeare's Mariana and Isabel, a novice of the order of Saint Clare and therefore resistant to the marriage solution that brutally enforces the happy ending of *Promos and Cassandra*.

The strategy of containment enacted in Whetstone's tableau hopes to provide external evidence of the characters hidden within women's inscrutable and potentially deceptive forms. By setting femininity, in its multiple qualities, before

the eye of the beholder, the tableau assumes the presence of a reliable link between a woman's inward state and outward show. In *Measure for Measure* this assumption is both resuscitated and troubled by the play's pervasive interest in defining—and, indeed, in constructing—women from the outside in and by its association of this skill with the dispensation of justice. In this respect Shakespeare, like Artemisia, explores the conjunction of women's painting and justice (particularly as rendered on the grounds of visual evidence), powerfully articulated in the figure of Judith. Lucio's description of women as "Pygmalion's images newly made" characterizes the masculine work of constructing femininity as at once a manipulation of external form that hopes to effect internal change and a sexual exploitation of women (that is, making maids into women through the loss of their virginity) that marks both the play's comic subplot and the main action of Angelo's attempted exploitation of Isabella (3.2.45). Thus, the debased specter of "your fresh whore and your powder'd bawd" permeates the subplot (3.2.59–60), with the painting woman's common associations with decay and death ("Does Bridget paint still," Lucio asks [3.2.79]), while Angelo encourages Isabella to acquiesce to his desire in terms that assume the mirroring of a woman's character in her external form:

> Be that you are,
> That is a woman; if you be more, you're none;
> If you be one (as you are well express'd
> By all external warrants), show it now,
> By putting on the destin'd livery. (3.4.134–38)

By giving into sex, Angelo argues, Isabella will be made a woman, one of Pygmalion's images, fashioned by her male governor from the outside in. The description of women's sexual subordination to men as a "destin'd livery," however, qualifies this masculine dream of control over women's will by underscoring the superficial nature (as livery) of what Angelo wishes to cast as a fundamental obligation of women to men (as destined). Figured thus as clothing that one may put on or cast aside but which at the same time is constitutive of one's identity,[99] men's constructions of femininity reside on the level of disguise, an especially vexed site (most obviously in the Duke's disguise) throughout the play.

If women are made as a result of the manipulation of superficial appearances, as the play suggests, Shakespeare explores the potential for women's collaborative and creative manipulations of these appearances in order to achieve powers of self-construction and self-definition. Pompey's claim that "Painting . . . is a

mystery; and your whores, sir, being members of my occupation, using painting, do prove my occupation a mystery" describes women's skill in self-creation by manipulating their appearances, a skill that extends beyond the female inhabitants of Vienna's stews to the play's triple heroines (4.2.37–39). The image of painting as a mystery suggests a guild of female painters (that is, of cosmeticians), perhaps a comic, debased version of the enrollment of remarkable women in the early modern guilds of painters—Lavinia Fontana's participation in the Accademia di San Luca, for example, and Artemisia Gentileschi's membership in the Roman Accademia dei Desiosi in 1620 and the Florentine Accademia del Disegno in 1644.[100] Smith's *Wonder of Wonders* imagines such a guild when the anticosmetic invective addresses "the young Ladies and Gentlewomen of the Society of Black-spotted Faces, newly taken into the Fellowship of the Company of Painter-Stainers."[101] The subplot's image of the female painters' guild provides a comic foil for the creative self-fashioning undertaken by Juliet, Isabella, and Mariana in the main plot. Pompey's assertion that painting is a mystery, moreover, indicates the profoundly uncertain status of judgments based upon the shifting ground of ocular proof: painting, as mystery, is as likely to deceive the viewer, to veil the truth, as to confirm it. It is a problem that carries pervasive implications for the play's meditation on the nature of justice. Finally, Pompey's comment confers upon painting the status of a mystery in the theological sense of the term, as referring to questions of faith that lie beyond the capacity of human reason, which can be known—albeit uncertainly—only through a confidence in divine revelation and presence. The mystery of women's painting, Pompey suggests, participates in the play's more general exploration of lingering pre-Reformation beliefs and institutions, in this instance removing the concept of mystery from the sacred to the profane and from the realm of essence to that of accident. Judgments based on the mystery of painting—evaluations of the painting woman, Judith, for example—must acknowledge that at their core lies only profound uncertainty. They must proceed on the basis of faith alone, continually at risk of falling victim to the deceptions of mere appearance.

If Whetstone's mournful feminine triad in *Promos and Cassandra* carries the trace of Catholicism's most memorable scene of female solidarity, the lamenting Maries, *Measure for Measure* also recalls pre-Reformation models of feminine community that, although (or perhaps because they are) no longer accessible to Shakespeare's Anglican audience, are explored as potent sites of feminine self-definition. Isabella's nunnery and Mariana's moated grange both recall, as Theodora A. Jankowski puts it, a "plurality of sexual/erotic arrangements within

Catholic medieval Europe" exiled by "the more limited and therefore restrictive sex/gender arrangements of early modern Protestant England."[102] The pre-Reformation answer to the problem of the fallen woman (barring suicide, the only alternative to marriage) explains *Promos and Cassandra*'s decree that "the maide which sind should ever after lyve/In some religious house, to sorrowe her misdeede" (2.3.3., K1v).[103] In *Measure for Measure* Shakespeare resuscitates these forms by portraying the nunnery and the grange as places of female autonomy and creativity, alternatives to domestic confinement. Shakespeare dissolves the patriarchal households of Vienna, at once allowing him to explore alternative sites of female friendship and to render these sites as "*Italian*-like"—that is, like women's painting, in the Puritan view, proper to Catholicism.[104] In the convent of Saint Clare women's friendships evade masculine scrutiny and government. Lucio's description of Isabella as "a novice of this place, and the fair sister/To her unhappy brother Claudio" underscores the double meaning of *sister* and the role of the convent as an alternative woman's network for Isabella that would, with her swearing, replace the family network over which her brother presides (1.4.19–20).[105] In a scene fraught with Isabella's allusions to the female networks in which she engages, she describes her "vain but apt affection" for Juliet (1.4.47), and she notes her duty "to give the Mother/Notice of my affair" (1.4.86–87). In her first interview with Angelo, moreover, she calls forth the nunnery as an emblem of female solidarity in the bribe that she ironically, and insultingly, offers the corrupt judge: she promises "prayers from preserved souls,/From fasting maids, whose minds are dedicate/To nothing temporal" (2.2.154–56).

If women and their alliances in the nunnery "cannot be one-dimensionally stereotyped," as Susan Carlson writes, Mariana's moated grange also offers "a location where women have respite from male control."[106] Like her ancestor, Whetstone's Polina, the "dejected" Mariana embraces the lamentation "bestowed upon her" by Angelo as the moated grange, highly eroticized, rewrites religious shame as mournful lovesickness (3.1227–28). Mariana's first appearance in the play seems to reproduce the visual logic governing Whetstone's drama, which objectifies women in ritual performances of mourning and shame in order to externalize the vexingly uncertain evidence of their characters. McKluskie thus argues that Mariana is presented as a tableau, accompanied like Whetstone's heroines by song, to "show . . . how the text focuses the spectator's attention and constructs it as male."[107] The scene initially promises to do so, but Shakespeare immediately shifts the two-dimensionality of the male-witnessed tableau to tri-

angulate the scene by describing Mariana's self-authored performance, her self-conscious construction of femininity through her control of appearances. When the Duke arrives, she dismisses the Boy, who sings for her and apologizes for the song:

> I cry you mercy, sir, and well could wish
> You had not found me here so musical.
> Let me excuse me, and believe me so;
> My mirth it much displeas'd, but pleas'd my woe. (4.1.10–13)

Mariana's mastery of two modes of behavior, one appropriate to women alone and the other accommodated to the censorious presence of men, implies both her willing self-division and her potential for self-definition. The situation of the grange at the religious house of Saint Luke's, moreover, associates her performance with the self-authorship of female painting by setting her within a space that bears the name of the patron saint of painters. Mariana's compliant self-representation in accordance with what she rightly perceives to be the Duke's demands manipulate and evade the partial religious and erotic views of her self-exile.[108]

As Shakespeare acknowledges Protestantism's banishment of these potent feminine communities, he also implies their persistence in the informal, improvised bonds linking the play's heroines. To explore these bonds, *Measure for Measure* dissolves both pre-Reformation women's networks, such as the nunnery, and the male-governed institution of the family that, in post-Reformation England, should replace these exiled women's communities. Like the shattered household that occasions Artemisia Gentileschi's testimony and serves as a prologue to her depictions of the widow Judith, the households of *Measure for Measure* are tenuous and porous, unable to provide for the women upon whom their honor depends. All three heroines are orphans: Mariana loses both "a noble and renowned brother" and "her combinate husband," Angelo, when her brother Frederick perishes with her dowry in a shipwreck (3.1.215–29); Juliet is an orphan whose "friends" control her dowry and therefore, presumably, her choice of husband (1.2.129–30); and Isabella's bond with her only surviving kin, Claudio, is threatened by her own resolution, "More than our brother is our chastity" (2.4.184), and by Claudio's effort to persuade her that "What sin you do to save a brother's life, / Nature dispenses with the deed so far / That it becomes a virtue" (3.1.132–34). Isabella's outrage at this notion, "Is it not a kind of incest, to take

life/From thine own sister's shame?" (3.1.138–39), graphically illustrates the play's troubled family networks and their inability to protect a woman's chastity and deliver her safely to the regulating confines of marriage.

Moreover, *Measure for Measure* stages the disastrous replacement of the informal networks governing women's behavior by the brutal intervention of the law. The disrupted betrothal of Juliet and Claudio reverses the trajectory of Artemisia's aborted courtship: it is not the product of informal processes that seek resolution in the law but the result of the destructive interference *of* the law. The Duke's advice in the play's closing lines, "She, Claudio, that you wrong'd, look you restore" (5.1.522), can only appear as ironic in light of the fact that not Claudio but the law has wronged Juliet. Mariana's betrothal, too, interrupted by the play's embodiment of juridical abuse, Angelo, is repaired through the Duke's intervention but uncomfortably results in her marriage to the would-be rapist of Isabella and the man responsible for her public shaming, whose "pretended . . . discoveries of [her] dishonor" parallel Tassi's attack on Artemisia's character (3.1.225–26). Moreover, Angelo himself in the play's final scene asks, not once but twice, to be granted a punishment of "death rather than [the] mercy" constituted by marriage (5.1.474).[109] If the play adopts the conventional idea of marriage as a "recompense" for a woman's sexual violation (3.1.253), the catastrophic deployment of the marriage solution—including the Duke's famously unexpected proposal to Isabella—exposes the shortcomings of this idea and challenges the notion that the law must intervene to control the informal processes of courtship and marriage. Indeed, it seems to be the other way around.[110]

In challenging the legal interventions enacted by Angelo and the Duke, *Measure for Measure* explores the means by which informal networks can exercise controls on behavior more successfully than the law can do and can, in fact, control the law through citizens' willingness or unwillingness to participate in its processes.[111] Retaining the memory of these informal networks, Shakespeare reinstates women's self-defining power in the face of his play's, and his culture's, foreclosure on these alliances. All three heroines are given power to define themselves within feminine alliances and thereby to resist, if only temporarily, the controlling gaze of male spectators, within the play and beyond.

Juliet's prison confession in act 2, scene 3, imitates and critiques the assumptions of the early modern culture of surveillance. Having been publicly shamed, "falling in the flaws of her own youth/Hath blistered her report" (2.3.11–12), Juliet enacts a ritual of penance by confessing to the disguised duke-as-friar—that is, emblematically, before both ecclesiastical and civil courts.[112] When the

Duke asks the clearly pregnant Juliet, "Repent you, fair one, of the sin you carry?" she answers obediently, "I do; and bear the shame most patiently" (2.3.19–20). Agreeing with the Duke's charge that "[her] sin was of heavier kind than [Claudio's]," she states, "I do confess it; and repent it, father," (2.3.28–29), and later she assures her confessor, interrupting and effectively silencing his penitential sermon, "I do repent me as it is an evil, / And take the shame with joy" (2.3.35–36). Throughout the ritual of penance Juliet occupies a doubled position, indicated by her careful deployment of pun, that parallels Artemisia's performance during her ritual of shame, the rape trial: like Artemisia mirrored in her opposite, Tuzia, Juliet is judged both guilty and innocent by the scene's sympathetic treatment of her shameful joy. By feigning compliance with her culture's public displays of penance and shame, Juliet doubles herself and affirms her evasion of the Duke's, and the play's, efforts, in Laura Knopper's words, "to induce the subjectivity of shame."[113] Finally, the bifurcated Juliet is tripled by her pregnancy: as the play's physical embodiment of female authorship in the act of childbirth, Juliet subverts the censorious male gaze that instills shame, replacing it with her creative and procreative joy. By usurping the privileged place of the male observer, Juliet offers a means of mediating between the stalemated demands of justice and mercy central to the play's measuring of feminine virtue and vice. Juliet's self-defined shame, her power to accommodate its meaning to her needs, as Victoria Hayne writes, "neither excuses sin nor exacts an irrevocable penalty for it."[114] Her self-authoring manipulation of the ritual of penance speaks an empathetic inclusion, symbolized by the procreative female body, that will make mercy possible in the play's final moments.

This possibility is visually represented by Isabella and Mariana, twins bound by the play's bed trick and joined again in the final scene's startling moment of female union: Mariana, inheritor of Cassandra's role, the rape victim turned wife, kneels to plead for Angelo's life and asks, "sweet Isabel, take my part; / Lend me your knees, and all my life to come / I'll lend you all my life to do you service" (5.1.428–30). A few lines later, persuaded by Mariana and prompted by the Duke, Isabella does just that: "His act did not o'ertake his bad intent," she argues, "And must be buried but as an intent / That perish'd by the way" (5.1.449–51). The tableau of female union is the culmination of several scenes of friendship and solidarity between Mariana and Isabella, most notably act 4, scene 6, whose sole purpose is to unite the two heroines following the offstage bed trick and before their separation throughout the first four hundred–odd lines of the lengthy trial that constitutes the final scene.[115] Isabella's decision to kneel with Mariana in this

moment is enabled by her empathetic self-description as a fallen woman in a public confession of shame that reverses the bed trick. By substituting a willing partner for an unwilling victim, the bed trick suppresses *Measure for Measure*'s explicit inheritance of rape but at the same time raises and responds to the period's growing concerns about the possibility of discerning women's characters, their hidden wills, through visible, externalized signs. The crucial question posed by the Tassi trial of a woman's willingness or resistance—the possibility that she might be a partner in the crime of rape—is made unanswerable by the bed trick's substitution of true and false witnesses, the craft that uses disguise to "pay with falsehood false exacting." Accordingly, while Whetstone's exoneration of Cassandra is repeated in *Measure for Measure*'s claim that "our compell'd sins / Stand more for number than for accompt" (2.4.55–56), it proves inadequate insurance of Isabella's chastity to satisfy the play's concerns about women's inscrutable wills. Stage-managed by the Duke to conclude Mariana's disrupted betrothal and by Shakespeare to clear Isabella, the bed trick relies too much on the willing participation of women, making them partners in crime: as the Duke rightly tells Isabella, Mariana's abandonment is "a rupture that *you* may easily heal" (3.1.245; my emph.). Moreover, the bed trick is a feminine reversal of the male-authored tricks common in early modern courtships—multiple betrothals or rape on the promise of marriage, for example—that frequently resulted in appeals, like the Gentileschi prosecution, for the formal intervention of the courts.[116] It is a comic equivalent to Judith's lethal bed trick—decapitating the unsuspecting Holofernes, "lull'd in her ceitfull bed"[117]—in which the Duke literally plays God. Through women's manipulation of this alliance the bed trick reveals a feminine subjectivity, expressed in Juliet's shameful joy and Mariana's mournful mirth, that can neither be discerned by male viewers nor controlled by male governors.

An extension and reversal of the bed trick, the last scene's spectacle of female solidarity stages an empathetic union between women that, like Juliet's pregnancy, is an emblem of the merciful intervention that the play ultimately supports. Isabella's public ritual of self-shaming enables her to identify and empathize with Mariana and resonates with her earlier efforts to move Angelo to mercy based upon a principle of empathetic identification.[118] "Go to your bosom," she encourages him,

> Knock there, and ask your heart what it doth know
> That's like my brother's fault. If it confess

A natural guiltiness, such as his,
Let it not sound a thought upon your tongue
Against my brother's life. (2.2.137–42)[119]

It is, moreover, a moment at which the play's implicit acknowledgment of the impossibility of externalizing women's interior desires merges with its explicit mediation of justice and mercy. Hayne has shown that *Measure for Measure* reflects seventeenth-century debates about the applicability of Mosaic law (which makes adultery punishable by death) to Anglican England and filters them specifically through the period's distinction between criminal punishment and ecclesiastical penance: as Richard Cosin explains the difference in 1593, the former performs "a publicke spectacle of shame and reproach," whereas the latter, "by these outward tokens of humilitie and submission, testifieth the inward sorow and grief of the sinne."[120] Punishment, like Angelo's justice, is geared toward separation; penance, like Isabella's mercy, toward reconciliation. As a crucial part of the play's tempering of justice by mercy, then, Shakespeare questions the accessibility of women's "inward sorow" through outward show and the need to instill shame in women to confirm by ocular proof their submission to male government.

Each member of *Measure for Measure*'s female trinity, however, is empowered by the play's constructions of female friendship to confirm her independent subjectivity and self-definition. Isabella, for instance, responds to Angelo's invasive scrutiny by appropriating his privileged place as viewer in her own eroticized projection, offered in defense of chastity rather than rape:

Th'impression of keen whips I'd wear as rubies,
And strip myself to death as to a bed
That longing have been sick for, ere I'd yield
My body up to shame. (2.4.101–4)[121]

This decoration of the female body with "rubies" of blood, which calls to mind the gemlike drops of Holofernes's blood that Artemisia depicts on Judith's dress and breast (see fig. 10), allows Isabella to define her femininity, at least provisionally, in opposition to Angelo's imposed interpretation. Isabella's dream of wielding power over Angelo through slander, "I will proclaim thee, Angelo, look for it . . . I'll tell the world aloud / What man thou art" (2.4.150–53), is realized in a public confession that is also an accusation. She assumes the power to witness Angelo's crime with a resistant subjectivity that persists, despite efforts

to suppress it, in the lifelong bond, the alternative marriage, she swears with Mariana in their moment of union: "I'll lend you all my life to do you service." Mariana, too, slandered by Angelo's false report of "her reputation . . . disvalu'd / In levity" (5.1.220), controls her fate by manipulating both marriage law and female friendship in the last scene, in which appropriately, men's fear of women's collusion—their complicity in bearing false witness—is expressed more than once (see 5.1.115 and 5.1.235).

If the specular logic that underlies the bed trick empowers, rather than suppresses, feminine subjectivity in the final scene, it also multiplies the categories that try in vain to contain the heroines, despite their subordination by the resurrected body of patriarchal domesticity at the play's close. It is, I suggest, the manifest failure of these categories to underwrite and sustain the marriage solution that renders the play's outcome so deliberately and disturbingly unsatisfactory. The definitions offered by the Duke's exasperated claim that Mariana is "neither maid, widow, nor wife!" reproduce themselves according to women's predictable bifurcation as virtuous or vicious (5.1.179–80). Thus, Lucio adds, "My lord, she may be a punk; for many of them are neither maid, widow, nor wife" (5.1.180–81), while Angelo's earlier comment that Isabella's desire to be more than a woman renders her "none" names the punk's opposite, the nun (2.4.133–35). These polarized extremes bear the trace of *Measure for Measure*'s attempted strategy of doubling women in order to contain them but also frustrate that effort by calling forth feminine alliances and subjects that evade the reductive categories of the play's male governors.[122] Whereas Whetstone's Cassandra complains, "My guilt doth make me blush, chaste virgins here to see, / I monster now, no maide nor wife, have stoupte to Promos lust" (1.4.2, E2v), *Measure for Measure* replaces this monster of instilled shame with the extreme representatives of women's alliances, the nun and the punk.

<div align="center">CRↃↃ</div>

The Gentileschi prosecution of Agostino Tassi did not repair rape with marriage, at least not to the rapist. Probably due to lingering doubts about Tassi's marital status, the court did not seek the marriage solution. It found Tassi guilty of Artemisia's defloration and gave him the choice of five years' hard labor or five years' exile from Rome ("Appendix" 443–44). Obviously, he chose the latter and was sentenced on November 28, 1612, only to manage his return to Rome four months later. One day after Tassi's sentencing Artemisia Gentileschi married the brother of her chief witness in the trial and left Rome to pursue her painting career in Florence.[123] Despite the marriage, the "near miss" of the

rape,[124] which nearly ended Artemisia's career, continued to inform her public image and her critical legacy. In the satirical eulogies that appeared following her death, she wields the chisel of infidelity much as her duplicitous Judith wields the sword.

Like Artemisia, the heroines of *Measure for Measure* endure spectacles of public shaming that "blister" their fame. While their textual ancestor, Whetstone's Cassandra, dreams of suicide—"But why do I not slaye my selfe for to appease this stryfe?" (1.4.4, E3)—the play's heroines, rescued from rape, do not. Nor did Artemisia Gentileschi. Her appearance as a witness in her own defense, and the brilliance of her subsequent career as a public woman, shed light on the resistance and resilience of Shakespeare's heroines.[125] Despite the attempts of the male jurists at the rape trial and within *Measure for Measure* to blame the victim, these female victims will not be blamed. In their refusal to internalize shame, they resist divisive male definitions and choose, rather, self-authoring alliances between and within women that turn rituals of public shame into powerful performances of female friendship, solidarity, and subjectivity.

The Mirror of Socrates

In his *De miraculis occultis naturae*, translated into French in 1567, Levinus Lemnius deploys the familiar topos of the mirror of Socrates to assert the value of the looking glass as a tool for self-reflection:

> Les miroers dont en ce temps on abuse en choses vaines & superflues, & à l'aide desquels les femmes mettent tout leur soing à s'atisser & farder, quand devant iceux elles se pigment & se parent & viennent à se paindre les jouës & les yeux d'antimoine & autres fards, ont bien esté inventez à meilleur usage, par l'industrie de l'ingenieuse nature, c'est à scavoir, à fin que nous contemplions continuellement la dignité de la forme humaine, & l'excellence de cest ouevre divin. Ce que Socrates aussi conseilloit de fair aux jeunes adolescens, à ce que s'ils se voyoyent d'un corps bien formé, & d'un beau visage, ils eussent crainte de se gaster. Que s'ils estoient laids de visage, & d'un corps difforme, ils s'evertuassent de recompenser ces deffaux là par un esprit bien endoctriné.

> [Looking-glasses that in our dayes are abused for luxury, and by which some women strive to make themselves beautifull when they kemb and dress themselves by them, and paint their cheeks and eyes with Stibium and other paints; the indus-

try of wise nature invented for better uses, namely that we might diligently con-
template the dignity of the form of Man, and the excellency of the Divine work-
manship. And *Socrates* was wont to advise young men to do the like, that if they
were of a beautiful and noble countenance they should not defile it with vices: but
if they were ugly, and not so comely of stature, they should recompence that with
good Ornaments of witt and honest behaviour.][1]

The story of Socrates' didactic use of the mirror, with its differentiation between
men's meditative approaches to the looking glass and women's material con-
cerns, is often rehearsed in early modern cosmetic and catoptric works.[2] Behind
this distinction between good and bad uses of the mirror lies the gendering of
the gaze in the early modern cosmetic debate and its alignment of masculinity
with substance and femininity with surface. Women's characteristic superficial-
ity, the argument runs, leads them to mistake the mirror as a tool to adorn the
body, overlooking its more serious, intellectual use. The mirror of Socrates fore-
grounds the interpretive skills required to negotiate the imperfect correspon-
dences between external appearances and their internal referents and suggests
that men alone possess this judgment. For Lemnius and writers like him, who
see women as essentially superficial creatures, the mirror provides an analogy
for, rather than a reflection of, woman herself: the severing of surface from
substance, exacerbated by the practice of painting, associates women with fraud-
ulent, floating appearances uprooted from a firm anchoring in deeper truths.
Lemnius' further assertion that mirror images are imprinted both on the glass
and on the eye, "car il en prent tout ainsi comme en quelque masse de cire ou
d'argille, en laquelle si vous imprimez un cachet, en la reflexion, les parties vien-
dront toute au contraire" ("for it falls out as it doth with Tables of Wax or Clay,
upon which, if you stamp the print of your Seal, in the taking of, the parts stand
contrary"), genders the mirror itself as feminine—malleable matter on which
masculine (in)sight imprints its shape.[3]

Reduced to the problematic realm of shifting surfaces, the mirror and the
painting woman are bound together by webs of related ideas across various early
modern discourses and genres that assert their deceptive and transitory natures.
Like the objectified female form it reflects, Sabine Melchoir-Bonnet writes,
"when the mirror was not reflecting the spotless divine model, it was the seat of
lies and seductions."[4] Thus, "a common iconographical image of the mirror [was]
that of a monkey who copies and ridicules everything he sees."[5] Cesare Ripa's
Iconologia (1593) expresses the twin suspicion of mirrors and women, now applied

to the art of painting, when his personification of *Imitatione* appears as "Donna, che nella mano destra, tiene un mazzo di pennelli, nella sinistra una machera & a' piedi una simia" (a woman, who in her right hand holds paintbrushes, in her left a mask, and at her feet is an ape).[6] And Martin Day's *Mirror of Modestie* (1630) calls painting women "limners" when he compares them to "painted sepulchres, like the Egyptian Temples, fairely built without . . . [and] adorned with . . . the utmost of Art or expence; but if you look inward to the Quire or Chancell, ye shall finde nothing but . . . an adulterous soule, an Ape limned, guilded and perfumed."[7]

Day's image of the painting woman as a corrupt church echoes Reformation portrayals of the corrupt church as a painting woman. While Catholic Leonardo Lessius' *Widdowes Glasse* (1621) argues that "colours & vernice . . . becommeth not one, that serveth Christ, but rather one who serveth Antichrist,"[8] Puritan Tuke personifies Catholicism as "this old Romish *Jesabel* . . . who defil[es] her selfe with corporall polutions and fornications, not onely to give allowance to publike Stewes and Brothel-houses, but that the Masse it self (which is the master peece of the Papacie) should be made the baude to much uncleannesse."[9] Calvin's *Institutes* condemns Catholic images in similar terms, charging that "brothels exhibit their inmates more chastely and modestly dressed than churches do images intended to represent virgins" ("equidem lupanaria pudicius & modestius cultas meretrices ostendunt, quam templa eas quas volunt censeri virginum imagines").[10] Elsewhere he complains that Christians "soyent souillez & profanez devant les idoles" (are soiled and profaned before idols), specifically the idol of the Catholic mass:[11] "Dieu n'a-il pas ordonné que ce signe fust engravé en nostre chair? Le corps doncques auquel la marque de Jesus Christ a estré polué aux abominations contraires?"[12] When Rouland Hall translates the passage into English in 1561, he employs anti-cosmetic commonplaces to stresses Calvin's equation of the polluted Christian body with that of the painting woman: "Hath god engraven in oure bodyes the armes and badges of his sonne that afterward we shulde pollute our selves with al uncleannes, with most foule spots and shame, & so unsemely deforme our selves that no kind or likenes of christian bewtie shulde appeare"[13] Thomas Draiton's quip that the painting woman is "a false coyner, who on brazen face, / Or coper nose can set a guilded grace,"[14] also recalls the counterfeit currency imagined by Calvin as the idolatrous effects of the Catholic mass: "Il n'est pas licite d'imprimer des coings en une piece d'or . . . & l'homme mortel se donera congè de falsifier le Baptesme, & la Saincte Cene de Jesus-Christe & dira qu'il n'y a nul mal?" ("It is not law-

ful, in coyning one peece of gold, to print two contrarie coynes . . . and shal a mortal man take upon him to counterfete and corrupt baptisme, and the most holye supper of Jesus Christe").[15]

As these commentaries suggest, the rupture between surface and substance central to Reformation debates on the integrity of religious ceremonies and images also governs early modern portrayals of female nature as reflected in the troublesome looking glass. The mirror of Socrates casts women as surface without substance, robbing them of subjectivity and displaying them as idols toward which men, alternately adoring and damning, turn their defining gaze. Practicing her idolatrous art, the painting woman embodies the idolatry of religious images that reformers see as threatening to entrap lay people, dazzled by the false shows of the *Biblia pauperum*, in a maze of deceptive appearances. If the mirror's surface figures the painting woman, her objectified form, in turn, serves as a metaphor for idolatry, and her cosmetic practices are a version of the idolater's craft. Tertullian's "On Idolatry," repeatedly resuscitated by Reformation iconoclasts, argues that, because the creation of the human form is the prerogative of God alone, "the artist, by forming a human image in stone or paint . . . is attempting to usurp God's function."[16] Tuke's *Treatise Against Painting* applies Tertullian's argument to the painting woman: "O woman, thou defaceth the picture, if thou dawbest thy countenance with materiall whitenesse, or a borowed red . . . If any man adulterate the work of God, he committeth a grievous offence. For it is an hainous crime to thinke that man can painte thee better then God."[17] John Downame's *Christian Warfare* echoes the sentiment and adds that painting women offend mankind "by deceiving and abusing them to admire a painted picture, in stead of the worke of God . . . What is it but to make themselves counterfeite idoles, that unto them lust may offer their sacrifices of uncleanesse?"[18]

In light of this pervasive suspicion of images and the gendering of debased forms of representation, is it possible for the early modern woman to control the mirror? Can she view her own reflection with self-awareness and insist upon her right of self-definition? Together, the two following chapters explore women's agency in negotiating the cosmetic culture's controlling assumptions and iconoclasm's paralyzing implications for women's creativity. The public women examined in these chapters—two queens, a professional painter, and a published writer—find in the shifting discourses surrounding imagery, painting, gender, and idolatry in early modern Europe the means to redeem femininity from the charges of misogyny and to empower it in the face of pervasive cultural stan-

dards for feminine beauty. Marguerite de Navarre, Lavinia Fontana, Elizabeth I, and Aemilia Lanyer navigate doctrinal debates on idolatry and iconoclasm, responding to their implications for women and stressing the continuity between concerns about the colors and essences of religious imagery and similar worries about those of femininity. All of these women engage the legacy of incarnationalism, with its elevation of the material (including, they argue, the female body) on the basis of Christ's assumption of the flesh, and they all exploit the rupture between internal essence and external appearances that marks the concept's trajectory in Reformation iconoclasm.[19] Each locates herself in relation to this rupture as she defends women's agency and self-representation through the contested figure of painting.

In this chapter I focus on works by Marguerite de Navarre and Lavinia Fontana in order to demonstrate how, by engaging Reformation and Counter-Reformation approaches to idolatry, they insist upon women's abilities to penetrate opaque surfaces and correctly interpret the substance hidden within. I locate their works within the context of the cosmetic debate and delineate the connections between this debate and theological discussions of idolatry through a reading of Jean Liébault's *Trois livres de l'embellishment et ornement du corps humain* (1582).[20] Despite its defense of women's painting, Liébault's cosmetic manual exemplifies the disappearance of the female subject practiced by the cosmetic culture—the loss of feminine agency that Marguerite de Navarre and Lavinia Fontana hope to restore. By portraying women as viewing rather than being viewed, Marguerite and Fontana evade the essentialist limitations of the cosmetic culture, mandated by Liébault, and construct a feminist view of woman's essence—that is, an essentialism self-consciously aware of the *fiction* of essence—predicated upon a redemptive reading of the female flesh. Marguerite's two textual mirrors, *Le Miroir de l'âme pécheresse* (1531) and *Le Miroir de Jhesus Christe crucifié* (published posthumously in 1552), blur the borders between self and other, flesh and spirit, to describe the specifically feminine experience of religious meditation on the "trescler mirouër" of Christ.[21] The poems trace the emergence of a new, gendered creature whose internal beauty is a function and refinement of her difficult materiality. Fontana's *Christ and the Samaritan Woman* (1607) illustrates the intimacy between the female subject and Christ as a matter of the flesh: like Marguerite, Fontana imagines a redeemed femininity enabled by women's material relationships with Christ incarnate. Energizing Counter-Reformation views of the observer's engagement with sacred images, Fontana depicts a woman's insightful interpretation of the figure of Christ himself. She

redeems both femininity and the art of painting by affirming the reliable connection between superficial appearances and the spiritual truths they promise to reveal.

Couched within nine pages defending cosmetics in Liébault's epistle "Au Lecteur" is a passage, placed in the mind of a woman, that worries that painting adulterates the spirit and usurps God's creative sovereignty, thereby constituting idolatry:

> Qu'elle pense que les couleurs, peinctures & toutes sortes de pigments le plus souvent servent de stimule à toutes impudicitez qui infectent, polluent & contaminent les beautez singulieres de l'esprit: Que, c'est faire tort à nature, de dissimuler, sophistiquer & adulterer la forme & figure du corps . . . Un bon peinctre reputeroit grande injure luy estre faicte; & auroit juste occasion de s'indigner contre celuy, qui voudroit corriger & reprendre un tableau ou simulachre qu'il auroit paracheué avec grand soing & diligence. Ne se servira donc d'aucun embellissement, sinon en grand necessité.[22]

> [She thinks that colors, paints, and all types of pigments most often serve as stimulants to all the immodesties that infect, pollute, and contaminate the singular beauties of the spirit. That it does harm to nature to dissimulate, sophisticate, and adulterate the form and figure of the body . . . A good painter would consider that a great injury had been done to him and would have just occasion to become indignant against he who would wish to correct and remake a picture or likeness that he had perfected with great care and diligence. Therefore, she will not make use of a single embellishment, except in great necessity.]

The passage at first seems incongruous in a text that instructs women in the formulation and use of cosmetics. Yet Liébault's attribution of the invective to a woman, perhaps a reluctant reader, enables him at once to acknowledge traditional charges against cosmetics and to define the terms on which women's painting can legitimately proceed. Liébault presents these imagined protests in order to argue that, in fact, "ce pour quatre occasions" (it is on four occasions) that women should—and *must*—make up:

> L'une quand apres avoir eu soing de l'embellissement de son esprit, elle recognoist quelque difformité fort male plaisante en son corps; qui pourroit donner sinistre argument & mauvais indice de quelque difformité d'esprit . . . Comme, si elle avoit les cheveux roux, d'autant que tell couleur demonstre une personne superbe, hau-

taine & addonnée à grand vice, elle pourra les blondir. La seconde, pour donner ordre à quelque accident de maladie survenué, qui outre le mal, altere & gaste sa beauté . . . La tierce popur attirer & se mettre en la bonne grace de quelqu'un qui la recerche pour espouse s'y est à marier: Ou, pour complaire ou obeyr à son mary, qui veut qui soit parée, s'y est mariée . . . La quatre, que, puis que la netteté, la propreté & venusté est naturelle à la femme, qu'elle se pare pour estre veue nette & propre. (a5v)

[The first is when, after having taken care to embellish her spirit, she recognizes some deformity so displeasing in her body that it might give a sinister argument & bad indication of some deformity of the spirit . . . For example, if she had red hair, and since that color suggests a proud and haughty person, given to certain grand vices, she could dye it blonde. The second, to give order to some accident of illness that has come upon her, which beyond the illness, changes and damages her beauty . . . The third is to attract and put herself in the good graces of someone who seeks to marry her, if she is to marry, or to please or obey her husband, who wants someone who is adorned, if she is married . . . The fourth, that, because neatness, cleanliness, and refinement is natural to a woman, so that she should adorn herself to be seen as neat and clean.]

By enumerating the *necessités* requiring cosmetic embellishment, Liébault curtails women's potential *self*-authorship through painting. Few would object to a woman's pragmatic and judicious use of cosmetics to repair damage wrought by illness.[23] Each of Liébault's remaining three conditions, however, limits a woman's creative license by subordinating her motives and her appearance to moral, marital, and natural hierarchies within which she is ranked below men. Thus, his third occasion for painting, to attract or retain a husband, ensures that a woman will use cosmetics primarily as an act of obedience.[24] The condition is intimately tied to Liébault's fourth *necessité*, the essentialist argument that feminine nature requires women to paint. As he explains, "la beauté est plus requise, plus necessaire, plus soubhaictée, & desirée en femmes, qu'en hommes: tant pour couvrir aucunement leurs imperfections interieures . . . que pour les rendre plus aymables aux hommes, plus plaisantes & aggreables à leurs maris" (beauty is more required, necessary, wished for, and desired in women than in men, not so much to cover in the least the interior imperfections . . . as to render them more amiable to men, more pleasant and agreeable to their husbands). This view rests upon his reading of Creation: "Aussi certainement la femme, estant creée de Dieu pour servir & complaire à l'homme . . . ne peut moins faire,

que d'estre soingneuse de sa beauté naturelle . . . pour en donner honestement plaisir à son mary" (Since certainly woman was created by God to serve and please man [she] . . . can do no less than to be careful of her natural beauty . . . to give honest pleasure to her husband).[25]

To defend women's painting on the essentialist grounds provided by the myth of Eden, Liébault enlists the aid of one of the period's most widely read and imitated works, Heinrich Cornelius Agrippa's *Declamatio de nobilitate et praecellentia foeminei sexus*. In deploying Agrippa throughout his epistle "Au Lecteur," however, Liébault reveals his reluctance to subscribe wholeheartedly to the feminist sentiments of his source. Thus, the imported treatise rests in an uncomfortable relationship with Liébault's hegemonic approach to women's painting. From Agrippa's work (translated into French in 1537) Liébault borrows the notion that "la femme . . . este creée belle de sa premiere naissance: quand, pour le dernier, ouvrage de ce grand ouvrier & createur, fust creée non du limon du terre, ainsi que fust l'homme, mais, d'une matiere beaucoup plus nette, plus delicate, plus tendre & plus purifée" (a3) (woman was created beautiful from her first birth: when, for the last work of the grand craftsman and creator, was created not from the mud of earth, as was man, but of a material more clean, more delicate, more tender, and more purified).[26] Accordingly, Liébault transcribes almost verbatim from Agrippa an exhaustive blazon describing ideal feminine beauty:[27]

> Observez en elle un corps tres-delicat, tant à veoir qu'à manier: la chair tendre: la couleur blanche & clere: la peau nette: la teste bien seante: la chevelure fort plaisante: les cheveux mollets, luisants, & longuets: le visage rondelet, gay & modeste: la nucque blanch comme laict: le front ouvert, large, poly & luisant . . . la bouche vermeille acompagnée de leurs tendrelettes . . . les jouës vermeilles comme la rose . . . la gorge delicate, blanche la neige. (a3)

> [Observe in her a very delicate body, to be seen rather than touched: tender flesh of a white and clear color: clean skin; a head well positioned: very pleasant hair: tresses wiry, gleaming, and long: a round, gay and modest face; a neck white as milk: her forehead open, large, smooth and glowing . . . her mouth red accompanied by tender lips . . . cheeks red like the rose . . . the throat delicate and white as snow.]

In Agrippa the blazon is one element in the text's overall assertion of women's preeminence over man. Both men and women, Agrippa claims, are endowed at

creation with "la divine essence de l'âme" ("the dyvyne substance of the sowle"),[28] and they are therefore equal. Women's physical beauty, however, argues their refinement of the raw material of creation embodied in man. "L'Homme n'est donc, à proprement parler, que le plus bel ouvrage de la nature," Agrippa insists, "mais la femme est la plus parfaite production de Dieu" ("And thus, man is the worke of nature, and womanne is the worke of god"). Accordingly, he argues, "la propreté et . . . la beauté admirable de la femme" ("[woman's] clenlynesse, & marveylous faire beautye") is proof that "la femme est-elle plus capable que l'homme de la splendeur divine, et souvent même elle en est toute pleine, toute rejaillissante" ("woman is many tymes more apt and mete then the man, to receyve the hevenly light and bryghtnes, and it is often replenyshed therwith").[29]

In part the *Trois livres* agrees with Agrippa's assessment of women's natures and their spiritual equality with men. Liébault's invocation of the mirror of Socrates, for example, departs from the usual gendering of the anecdote in suggesting that women as well as men might profit from consulting the mirror to reflect upon their souls:

> Donc, autant que de se servir des embellissements que mettons en avaunt, faut qu'elle experimente premierement au miroir de Socrates, quelle est sa beauté: à fin que, si en ce miroir, elle se recognoist laide de corps, s'efforce d'avoir l'esprit beau, pour corriger ceste turpitude & laideur de corps: aussi, si elle se recognoist belle de corps, mette peine, que son esprit responde à la beauté du corps. (a5)

> [Thus, before utilizing the embellishments that we give here, [a woman] must first determine in the mirror of Socrates of what sort is her beauty: so that, if in this mirror she recognizes ugliness of the body, she will encourage herself to have a beautiful spirit, to correct this corporeal turpitude and ugliness: and, if she sees bodily beauty, she will take pains that her spirit corresponds to this beauty of the body.]

The advice that women meditate upon the mirror as a vehicle for self-reflection forms part of Liébault's defense of painting, which insists, "qu'il seroit difficile, voire impossible, que la beauté du corps fust honnorable, si l'esprit estoit laid & difforme" (a4v) (that it will be difficult, if not impossible, for corporeal beauty to be honorable if the spirit is ugly and deformed). Although he initially appears to attribute to women the discretion and self-awareness needed to penetrate their own troubling appearances and observe the spiritual truths hidden within, the gendered dichotomy of surface and substance, which ordinarily attends the

anecdote, pervades Liébault's discussion of beauty and ultimately overwhelms his optimism about women's interpretive abilities. "Au corps humain, nous devons admirer deux excellents beautez" (in the human body we must admire two excellent beauties), he writes: "L'une qui consiste en la structure, coagmentation, forme, espece, & harmonie de ses parties . . . L'autre beauté est une splendeur & lumiere agreeable . . . accompagnée de naifve couleur, traits amiables, & lineaments gratieux" (a2v) (The one consists in the structure, coagmentation, form, space, and harmony of its parts . . . The other beauty is a splendor and agreeable light . . . accompanied by naive color, amiable traits, and gracious lines). He concludes, "à l'homme plus appertient la premiere beauté: & à la femme, la seconde" (the first beauty appertains mostly to man, and, to woman, the second). Thus, "la dignité, l'authorité, la grandeur, la majesté" (dignity, authority, grandeur, majesty) are proper to men, while "la grace, la venusté, la propreté, la netteté" (grace, refinement cleanliness, neatness) are natural for women (a2v).[30] Women's beauty is shallow and fleeting, men's deep-seated and lasting. Given that the God-like virtues are masculine, while superficial adornments are feminine, Liébault's blazon, unlike Agrippa's, enumerates women's ephemeral appearances; the dazzling surface that distracts men from, rather than directing them toward, internal virtue. Far from arguing that woman's superior beauty more perfectly reflects that of God, Liébault reduces her to mere surface, parceling and objectifying her form in the blazon's relentless anatomization.

Liébault's egalitarian casting of the mirror of Socrates is undermined by his association of women with surface, severed from the substance hidden within. The first of his conditions mandating women's cosmetic adornment, in fact, demonstrates the double bind in which his painting woman finds herself. Recognizing "quelque difformité [du corps] qui pourroit donner sinistre argument & mauvais indice de quelque difformité d'esprit" (some physical deformity that might give a sinister argument and bad indication of some deformity of the spirit), she must employ cosmetics. Because a woman's appearance is seen as an index of her inward nature, she is compelled to paint in order to dispel the *sinistre argument* elicited by physical deformities. Yet painting itself signals her internal corruption. Leonard Fioravanti, for example, concludes his discussion of makeup's toxicity in *Dello specchio di scientia universale*, translated into French five years after Liébault's *Trois livres* appeared,[31] with a chapter on those cosmetics that women can use without harm ("de fards desquels l'on peut user, sans se faire tort"): "On ne trouve aucune sorte de fard, qui orne mieux le visage d'une femme, que l'alegresse & contentement d'esprit" (One cannot find a single kind

of makeup that better adorns the face of a woman than lightness and content-
ment of spirit). Health (*d'estre saine*), honesty (*l'honnesteté*), and prudence (*la pru-
dence*) complete his survey of the cosmetics "qui doivent estre en l'interieur du
coeur: & les femmes qui se pareront de tel fards seront plus belles que toute les
autres" (which must be in the interior of the heart, and women who will adorn
themselves with such cosmetics will be more beautiful than others).[32] While
Fioravanti sees inner beauty—a kind of spiritual painting—as an alternative to
external adornment, Liébault's cosmetic recipe book is plagued by the troubled
relationship between essence and colors. Although Liébault insists that a woman
should repair external deformities only *after* she has examined her soul, his re-
quirement that she alter her appearance to dispel any suggestion of vice licenses
her creation of an "angelick complexion," as Smith's *Wonder of Wonders* argues,
to hide an "infernal Daemon" within.[33]

An anxiety, then, about the unverifiable connection between inward and out-
ward beauty disables Liébault's optimistic view of the mirror of Socrates. As he
debases feminine beauty as superficial, he imagines woman first and foremost as
a sight to be scrutinized and interpreted by men: she must adjust her appearance
to avoid a *mauvais indice* of the status of her soul. Severed from a redemptive link
to internal truth, the painting woman becomes a problematic icon of the moral
ambiguities surrounding imagery and illusion. Unable to root her morality in
her essential virtues, Liébault, perhaps inadvertently, casts her as a "deed and
unsensyble image," to apply Martin Bucer's concise description of an idol.[34] Her
superficiality becomes mere surface and her made-up face an emblem of the
corruptible flesh, an affective memento mori. Moreover, Liébault's equation of
woman with surface, man with substance, revises Agrippa's interpretation of
Eden in terms that resonate with the Reformation claim that images have their
origins in the Fall. As Quaker George Fox will argue in *Iconoclastes* (1671), al-
though man and woman were made in the image of God, their seduction by Satan
severed them from that original likeness and introduced idols into the world.[35]
The feminine duplicity that caused the Fall, in this view, marks the origin of
deceptive surfaces, divorced from defining relationships to their essences. Thus,
medieval and early modern iconography frequently portrayed Eve holding a mir-
ror,[36] an emblem of woman's superficiality and the embodiment of woman as sur-
face. The world created in Eve's image is a fallen world of shadows.

These surprising connections between the early modern cosmetic debate and
Reformation discussions of idolatry invite us to consider the implications of
reformed and Counter-Reformation views of images for women's creation and

self-creation. From the church fathers early modern theologians inherited a defense of images grounded on two related tenets. John of Damascus argued that the Incarnation validated and elevated matter and therefore licensed visual approximations of divinity—admittedly obscured and imperfect, seen through a glass darkly, due to the limitations of matter and human nature. Given the validity of religious representations, derived from the material presence of Christ, Pope Gregory I supported the efficacy of images as a *Biblia pauperum*.[37] Gabriele Paleotti's *Discorso intorno alle imagini sacre e profane* (1582), for example, defends images as "un libro populare" (a popular book) within a program "di riformare il catholico" (Catholic reform) based upon the final session of the Council of Trent in 1563, in which Paleotti participated.[38] Thus, he opposes "gli heretici, & Iconomachi, che . . . hanno cercato di esterminar [le imagini] da tutti i luoghi" (the heretics and iconoclasts who . . . have sought to eliminate [images] in all places), on the one hand, and "[gli] catholici, i quali ritenendo l'uso delle imagini, hanno nondimeno in varii modi corrotta & difformata la dignità loro" (Catholics, who, retaining the use of images, have nonetheless in various ways corrupted and deformed their dignity), on the other. For Catholic apologists the affinities between images and their prototypes guaranteed the divine content of religious ceremonies, representations, and objects,[39] the Eucharist in particular. As Nicholas Sander argues in *A Treatise of the Images of Christ, and of his Saints* (1567), "Outward holie things are Signes of the inward," and thus the Eucharist is a "naturall image," containing the essence of Christ in its material form.[40] He describes with horror an incident of iconoclasm in Antwerp in 1566: "What shall I speake of the Blessed Sacrament of the Altar, which they trode under their feete and (horrible is to say) shed also their stinking pisse upon it, as though, if it were not Christes owne bodie, it were not by their owne doctrine, a mysticall figure of his body. Or if it be not so, yet at the least a creature of God, which of purpose ought not to be spitefully handled."[41]

Despite his confidence in the real presence of Christ in the Eucharist, Sander's equivocation about its status reflects a perceived rupture between internal state and outward form that prompted reformers to reject both transubstantiation and images. Whereas for Sander the Eucharist is "Christes owne bodie," or "a mysticall figure" of it, Protestant writers emphasized the spiritual, rather than material, component of the sacrament and rejected images as mere shadows of truth. Thus, Calvin condemns the Catholic understanding of the Eucharist as a vain idol, urging, "Away, then, with those who, on the view of a missal—god of wafer, bend their knees in hypocritical adoration, and allege that they sin less because

they worship an idol under the name of God!" ("Eant nunc, qui ad missalis illius e panario Dei conspectum, genua simulandae religionis causa inclinart: & levius se delinquere iactant, quad sub Dei nomine idolum adorent").[42] Martin Bucer, too, offers a revised interpretation of the Incarnation that responds to both of the standard defenses of images:

> Fynnally [Christ] lefte nothing behynde to the shadowing & fyguringe of himselfe largely to them. I say / how fortuned it / if ymages be so profytable / that god for al this insomoch dyd nothing esteme them that he wold in no wise sufre them to be amonge his people. Syth than it is so / that it was not lawful for the people / which was yet rude and ignorante to have any maner ymages . . . Howe moch lesse shall it be lawfull for us / whom the truth succeeded into the place of shadowes / hathe nowe made free from outwarde ceremonies / requyryng non other honour or servyce of us / than that which standeth in spirit and truth.[43]

Bucer discounts the material aspects of religious ceremonies to advocate the internal, spiritual experience of the worshiper, grounded in individual study of the Bible.[44] The visual *Biblia pauperum*, according to this view, impedes laymen's access to the Scriptures, exposing them to the letter rather than the spirit. As Calvin writes: "I am not ignorant, indeed, of the assertion, which is now more than threadbare, 'that images are the books of the unlearned.' So said Gregory: but the Holy Spirit gives a very different decision" ("Scio quidem illud vulgo esse plusquam tritum, Libros idiotarum esse imagines. Dixit hoc Gregorius: at longe aliter pronunciat Spiritus Dei").[45] In place of these dead and insensible idols Calvin imagines a living faith that reinterprets all of material creation as God's image and which "acknowledge[s] none but Him, who has manifested himself in his word" ("ne alium admitterent fideles quam qui se verbo suo paterfecerat").[46]

Bucer's claim that the reformed church, emancipated from "the place of sha-dows," has been "made free from outwarde ceremonies" summarizes the Protes-tant elevation of the spirit above the letter and reflects a common equation of Catholicism with idolatry. This formulation has a Counter-Reformation equiv-alent in the defense of Catholic images against Old Testament forms of idolatry. Paleotti, for example, claims that "i Guidei . . . ostinanti nela supersticiè della lettera delle legge antica . . . non venerano le imagini riputandole Idoli" (the Jews . . . obstinate in the superstition of the letter of the old law . . . did not ven-erate images, reputing them to be Idols), but "essendo di poi venuto al mondo il Salvatore nostro . . . & essendo gia in essere l'uso delle sacre imagini, fù per l'avvenire continuata sempre la osservanza loro" (our Savior having come into

the world . . . and, sacred images already being in use, assured for the future the continuity of their observation).[47] The association of idolatry with the dead letter of the old law rests upon Christ's dictum to the Samaritan woman in the Gospel of John—an episode that I will consider at greater length later in this discussion—that "the hour cometh, and now is, when the true worshipers shall worship the Father in spirit and in truth" (John 4:23). As Fox puts it, "Christ he ends the true Figures and Shaddows, and the Apostle preacht them down, not only the Gentiles Images, and Likenesses, but the true Tipes and Figures of Christ Jesus; for they preacht up the Substance, Christ Jesus."[48]

Despite Catholic defenses of the efficacy of religious images, Protestants saw their use as an adulation of the creation above the creator, an idolatrous self-love embodied in the excesses of Catholic ceremonies. Whereas Paleotti sees the painter as a servant of God, "ammasetrando elle l'intelletto, movendo la volontà, e rifrescando la memoria delle cose divine" (teaching the intellect, moving the will, and refreshing the memory of things divine),[49] Bucer argues of man-made images that "soner shall the remembraunce coome to thy mynde of the Carver or Paynter / whose workmanship thou dost marveyle at / than the remembraunce of god / the creatour & maker of all things." He concludes: "It is therefore nothynge els but a pure disceyte of the devyll / which calleth us from the praisyng and charytable lovynge of the lyve ymages of god / unto deed ymages of wood or stone / which some man a folysshe counterfaiter of god / hath folysshlye carven or paynted."[50] Like the painting woman, the idolater worships the creation rather than the creator and usurps God's creative sovereignty by constructing a likeness of the painter herself.[51] Voicing this conflation of cosmetics and idolatry, Calvin asserts that the Catholic mass, "qui s'achetent chacun jour, sont comme des putains de bordeau" ("set forth dayly to sale . . . are not unlike to harlots . . . in the stewes"). He continues:

> La Messe parochiale est comme un paillarde, laquelle covure du nom de son mari pour se tenir en reputation de femme de bien. Combien que la similitude n'est pas du tout propre: car un paillarde mariée aura encore quelque vergongne de s'abbandoner à tous venants: mais la Messe parochiale est l'idolatrie la plus commune de toutes. Tant a que cieux la fardent de ceste couleur, qu'elle retient encores quelque trace de la Cene de Jesus-Christe.

> [the high masse [is] very like the same harlot which dothe craftelye abuse the honest name of an husband to hide her unshamefastnes & to retayn & defend the estimation of an honest & chaste wife. Althoughe this simylitude doth not agree on

every parte, because the harlot joyned in matrimonye to an husband wil have some shamefastnes & modesty, that she will not set forthe & make her selfe common to all that commeth: but the parish or high mass is an whorysh idolatry of al other most common, ready, & set forthe to al mens desires and wycked lustes: although these filthy bawdes do colour and smothe here with thys colour and such beautye, that they retaine still some relikes of Jesus Christes supper.][52]

All the more offensive in that it approximates truth with the diabolical "relikes" of truth, Calvin imagines this "Cene fardee" ("hypocriticall supper") as literalized in the polluted female body[53]—an idol before whom, through the pandering of Catholic priests, "ad prostitutendum idolatrae populo, que cum fornicatur" ("an idolatrous people were to prostrate themselves and commit fornication!").[54]

In the face of this painted bawd, this counterfeit sacrament, the female writer will seek the means to ransom problematic surfaces and to sanctify femininity in a redemptive mirror of her own making.

For Marguerite de Navarre the adornment of the female body constitutes an idolatry in need of correction through meditation on the mirror of Christ:

> Helas, mon Dieu, quant bien je suis recordz
> que trop aymé j'ay mon malheureux corps,
> par qui j'ay tant chascun jour trevaillé;
> pour le garder j'ay mainte nuict veillé,
> et que j'en ay faict, mon Dieu, mon ydolle:
> trop plus aymé ma chair fragile et molle. (*MJCC*, 905–10)

[Alas, my God, when I recall well how much I have loved my unhappy body, which I have worked so much everyday and spent long hours at night to maintain, and that I have made of it, my God, my idol: loving too much my fragile and feeble flesh.]

Together, Marguerite's two mirrors, which mark the beginning and the end of her literary career, record the transformation of the fragile female body into a new creature in Christ: "[une] creature nouvelle, / Pleine de Dieu, qui [elle] faict estre belle" ("a godly, and beautifull creature").[55] Thus, *Le Miroir de l'âme pécheresse* elaborates a holy incest that asserts the speaker's intimacy with Christ in her roles as the Savior's "mere, fille, soeur, et espouse" (171) ("mother, daugther [*sic*], syster, and wife" [*Glass* 13]). *Le Miroir de Jhesus Christe crucifié*, meanwhile, offers

a blazon of Christ's body on the cross in which the speaker sees her own body and sins mirrored. The poem culminates in the union of Christ and the speaker, now purified and re-created through his sacrifice: "o miroër, je sens mutaïon / ... car ta clarité que devers moy tu tourne, / en toy me chang[e] et en toy me transforme" (*MJCC* 1240–44) (O mirror, I feel change ... because your clarity, which you turn toward me, changes and transforms me into you).

If the Incarnation, for Catholic apologists in the iconoclastic debate, validates the material world and, thereby, the use of religious images, Marguerite similarly describes the reformation of the female flesh. Both *Miroir*s rely on the materiality of the female body and Christ's humanity to enable their speakers' intimacy with divinity.[56] She imagines a repair of the rupture between the interior and exterior aspects of the woman's body that would guarantee ephemeral surfaces by rooting them in spiritual certainties. This reformation, in turn, regenders the gaze. Rather than casting woman as the object of male scrutiny and interpretation, as the cosmetic culture does, Marguerite places her before the mirror of Christ, an agent in her own self-interpretation and self-knowledge. Indeed, as author of these mirrors, Marguerite assumes the active role of self-creator. Thus, the first *Miroir*'s address "Au Lecteur" offers a disclaimer of the poem as a feminine work that also elevates its author by affirming her identity as a vessel filled with God:

Si vous liséz ceste oeuvre toute entiere,
Arrestéz vous, sans plus, à la matiere:
En excusant la Rhyme, et la langaige,
Voyant que c'est d'une femme l'ouvraige:
Qui n'a en soy science / ne sçavoir,
Fors ung desir, que chascun puisse veoir,
Que faict le don de DIEU le Createur,
Quand il luy plaist justifier ung cueur:
Quel est le cueur d'ung homme quant à soy
Avant qu'il ait recue le don de Foy:
Par lequel seul l'homme a la congnoissance
De la Bonté / Sapience / et Puissance.

[If thou doest rede thys whole worke; beholde rather the matter, and excuse the speeche, consydering it is the worke of a woman: wiche hath in her neyther science, or knowledge, but a desyre that eche one might se, what the gifte of god doth when it pleaseth hym to justifie the harte of a man. For what thinge is a man, (as

for hys own strengt) before that he hath receyved the gifte of fayth: wherby onely hath the knowledge of the goodnes, wisedom, and power of god. (*Glass* 5)]

Without the divine gift of faith, men as well as women are powerless. As Susan Snyder writes, "'Femme' thus slides into 'homme,' and Marguerite's gendered humility transmutes into a veiled assertion of equality with men."[57] Like the female body, the body of Marguerite's poem may appear weak and inferior, but it holds in its heart "the goodnes, wisedome, and power of god."[58]

Marguerite's mirrors deploy the vocabulary and concepts of the iconoclastic debate to empower the female subject, but they stand in a contested relationship to Reformation discourses in sixteenth-century France.[59] The publication of *Le Miroir de l'âme pécheresse* was surrounded by events that place Marguerite, at least by reputation, firmly within this debate. In October 1533 the Faculty of Theology of the Sorbonne issued a tentative censure of the book's second edition as heretical, a condemnation that was lifted when Marguerite appealed to her brother, François I, for royal intervention.[60] Shortly after the censure, in June 1534, statues of the Virgin and Saint Claude were stolen from a church on Marguerite's lands in Alençon, and hung from the gutters of a house. That October students at the College de Navarre presented a farce portraying Marguerite as a violent attacker of Catholicism.[61] Finally, in the same month, suspicions of Marguerite's involvement in the Affair of the Placards, in which broadsheets proclaiming the idolatry of the Catholic mass were posted in Paris and Rouen, caused her to retire from Paris to Nérac.[62]

Although the reasons for the Sorbonne's censure of Marguerite's poem are unclear,[63] her sympathies for the reformed religion were widely known. The influence of Guillaume Briçonnet, bishop of Meaux, with whom Marguerite corresponded from 1521 to 1524, pervades her first *Miroir*, as do generous scriptural citations derived from Jacques Lefèvre d'Étaples's French translation of the Gospels.[64] From these reformers, the latter of whom was visited by Calvin at Marguerite's court at Nérac in 1534,[65] Marguerite would have developed her belief in the meditative dissolution of the flesh, which stresses internal religious experience rather than external ceremonies and in the centrality of individual reading of the Bible to that experience. Both of these beliefs permeate her textual mirrors. Nonetheless, the poems stop short of fully adopting a reformist agenda: Marguerite's mirrors blend materiality and spirituality, attempting a reconciliation between a Catholic faith in the redemptive potential of incarna-

tionalism and a reformist advancement of the believer's direct engagement with Christ as the Word.

Reflecting current iconoclastic debates, Marguerite situates *Le Miroir de l'âme pécheresse* at the disputed juncture of textual and visual images, exploring rival notions of the value of material and biblical reflections of God. In embracing Christ incarnate in the Word, the poem merges corporeality and textuality as mutually dependent means of achieving redemption and spiritual enlightenment. Early in the poem she laments that "trop estoit ma paovre ame repue / De maulvais pain, et damnable doctrine" (132–33) ("For my poore soule was to moche fede with yll bread and damnable doctrine" [*Glass* 11v]), relating the Eucharist to the (contested) sustenance of Christian doctrine. As the poem progresses, the speaker moves from a "rhetoric of corporeality" to a view of the Incarnation as redeeming not only the flesh but also feminine speech: thus, a cluster of biblical citations (nine between ll. 46 and 59) corrects Marguerite's erroneous speech with God's Word.[66] The material bodies of Christ and the female speaker remain, however, central to Marguerite's incarnational poetics throughout the *Miroir*, marking the speaker's initial awareness of her polluted carnality and enabling her redemption through holy incest. The opening passage contains a remarkable blazon of the speaker's body, transformed by sin into a tree imprisoning and strangling the soul:[67]

> Si je cuyde regarder pour le mieulx,
> Une branche me vient fermer les yeulx,
> En ma bouche tombe, quand veulx parler,
> Le fruict par trop amer à avaller.
> Si our ouyr mon esperit s'esueille,
> Force fueilles entrent en mon oreille:
> Aussi mon néz est tout bousché de fleurs.
> Voyla comment en peine, criz, et pleurs
> En terre gist sans clarité ne lumiere
> Ma paovre ame, esclave, et prisonniere,
> Les piedz liéz par sa concupiscence,
> Et les deux bras par son accoustumance. (*MAP*, 13–28)

[If i thinke to loke for better, a braunche cometh and doth close myne eyes: and in my mouth doth fall when i wolde speake the frutte wich is so bytter to sualowe down. If my spirite ber styrred for to karken: than a great multitude of leaffes doth

entre in myne eares and my nose is all stoped with flowres. Now beholde how in payne, cryenge, and wepinge my poore soule, a slave, and prisonnere doth lye, withoute claritie, or light havinge both her fete bound by her concupiscence, and also both her armes through yvell use. (*Glass* 7–7v)]

Marguerite's female body, as the Tree of Knowledge of Good and Evil, symbolizes the Fall. As femininity is indicted in the Old Testament account of the Fall, it is redeemed by New Testament salvation. The latter is embodied in Marguerite's mirror in the female body's incorporation of the Word, in imitation of the Virgin. "Pour luy avoir au cueur escript le rolle," she writes, "De vostre Esprit, et sacrée parolle/. . . Par quoy daignéz l'asseurre, qu'elle est Mere/De vostre filz, don't vous etes seul Pere" (181–82 and 187–88) ("Because thou hast written in her [the soul's] harte the rolle, of thy spirite, and holy word . . . Therefore doest thou vouchesafe to assure [her that] she is mother of thy sonne [to w]hom thou art the only father" [*Glass* 13v]). The female form is imagined as the vessel containing Christ, and the Virgin's "sainct ventre" (287) ("holy wombe" [*Glass* 18]) becomes, by humble imitation, Marguerite's own:

Car vous etes sa mere corporelle,

E sa mere par Foy spirituelle:

Mais en suyvant vostre Foy humblement,

Mere je suis spirituellement. (315–19)

[For thou art his corporall mother, and also (through faith) his spirituall mother. Than i (followinge thy faith with humilitie) am hys spirituall mother. (*Glass* 19)]

Le Miroir de l'âme pécheresse redeems the female speaker through her internalization of Christ as the Word. Marguerite elaborates this process in her adaptations of four biblical narratives, each presenting the speaker in intimate, incestuous relationships with Christ. Thus, the story of "l'enfant prodigue" (383) from Luke 15 explores the soul's "amour filliale" (260) for Christ (379–414); the story in 1 Kings 3 of the mother claiming maternity of a disputed child before Solomon is adapted to explore the speaker's identity as the Christ's mother (415–96); the narrative of Miriam's censure of her brother, Moses', marriage, her consequential punishment with leprosy, and her cure in Numbers 12 is retold to explicate Christ's fraternal love for the speaker (497–580); and the story of an unfaithful wife who is accepted back into her husband's home, from Hosea 1–3, describes the speaker's infidelity to her "mary" (585), Christ, and his forgiveness (581–830). As Marguerite explains, the speaker's embodiment of the exemplary

relationships of daughter, mother, wife, and sister of Christ is enabled by God's descent into the flesh, his choice of proximity with mankind in the Incarnation:

> Il vous a pleu, de nous tant l'approucher,
> Qu'il s'est uny avecques nostre chair:
> Qui le voyant (comme soy) nommé homme,
> Se dit sa Soeur, et Frere, elle le nomme. (*MAP* 194–97)

> [It hath pleased the to put hym so neere us, that he did joyne himselfe unto oure fleshe: than we (seyenge hym to be called man) doo call hym syster, and brother. (*Glass* 14)]

Throughout her imagery of holy incest, Marguerite explores the materiality of the *corpus Christi* and textualizes her body in relation to the mirror of Christ. Thus, she presents herself as an exemplum for imitation by readers of the poem.[68] She includes an episode demonstrating the speaker's exemplary reading, significantly, of a passage that argues the visible manifestation of a woman's vices on her flesh. Reading "une simple escripture" (728), Jeremiah 3.3, in which the prophet castigates Israel as a wanton wife, the speaker finds herself indicted by this blazon of the polluted female body:

> Ton visage, ton oeil, ton front, ta face,
> Autoit changé du tout sa bonne grace:
> Car tel' estoit, que d'une meretrice:
> Et si n'as eu vergoingne de ton vice. (*MAP* 777–80)

> [Thyne eye, thy forehed, and thy face, had loste all their good maner: For they were suche, as those of an harlotte, and yet thou haddest no shame of thy synne. (*Glass* 37)]

"Par moy mesme jugeant mon cueur infame," Marguerite's speaker concludes, "D'estre sans fin en l'eternelle flamme" (787–88) ("yeldinge myselfe condemned, and worthy to be for ever in the everlastinge fyre" [*Glass* 37v]). The speaker's experience of reading the passage leads her to view her own image in the text with discrimination and self-awareness. As she recognizes herself in Jeremiah's invective—a version of the mirror of Socrates—Marguerite empowers the woman before the mirror to penetrate superficial appearances and judge the substance beneath. This regendering of the gaze enables the speaker to evade interpretations and definitions imposed upon the female body from beyond. If Jeremiah's censure of Israel's wanton appearance suggests, as do early modern

anti-cosmetic invectives, that a woman's internal vices are reflected in her face, Marguerite's speaker-as-reader demonstrates that women, as well as men, possess the reasonable and discretionary faculties to see themselves reflected in the mirror of Scripture. By replacing the censorious gaze of the patriarch as he peruses the harlot's face with the woman's self-reflective vision, Marguerite guarantees the relationship between a woman's external appearance and internal features. Her intimacy with Christ, the *parolle* inscribed in the female heart, ensures her redemption.

This revisionist gaze is even more powerfully employed in *Le Miroir de Jhesus Christe crucifé,* in which the fluid boundaries between self and other explored in the first *Miroir's* trope of holy incest inform an effort to penetrate corporeal surfaces and unify the body's disparate parts. Marguerite's second *Miroir* returns to the first, echoing and redirecting its imagery.[69] For example, the closing image reaffirms the speaker's identity as the Spouse of Christ:

> l'espouse icy voit son expoux à plain
> et de ce doulx regard son cueur est plain;
> icy l'espoux embrasse son expouse,
> icy mon cueur dedans ce cueur reppose. (*MJCC* 1356–59)

> [The wife here sees her husband plainly, and with what she sees her heart is full; here the husband kisses his wife, here my heart reposes within this heart.]

These lines suggest the intimacy and the unity between Christ and the speaker that are the goal of the poem and also express the merger and equality of persons and genders resulting from the poem's emphasis on the body. The gendered mirroring of the terms *espouse/espoux* and the image of the shared heart position the speaker at once within and outside this hermaphroditic form, as both the object of the poem's explication and the subject anatomizing her reflection in the glass.

Corporeality is at the center of Marguerite's Eucharistic poetics in *Le Miroir de Jhesus Christe crucifié.*[70] The poem is wholly comprised of a blazon of the body of Christ on the cross, the speaker's "blanc et . . . exemple" (*MJCC* 13) (target and . . . example), in whom she sees herself mirrored: "en toy me puis mirer, congnoistre et v[eoir], / car de me veoir hors de toy n'ay pou[vo]ir" (3–4) (through you I can reflect, know, and see, because I have no power to see myself outside of you). In painstaking detail Marguerite dissects the body of Christ, meditating upon each part, describing the horrors of its physical mutilation as images of the

speaker's own vile corporeality, and turning from this externalized manifestation of her sinfulness toward a redemptive internalization of the purified, and purifying, Corpus Christi. The result of this empathetic blazon is the merger of speaker's debased female body with the body of Christ, a union expressed formally in the poem's oscillations between descriptions of Christ's form and the speaker's own and thematically in its frequent images of shared and shifting identities. Like Shakespeare's Lucrece positioned before the painting of Troy or like Barbara Sirani before the portrait of her sister, Elisabetta, Marguerite imagines self-reflection as an affective, empathetic union of self with other, grounded in the recognition of oneself in another. In her textual mirror this merger is enabled by Christ's humanity. Repeatedly, the poem stresses the Incarnation as Christ's sacrificial choice, a voluntary donning of the "vesture" of humanity (836). Thus, she sees her "corps fragile/prins de la fange et peu durable ar[gile]" (833–34) (fragile body, made of mire and transitory clay) mirrored in Christ's, "duquel, Seigneur, as prins semblance et forme" (835) (of which, Lord, you have taken the semblance and form). Exploring the material implications of the Incarnation for women in particular, she sees the "laideur" of the crucified Christ as an embodiment of her own spiritual ugliness and describes Christ's humanity as a disguise obscuring his divinity (108):

> O Filz de Dieu, tant saige, et bon, et beau,
> qui ne verroit de toy que le manteau,
> te jugeroit l'homme plain de douleur,
> mauldict de Dieu et ramply de malheur. (840–43)

> [O Son of God, so wise, and good, and beautiful, he who would see only your coat would judge you to be a man full of sorrow, accursed of God and replete with unhappiness.]

Elsewhere the speaker specifies that it is her own troubled flesh in which Christ clothes himself, "covert de ma foiblesse,/ma villité offuscant ta noblesse" (885–86) (covered in my weakness, my vileness obscuring your nobility). Indeed, the poem begins with the speaker's impression of God's "injustice" in condemning his innocent son (60), seeing him as "ung cruël, implacable et dur juge . . . sans misericorde" (33–36) (a cruel, implacable, and harsh judge . . . without mercy), before she realizes that it is because Christ has dressed in "mon vestement du vieil Adam taché" (64) (my stained clothing of old Adam) that he is unrecognizable to the father and worthy of punishment: "car te voyant le Pere revestu/de

mon habit tout contraire au vertu /. . . comme pecheur il t'a voulu punir" (69–72) (because the Father seeing you wearing my habit completely contrary to virtue . . . like a sinner he wanted to punish you). Thus, the poem traces the gradual development of the speaker's ability—here imagined as surpassing that of God the Father to whom Christ, disguised in the costume of corrupt humanity, is unrecognizable—to see beyond the surface of the flesh to the spiritual truth within.

The effects of the speaker's material participation in the crucifixion through the poem's double blazon is to transfer the redemptive implications of the Incarnation to the corrupt female flesh. Repeatedly, Marguerite foregrounds her physical characteristics, including her beauty or ugliness, and their correction by comparison with the physical features of Christ. "O ma beaulté," she addresses her own face, "que cuydois estre belle, / vyens toy mirer, pour ne trouver telle!" (156–57) (O my beauty, who thinks yourself beautiful, come and view yourself to find you are not so!). She continues, "Pour embellir de ton âme la face / en sa laideur ta laideur il esface, / te randant beau devant les devins yeulx" (*MJCC* 161–63) (To embellish with your soul your face in its ugliness, he effaces your ugliness, to render you beautiful before the divine eyes). The features and accoutrements of Christ's crucified body indict and redefine those of the speaker: for example, the thorns crowning Christ's head condemn the speaker's "ydolatre avarice mauldicte . . . qui sembloit doulce au cueur ramply de terre" (136–40) (idolatry [and] accursed avarice . . . which seem sweet to the heart filled with earth). In an amazing comparison of the speaker's hair with that of Christ, Marguerite comments upon the idolatry of cosmetic self-creation and displaces it with spiritual re-creation through her shared identity with Christ:

> O beaulx cheveuz du vray Nasariën,
> en toy me fault mirer mon puvre rien,
> mez foulx cheveulx que j'ay pignéz, friséz,
> voyans les tiens rompus et debriséz.
> J'ay prins plaisir en choses si caducques,
> que j'ay cuydé par les mortes perouques
> tant amander la beaulté de nature,
> que me faisois une aultre creature.
> Estois je noir, blanch, me voulais monstr[er]
> par mez cheveulx mortz, estainctz, acco[utrer];
> Et si le noyr me sembloit plus honneste,
> je noysseroys les chaveulx de ma teste. (500–510)

[O beautiful hair of the true Nazarine, in you I must see my poor nothing, my mad hair which I have combed, curled, seeing yours broken and disheveled. I have taken pleasure in such empty things, that I have thought by this dead wig, changing so much the beauty of nature, to have made myself another creature. Being black, I wanted myself to appear white by adorning my dead, tinted hair; and if black seemed to me more honest, I would dye the hair of my head black.][71]

In rejecting the painting woman's idolatrous self-creation, which abuses art to construct "une aultre creature," Marguerite echoes anti-cosmetic polemicists, such as Lessius, who warn: "To what purpose should there be colours & vernice used to paint the face of a Christian? . . . [I]f any looke towardes heaven with such a face, Christ wil not know them, since they have changed that shape which he gave them."[72] She releases women, however, from the defining male gaze of the cosmetic culture, with its moral censure and objectifying aesthetics. Despite alterations to her physical form, Marguerite argues, God both recognizes her and is willing to exchange his divinity for her humble and tainted flesh. She describes women's intimacy with Christ, grounded in their shared humanity, as the basis on which women, without the guidance or intervention of male governors or spiritual authorities, are capable of self-knowledge. As subjects before God, they are able to recognize the gift of grace that re-creates the flesh in the image of God. Anti-cosmetic polemicists worry specifically about the painting women's refusal to submit to male authority, complaining, for instance, that it is "but grosse irreverence, and disobedience, when women . . . make themselves wiser then their masters . . . as if forsooth they knew better what were good, and what were evill."[73] Empowered by the divinity of Christ, residing within her redeemed flesh, Marguerite claims for women the discernment and self-awareness to entrust the government of their bodies and souls to this internalized *parolle*.

Marguerite describes this renovation of the female flesh by relentlessly troubling and interrogating the relationship between colors and essence, moving continuously between true and false images of material surfaces in the twin blazon of Christ and the speaker and between superficial impressions and their correction in the substantive realities guaranteed by the Incarnation. Thus, the poem redirects the Petrarchan reds and whites with which the cosmetic culture decorates and describes the woman's body toward the red of Christ's blood and the white of his body, "ta pain tresbl[anc] / par qui mangeons et ta chair et ton sang" (803–4) (your very white bread / of which we eat, and your flesh and your blood). These colors also inform Marguerite's images of blood and water, both

of which issue from the body of Christ. She equates the former with New Testament salvation, the latter with Old Testament law, by which she is condemned (*damné par la loy* [310]). Thus, she writes, "L'eau et le sang m'esjouyssent ensemble / car en voyant l'eau sans sang je tramble" (1109–10) (Water and blood together excite me, because seeing the water without blood I tremble). At the same time that Marguerite revises cosmetic colors, her insistent depiction of the flesh as a garment that God puts on and sheds at will sees the body's exterior surface itself as a kind of makeup. The body is an adornment or a curse (a leprosy, "lepre" [168], as the poem calls it, recalling Miriam's affliction in Marguerite's first *Miroir*) but one that does not alter the sacred essence within. She writes:

> Regarde icy, mon corps, pour tez vestures
> combien Jesus a de deschiquetures,
> quel masque il porte et quel deguysement,
> pour satisfaire a ton accountrement
>
> regarde icy que pour te randre sain
> c'est faict malade, et ne veult desdaigner
> de te donner son sang, pour te baigner.
> Plonge toy donq en ce bain tant nouveau
> et te reveste de ceste digne peau,
> que pour toy voy ainsi deschiqueter:
> [faictz toy dedans si bien] enpaqueter,
> que ton peché ne toy plus ne soit veu
> de l'oeil divin: alors seras receu
> tant soulement pour ceste couverture
> en qui seras nouvelle creature. (*MJCC* 929–32 and 936–46)

[Look here, my body, for your clothing how much Jesus has been torn, what mask he wears and what disguise to satisfy your adornment . . . Look here what to make you healthy is made ill and does not disdain to give you his blood to bathe yourself. Plunge therefore into this new bath and dress yourself in this worthy skin, which for you is seen thus torn to pieces to make you so well reassembled within it that your sin neither to you nor to the divine eye will be seen anymore: thus, you will be received solely because of this covering in which you will be a new creature.]

The passage comments on the blazon itself and upon Marguerite's feminist appropriation of the strategy. In describing the dismemberment of the female body

and its reassembly in and as *digne peau*, Marguerite replaces the dead and insensible image produced by the traditional blazon with the living flesh of a new creature fashioned in the image of God. Marguerite's redeemed and redemptive poetics adopt the dead letter of the blazon and reinvigorate it with the spirit of God, lodged within and emanating from the female author. As she portrays the body of Christ, she also paints a self-portrait. The self-authorship denied to the painting woman by the mirror of Socrates is reinstated and affirmed in the female author's intimacy with God.

The Eucharistic poetics of *Le Miroir de Jhesus Christe crucifié* imagine the body and blood of Christ as transubstantiated in the redeemed flesh of the new creature, the speaker herself. As Herbert Grabes notes, the Eucharist was associated with the mirror by Catholic theologians: "just as the fragments of a broken mirror each furnish a complete image of an object, Christ is wholly present in each fragment of broken bread."[74] Thus, the speaker poised before the mirror of Christ also eats at the celestial table (*"icy je mange a la celleste table"* [1338]), where, washed in the blood of Christ, she is made "ung aultre toy" (1215) (another you).[75] For Marguerite the ingestion of the *corpus Christi* is highly gendered: as a result, her poem elaborates a specifically feminine version of the Passion in which female exemplarity, modeled on the Virgin, constructs a community of women worshipers, of which the speaker is one member. The poem casts the figurative merger of the speaker and Christ as an extension of the material blending of mother and son and their spiritual connection at the moment of the Crucifixion: "ce doulx regard tu as baissé en terre," Marguerite writes,

> [ver tez] amis, et [ta parfaicte mere]
> qui n'avoit moins de toy tristesse [amere]
> car l'unÿon de vous deux, ce me [semble],
> par une mort en tuot deux ensemble. (192–96)

> [you lowered this sweet glance toward earth, toward your friends and your perfect mother, who had no less bitter sadness than you, because the union between you two seemed to me by one death to have killed two together.]

Positioning herself at the foot of the cross alongside the "les trois Maries" (727), where "de lever les yeulx prendz hardinesse" (822) (to raise [her] eyes takes courage), she records Christ's consolation and disposition of his mother (267–70). She casts herself as a second Magdalen, washing the feet of Christ with her tears: "O mon Seigneur, mon ame pecheresse / treshumblement a tez doulz piedz

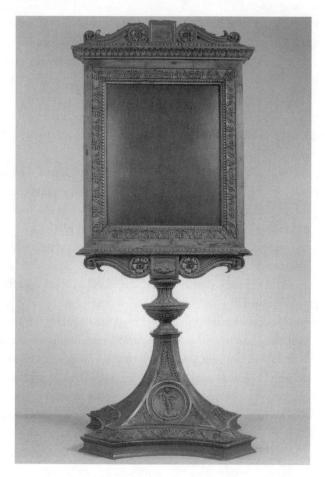

Fig. 15. Mirror (Venetian, 1510). Victoria and Albert Museum, no. 7695-1861.

s'adresse:/ne me dictz poinct 'noli me tangere'" (783–85) (O my Lord, my sinful soul addresses your sweet feet most humbly: do not say to me, "noli me tangere"). Finally, she suggests that Christ himself offers the ultimate exemplum for Christian women when she notes that he has vanquished God with his obedience ("tu as vaincu par ton obeyssance/Dieu" [875–76]). The feminized Christ joins and authorizes the feminine community established in Marguerite's text and within the soul of her speaker.

Le Miroir de Jhesus Christe crucifié presents the female speaker as a mirror for women whose spiritual insight enables her to penetrate the difficult opacity of the body's surface, to glean the divinity obscured by the garment of flesh, both

Christ's and her own. By repairing the rupture between colors and essences, by mastering the shifting meanings of materiality, Marguerite constructs a transgendered new creature, a free subject before God. Her capacity for self-reflection and self-definition is guaranteed by her reliance upon the validating presence of Christ contained within and redeeming the fragile human vessel that enables his Incarnation.

Throughout Marguerite's textual mirrors the literal figure of the woman, poised before her looking glass, is never far from the speaker's mind, and her conversion of the material practices of the painting woman into the spiritual insight of her *nouvelle creature* finds an analogue in her own mirror (fig. 15), now preserved in the Victoria and Albert Museum. A luxury item made of fine Venetian crystal, the carved walnut plinth is decorated with emblems whose meanings border on the arcane: the images include an elephant and a fly; a goose carrying a pin in its mouth; a representation of a woman's braided hair; an ermine.[76] The top and bottom of the mirror's frame bear Marguerite's personal device, daisies (in Italian, *margherite*), allegorically interpreting and naming the person reflected in the glass. Reimagined as an erudite text to be deciphered by the discriminating reader, the mirror is converted from an emblem of vanity to one of self-knowledge. The allegories offer a substantive reflection of the mirror's owner that, like her textual mirrors, attest to her abilities to penetrate the surface of things and to observe the meaning hidden beneath. As such, Marguerite's mirror offers a feminist answer to the troublesome mirror of Socrates and illustrates that a woman's self-authoring control over the mirror can establish her subjectivity.

If Liébault's optimistic mirror is dimmed by the obfuscation of the painted surface, the *Trois livres* nonetheless puts forth a suggestive image of the redemption of the female body. The title page of the volume includes an engraving of Christ and the Samaritan woman (fig. 16), an allusion to the story in John 4 of the Savior's interaction with this disreputable woman (as Christ tells her, "thou hast had five husbands; and he whom thou now hast is not thy husband" [John 4:18]) at the well of Jacob. Although it is doubtful that Liébault himself authorized the use of the image to decorate his work,[77] it offers a commentary on the status of women that may respond to his importation of Agrippa's treatise into the cosmetic text and which may carry the trace of Marguerite's powerful stagings of feminine interpretation before the mirror of Christ some thirty years earlier. Moreover, the title page introduces into Liébault's work a story whose medita-

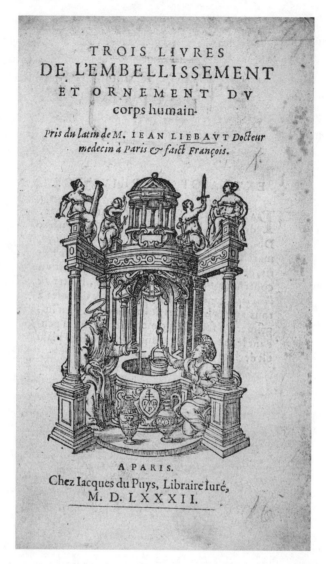

Fig. 16. Title page from Jean Liébault, *Trois livres de l'embellissement et ornement du corps humain* (Paris: Jacques du Puys, 1582). By permission of the British Library, shelf mark 1174.d.3.

tion on the difficult problem of visible surfaces and hidden truths is pointedly focused on the female form. It is an image that summarizes the interactions with the discourses of cosmetics and idolatry undertaken by the women considered in this chapter and the next.

The title page of the *Trois livres* presents the Samaritan woman as an exemplum, one entry in Agrippa's catalogue of famous women in which she supports the view of women's interactions with Christ as superior to those of men, including those of the male apostles. "Que dirons nous de la Samaritaine," Agrippa asks, "avec laquelle Jesus-Christ ne dedaigna pas de s'entretenir aupres du puits de Jacob . . . il refusa les viandes que lui presentoient les disciples, pour la nouriture de son corps" ("What shall I saye of her the samaritan, with whom Christe spake at the well: and beinge fedde with the faythe of this beleving woman, refused the meate that the apostlles broughte?").[78] Agrippa's Samaritan is an emblem of the special intimacy between women and Christ that is also the subject of Marguerite's poems. Not surprisingly, *Le Miroir de Jhesus Christe crucifié* also invokes the figure in the context of Christ's invitation to drink of his fountain of living waters, "Venez icy de soif tout langoureux,/fontaine suis de parfaictz amoureux" (1067–68) (Come here all who are sluggish with thirst, I am the fountain of perfect lovers). "Or prens exemple a la Samaritane," the speaker notes, "qui tant gaigna auprés d'une fountaine" (1073–74) (Or take the example of the Samaritan, who gained so much at a fountain).

On Liébault's title page the well appears as a Temple of Fame surmounted by four allegories of feminine virtue. The classicizing architecture links the biblical narrative to the histories of Roman worthies commonly ushered forth in texts of the *querelle des femmes* (including Agrippa's) to argue women's transhistorical and universal value.[79] The positions and appearance of the two figures before the well illustrate the intimacy and affinities between Christian women and the Savior. He gestures toward the Samaritan as she kneels before him, her hand touching the bucket representing the living water of salvation: "If thou knewest the gift of God, and who it is that saith to thee, Give me to drink: thou wouldest have asked of him, and he would have given thee living water" (John 4:10). Moreover, the halo above Christ's head is echoed by the headdress of the Samaritan woman, and the water jug resting before her knee is doubled in a second vessel standing before Christ. These details merge Christ and the Samaritan woman, reminding the viewer of the fact of the Incarnation (enacted through the woman's body as vessel) and feminizing Christ through his association with the water jug. The reciprocity between the two suggests that the Samaritan's ability to recognize the divinity residing within Christ's humble body ensures her salvation, rendering her a vessel filled with living water.

Lavinia Fontana's *Christ and the Samaritan Woman* (fig. 17), now in Naples, illustrates the intimacy between the Savior and the Samaritan woman while fore-

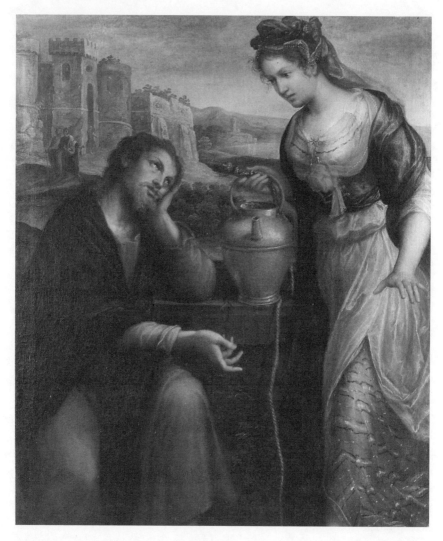

Fig. 17. Lavinia Fontana, *Christ and the Samaritan Woman* (1607). Museo Nazionale di Capodimonte, Naples, inventory no. 84087, inv. IC. n. 182.

grounding the question of color, in the artistic medium and as a metaphor for the representation and interpretation of surfaces. Fontana explores the Samaritan's abilities as an interpreter of the visible evidence of Christ's form and thematizes the viewer's perceptions of her protagonist's polysemous appearance. She offers a visual representation of the redemptive poetics undertaken in Marguerite's textual mirrors and a defense of painting that joins their feminist proj-

ects across the divide of Reformation and Counter-Reformation approaches to the image.

Influenced early in her career by Paleotti's *Discorso intorno alle immagini sacre e profane*, Fontana's small-scale religious works are, in Caroline Murphy's phrase, "effective devotional theatre."[80] *Christ and the Samaritan Woman*, although a late work (dating from the middle of Fontana's Roman period, from 1604 to her death in 1614), typifies this theatrical style. Fontana places the two central figures in the extreme foreground of the scene, emphasizing the interaction between them. She stresses Christ's humanity by giving visual form to the biblical detail that "Jesus therefore, being wearied with his journey, sat thus on the well" (John 4:6). His head resting on his hand, he glances up into the face of the Samaritan woman in a gesture that underscores the vulnerabilities of the flesh (hunger, thirst, and fatigue, all of which are central to the episode), Christ's sacrificial willingness to assume these frailties in the Incarnation, and his dependence upon women during his lifetime to offer him comfort and relief. Fontana illustrates the story's preoccupation with Christ's materiality in a background vignette depicting the apostles returning from the city of Sicar, where they had gone, according to John, to procure food for the Savior. In the foreground she concentrates on the moment of Christ's initial request for water from the Samaritan woman and her surprise at being addressed by him, given the traditional animosity between Samaritans and Jews. Her surprise may also respond to the request's violation of the boundaries of gender: in the early modern context a woman's address by a strange man was commonly viewed as sexually threatening and her engagement in conversation with him suggestive of her own looseness. The Samaritan's promiscuity, the details of which Christ discerns prophetically, may be gleaned in her wardrobe and jeweled headdress, rendered in rich colors by Fontana. As Christ's open hand gestures toward the Samaritan and her outstretched hand registers her surprise, Fontana practices a "visual rhetoric" intended to enhance the female viewer's empathetic engagement in the exchange and her identification with this difficult exemplum of femininity,[81] represented here on the verge of redemption.[82] Her Samaritan is an exemplary figure,[83] and her "rhetoric of corporeality" emphasizes, as Cantaro writes, "un sentimento religioso profondamente umano" (a profoundly human religious sentiment).[84]

As in the title page of the *Trois livres*, Fontana's rendering of the scene stresses woman's role in the Incarnation by constructing a visual metaphor between the water jug, here positioned in the center of the canvas between the woman and Christ, and the woman's body. Fontana underscores this association by echoing

the form of the jug in that of the Samaritan's shoulders and waist. She repeats the color of the jug in the bright gold silk of the Samaritan's dress, gathered at the waist in a horizontal line that repeats the line encircling the water jug, to emphasize further the connection between the womb and the vessel. Finally, the prominent cord in the Samaritan's hand, which she joins to the handle of the jug, connotes the umbilical cord, recalling the Incarnation and claiming for the Samaritan—the woman who appeases Christ's spiritual hunger and bodily thirst— the Virgin's maternal role of nourishing the Savior. She becomes, in effect, the mother, sister, daughter, and wife of Christ.

Fontana's *Christ and the Samaritan Woman* participates in the Reformation debate on painting and idolatry, aligning women's painting—Fontana's and the Samaritan's—with the redemption of material surfaces enacted, according to Catholic theorists of the image, with the Incarnation. Her choice of subject, in fact, foregrounds the distinction between letter and spirit, colors and essence, that attends both Protestant and post-Tridentine approaches to images.[85] For Calvin the narrative offers a paradigm for defining Catholic ceremony as idolatrous:

> Iam & Samaritanorum religionem non ob id imitari non licebat omnino, quod deorem esset alienarum cultu implicata: sed quod pravo illegitimoq[?]; Dei cultu polluta foret. In hoc, mi frater, in hoc fallimur, quod dum immundas per se & sacrilegas ceremonias esse non putamus, nisi quae gentilium deorum nominibus polam sint insignitae, sacrosanctum Dei nomen profanaie, summum esse sacrilegium obliviscimur.

> [Again, it was altogether unlawful to imitate the religion of the Samaritans, because it was mixed up with the worship of strange gods, and polluted by a depraved and illegitimate worship of the true God. Our mistake, dear brother, lies here— thinking no ceremonies to be in themselves impure and sacrilegious but those which are publicly stamped with the names of heathen gods, we forget how extremely sacrilegious it is to profane the holy Name of God.][86]

For both Protestant reformers and Counter-Reformation advocates of personal devotion, Christ's exchange with the Samaritan woman is a polemical crux. It is here that Christ insists that God must be worshiped in spirit and truth; here that he distinguishes between Old Testament and New Testament spirituality, associating the former with the dead letter, the latter with the living spirit; and it is here that the figure of Christ as the fountain of living waters displaces the literal well of Jacob and the spiritual sustenance of salvation displaces the material sus-

tenance of the flesh. When the disciples return with food, Christ responds, "I have meat to eat that ye know not of . . . My meat is to do the will of him that sent me, and to finish his work" (John 4:31–34). Agrippa's emphasis on the central role of the Samaritan woman in this spiritual feeding, noting that Christ, "beinge fedde with the faythe of this beleving woman, refused the meate that the apostlles broughte," glosses Fontana's approach to the subject. In the background of Fontana's painting the medieval walls of Sicar suggest the Old Testament law, replaced by the spiritual community established between Christ and his female disciple. A reflective lake lies in the background between the two protagonists. Positioned like a mirror below the Samaritan's downturned face, the lake recalls the painting woman's mirror of vanity, on the one hand, and the art of painting, on the other, which Alberti compares to the pool of Narcissus in "embrac[ing] what is present on the surface of the water" ("abracciare con arte quella ivi superficie").[87] As Fontana performs a conversion from dead objects to living faith in the move from the background to foreground of the picture, she redeems the art of painting and predicts the missionary role of the Samaritan woman, in which she leaves behind the material icon of her salvation, the water jug, to avow the living water: "The woman then left her waterpot, and went her way into the city, and saith to the men, 'Come and see the man, which told me all things that ever I did: is not this the Christ?' . . . And many of the Samaritans of that city believed on him for the saying of the woman, which testified, He told me all that ever I did" (John 4:28–29 and 39).

At issue in the story, and crucial in Fontana's rendering of it, is the connection between surface and substance as they attend both painting and femininity. As Paleotti argues, the sacred image leads the viewer to a spiritual delight that "traspassano di gran longa tutte le altre, che derivano dalle cose materiali" (surpass[es] by a great distance all others, which derive from material things).[88] Like the orator, the painter appeals to the senses of his audience through superficial techniques, "per la varietà de' colori, per l'ombre, per la figure, per gli ornamenti, & per le cose diverse che si rappresentano" (by the variety of colors, shadow, figures, ornaments, and by diverse things represented), in order to lead them to "la rara, & ammirabile bellezza" (to rare and admirable beauty) and "per mezo di queste cose create farè scala a gli huomini per penetrare le eterne" (by means of these created things make a ladder for men to penetrate the eternal).[89] Through the artistry of the painter Paleotti's Christian viewers (*gli huomini*) are able to penetrate the surfaces presented to the eye and, with spiritual insight, comprehend the religious truths that they both conceal and reveal. Fontana's

Samaritan, then, is the ideal post-Tridentine viewer, whose exemplary *feminine* spectatorship validates the female painter's mastery of surfaces.

Fontana's image argues, like Marguerite's poems, that women's exemplary reading, their ability to recognize the divinity of Christ obscured by the veil of mortality, enables a shift from the material to the spiritual, from letter to spirit. Moreover, this insight guarantees the shifting surfaces of the painted image in terms advocated by Paleotti's *Discorso*. Since Paleotti includes "i Samaritani" among ancient idolaters,[90] and the biblical episode itself refers to their idolatry when Christ tells the woman that her people "worship ye know not what" (John 4:22), Fontana may have had the tale's explicit engagement with idolatry in mind as she created her image. Her handling of the idolatrous image of the painting woman, however, portrays a redemptive link between body and spirit. Even the colors in which Fontana clothes her twin protagonists suggest this bond: the Savior's red gown and blue robe are echoed in the red bodice and blue shawl of the Samaritan woman. Dressed in the robes of salvation (which, from another point of view, indict her licentiousness), her face highly tinted with a blush (which may suggest her painting or her natural modesty), Fontana's anamorphic Samaritan advances toward her Savior, fully aware of his identity and of her own, despite the incongruous and deceptive appearances surrounding and creating her. Engaged in an art of self-creation guaranteed by the internalized image of Christ, the Samaritan is an icon of women's painting that converts idolatry to redemption, the dead image to the living faith. Fontana's signature upon the canvas, "Lavinia Font. Za. Fa. MDCVII," reminds us of her surname, *fontana*—that is, fountain or well—and invites us to imagine that the Samaritan may also be a portrait of her creator, the daughter and wife of painters and the disciple and practitioner of a reformed art of painting.[91] Moreover, Murphy suggests that Fontana may have found a model of women's exceptional intellectual and artistic abilities in Samaritana Samaritani, "a noble woman of scholarly and artistic leanings" who "may have known Prospero [Fontana] and joined the meetings of the learned that took place in Prospero's home."[92] It is tempting to believe that, near the end of her career, engaged in depicting the story of a woman's interpretive intelligence and her consequential fellowship with the most illustrious of male companions, Fontana may have resurrected Samaritani from her childhood. Like Samaritani's living model, Fontana's image erects a mirror for women that illustrates not only their capacity for insightful viewing—their ability to move from surface to substance—but also the painting woman's creative and re-creative art.

Colors and Essence

In the collection of the Victoria and Albert Museum is a casting bottle dating from the mid-sixteenth century (fig. 18). Used by noblewomen to hold perfume, such bottles were common New Year's gifts during the reigns of Henry VIII and his Tudor successors. The body of the container is composed of Egyptian rock crystal that predates its mounting by about five centuries: the curators speculate that "the rock crystal may have contained a holy relic and come to England after the Crusades. It was later mounted in silver and given its new use when religious relics were prohibited after the Reformation."[1] As such, the object records the vicissitudes of pre- and post-Reformation beliefs, particularly as they pertain to the physical body. As a reliquary, it would have housed a material remnant of a saint, perhaps a fragment of the sacred body. With the dissolution of the cult of the saints and the iconoclasm precipitated by the Reformation, the object's function changes, no longer preserving the venerated corpse but adorning the noblewoman's ephemeral body. The casting bottle serves to literalize the doctrinal losses of the Reformation, giving material form to the failed link between spirit and matter—grounded in the Incarnation and asserted, for instance, in the idea of transubstantiation—and the attendant corruption of surfaces severed

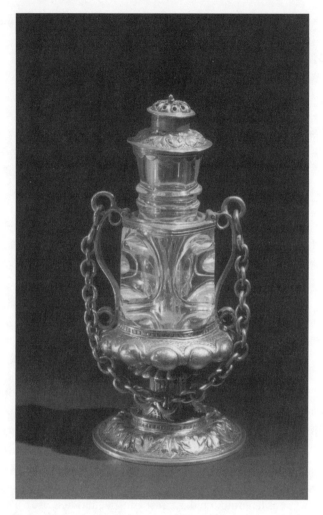

Fig. 18. Casting bottle (rock crystal bottle, 900–1000; mounted 1540–50). Victoria and Albert Museum, no. M.78-1910.

from their essential qualities. The ancient, unassailable beliefs, ceremonies, and icons of Catholicism are now as fleeting as the scent of rosewater.

This suggestive object, poised between pre- and post-Reformation notions of the body and its meaning, also illustrates points of contact between religious debates on idolatry and the period's literal and figurative approaches to the painting woman, a topic discussed in relation to the works of Marguerite de Navarre and Lavinia Fontana in the previous chapter. Early modern polemicists resur-

rected classical Roman anti-cosmetic invectives that conflate the makeup box with the woman's painted body, both beautiful containers belying polluted contents.[2] Similarly, the casting bottle figures the vessel of woman's body, its double function emphasizing the corruption of odoriferous female flesh as opposed to the incorruptibility of the saint's (or the Virgin's) body. Certainly, the fall into secularism in the reliquary's redeployment involves a debasement of the sacred that Catholics would have found abhorrent: as Nicholas Sander complains of Protestant iconoclasts, "they say we worship Idols in our Churches, which is not true, but certainly they worship Idols in their harts. For some of them so worshipped covetousnes, that . . . they would imagine our Images to be Idols, that they might have occasion to carie away our gilded crosses, our silver candlestickes, and other jewels and Images of price."[3] The resourceful recycling of the object (a luxury item not easily or lightly destroyed), however, points toward the ever-increasing preoccupation with personal appearance and adornment in the reigns of the Tudor monarchs, culminating in the replacement of discarded Catholic icons by royal images in the "cult of Elizabeth" detailed by Roy Strong some forty years ago.[4] Reports of Elizabeth's physical appearance, although sometimes not wholly reliable, frequently note her generous use of cosmetics, while documentary evidence and material artifacts—apothecary's records, inventories of mirrors, and surviving mortars and pestles, used to grind and mix makeup—suggest the queen's interest in physical comfort and cosmetic self-creation.[5] Anthony Rivers's oft-quoted claim that the queen was painted "in some places near half an inch thick,"[6] for example, may reflect Jesuit suspicion of Elizabeth rather than conveying accurate details of her appearance. Similarly, the fact that "at the beginning of the sixteenth century, mirrors were an unusual luxury, but at the end of Elizabeth's reign they had become a universal necessity" may or may not argue that "Elizabeth's vanity influenced the whole environment of court life."[7] Nonetheless, the aesthetic and material effects of Elizabeth's painting—that is, the artful imitation of the sacred body's incorruptibility—are evident in the idealizing masks of majesty and youth displayed in her portraits from the 1570s forward and in accounts such as that of Thomas Platter, who writes in 1599 that, "although she was already seventy four, [Elizabeth] was very youthful still in appearance, seeming no more than a girl of twenty years of age" (fig. 19).[8]

If the reliquary–turned–casting bottle represents the female body, its transparency complicates this symbolism. As we have seen, anti-cosmetic invectives depend upon an alliance between a woman's inner nature and outward appear-

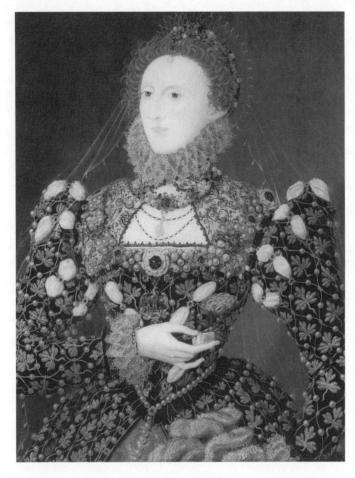

Fig. 19. Nicholas Hilliard (attrib.), *Phoenix Portrait* (1575). National Portrait Gallery, London, inventory no. 190.

ance and obsessively note the rupture of this link wrought by deceptive surfaces themselves. Thus, R. Smith's *Wonder of Wonders* (1660) claims that "these Dyes, Tinctures, and colours dawbed on womens faces, do signifie that the soul is sick within . . . as branded marks make known a Fugitive, so beautiful colours disclose a Harlot,"[9] and Thomas Taylor's *Glasse for Gentlewomen* insists that "no outward ornament or habit may be used upon the bodie, which is severed from the inward ornaments of grace upon the soule . . . all artificiall colours and covers are but filthinesse, where this [sanctification] is wanting." He concludes with a paraphrase of Proverbs 11:22: "A jewell of gold in a swines snout, is a beautiful

woman without inward comelinesse."[10] The ideal woman of the anti-cosmetic polemicists is a woman of transparent surfaces—a "crystall glasse,"[11] as the period's mirrors for women frequently call her—whose colors are in agreement with her essence. At the same time, the accretion of colors upon the surface of the female body, practiced figuratively in the poetic form of the blazon (such as Shakespeare's blazon of Lucrece and Liébault's blazon of ideal feminine beauty) and literally by early modern women, has as its primary goal the simultaneous display and disappearance of its subject;[12] the dismemberment of the body into patterns and parts described superficially, rendered in a two-dimensionality that robs women of agency and subjectivity. We can return Elizabeth's *Phoenix Portrait*, attributed to Nicholas Hilliard (see fig. 19), as a case in point. Painted around 1575, when Elizabeth was in her early forties, Hilliard's portrait "marks the beginning of a period to last up to her death where the queen's body becomes an emblem for female virtue."[13] Hilliard makes no attempt to offer a facial likeness of the queen; rather, his painting, along with the contemporaneous *Pelican* and *Darnley* portraits, displays the "mask of majesty" that was the pattern—literally, as Strong has shown—for Elizabeth's images until 1588 (when she appears to have sat again for a portrait). Indeed, the *Phoenix Portrait* is simply a reverse-image version of the *Pelican Portrait*, also attributed to Hilliard.[14] While her face is reduced to a painted effigy, Elizabeth's clothing and jewels are represented "from life," carefully documenting her "liking for elaborate forms of dress; the use of sumptuous fabrics with highly detailed embroidery, expensive, carefully crafted jewels, headdresses and other accessories."[15] Elaborately painted, Elizabeth is not a woman but a mirror of majesty. Her virtues are externalized and laid forth—materialized in and as the phoenix jewel from which the painting derives its name—precisely because she is robbed of interiority.[16] She is all dazzling surface.

It is a critical commonplace that the iconic, anti-representational style of Elizabethan portraiture responds to Protestant nervousness about imagery and reflects the iconoclasm initiated with Henry VIII's dissolution of the monasteries, institutionalized under Edward VI with the 1548 removal of images, reversed by Mary, and reinstated in a qualified form by Elizabeth I.[17] What has rarely been noted, however, are the implications of iconoclasm for attitudes toward the (especially female) body and its adornment or the continuity between Protestant condemnations of idols and castigations of women's painting. Tuke describes painting women's artifice as a form of idolatry when he calls them *"violators of the Temple of Christ,"*[18] while Taylor's claim that women's external ornaments are

"filthinesse" resonates with Henry Hammond's etymology of "*Idol*" as meaning, among other things, "Pollution, Filth."[19] This notional continuity rests on similar concerns about the sundering of correspondences between inward essence and outward form in religious images and women's bodies and similar views of artistic creation and cosmetic self-creation as transgressive. Bishop John Jewel's claim that "an Image is a creature & no God. And to honour a creature . . . is Idolatry"[20] parallels charges that the painting woman creates a material idol that she worships in the place of God. As Tuke bluntly puts it, "A painted face is not much unlike an Idoll; it is not that, it would be taken for: and they, that make it, are like unto it, and so are all they that doe delight therein, and worship it."[21] Martin Bucer's description of images in his iconoclastic treatise of 1535 can easily be applied to women's diabolical painting: "Who is he than / that doth nat here so what smell and perceyve the false wyly craftes of our olde enemy . . . desceyvyng al maner of men with the vayne apparence & outward syght of ymages."[22] And Henry Ainsworth's description of Satan's chief deception echoes Calvin in linking idolatry and painting, here in the figure of Jezebel:

> The old Serpent called the Divil & Satan hath for the beginning sought to draw men from the service of God, to the service of himself; and this he hath doon . . . cheefly by idolatry . . . The pseudocatholick Church or false ecclesiastical monarchie, is an idol or beast bread in the bottomlesse pit . . . [W]hen this Jezebel shewed her selfe on the stage of the world, she made all men astonied at her majestie, enamoured the nations with her bewtie, bewitched them with her sorceries, & made them drunken with the wine of her fornications.[23]

The previous chapter has shown that Marguerite de Navarre's *Le Miroir de l'âme pécheresse* and *Le Miroir de Jhesus Christe crucifié* place woman before the mirror of spiritual contemplation in order to redefine feminine beauty based upon her gendered relationship with the *corpus Christi*. This chapter follows Marguerite's mirrors into England, where their adaptations by Elizabeth Tudor and Aemilia Lanyer engage specifically Anglican concerns about the difficult correspondences between colors and essence, both in religious imagery and in the female form. Elizabeth's youthful translation of Marguerite's first mirror, presented to Katherine Parr in manuscript in 1544, learns from Marguerite's complex handling of women's sexualized intimacy with Christ strategies for self-fashioning that inform Elizabeth's later career as queen. John Bale's publication of Elizabeth's *Glasse* as *A Godly Medytacyon of the christen sowle* (1548) frames the work within an explicit discussion of iconoclasm, on the one hand, and a defense

of Elizabeth's legitimate claim to the throne, on the other, laying the founda-
tions for later acts of self-representation by Elizabeth in her manipulations of
visual images and her physical form. Lanyer's *Salve Deus Rex Judaeorum* (1611)
responds to the difficult and contradictory legacy of Elizabethan representation,
with its deification of Elizabeth despite Anglican rejections of painting and arti-
fice. Like Marguerite's *Le Miroir de Jhesus Christe crucifié*, Lanyer scripts the
emergence of an immaculate femininity, rooted in and refining feminine beauty
by means of women's unique intimacy with Christ. If Elizabeth, in her famous
speech at Tilbury, imagines herself as having "the body but of a weak and feeble
woman, but . . . the heart of and stomach of a king,"[24] the works considered in
this chapter describe woman as a vessel containing the heart and stomach of the
King of Kings—a new creature in whom the idolatry of feminine painting is
refigured and redeemed as she becomes, as Bale writes of Elizabeth, "the ryght
ymage of Christ."[25]

Like Marguerite de Navarre, Elizabeth I is remembered as a master of surfaces.
In his *Treatise Concerning the Art of Limning* her portraitist, Nicholas Hilliard,
recounts a conversation with the queen in which he explains that a portrait "shad-
owe[d] as if it weare not at all shadowed, is best shadowed," since a painting over-
shadowed "is like truth ill towld." "Here her majesty conceived the reason,"
Hilliard writes, "and therefor chosse her place to sit in for that porposse in the
open alley of a goodly garden, where no tree was neere, nor anye shadowe at all
. . . This her Ma[jes]tie['s] curiose dmuand hath greatly bettered my Jugment
besids divers other like questions in *Art* by her most excellent Ma[jes]tie."[26]
Hilliard's anecdote points toward two related phenomena pervading ideas of rep-
resentation, including cosmetic self-fashioning, in Elizabethan England. On the
one hand, Hilliard's suspicion of chiaroscuro bespeaks the difficult status of the
visual arts under Elizabeth, following a cultural and representational "vacuum,"
as Lucy Gent calls it, caused by iconoclasm.[27] As Gent has shown, the limited
vocabulary available to Elizabethans to translate concepts from Italian works on
art criticism and practice bespeaks England's lack of familiarity with the visual
arts as they developed on the Continent and reflects the low status of painting
and its associations with diabolical and debased representational practices.[28] On
the other hand, when Hilliard describes Elizabeth's stage management of her sit-
ting for the miniature and attributes the development of his own artistic exper-
tise to her "curiose dmaund,"[29] he poses the question of the queen's control over
her images—the degree to which Elizabeth's portraits and written accounts of

her social performances, including her self-adornment, indicate her agency and self-determination.

In the context of Anglican iconoclasm Continental discussions of the art of painting posed significant difficulties for Elizabethan theorists of the visual arts. Techniques such as chiaroscuro and perspective led Elizabethan writers to emphasize painting's inherent deceptiveness. For example, Thomas Elyot defines *adumbro* in his *Bibliotheca Eliotae* (1545) as "to make or gyve shadowe, to represent or expresse, as peynters doo, that do shadowe ymages in playn tables, to make them show imboced or round," but also "to trycke a thynge or draw it grossely, as paynters doo at the begynning," and, finally, "to feyn or dissemble a thing."[30] Hilliard sees perspective as a strategy that "by falshood to expresse truth in the very cunning of line . . . deseave[s] bothe the understanding and the eye,"[31] and Haydocke translates Lomazzo's claim that, although perspective "imitateth the *life* . . . it also causeth a man to oversee and bee deceaved" ("che seguendo il naturale fà travedere l'huomo, & l'inganna").[32] The moral implications of these comments are clear in Hilliard's *Treatise*, when he insists—pragmatically, as a miniaturist and goldsmith working in intricate detail on small swatches of vellum—that "cleanlynes" and purity are the chief prerequisites in the colors chosen by the painter and in his personal demeanor and moral character as well.[33] Clearly, this perception of painting's moral ambiguity responds to anxieties attending Anglican fears of idolatry. Haydocke's nervousness about idols is expressed in his preface, which edits Lomazzo's discussion of religious painting, explaining that "it crosseth the doctrine of the reformed Churches," but nonetheless affirms the value of painting as a *Biblia pauperum*.[34] He later translates Lomazzo's lamentation of an incident of iconoclasm in which images of "the foure *Evangelists* after *Bramantes* handling" ("quattro Evangelisti . . . di mano di Bramante") in Milan were "defaced, when the whole church was whited at the instance of a certaine grosse-headed *Church-warden*, who had no more judgement in painting, then a goose" ("futono poi cancellati quando tutta la chiesa, per commessione di certo Economo che non havea gusto, di buone pitture fù imbiancata").[35] Both the content of the *ekphrases* that Haydocke inherits from his source and the Catholic sentiments that elevate and protect the visual arts trouble the easy transmission of Lomazzo's theory of painting into the Anglican context.

If Elizabethan iconoclasm casts an inhibiting shadow over art critical discussions, the moral censure permeating Anglican treatments of women's cosmetics also threatens the art of painting. The Elizabethan understanding of painting as

essentially an art of coloring meant that it was associated with the problematic practices of cosmetics and rhetoric (as we have seen, for example, in Shakespeare's "Rape of Lucrece").[36] Moreover, the common ingredients of the materials used in both forms of painting paired the painting woman and the artist in their creative practices and their aesthetic and moral effects. When Hilliard provides recipes for ceruse, vermilion, carnation, and other colors used by the miniaturist to create the flesh tones of the face, his *Treatise* reads like the cosmetic recipe books of Plat, Marinello, or Liébault: "Of whits, *Whitlead* lead is the best pict out and grinded, and dried one a chalke stone . . . Iter *Serusa*, which is made fine . . . the first and finest, which will glisten, I call sattin whit . . . the last and coursest, being once againe grinded, is best to be ussed for the flesh couller, properly called cornations . . . [T]her is also an excelent whit to be made of quicksilver which draweth a very fine lyne / this whit the women painters usse."[37] As the language of Elizabethan art theory was infected by debased associations with cosmetics, writers on cosmetics portray the painting woman as an illicit artist and idolater. Thus Tuke argues that the painting woman is at once a demonic master of surfaces and a problematic canvas when he complains: "Not *truths*, but *shadowes* of truths shee is furnisht with; with *seeming* truths, and with *substantiall* lies. Yet with all her faire shewes she is but like a peece of *course cloth* with a *fine glasse*, or *faire die*."[38] Haydocke's translation of Lomazzo's claim that painting is "the Counterfeiter and (as it were) the very *Ape* of Nature" ("è imitatrice, & come à dire simia de l'istessa natura")[39] resonates tellingly with Martin Day's portrait of the painting woman in his *Mirror of Modestie* as both a "limner" and "an Ape limned, guilded and perfumed."[40] These comments censure the painting woman's self-creative practices and objectify her as an emblem of the diabolical art of painting. She is both the canvas and the falsehood that decorates it, both the inept imitator of nature and the subhuman product of that imitation, disguised and denigrated by the art that creates and condemns her.

For the female monarch the legacy of Tudor iconoclasm and its implications for women's cosmetic self-creation troubled the construction of her public image. Whereas the Edwardian "Order of the Privy Council for the Removal of Images" in 1548 signaled, as Strong writes, "the abrupt end of the industry which had employed painters, sculptors, embroiderers, and gold and silver smiths," Elizabeth's approach to the question of religious images was more moderate than her brother's. The 1560 "Proclamation against breakyng or defacing monuments or antiquities" responds to bouts of iconoclasm that followed Mary's death by approving of images in their commemorative function, viewing images as "indif-

ferent," and condemning only "abused" images (that is, those subject to worship).[41] Beginning shortly after her accession, however, Elizabeth took steps to control the production and dissemination of her own portraits, and sporadic episodes of state-mandated iconoclasm directed toward illicit images of the queen occurred throughout her reign. A 1563 draft proclamation complains that "great nomber of Paynters, and some Printers and Gravers have already and doe daily attempt to make in divers manners portraictures of hir Majestie . . . wherein is evidently shewn, that hytherto none hath sufficiently expressed the naturall representation of hir Majesties person." To remedy the situation, the proclamation suggests "that some special coning paynter might be permitted access to hir Majestie" to produce "some perfect patron and example the same may be by others followed." Until the pattern is available, the proclamation charged officials "to reform the errors allredy committed and in meantyme to forbydd and prohibit the showing and publication of such as are apparently deformed until they may be reformed which are reformable."[42] The reformation of deformities in Elizabeth's likenesses was, at least on one occasion, widespread and violent. In 1596 the Privy Council ordered the destruction of all unseemly portraits of the queen. Despite the lengths to which Elizabeth went to regulate her likeness, John Evelyn suggests her limited success: "Had *Queen Elizabeth* been . . . circumspect [in controlling her image], there had not been so many vile *copies* multiplyed from an ill Painting; as being call'd in, and brought to *Essex*-house, did for several years, furnish the *Pastry-men* with *Peels* for the use of their Ovens."[43]

Elizabeth's avowed reluctance to sit for a portrait—"whereof," as the 1563 proclamation states, "she hath been allwise of hir own right disposition very unwillyng"[44]—parallels reports of her difficult relationship with the looking glass, particularly late in her reign.[45] Ben Jonson writes that, because "Queen Elizabeth never saw her self after she became old in a true Glass, they painted her & sometymes would vermilon her nose."[46] The notion of the aged queen made ridiculous by paint provides a startling comment on the masque of youth displayed in her late portraits, invoking the arduous and taxing material practices that created a living imitation of the iconic figure preserved in art. The queen's body becomes a canvas on which she (or, in Jonson's anecdote, her malicious maids of honor) creates an artificial double, the equivalent of her "deed and unsensyble" portraits,[47] patterned one upon the other and only remotely connected to life.[48] Jonson's mention of a "true Glass," moreover, invokes its opposite and recalls discussions in a variety of texts, from anti-cosmetic invectives to treatises on witchcraft, of the uses and abuses of the mirror. Barnaby

Rich, for instance, contrasts his own reliable *My Ladies Looking Glasse* with the false glasses preferred by women: "Amongst Looking glasses, there be some that be over much flattering, that will make the beholders to seeme more yong, more smoth, and better favoured than they be, and these sortes of glasses are best of all esteemed, but especially amongst women."[49] Elizabeth's presumed vanity prompted Elizabeth Southwell to include in her account of the queen's troubled deathbed the detail that Elizabeth "desired to see a true loking glass which in 20 years befor she had not sene but onlie such a one which of purpos was made to deceive her sight which glas being brought her she fell presently exclaiming at all those which had so much commended her and toke yt so offensivelie, that all those which had befor flattered her durst not come in her sight."[50] In these accounts, as in her visual portraits, Elizabeth carries traces of the objectification and duplicity of the painting woman, imagined at once as the idolatrous prod-uct of her art and the demonic practitioner who creates it—both limner and limned Ape. Queen Elizabeth embodies both the false glass and the perverted female spectator of her deformities. In the same way that the mirror of Socrates enables male observers to control the threatening creativity of the painting woman, Jonson's and Southwell's accounts respond to Elizabeth's powerful mas-tery of appearances, practiced throughout her reign, and co-opt that power to denigrate and debase the aging queen. If the mirror of majesty crafted by Hilliard in the *Phoenix Portrait* illustrates the dismemberment and dissolution of its fe-male subject (see fig. 19), it also scripts the legacy of Elizabeth's efforts to con-trol the vagaries of the looking glass and the troubled trajectory of that project in the misogynistic and iconoclastic culture of early modern England.

To consider the origins of Elizabeth's self-definitions through the creative mastery of surfaces—both the mirror and its reflection, painted on her body and on the canvas—we must turn to her translation of Marguerite de Navarre's *Le Miroir de l'âme pécheresse*. When the eleven-year-old Princess Elizabeth pre-sented the manuscript translation to her stepmother, Katherine Parr, on New Year's Day 1544, the gesture displayed her "careful self-presentation, her aware-ness of her status and filial obligations, and her efforts to gain advantage from the important occasion of gift-giving."[51] The manuscript was bound within a cover embroidered by Elizabeth's own hand, which, as Lisa M. Klein has argued, visually reassures Katherine of her privileged place in the royal family while underscoring Elizabeth's own marginalized and dependent position.[52] Eliza-beth's letter accompanying the gift offers it as a work undertaken against idle-ness, since "even so shall witte of a man, or woman, waxe dull, and unapte to do,

or understand any thing perfittely, onles it be always occupied upon some maner of study" (*Glass* 2v). In an apparent imitation of Marguerite's preface "Au Lecteur," Elizabeth "evinced an appropriate, feminine modesty that was paradoxically empowering":[53] "i knowe that, as for my parte, wich have wrought in it: (as well spirituall, as manuall) there is nothinge done as it shulde be. or els worthy to come into your graces handes, but all unperfytte and uncorecte: yet do i truste also, that oubeit it is like a work wich is newe begonne, and shapen: that the syle of your excellent witte, and godly lerninge, in the redinge of it (if so it vouche[seth youre] highnes to do) shall rubbe out, polishe, and mende (or els cause to mende) the wordes" (3v). In calling upon Katherine to coauthor the work through her emendations, Elizabeth both acknowledges herself as a student of the erudite queen and stresses Katherine's parental and pedagogical obligations to her. If Marguerite's preface to the reader informs this gesture, it also seems to lie behind Princess Elizabeth's careful inclusion of both sexes in her claim that "the witte of a man, or woman" depends upon continual use to remain sharp. Even as Marguerite's addresss "Au Lecteur" asserts that, despite her poem's inferior status as a woman's work ("d'une femme l'ouvraige") its author has "le cueur d'ung homme" ("the harte of a man" [5]), so Elizabeth underscores the fact that women, as well as men, possess the intellectual capacities for study and meditation.

From Marguerite, Elizabeth also seems to have learned, as Maureen Quilligan puts it, "the effectiveness of . . . multiple [subject] positions—so useful for preserving her autonomy," implicit in Marguerite's deployment of "the bizarre metaphor of an incestuous genealogy."[54] As Quilligan has shown, printed editions of Elizabeth's *Glasse*, from Bale's 1548 edition to Ward's reprint in 1590 (a textual equivalent to Elizabeth's *Coronation Portrait* of 1600, both of which represent the elderly queen in the guise of her own girlhood),[55] emphasize Elizabeth's roles as daughter, mother, sister, and spouse of Christ in relation to the political and personal alterations punctuating her reign.[56] Bale's publication of the work incorporates Marguerite's holy incest into a framing apparatus in which the shared moral vocabulary of Elizabethan art theory and iconoclasm informs his presentation of the text and underwrites his legitimization of its young author. Thus, for example, Bale's "Epistle Dedycatory" paraphrases Marguerite's self-description as God's "fille d'adoption" (*MAP* 324) ("daugther [*sic*] of adoption" [*Glass* 19v]) to defend Elizabeth's nobility by arguing that "of the most excellent kind of nobility is he sure . . . which truly believeth and seeketh to do the will of the eternal father . . . By that means becometh he the dear

Fig. 20. Title page, *A Godly Medytacyon of the christen sowle* (Marburg: Dirik van der Straten, 1548). By permission of the British Library, shelf mark G.12001.

brother, sister, and mother of Christ . . . yea, the child of adoption and heir together with Christ in the heavenly inheritance" (A6v–A7). Bale also follows Marguerite in invoking the Virgin to validate Elizabeth's identity as "a noryshynge mother to hys dere congregacyon to their confort and hys hygh glorye" (*MAP* 275–318; B1v) and her discourse as an imitation of the Magnificat: "Your penne hath here plenteouslye uttered the habundaunce of a Godly occupyed herte, lyke as ded the vyrgynall lyppes of Christes most blessed mother, whan she sayd with heavenly rejoyce, My sowle magnyfyeth the lorde and my sprete rejoyceth in God my saver" (B1). And his "Conclusion" prays that Elizabeth "and other noble women . . . kindle their myndes and inflame their hartes in the love of Christ their eternall spowse as thys present boke requyreth" (F7).

A woodcut accompanying the edition illustrates Elizabeth's intimacy with Christ, grounded in the incestuous relationships elucidated both in her translation and Bale's editorial matter (fig. 20). In the foreground Elizabeth kneels be-

fore the risen Christ with a book (perhaps the Bible or perhaps a copy of her translation) in her hand. Christ's humanity is emphasized by his position (level with the princess), his downcast eyes, which suggest the humbling of his divinity in the interaction with Elizabeth, and the prominent wound in his foot, a reminder of the Crucifixion. In its emphasis on the unique relationship between the female worshiper and the Savior and its reminiscences of the Incarnation, the woodcut shows affinities with Renaissance illustrations of the *noli me tangere* theme, to which Marguerite's *Le Miroir de Jhesus Christe crucifié* also alludes: "O mon Seigneur, mon ame pecheresse / treshumblement a tez doulz piedz s'adresse: / ne me dictz poinct 'noli me tangere'" (783–85) (O my Lord, my sinful soul addresses your sweet feet most humbly: do not say to me, "noli me tangere"). Since the problematic materiality of the risen Christ is a central concern of the *noli me tangere* topos—as Christ tells Mary Magdalen, "Touch me not, for I am not yet ascended to my Father" (John 20:17)—the woodcut comments upon the implications of the Incarnation, specifically for the redemption of the female flesh.[57] By situating the princess in close proximity to the risen Christ and subtly foregrounding the Incarnation as the condition of that proximity, the woodcut gives visual form to the dominant theme of Marguerite's two mirrors: the redemptive intimacy between Christ and the female worshiper. Elizabeth is here depicted as "[une] creature nouvelle, / Pleine de Dieu" (*MAP* 833–34) ("a godly, and beautiefull creature" [*Glass* 39]), possessing, as Bale writes, "a Godly occupyed herte." The image, moreover, continues Marguerite's reformation of visual representation toward a logocentrism that stresses Christ's Incarnation in and as the Word: both the detail of the book in Elizabeth's hand and the woodcut's function, created for textual reproduction and uncomplicated by dubious coloring, displace idolatry with textuality.[58]

Behind the foreground couple, Christ and Elizabeth, the woodcut depicts a crumbling pedestal supporting a classical column, implying, as Quilligan remarks, that the edifice is "in need of reform by means, perhaps, of the immediacy of the relationship presented in front of it."[59] The architecture alludes to Roman Catholicism and illustrates one of the central arguments of Bale's editorial matter: that Elizabeth, as "the ryght ymage of Christ," promises to overwhelm "those paynted sepulchres" of Catholicism through her promulgation of the reformed religion (A8). In support of this argument Bale relocates the incestuous thematics of *Le Miroir de l'âme pécheresse* within the explicit context of iconoclasm. Thus, he claims that Elizabeth's nobility, grounded in her kinship with Christ, corrects the "monstrouse, or whether ye wyll, a prestygyouse noby-

lyte [of] the Romish clergy," associating this false nobility specifically with Catholic idolatry. Condemning their worship of "S. frances paynted woundes," Bale laments: "O blasphenous bellycastes & most ydell wytted sorceres. How ydolatrously exalte they themselves above the eternal lyvynge God and hys Christ?" (A4v). While he paraphrases Marguerite's address "Au Lecteur" to excuse the work's "hombly speche" as "the worke of a woman" (E7v), he also exalts the humble vessel of Elizabeth's *Glasse* above the "Masses and momblynges" of Catholicism (B1v), claiming, "neyther fyne paynted speche, wysdome of thys worlde, nor yet relygyous hypocresye . . . are herin to be loked for" (E7). Against these "old dottynge bawdes [who] . . . taketh every paynted stocke & stone for their God" (F1), Bale offers the youthful princess and her work: "The first frute is it of her yonge, tender and innocent labours. For I thynke she was not full oute xiiii yeares of age at the fynyshynge therof. She have not done herin, as ded the relygyouse and anoynted hypocrytes in monasteryes, conventes, and colleges, in spearynge their lybraryes from men studuouse, and in reservynge the treasure contayned in their bokes, to most vyle dust and wormes. But lyke as God hath graciously geven it, so do she agayne most freely dystrybute it" (E4v). Bale's image of Elizabeth as a nourishing mother, an inheritor of the Virgin's sanctified speech, here underwrites and explains his publication of her text. He revises the work's original (private) function toward a reformed, humanist vision of Elizabeth's role in promulgating a new *Biblia pauperum*. Like her "most noble and worthy brother Kynge Edwarde the sixt," whom Bale praises for following the examples of Old Testament kings in "put[ting] downe ydolls" and "destroy[ing] all theyr carved ymages . . . restorynge agayne the law of the lorde" (A5v–6), Elizabeth and her text promise to correct the idolatrous abuses of Catholicism.

Despite the fact that Elizabeth was only a teenager when Bale published her *Glasse*, the edition integrates the image of holy incest within a condemnation of Roman idolatry in order to position the princess as a legitimate heir to the throne and as a powerful defender of the reformed faith. Throughout his framing apparatus Bale foregrounds and defends Elizabeth's contested familial relations, ultimately repairing the damaging legacy of incest and illegitimacy that haunted her youth with a vision of kinship in Christ—Elizabeth as Christ's mother, sister, wife, and daughter—which, he insists, bestows upon her true nobility.[60] Thus, she is described repeatedly as "the noble doughter of our late soveraiyne kynge Henry the viii" (A2) and "the kynges [that is, Edward VI's] most noble syster" (E7), relocating the poem's holy incest within dynastic poli-

tics, using the former to repair the latter. The woodcut on the work's title page is framed by references to Elizabeth's identity as Henry's daughter: immediately above the image, she is described as "the ryght vertuouse lady Elyzabeth doughter to our late souverayne Kyng Henrie the viii," and, immediately below, the Latin phrase "Inclita filia, serenissimi olim Anglorum Regis Henrici octavi Elizabeta, tam Graecae quam latine foeliciter in Christe erudita" (The Famous daughter of one-time King of England, the Most Serene Henry VIII, Elizabeth, happily learned in both Greek and Latin) both recalls and elides Elizabeth's difficult childhood and suggests that its reparation lies in her perfection of studies devoted to her father, brother, son, and spouse, Christ, and exemplified in her text.

When Bale deploys Marguerite's trope of incest to advance Elizabeth's dynastic claim, he offers a potent model for Elizabeth's later self-fashioning as a Protestant prince. As Anne Lake Prescott puts it, Elizabeth's *Glasse* "would have reminded her that although she had no father, brother, husband, or son, she had God as all of these—but then, perhaps equally important to Elizabeth, she also had England."[61] The work provides a telling commentary on Elizabeth's later efforts to control her visual representations, both in the production and dissemination of her portraits and in the adornment and presentation of her physical form. Bale is at pains to enlist Princess Elizabeth, the uncorrupted and prodigious "babe" to challenge the "old dottyinge bawds" of Catholicism (F7), casting her youth itself as an authenticating condition of her speech: as Christ's "child of adoption," Elizabeth's devotional writings are guaranteed by her unique intimacy with God. Despite her humble appearance, Elizabeth is a vessel containing God—a nursing mother who feeds her children with the sanctified body and blood of her textual offspring. Implicit in Bale's textual portrait of the princess are the commonplaces of Queen Elizabeth's later representations. Elizabeth's *Glasse* and its publication offer a case study in the creation of Elizabethan royal iconography and invite us to consider Elizabeth herself as an active participant in the invention of the colors—visual, textual, and rhetorical—through which her symbolic images were produced.[62]

These colors, however, threaten to obfuscate the clear glass of Elizabeth's youthful translation and Bale's enthusiastic edition. When Nicholas Sander responds to Jewel's rejection of Catholic idols by charging that "the Queens Majesties face in her coynes, is a kind of graven Image, and I thinke M. Jewel hath some of them in his purse,"[63] he points out, as Strong notes, "the pathetic weakness of the Anglican image position": that, in spite of its rejection of religious

images, the cult of Elizabeth resulted in a secular idolatry to rival the Catholic image worship it replaced.[64] Despite the efforts of Anglican apologists to clarify the status of the royal image,[65] a confusion between substance and shadow was pervasive in Elizabethan England. The belief that the queen's real presence was contained within her "naturall representations" accounts for attacks on Elizabeth's images. As James R. Siemon writes, "repeated attempts to stab, burn, hang, or even secretly poison images of Queen Elizabeth indicate an intention to destroy not only her but the principles and qualities such schematic likenesses represent."[66] Clearly, the lack of verisimilitude of these "schematic likenesses" is beside the point. In the same way that the artificiality of early modern cosmetics would seem to nullify polemicists' repeated worries about the deceptiveness of women's makeup yet fail to do so, the anti-representational nature of Elizabeth's portraits in no way mitigates the royal power they are imagined to contain. Inherent in Elizabethan approaches to the queen's image—and in Elizabeth's own self-fashioning—is a traditional adherence to notions of the unity of surface and substance that previously supported Catholic defenses of imagery, now applied to the secular body of the queen. At the same time, a reformed suspicion of the rupture between inner essence and outward shadow renders Elizabeth, like any painting woman, a memento mori—a dead idol severed from essential meaning. Thus, the Spanish envoy to Elizabeth's court remarks that "all is falsehood and vanity" with the queen,[67] and Paul Hentzner's description of Elizabeth in her sixty-fifth year notes the ravages of her cosmetic use in unforgiving terms: "her face oblong, fair but wrinkled . . . her nose a little hooked, her lips narrow, and her teeth black."[68]

If Elizabeth's self-fashioning constitutes idolatry, its legacy is at once one of a woman's exemplary creative sovereignty and her debased, diabolical self-display. Elizabeth's efforts to control her image for posterity resonate poignantly with John Clapham's comments on the necessity of avoiding flattery in historical reports of the queen's reign. "Like a painted face without a shadow to give it life," he writes, "the credit of such things as are truly reported would be much doubted and diminished."[69] Ironically, as Hilliard reminds us, Elizabeth stage-managed her portraits uniformly to display unshadowed faces, offering to posterity a false history composed of "materiall whitenesse, and a borrowed red,"[70] divorced from the deeper meanings that might guarantee their truth.

Aemilia Lanyer's poem of the Passion of Christ, *Salve Deus Rex Judaeorum*, begins under the sign of the risen Elizabeth:

Sith Cynthia is ascended to that rest
Of endlesse joy and true Eternitie,
That glorious place that cannot be exprest
By any wight clad in mortalitie,
In her almightie love so highly blest,
And crown'd with everlasting Sov'raigntie;
 Where Saints and Angels do attend her Throne,
 And she gives glorie unto God alone.

To the great Countesse now I will applie
My Pen, to write thy never dying fame.[71]

Pragmatically speaking, the lines reflect the redirection of Lanyer's bid for patronage with the death of the queen: thus, she applies her pen to the praises of Margaret Clifford, countess of Cumberland, in Elizabeth's absence.[72] That Lanyer's poem, written eight years after Elizabeth's demise, should open by recalling her, however, suggests that the memory of the monarch may permeate the work more generally and invites consideration of how and why Lanyer engages this powerful image. *Salve Deus Rex Judaeorum* offers an extended meditation on the problematic correspondences between women's inner essences and outward colors, conducted in terms that resonate with Reformation discourses of idolatry and the early modern cosmetic culture. Within this meditation the difficult legacy of Elizabeth's cosmetic and visual self-creation is crucial. The image of Elizabeth ascendant, no longer clad in the garments of mortality, her beauty therefore ineffable, informs Lanyer's efforts throughout her poem to script women's beauty as at once internalized and expressible. Moreover, the image of Elizabeth in beatitude conveys a subtle critique of the queen's vanity in life. The illusion of immortality she sought in her paintings, in both senses of the term, is replaced now by "true Eternitie." As Lanyer attempts to redeem feminine flesh through the spiritual painting undertaken in her poem, she criticizes the Elizabethan engagement with idolatry, with its contradictory condemnation of the dead letter of Catholicism and advancement of the dead and insensible mask of its deified monarch. She conducts this critique by adapting Marguerite's strategies in both of her textual mirrors to reply to the royal portraiture initiated in Elizabeth's *Glasse* and sustained through its published editions throughout Elizabeth's reign.

A reading of *Salve Deus Rex Judaeorum* alongside Marguerite's *Le Miroir de Jhesus Christe crucifié* reveals numerous parallels between them. Lanyer's poem

shares with Marguerite's a strategic display of the gradual development of feminine interpretive skills throughout the work; an invocation of the Virgin as a model for feminine redemption and self-authorship; a revision of Petrarchan reds and whites in the body and blood of the crucified Christ; descriptions of the Incarnation as Christ's assumption of the garments of the flesh; the establishment of a community of female saints in the text, headed by the feminized Christ; and the scripting of a specifically feminine narrative of the Passion.[73] Like Marguerite, Lanyer imagines her text as a mirror, reflecting both the passion of Christ—presenting, as Lanyer writes, "even our Lord Jesus himselfe" (34)—and a community of women convened within the work by an extensive series of dedicatory verses.[74] She invites "all vertuous Ladies in generall" to "beautifie [their] soules" in "my Glasse" (12), casts her book as "a mirrour of [the] most worthy minde" of Margaret Clifford (35), and promises to reflect feminine virtues accurately: "My Glasse beeing steele," she assures us, "declares them to be true" (31). In erecting a mirror for women, Lanyer is not concerned with depicting her subjects' superficial beauties but in granting them an interiority to validate and redeem their problematic femininity. Her "Invective against outward beuty unaccompanied by virtue" challenges the assumption that women are incapable of spiritual self-reflection. Lanyer discounts the "gawdie colours" of feminine beauty and disparages "the matchlesse colours Red and White" as "perfit features in a fading face" (59). While the cosmetic culture, as we have seen, commonly insists that women imitate the Petrarchan ideal of feminine beauty, Lanyer's disclaimer of women's external beauty argues that "a mind enrich'd with Virtue, shines more bright,/Addes everlasting Beauty, gives true grace" (59). Like anti-cosmetic polemicists, such as Leonard Fioravanti, Lanyer suggests that "Cheerfulness and Contentment," "Health . . . Honesty . . . [and] Wisedome," are the cosmetics that must decorate women's faces and their hearts.[75] Beyond this, however, as Barbara Bowen has argued, "Lanyer takes on the Petrarchan ideal at an especially charged moment in its history [when] the cult of red and white . . . had been energized by the tradition of representing Elizabeth I in terms of her lily-and-rose beauty."[76] Lanyer's invective thus implicates the specifically Elizabethan use of reds and whites, deploying an Anglican suspicion of the disjuncture between surface and substance to discount women's external beauty, on the one hand, and to trouble the cult of Elizabethan idolatry, on the other. The goal of the invective, like that of the poem more generally, is to delineate the conditions of a more valid, authenticating connection between women's colors and essences. Accordingly, the invective demonstrates the limitations of

women's physical beauty through a survey of famously problematic beauties—Helen, Lucrece, Cleopatra, Rosamund, and Mathilda—who, not incidentally, are also the subjects of popular male-authored literary works.[77] In invoking these figures, however, Lanyer redirects the conventional anti-cosmetic invective away from the usual indictment of women's duplicity and vice, toward a reading of feminine beauty that sees men's responses to it as the problem. "For greatest perills do attend the faire," she writes, "When men do seeke, attempt, plot and devise, / How they may overthrow the chastest Dame, / Whose Beautie is the White whereat they aime" (59–60). Lanyer condemns men's vices rather than women's, and her critique includes textual representations of women that render them objects scrutinized and anatomized by their male authors and readers. Like Marguerite's *Miroirs*, Lanyer's "Invective" suggests that the objectifying male gaze that reduces women to mere surface may be replaced by the self-reflective vision of the female subject herself.[78] If women's beauty is the "White" at which men aim, Marguerite's description of Christ as her "blanc et . . . exemple" (target and . . . example) (*MJCC* 13) provides Lanyer with a suggestive model for rooting femininity in, and redeeming it as, the image of God.

The redirection of charges usually brought against women's beauty to indict men's lasciviousness in the "Invective" participates in the poem's more general argument that men, "like Vipers defac[ing] the wombes wherein they were bred," are responsible for "dishonour[ing] Christ his Apostles and Prophets, putting them to shamefull deaths" (48–49). Women, however, enjoy a special intimacy with God, as demonstrated by Lanyer's feminist retelling of the Passion, culminating in the moment of Christ's empathetic speech to the mourning Daughters of Jerusalem (93–95).[79] Lanyer's description of Christ's sorrow in the Garden of Gethsemane, "which did now embrace / His holy corps," emphasizes the Incarnation and the Crucifixion (since the *corpus Christi* is also a corpse) and casts the Passion as a second Fall of man brought about by "Vipers, objects of disgrace" inhabiting the garden (67). As the succeeding stanzas illustrate, the vipers in question are not only the Jews and Romans who put Christ to death (whom Lanyer associates with the false colors of hypocrisy, calling Pilate "a painted wall, / A golden sepulchre with rotten bones" [91]) but the apostles as well, who betray and abandon him. Recalling Shakespeare's "Rape of Lucrece," she demands of the sleeping Peter, James, and John, "What colour, what excuse, or what amends, / From thy Displeasure now can set them free?" (69).[80] The passage associates the womb defaced by vipers with the garden containing the holy corps, and Lanyer imagines her own poem (the garden) as the vessel carrying Christ

and ensuring his Incarnation. At the same time, her view of the apostles as vio-
lating Tarquins to Christ's passive Lucrece feminizes Christ and recalls Lucrece's
appearance in the "Invective," in which beautiful women appear as victims of
serpent-like men (serpent-like, that is, because bent on seduction). As in Mar-
guerite's second *Miroir*, Lanyer's feminized Christ joins and unites the text's com-
munity of female faithful. Marguerite claims that God is vanquished by Christ's
feminine obedience ("tu as vaincu par ton obeyssance / Dieu" [*MJCC* 875–76]),
and Lanyer similarly praises the "faire Obedience shin[ing] in his breast" (74).

The poem's indictment of men and exoneration of women is, of course, most
clearly articulated in "Eves Apologie," in which Lanyer revisits Eden to show
that, whereas Eve was "simply good" (84), merely deceived by the serpent, *"Adam*
can not be excusde"* (85) because, in full knowledge of the consequences of his
actions, he ate of the forbidden fruit. The passage exploits the typology of the
Fall and the Crucifixion, stating, "Let not Women glory in Mens fall, / Who had
power given to over-rule us all" (84). "Mens fall" here refers to their inexcusable
role in putting Christ to death: "Her weaknesse did the Serpents words obay; /
But you in malice Gods deare Sonne betray" (86). Lanyer's defense of Eve relies
heavily on Heinrich Cornelius Agrippa's *Declamatio de nobilitate et praecellentia
foeminei sexus*, a work that also serves, as we have seen, as a source for Liébualt's
defense of women's painting in *Trois livres de l'embellissement et ornement du corps
humaine*. The source highlights questions of women's agency and self-determi-
nation and brings to bear upon Lanyer's poem concerns about women's powers
of creation and self-creation that inform her revisionist treatment of feminine
beauty and her poetic project.

From Agrippa, Lanyer takes the main features of "Eves Apologie," following
her source in exonerating women from guilt for the Fall by emphasizing that, as
the 1542 English translation states it, "the fruyte of the tree was forbydden to the
man, but not to the woman . . . Therefore the manne sinned in eatynge, not the
woman. The man gave us deathe, not the woman."[81] She adapts from Agrippa
the usually overlooked "wyfe of Pylate,"[82] in whose mouth Lanyer places Eve's
defense. And Lanyer's summation of the apology, "Then let us have our Liber-
tie againe, / And challendge to your selves no Sov'raigntie," charges husbands
with "tyranny" in a direct allusion to Agrippa (87), who condemns "men, why-
che by relygion clayme authoritie over women, and prove theyr tyranny by holy
scriptures: the whiche have this cursed sayenge, spoken to Eve, contynually in
theyr mouth: Thou shalt be under the power of men."[83] Beyond "Eves Apolo-
gie" Agrippa's argument that "woman was not made to the ymage of God, but

to the simylitude of Christe" provides Lanyer the means to counter essentialist arguments,[84] such as Liébault's, which subordinate women to men. The argument underwrites the intimacy between women and Christ that guarantees and validates femininity throughout *Salve Deus Rex Judaoerum*. Thus, Lanyer paraphrases Agrippa in her address "To the Vertuous Reader" to defend women on the basis of the honor shown to them by Christ:[85] "it pleased our Lord and Saviour Jesus Christ, without the assistance of man . . . to be begotten of a woman, borne of a woman, nourished of a woman, obedient to a woman; and that he healed woman, pardoned women, comforted women: yea, even when he was in his greatest agonie and bloodie sweat, going to be crucified, and also in his last houre of his death, tooke care to dispose of a woman: after his resurrection, appeared first to a woman, sent a woman to declare his most glorious resurrection to the rest of his Disciples" (49–50). Arguing that woman is "the print of the Creator,"[86] Lanyer returns to Eden to claim for women a licit mastery of surfaces, including the surface of the female body. Women need not paint to please and obey their husbands, as Liébault had insisted. Rather, they may exercise creative "Sov'raigntie"—including the writing of a devotional poem in praise of women—to re-create themselves in the image of God. For Lanyer, Agrippa's treatise provides the means to challenge essentialism: in her handling, Eden becomes a site for the construction of gender and, as such, an opportunity to reimagine the nature of women and to redeem Eve's duplicitous associations with false images and deceptive shadows. Presenting women as "the simylitude of Christe" throughout her poem, Lanyer, like Marguerite, undertakes a feminine interjection into the discourses of iconoclasm and *cosmesis* to insist upon the integrity of the female subject. If the Reformation severing of surface and substance results in a demonization of images that parallels the demonization of women's painting, Lanyer repairs this rupture and redeems femininity by imagining, in Agrippa's words, "a new creature." "For in Christ," he writes, "neither male nor female is of value, but a new creature."[87] Accordingly, Lanyer invites her female readers,

> Thus may you flie from dull and sensuall earth,
> Whereof at first your bodies formed were,
> That regen'rate in a second berth,
> Your blessed soules may live without all feare. (15)

Agrippa deploys women's physical beauty to prove their preeminence over men: because "man is the worke of nature, and womanne is the worke of god,"

he argues, "woman is many tymes more apt and mete then the man, to receyve the hevenly light and bryghtnes, and it is often replenyshed therwith: whiche thyng is easy to be sene, by her clenlynesse, & marveylous faire beautye."[88] This argument becomes the basis on which the women addressed and depicted in *Salve Deus Rex Judaeorum*, and the female poet herself, are cast in the image of Christ. As in Marguerite's mirrors, the affinity between Christ and the female worshiper is grounded in the Incarnation. Lanyer, too, stresses the bond between mother and son in describing "the sorrow of the virgin Marie" at the Crucifixion (94). Like Bale, Lanyer recalls the Magnificat to praise the Virgin as the vessel through which Christ assumes the "fraile clothing" of flesh and to validate her own poetic speech (95, 99). As Mary redeems Eve by receiving the print of Christ on her flesh, Christ's image redeems the body of Lanyer's poem: "But yet the Weaker thou doest seeme to be," she claims, "In Sexe, or Sence, the more his Glory Shines" (63). The Virgin as "Servant, Mother, Wife, and Nurse / To Heavens bright king" appears as an *exemplum* of women's multiple relationships with Christ and as an emblem of women's self-determination and creative sovereignty (98). For Lanyer the Virgin is unique among women in being "from all men free" (97).

If the mirror of Socrates renders woman a sight, incapable of viewing surfaces with the insight of which man is capable, Lanyer's "Mirrour of a worthy Mind" redeems the female flesh not by affirming women's essential virtues but by constructing the female subject based upon her identity with Christ (5). The failure of a necessary link between women's inner and outer natures—a Reformation phenomenon related to the failure of Incarnationalism in the discourses of idolatry—offers an opportunity for the woman writer to describe the construction and reconstruction of the female self as a productive form of self-creation. "Painting," for Lanyer, involves the repair of the severed link between color and essence but one that proceeds by constructing feminine interiority as women's incorporation of the image of Christ. If iconoclasm's implications for the painting woman trouble and demonize her love of surfaces, Lanyer appropriates and reclaims the art of shadow to create the feminine self.

To do so, she follows Marguerite's revision of the blazon in *Le Miroir de Jhesus Christe crucifié*, in which the regendering of the gaze revivifies the objectified female body. She places women at the foot of the cross, before the mirror of Christ:

No Dove, no Swan, nor Iv'rie could compare
With his fair corps, when 'twas by death imbrac'd;

No rose, nor no vermillion halfe so faire
As was that precious blood that interlac'd
His body. (39)

Like Marguerite, Lanyer recasts the reds and whites of the cosmetic culture as the body and blood of Christ, offering first a blazon the crucified Christ (101), followed by an anatomy of his resurrected form. The latter returns the conventional discourses of painting to their biblical origins in Song of Songs and applies them to the male, rather than the female, body:

This is that Bridegroome that appears so faire,
So sweet, so lovely in his Spouses sight,
That unto Snowe we may his face compare,
His cheekes like skarlet, and his eyes so bright
As purest Doves that in the rivers are,
Washed with milke, to give the more delight;
 His head is likened to the finest gold,
 His curled lockes so beauteous to behold. (107)

Also like Marguerite, Lanyer uses the metaphor of clothing to describe the Incarnation, and she continues her reclamation of feminine colors within this imagery. When Herod's soldiers deride Christ by dressing him in purple, Lanyer takes the occasion to note that Christ is worthy of "robes of honor": "Pure white, to shew his great Integritie" and "Purple and Scarlet [which] well might him beseeme, / Whose pretious blood must all the world redeeme" (89–90). Similarly, the Incaration is described as Christ's exchange of "his snow-white Weed" for "Our mortall garment in skarlet Die" (99).[89] As Marguerite sees Christ as "covert de ma foiblesse, / ma villité offuscant ta noblesse" (covered in my weakness, my vileness obscuring your nobility) (*MJCC* 885–86), Lanyer notes "His Greatnesse clothed in our fraile attire" (105). Her description of the *corpus Christi* at the moment of burial is a study in reds and whites, "Imbalmed and deckt with Lillies and with Roses" (106). Finally, the poem's closing gesture extends this incarnational imagery to underscore the intimacy between the female subject (here Margaret Clifford) and Christ:

Loe Madame, heere you take a view of those,
Whose worthy steps you doe desire to tread,
Deckt in those colours which our Saviour chose;
The purest colours both of White and Red.

Their freshest beauties I would faine disclose,
By which our Savior most was honoured:
 But my weake Muse desireth now to rest,
 Folding up all their Beauties in your breast. (128–29)

Lanyer imagines the saints, clothed in sanctified reds and whites, as simultaneously the colors of her poetic speech and the *imago Christi* internalized in the breast of Margaret Clifford. The passage summarizes her revisionist approach to women's painting. Exploiting the validating intimacy between women and Christ, Lanyer traces the movement from vision to internalization that redeems the female subject and her troublesome flesh. She scripts women's redemptive self-creation through their correct interpretation and adoption of the colors of Christ. As such, Lanyer's blazon of the resurrected Christ ends with a self-conscious gesture toward her own representation of the parceled *corpus Christi* and offers a portrait of exemplary feminine reading:

Ah! give me leave (good Lady) now to leave
This taske of Beauty which I tooke in hand,
I cannot wade so deepe, I may deceave
My selfe, before I can attaine the land;
Therefore (good Madame) in your heart I leave
His perfect picture, where it still shall stand,
 Deeply engraved in that holy shrine,
 Environed with Love and Thoughts divine. (108)

The redemptive internalization of the image of Christ within the female reader provides corroborating evidence of her inner beauty to validate her appearance. Significantly, however, Lanyer foregrounds feminine agency—that of the poet and of the reader—in constructing this virtue. Rather than rendering women as passive objects of observation, *Salve Deus Rex Judaeorum* exploits the perceived separation of colors and essences to empower the woman reader and writer to self-create.

This model of female creative agency is also in play in Lanyer's catalogue of Old Testament heroines, adapted from Agrippa, in which Margaret Clifford's constancy is praised above that of Susanna. Margaret's intellectual virtues, Lanyer argues, surpass Susanna's merely superficial strengths:

But your chaste breast, guarded with strength of mind,
Hates the imbracements of unchaste desires;

You loving God, live in your selfe confind
From unpure Love, your purest thoughts retires,
Your perfit sight could never be so blind,
To entertaine the old or yong desires
 Of idle Lovers; which the worldly presents,
 Whose base abuses worthy minds prevents. (117)

Here Lanyer describes an internalized Susanna: the physical purity of the hero-
ine is recast as the intellectual and spiritual purity of the countess. While Susanna
is the material object of the male gaze, an index of the violence of masculine
voyeurism, Margaret Clifford is imagined not as spectacle but as spectator, whose
"perfit sight" corrects the abusive vision of the original. Thus, Lanyer rewrites
the passive female object as an active female agent, the guarantor of her own
virtues. Moreover, the movement from surface to substance undertaken in this
rewriting of Susanna suggests Lanyer's manipulation of Reformation discourses
of iconoclasm throughout her poem. The Anglican rejection of idols, as we have
seen, was commonly presented as an emancipation of the New Testament re-
formed church from the idolatrous errors of Old Testament Catholicism, cast
by Ainsworth as a painted Jezebel: thus, Bucer claims, "Howe moch lesse shall
it [idolatry] be lawfull for us/whom the truth succeeded into the place of shad-
owes/hathe nowe made free from outwarde ceremonies/requyryng non other
honour or servyce of us/than that which standeth in spirit and truth."[90] Lanyer's
Old Testament Susanna represents the externalized struggle of chastity and lust,
played out with high visibility on a public stage and subject to the determination
of the law. Her internalized heroine, however, represents the New Testament
advancement of the spirit over the letter. Couched within the breast of Margaret
Clifford, subject not to the law but to the judgment of her "perfit sight," Susanna
symbolizes reformed worship in spirit and truth. Bucer's iconoclastic claim that
freedom from "outwarde ceremonies" ratifies private spiritual worship glosses
Lanyer's translation of Susanna's emblematic chastity from icon to internalized
text. As Susanna moves inward, she effectively creates feminine interiority by
replacing the objectifying male gaze with woman's self-reflective vision.[91] Like
Lanyer's "Invective against outward beuty unaccompanied with virtue," her re-
vised Susanna exploits the twin debates on idolatry and *cosmesis* to advocate
women's creative agency: men's violations of women's beauty, rather than women's
incapacity for self-reflection, vex and trouble the surface of the female body and
its adornment.

One final episode in *Salve Deus Rex Judaeorum* examines this advancement of
the New Testament spirit over the Old Testament letter as it bears upon the cre-
ation of Lanyer's "new creature." Moreover, the passage considers this issue
with reference to the legacy of Elizabethan engagements with colors and their
problematic essences. Lanyer's lengthy description of the Queen of Sheba's
journey "To heare the Wisdom of this worthy King" (118), Solomon, offers a
portrait of women's intellectual curiosity and spiritual zeal, painted in redeemed
colors and stressing the intimacy between and equality of Solomon and Sheba:

> Here Majestie with Majestie did meete,
> Wisdome to Wisdome yeelded true content,
> One Beauty did another Beauty greet,
> Bountie to Bountie never could repent. (119)

When Sheba is offered as an Old Testament prototype of the reformed Mar-
garet Clifford, Lanyer casts the movement from letter to spirit in terms that
engage the iconoclastic debate. "Pure thoughted Lady," Lanyer addresses the
countess, "blessed be thy choyce/Of this Almightie, everlasting King" (122),
and she continues:

> Of whom that Heathen Queene obtain'd such grace,
> By honouring but the shadow of his Love,
> That great Judiciall day to have a place,
> Condemning those that doe unfaithfull prove:
> Among the haplesse, happie is her case,
> That her deere Saviour spake for her behove;
> > And that her memorable Act should be
> > Writ by the hand of true Eternitie.

> Yet this rare Phoenix of that worne-out age,
> This great majesticke Queene comes short of thee,
> Who to an earthly Prince did then ingage
> Her hearts desires, her love, her libertie,
> Acting her glorious part upon a Stage
> Of weaknesse, frailtie, and infirmity:
> > Giving all honour to a Creature, due
> > To her Creator, whom shee never knew. (123)

Unlike Sheba, who sees only the shadow of the true Christ, Margaret worships in spirit and truth. In worshiping the creation rather than the Creator, Sheba practices an idolatry that displaces substance with shadow.[92] Margaret, emancipated from "the place of shadows," is capable of seeing no longer through the glass darkly but face to face. When Lanyer describes Sheba as "this rare Phoenix of that worne-out age," she alludes to Queen Elizabeth's personal emblem, also commemorated in Hilliard's *Phoenix Portrait* (see fig. 19), and recalls the poem's opening image of Cynthia enthroned in majesty in the repeated phrase "true Eternitie" (51, 123). Like Elizabeth's own idolatry—that of the painting woman—Sheba's infraction is practiced upon a stage of weakness, frailty, and infirmity. The earthly prince whom she worships, one is tempted to surmise, is Elizabeth herself. In correcting the calcified letter of the Old Testament with the living truth of the New, Lanyer is also scripting the demise of Elizabethan forms of feminine self-fashioning. The new creature whom she imagines is redeemed both from twin specters of Catholic ceremony and Elizabethan painting. Accordingly, her treatment of Sheba concludes with an image that converts Christ's crucified body to a text, a surface correcting the painted flesh of the female body on which are inscribed "in deep Characters" the names of the saved:

> For by his glorious death he us inroules
> In deepe Characters, writ with blood and teares,
> Upon those blessed everlasting Scroules:
> His hands, his feete, his body, and his face,
> When freely flow'd the rivers of his grace. (124)

Recalling Marguerite's imagery of blood and tears in *Le Miroir de Jhesus Christe crucifié*, which claims that "l'eau et le sang m'esjouyssent ensemble" (water and blood together excite me) (1109), Lanyer concludes her redemption of reds and whites. Here the blood of Christ becomes a "christall streame . . . Where souls do bathe their snow-white wings" (125). Through this "Well of Life" (15), Marguerite's "fontaine . . . des parfaictz amoureux" (fountain . . . of perfect lovers), where "la Samaritaine . . . tant gaigna" (the Samaritan gained so much), the female subject becomes a new creature, imprinted with the image of Christ (*MJCC* 1068, 1073–4).

The project of constructing female subjectivity, outlined in the last two chapters, challenges the essentialist assumptions of the cosmetic culture, which understand women's nature as alternatively decorative (in the cosmetic manuals' view that woman was created to please man) and debased (in the commonplaces

of anti-cosmetic polemicists, which stress women's vanity and weakness). To grant women the power of self-determination by insisting upon their interpretive ability and intellectual capacity for discrimination does not simply replace one essentialist view with another. Rather, the artists and writers described here imagine femininity as performative insofar as it is constructed through the individual's engagements with cultural and discursive genres and material practices. These are self-conscious engagements that are clearly aware of the conventional gendering of the genres and practices they deploy and which seek to redefine "masculine" traits (self-reflection, for example) as equally available to women. Moreover, the emphasis placed on women's intimacy with Christ in Marguerite's poems and their English adaptations does not rest upon an essentialist understanding of "woman," as Christ's cross-gendering by Marguerite and Lanyer suggests. Deploying a *fiction* of essence, the women examined in these chapters envision a new femininity that is a product of a woman's acts rather than her nature. Lanyer's redemptive painting, as it moves from the body's surface inward, constructs the interiority—the "essence"—of this new woman.

If Reformation discussions of the nature of religious images and ceremonies foster suspicions of the painting woman, they also afford women writers and artists the means to imagine this new femininity by troubling the rupture between surface and substance, colors and essence, which is fundamental to the iconoclastic debate. By the mid-seventeenth century the legacy of this severance promotes widespread uncertainty about the quality and reliability of self-reflection—whether the view of the self provided by the mirror of Socrates is approved by the conscience or distorted by custom. It is in relation to these two contested terms that the writers and artists considered in the next chapter undertake a reformation of painting and a vindication of the difficult and disobedient painting woman.

Custom, Conscience, and the Reformation of Painting

In *A Glasse for Gentlewomen to dresse themselves by* (1624), Thomas Taylor condemns face painting as a product of erroneous custom: "stamping pride on [women's] faces by painting and colours," he writes, "can by no colour be warranted. Say not, It is custome, for all custome must bee ruled by the word of Christ, who said, *I am Truth*; and not *I am Custome*."[1] In anti-cosmetic invectives painting is considered a diabolical custom whose relationship to truth parallels that of the painted face to the unadorned visage. Authors of mirrors for women promise unadulterated views of women's internal state of mind to correct the distorted mirrors of custom and vanity licensing the practice of painting. Barnaby Rich's *My Ladies Looking Glass*, for example, assures his female readers that "you may with a cleare conscience, and an unbended brow . . . vouchsafe to reade . . . when there is nothing therein conteined but justifiable truth."[2] At the same time, he argues that painting is a matter of conscience and relies upon the body's surface as an index of the substance within: "for she that is not ashamed to falsify those exterior parts of the body, is much to be suspected that she will make little conscience to adulterate the inward beauty of the mind."[3] In John Downame's estimation, "even those who practice [painting] doe condemne it in their

owne consciences, and would be much ashamed (if long custome hath not made them impudent) to be taken with the fact,"[4] and Ben Jonson complains of "the Impostures, paintings, drugs,/Which her bawde Custome daubes her cheekes withall."[5]

While anti-cosmetic invectives denounce the vagaries and falsehood of custom and enlist painting as proof of a corrupt conscience, cosmetic instructional manuals commonly express a different view. When Liébault's *Trois livres* argues that a wife must paint in obedience to her husband (see chap. 3), he stresses that obedience includes submitting her conscience to her husband's rule: "en quoy toutesfois doit faire en sa conscience telle protestation que feit Hester: & dire avec elle, qu'elle abomine toute vanité, & que ce qu'elle se pare & fait monstre de sa beauté, n'est pour son privé: mais pour complaire à son mary" (to which at times she must protest in her conscience as Esther did; and say with her, that she abominates all vanity and that she adorns herself and displays her beauty not for herself alone but to please her husband) (a5). By the mid-seventeenth century custom provides the grounds to defend a woman's right to cosmetic self-creation according to the dictates of her own conscience.[6] John Gauden's *Discourse of Artificial Beauty, In Point of Conscience Between Two Ladies,* first published in 1656, sees custom as a reason to justify, rather than reject, makeup. Condemning opponents of face painting as "captives to custome, prejudice and popularity" (235), Gauden's dialogue maintains that use is sufficient to establish the validity of the practice because "nothing is and ever hath been more natively common . . . to all Nations in the world, then men and women *painting* and adorning themselves with several *colours*" (164).[7] "Vain and vicious minds," his female speaker argues, abuse customs that, practiced soberly, are without offense to God. Thus, Esther utilized the "*purifications* appointed her" and the trappings of "*Persian* delicacy" without sin; indeed, "it had been so far a sin not to use them" (25–26). Countering the charge that women paint "to the deforming of their Souls, and defiling of their Consciences" (2), Gauden's speaker promises to mediate "between Ladies *Countenances* and their *Consciences*" (176).

This transvaluation of custom and conscience is a central feature of seventeenth-century constructions of the female subject. The twin literary genres of the beauty culture, the anti-cosmetic invective and the cosmetic manual, traditionally view both custom and conscience as disciplinary practices that render women passive victims. As the "bawde Custome" leads women, like puppets, into harlotry, Liébault's invocation of conscience to underwrite wifely obedience belies any suggestion of feminine interiority: a woman's conscience is merely her

husband's. Post-Reformation descriptions of conscience, however, involve a more active, dialogic interaction between the individual and internalized authorities than these cosmetic texts allow. As William Perkins's *Whole Treatise of the Cases of Conscience* (1606) explains, "Man hath two witnesses of his thoughts, God, and his owne Conscience; God is the first and chiefest; and Conscience is the second subordinate unto God."[8] Conscience, then, is "God's substitute" and "deputy," his voice internalized in the mind of the believer.[9] Because, in this view, the subject is constructed through dialogue with internalized authorities—whether scriptural, rational, or cultural—feminine subjectivity is also imagined as the product of an inaudible conversation between the individual and God's deputy within.

This active view of the female subject, this chapter argues, is exploited by feminist writers and artists in the post-Reformation period to depict feminine interiority in their works and to argue women's authority to deliberate and to act based upon their dialogic interactions with the voices of reason and religion couched within.[10] To describe Catholic and reformed approaches to these concerns, I concentrate on two English texts, Cary's *Tragedy of Mariam* and Gauden's *Discourse of Artificial Beauty*, which locate themselves in relation to distinct historical moments—the Gunpowder Plot in 1605 and the Restoration in 1660, respectively—when institutions of the Oath of Allegiance crystallized questions of conscience. I also turn my attention to two Italian Baroque paintings, by Orazio Gentileschi and his daughter, Artemisia, which explore conscience and custom in relation to Catholicism's heightened emphasis on penitential self-examination in the seventeenth century. Two conceptual links between these works—the post-Reformation project of casuistry, on the one hand, and emerging views of the dialogic nature of subjectivity, on the other—suggest the continuity of similar concerns across doctrinal and national borders and intimate similar approaches undertaken by feminist writers and artists. Cary's *Tragedy of Mariam*, Artemisia's *Mary Magdalen*, and Gauden's *Discourse of Artificial Beauty* share an awareness that performances of femininity are themselves creatures of custom. Thus, each work explores the means by which a woman comes into being through the dialogic process of reconciling her countenance with her conscience.

<div align="center">❦</div>

Two sixteenth-century Italian images, often considered together,[11] illuminate the "good" and "bad" painting emerging from the two major textual traditions of the cosmetic debate. They also suggest the need for, and the direction of, the

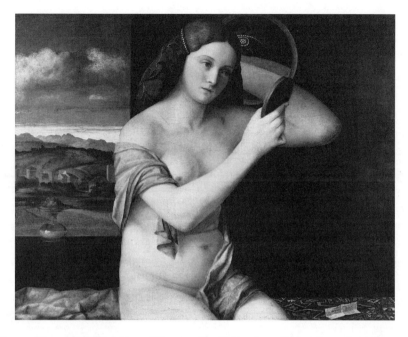

Fig. 21. Giovanni Bellini, *Young Woman at Her Toilette* (1515). Kunsthistorisches Museum, Vienna, inventory no. GG 97.

dialogic construction of feminine interiority undertaken a century later in textual and visual mirrors for women. In Giovanni Bellini's *Young Woman at Her Toilette*, now in Vienna (fig. 21), a nude woman, engaged in her toilette, looks into a small handheld mirror, while behind her a larger, round mirror reflects the scene. She arranges her headdress, a *reticella*, which indicates her status as a married woman.[12] Beside the woman, on the windowsill, is a crystal vase that Frederick Cummings identifies as a *sponzarol* (Venetian dialect for *spongiarolo*), a necessary accoutrement in women's painting that holds a sponge used to apply or to remove makeup.[13] The convex sides of the transparent container reflect a light source from beyond the canvas. Visible within it is a substance that varies in color according to its relationship to this light: to the left the substance appears lighter, approximating the tone of the young woman's flesh, while the darker areas echo the tones of the landscape beyond the window. The substance, I suggest, is ceruse, and the object surmounting the vase's neck is a sponge that the woman has used (or perhaps will use) to apply it to her face and body.[14]

Bellini's deployment of the mirror and the glass *sponzarol* merges the subject of women's painting with the art of painting proper, with a uniquely Venetian

understanding of the centrality of color to the art. Thus, the *sponzarol*, placed in the threshold between the painting's interior and exterior spaces, encapsulates the palette and literalizes the material that creates the landscape and the nude female form. Bellini's comparison of the art of painting with women's face painting reflects the fact that the materials of both practices were identical and makes use of the familiar technique of casting "the image of the beautiful woman as an image of beautiful art."[15] Moreover, the Venetian elevation of *colore*, at the expense of *disegno*, was also frequently discussed in gendered terms in the period, most famously in Michelangelo's denigration of Titian's *colorito* as effeminate.[16] The mirror, meanwhile, symbolizes the triumphant reproduction of nature in the artist's virtuoso performance and thereby offers an allegory of the Albertian art of painting that, as *Della pittura* insists, "is concerned solely with representing what can be seen" ("solo studia . . . fingiere quello se vede").[17] The mirror registers the artist's role in reflecting and re-creating nature, while its placement in the woman's hand parallels the painter's creative sovereignty with the painting woman's as she adorns and redefines her face. Bellini's inclusion of *two* mirrors in the scene, as Goffen has argued, invokes the *paragone* between the arts of painting and sculpture: by depicting two views of the woman's form at once, the mirrors argue the ability of painting to accomplish what sculpture cannot.[18] Bellini's work meditates upon the customs defining and constructing femininity in sixteenth-century Venice and deploys these customs as metaphors for the art of painting. If the woman engaged in her toilette, as Melchoir-Bonnet suggests, "incarnates controlled nature,"[19] she offers an image of the artist's control over nature, indexed by the visual representation of their shared material, ceruse, contained in the *sponzarol*. Moreover, the "crystall glasse" of the *sponzarol* (like the Tudor casting bottle discussed in chap. 4; see fig. 18) represents the woman's body: thus, Bellini's handling of the object adopts the positive view of makeup, common in cosmetic manuals, as enhancing a woman's natural beauty in order to please her male governors. As a married woman, restraining her hair in the *reticella*, the subject registers her compliance with the regulatory powers of the beauty culture, and of marriage, to define and describe her. Painting is an act of wifely obedience. Incongruously, then, cosmetics serve as an emblem of the subject's purity. If her nudity affirms her chastity, Bellini is self-consciously aware that her nudity is itself the product of painting. The smooth brush strokes with which he creates her form ensure that his "heroine appears chaste despite her nudity,"[20] but her nudity veils the art that creates it. Bellini's art and that of the painting woman coalesce.

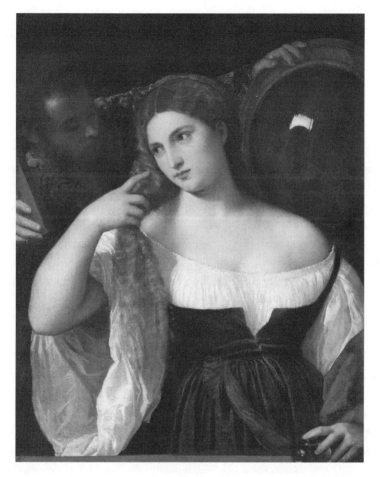

Fig. 22. Titian, *Young Woman at Her Toilette* (1512–15). Louvre, Paris. Erich Lessing / Art Resource, New York.

Whereas Bellini's celebration of his artistic virtuosity cheerfully exploits this positive view in its comparison between makeup and the art of painting, anti-cosmetic invectives are less accepting of the painting woman's claim to self-creation. At issue in these condemnations is the uncomfortable association of women's artistry with artifice—a concern about the possibility of feminine deception that demonizes women's painting and associates their physical beauty with vanity. Titian's *Young Woman at Her Toilette*, now in the Louvre (fig. 22), shares the assumptions of the anti-cosmetic polemicists. As in Bellini's canvas, the subject gazes into a small mirror, here held by a male attendant, while be-

hind her a convex mirror reflects the scene. She is dressed, or partially undressed, in a *camica*, which enhances her sexuality.[21] On a table in the foreground the woman holds a cosmetic jar, associating her with Mary Magdalen, whose standard accessory is the pyx, or ointment jar, that alludes (in an early modern conflation of three biblical Maries) to her anointing of Christ's feet and her attendance on his body following the Crucifixion.[22] The painting's allegory of vanity, its embodiment of "the idea of transience and death,"[23] is subtle but definite: the woman's gaze is locked on her own reflection in the handheld mirror, rendering her for some viewers an image of feminine pride and self-love, for others a melancholy memento mori.[24] This theme is reflected in Titian's style: in contrast with Bellini's smooth brush stroke, Titian "uses the rough *impasto* of the loaded brush," which serves at once to emphasize the sexuality of his subject and to suggest "the temporality of the depicted moment, hence the possibility of change." As Rona Goffen argues, "evoking the physical, sensual experience of sight, his heavy *impasto* also recalls the process of creation: medium and technique memorialize Titian's rapid brush stroke."[25] If Bellini's style aligns his art with that of the painting woman, Titian's *impasto* suggests a masculine imposition and inscription of sexuality upon the female form.[26]

As in Bellini's *Young Woman at Her Toilette*, Titian's depiction of two mirrors in the scene emphasizes his own artistic virtuosity and comments upon the supremacy of painting over sculpture in the *paragone*. Titian's innovation, however, is to include the male attendant—a shadowy figure, half-hidden in darkness, whose presence alters the viewer's relationship to the female subject. The male attendant thwarts the dream of ocular possession by underscoring the distance between the represented female form and the viewer: although she is available to him, at least physically, she is out of reach of the viewer beyond the frame. The painting therefore mirrors the problematic display of the female form in anti-cosmetic invectives, which obsessively worry about the inaccessibility of a woman's internal state, virtuous or vicious, given painting's obfuscation of the body's surface. She cannot be known or possessed by means of mere vision. If, as Goffen suggests, the male attendant's hands holding the mirror, emerging from darkness into light, "recall the painter's hands holding the brush that mirrors beauty,"[27] this mimesis debases and objectifies the form it reflects. Usually identified as the woman's "lover,"[28] the male attendant's evident servility calls forth the conventions of Petrarchism, whose standards of female beauty pervade the period's cosmetic culture and female portraiture alike. Titian is concerned, however, not only with Petrarchism's ideals of beauty but also with its

construction of femininity by means of masculine vision. Although the woman dominates the scene, in a visual parallel to the dominance granted to the Petrarchan *donna*, the presence of the attendant reminds us that the female beloved is rendered silent by the male poet's praises and that the poetic blazon's enumeration of her beauties effects her fragmentation and objectification.[29] A visual equivalent of the blazon, Titian's painting both displays and disappears the female subject: his aggressive *impasto*, like the male attendant's pose of servility, imposes upon the woman the defining gaze of the cosmetic culture and associates her fleeting beauty with sexuality, transience, and death. As such, the insidious attendant recalls the common charge of anti-cosmetic invectives that painting is the invention of the devil. As Tuke summarizes the claim, "the Ceruse or white Lead, wherewith women use to paint themselves was, without a doubt, brought in use by the divell . . . therewith to transforme humane creatures, of faire, making them ugly, enormious and abominable . . . O hellish invention, O divelish custome."[30] Illustrations accompanying anti-cosmetic invectives sometimes depict painting women attended by demons or by Satan himself,[31] a notion personified in Guido Cagnacci's *Martha Rebuking Mary for Her Vanity*, now in Pasadena (fig. 23), in which, behind the now-reformed saint, an angel drives out the demon of feminine Vice.[32] Cagnacci's allegory renders visible the duplicities—of both the demonized painting woman and her seductive companion—implicit in Titian's painting, while his narrative of redemption emphasizes the lost opportunity memorialized in Titian's work, the hint of a Magdalenesque conversion that is, as yet, unrealized.

In Bellini's and Titian's paintings the deployment of twin mirrors initiates and enables dialogic relationships that pointedly exclude their female subjects. Melchoir-Bonnet argues that, through the "introspective and mimetic" view of the mirror image, "the individual could define himself as a subject." She explains, "By consistently reengaging the subject in a dialectic of being and seeming, the mirror appeals to the imagination, introducing new perspectives and anticipating other truths."[33] Representing multiple views of the female form, noting the continuities and the distinctions between being and seeming in their painted mirrors and the "realities" they reflect, Bellini and Titian engage in the *paragone*, the ongoing dialogue between painting and sculpture. Moreover, as they exploit the affinities between the face painting and the art of painting, their images situate their creators in proximity with the objectified female form. Thus, Bellini's signature is included on the *cartellino* beside his nude, "suggesting the actual presence of the painter in the scene,"[34] while Titian figures his creative sovereignty

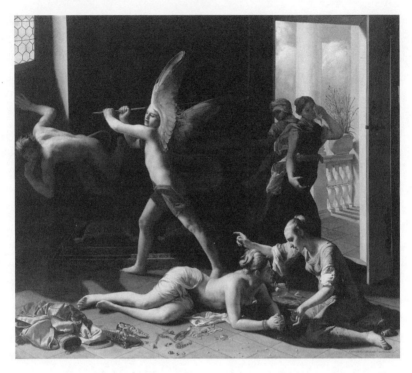

Fig. 23. Guido Cagnacci, *Martha Rebuking Mary for Her Vanity* (after 1660). Norton Simon Art Foundation, Pasadena, California, M.1982.5.P.

over his woman in the guise of the male attendant who assists her toilette. While each painter explores productive correspondences between his work and its subject, and between the work and the cultural conventions from which it emerges, each deprives his female subject of interiority, or, more correctly, each provides for her an imagined essence—the purity of Bellini's bride, the decadence of Titian's beauty—grounded in the assumptions of the early modern cosmetic debate. Caught within the two mirrors by which she is transfixed, the painting woman sees herself, fragmented and objectified, in an infinitely recessive series of reflections that bounce between the specular surfaces.

Bellini's and Titian's twin mirrors provide an emblem of the dialogic construction of the subject imagined by feminist writers, such as Elizabeth Cary, and illustrate the means by which the cosmetic culture curtails that subjectivity for those whom it governs. For Cary the challenge posed by the cosmetic culture is to describe how the multiple perspectives available to a woman in dialogue with

internalized authorities, her ongoing negotiations between being and seeming, can affirm the existence and authority of her conscience and thus of herself.

The Life of Lady Falkland, written by one of Elizabeth Cary's daughters, contains a scene of Cary at her toilette that asserts her use of embellishments as an act of wifely obedience: "Dressing was all her life a torture to her, yet because [her husband] would have it so, she willingly supported it, all the while that she lived with him, in her younger days, even to tediousness; but . . . [never] was her mind the least engaged in it, but her women were fain to walk round the room after her (which was her custom) while she was seriously thinking on some other business, and pin on her things and braid her hair; and while she writ, or read, curl her hair and dress her head."[35] As critics have recently noted, the episode underscores Cary's awareness of the distinction between conscience and custom in terms that, on the one hand, reflect Catholic defenses of "lawful equivocation" and, on the other, inform Cary's constructions of femininity in her closet drama *The Tragedy of Mariam*.[36] Post-Reformation discussions of conscience share with the texts of the cosmetic debate a reliance on the belief that one's inward state can be gauged by outward appearances and an awareness that another's mind can never be fully known and that appearances can easily be made to deceive. This tension between being and seeming pervades the interrelated concerns of Cary's play with women's licit and illicit painting, the scope and limits of wifely obedience, and the moral and immoral uses of verbal and visual equivocation. In the *Tragedy of Mariam* the contradictory demands of custom and conscience inform the characterizations of Mariam, "a precious mirror made of wonderous art," as Herod calls her, and her mirror image and opposite, the "custom-breaker" Salome.[37] As Bellini's and Titian's images of painting women respond to the dual legacy of the literature on cosmetics in different ways, Cary's Mariam and Salome are joined and defined by the twin strands of this tradition, constituting, in Margaret Ferguson's words, "two aspects of a complex, indeed profoundly equivocating, whole."[38] The anti-cosmetic view of women's painting as diabolical is embodied in Salome, in which, nevertheless, the simple correspondence between a woman's painted face and her corrupt moral character is troubled by her ultimate success in the play. If Salome is a version of Titian's painted beauty, Bellini's chaste, obedient, but problematically painting wife is reflected in Mariam, in whom Cary attempts to reconcile the countenance with the conscience. Salome presents a troubling allegory of feminine vanity, while Mariam

struggles toward subjectivity based upon a sovereign conscience that would control the body's appearance, if not its ultimate fate and meaning.

Asserting the difficulty in judging women's characters on the basis of appearances, Gauden's pro-cosmetic speaker notes: "*Tamar* an harlot will dress her self with the vail of modesty as well as chast *Rebekah*. The wanton and cunning woman . . . decketh her self to all extern advantages, applieth with all amorous civilities, *perfumeth* her bed and chamber, pretendeth great love" (37–38). This image of a woman who veils her sin with craft aptly describes Salome. Despite her checkered career and manifest duplicity, she is able to maintain her status in the public sphere and her influence over her brother, Herod. As part of Cary's exploration of the tension between a woman's "public voice" and private thoughts (1.1.1), both Salome and Mariam engage in a series of soliloquies, with different effects.[39] Salome's soliloquies, in which she lays forth her hidden motives and machinations, represent her as a stereotypical Machiavel and cast feminine duplicity as a function of her face. " 'Tis long ago," she admits, "Since shame was written on my tainted brow" (1.4.282–83), and later adds, "But shame is gone, and honour wip'd away, / And Impudency on my forehead sits" (1.4.294–95). Salome's inability or refusal to blush recalls the harlot chastised in Jeremiah's invective, "thou hadst a whore's forehead, thou refusedst to be ashamed" (Jer. 3.3), a passage often quoted by anti-cosmetic polemicists: as Rich recalls it, "the Prophet Jeremie tearmeth to be gracelesse, the Forehead that is past shame and cannot blush."[40] It is precisely the vexed relationship between feminine being and seeming to which anti-cosmetic invectives, and *The Tragedy of Mariam*, repeatedly return. Thus the Chorus claims,

> 'Tis not enough for one that is a wife
> To keep her spotless from act of ill:
> But from suspicion she should free her life,
> And bare herself of power as well as will. (3.215–18)

Cary anticipates the cautionary wisdom of Tuke's *Treatise Against Painting*, in which the suspicion of painting's artificial blush, which "undermines and makes unreadable supposedly 'natural' distinctions . . . between modest and immodest women,"[41] glosses Salome's "Impudency." "It is not enough to be good," Tuke insists, "but she that is good, must seeme good, she that is chast, must seeme chast . . . she that is modest, must seeme to bee so, and not plaister her face, that she cannot blush upon any occasion (though she would) so as to be discerned of

another."[42] Constabarus, too, adopts the commonplaces of anti-cosmetic invectives when he calls Salome

> a painted sepulchre,
> That is both fair, and vilely foul at once:
> Though on her outside graces garnish her,
> Her mind is fill'd with worse than rotten bones. (2.4.325–28)[43]

As Salome's personification of the vicious painting woman exposes her to the condemnations of painting permeating Cary's culture, the biblical sources of this critique strengthen the links between seventeenth-century England and the proto-Christian Palestine of the play's setting.[44]

In exploiting the rupture between appearance and truth, Salome is the quintessential creature of custom, mimicking modest women's behavior and mirroring the desires of her male governors in order to work her own will. Her self-declaration as "custom-breaker" proceeds (1.4.309), as Karen Raber notes, "in the name of radical selfishness which exactly mirrors her brother's self-interested irrationality."[45] As Salome assumes the power to break and re-create custom, and to re-create herself in its image, she manipulates the slippage between inner and outer selves that plagues anti-cosmetic polemicists, and she underscores the intersection of customary practice with this troublesome duplicity. When Thomas Draiton concludes of the painting woman, "shee's a Mimique, and can make good faces," he expresses an anxiety shared by the men of Cary's play about the difficulty of gauging a woman's mind by her face.[46] Moreover, Salome's appropriation of custom reflects the centrality of the concept to Reformation debates on religious imagery, in which Protestant rejections of idols parallel the castigation of women's painting and Catholic defenses of images prefigure later vindications of cosmetics. Thus, Henry Hammond claims that idolatry is a result of "long popular, nationall, oecumenicall custome,"[47] while Nicholas Sander justifies religious images according to "the universall custome of the Church."[48] As Salome "show[s] her sex the way to freedom's door" by challenging men's customary privileges (1.4.310), and therefore their authority, she also usurps the creative sovereignty that the discourses of iconoclasm, like those of cosmetics, reserve for God alone. Her self-creation, like that of the painting woman, "impudently *outface[s]* God and man" (Gauden, *Discourse of Artificial Beauty* 6).

Salome's manipulation of custom also resonates with early modern discourses

of conscience. In the period of the play's composition both Catholic and Protestant clergy were increasingly engaged in sometimes conflicting projects of casuistry, the systematic application of general moral principles to particular cases.[49] As early as 1593, Phillip Stubbes complained that "there is no sinne so grosse, which is not blanched and smeered over with such counterfait colours,"[50] thus casting casuistry itself as a cosmetic art employed to flatter and deceive the conscience. The seemingly endless proliferation of probable resolutions to any given case fostered two theories of the conscience, each with attendant problems of its own.[51] In the first view enthusiasts maintained the absolute sovereignty of the individual conscience, guided by an innate certainty of the will of God, which necessarily remained unverifiable to outward authority. As William Perkins states the enthusiast position, "a man's conscience is knowne to none besides himself, but to God . . . and it is God onely that gives liberty to the conscience, in regard of his owne lawes."[52] This view was criticized as licensing subversion, particularly following the enactment of the Oath of Allegiance in the wake of the Gunpowder Plot and again at the Restoration, when Catholics and nonconformists invoked conscience as grounds on which to resist. As Perkins explains, "no man's commandement or Law can of it selfe, and by its owne soveraigne power, bind the conscience." Thus, he argues, "an Anabaptist that holdeth it unlawfull to sweare, sinneth if he take an oath . . . because he sweares against the perswasion of his Conscience."[53] Bishop Gauden himself published *A Discourse Concerning Publick Oaths* in 1662 (the same year that the second edition of his *Discourse of Artificial Beauty* appeared) that attempts to "answer the scruples of the Quakers" concerning the Oath of Allegiance by showing that they have "set up Idols in their own imaginations in God's place." "The will of God," he insists, "which is clear either in Right Reason or true Scripture demonstration,"[54] is sufficient to mandate conformity with the oath. Moreover, Gauden points to the difficult status of both progressive Protestant and Catholic conscientious objections when he states of the Quakers' "*Raptures* and *Enthusiasmes*," "God knows some suspect Jesuitick Arts [that is, equivocation] to be among them."[55] The alternative view of the conscience held that an individual's innate disposition toward truth was invariably deflected and perverted by custom. The vulnerability of the conscience to corruption by erroneous custom required the intervention of external authority—specifically that of the casuists—to guide it to God's will. Thus, Protestant casuist Jeremy Taylor maintains, somewhat counterintuitively, that "a conscience determined by the Counsel of Wise Men, even against its inclination, may be sure and right."[56] Eventually, the

acknowledgment that judgments of conscience may be intractably wedded to custom led, by the middle of the century, to an uncomfortable awareness of the relativism of moral judgments and skepticism as to the value and existence of any innate disposition to truth.[57]

In appropriating for women the right of divorce granted to men by Mosaic law, Salome claims, "I mean not to be led by precedent, / My will shall be to me instead of Law" (1.6.453–54). Since the custom against which Salome rebels is authorized by Scripture, her violation of custom also constitutes a refusal to conform her will to God's. As such, Salome offers a caricature of the enthusiast advancement of individual conscience: like the Quakers, according to Gauden, Salome sets up "an idol of the imagination" in substituting her will for God's law. Her break with custom—particularly as rationalized within the dramatic device of the soliloquy—externalizes the occult negotiations of the conscience with divine revelation that is the object of casuistry. By externalizing this process, Cary exposes and criticizes enthusiasm as an idolatry in which the individual's sovereign will usurps, rather than apprehends, divine law. Salome's affiliations with debased custom, moreover, reflect the problematic assault on conscience advanced as the raison d'être for casuistry, but her refusal to be ruled by any authority beyond her own will plays out the perversion of conscience by custom. Salome's casuistry is sophistry. Her innovation constitutes a perverse application of early modern approaches to conscience that, in another context, might enable a claim for the sovereignty of women's reason and discretion. Distorted by Salome's irrational will, her position becomes idolatry, the sin with which painting women are most commonly charged by anti-cosmetic polemicists.

The Tragedy of Mariam was probably written between 1603 and 1610, about twenty years before Cary's public conversion to Catholicism, which resulted in a bitter separation from her husband.[58] As a product of the first turbulent years of James I's reign, the play reflects the polemics surrounding the Gunpowder Plot of 1605 and responds to a crisis of conscience for Catholic recusants in England and an interpretive crisis for Anglicans precipitated by this event. A common feature of Catholic recusancy in the period was the practice of equivocation or mental reservation, which stated that it was permissible to lie, or equivocate, in some circumstances. Such a lie could be reconciled with the conscience by enumerating conditions under which the lie might be condoned or by mentally adding a qualifying phrase that would, technically, render the information true. Thus, for example, when "English Catholic priest John Ward was asked by his Protestant captors in 1606 whether he was a priest . . . he answered

no . . . by adding 'of Apollo.'"[59] The trial of Jesuit priest Henry Garnet, who was implicated in the Gunpowder Plot, exposed this "new art of lying," as Henry Mason terms it,[60] and prompted a series of anti-Catholic treatises that focused wide attention on the practice, particularly after the Oath of Allegiance was established in 1606.[61] Tellingly, the terms by which Protestant polemicists describe Catholic equivocators parallels those they apply to painting women: thus, Mason warns of their "forgeries . . . which seeke to cozen you with an hundred lying devises,"[62] while Thomas Morton compares the methods of equivocators with those of "certaine Apothecaries who painted upon their boxes of poison the titles of *Antidote or Preservatives against Poison.*"[63] Tuke makes the association explicit when he answers proponents of painting who argue that "the great Proctors of the Romish religione, do hold it lawfull, that in Spaine, where the Sunne beame doth swart their women; it should be permitted to them to paint, as conciliation of love between them and their husbands." He replies, "Surely it is a doctrine that doth well enough become the Jesuites, who, as they are the great Masters of lying, equivocation, and mental reservation, so doe they make no difficultie, to teach that it is lawfull to belie the face, and the complexion."[64] When Morton further describes equivocation as a form of "Machiavellisme,"[65] he suggests Salome's personification of this art in *The Tragedy of Mariam* and Cary's merger of verbal and cosmetic equivocation. Salome's manipulation of conscience in the service of craft embodies a demonized, feminized art of equivocation as a form of feminine painting. She represents Cary's response to the insidious aspects of equivocation so widely and vehemently criticized in the period of the play's composition (and which ultimately led Pope Innocent XI to ban the practice some seventy years later).[66]

While Cary thus inscribes within her play's villain the discredited practice of Catholic equivocation, she also explores, in her heroine, the potential grounds for a licit form of conscientious objection constructed on the freedom of the feminine conscience that might be more credible and more easily condoned. The two female leads are mutually implicated, however, by the vicissitudes of custom and conscience throughout the play. Because equivocation, like enthusiasm, insists upon a private relationship—an internal dialogue—between the individual conscience and God, it is as easily abused as enthusiast claims: Gauden's suspicion that "Jesuitick Acts" may inform Quaker resistance underscores the vulnerability of both Catholic and Protestant formulations of conscience. Moreover, because claims to conscience based upon equivocation and enthusiasm put "secular authorities into the role of spectators vouchsafed only a part of

the truth,"[67] they pose the same interpretive problem represented by women's painting. While Salome's vicious painting, both literal and metaphoric, exposes her to the censure of her male governors, it also ensures her success throughout the play. And, although these male commentators are at pains to distinguish between Salome's "tainted brow" (1.4.283) and Mariam's "purer cheek" (2.3.223), Mariam is ultimately charged with the same crime as Salome, on the same terms. When Salome claims that Mariam's "heart is false as powder" (4.7.430), she registers Cary's conflation of cosmetics and equivocation (by way of the topical allusion to the Gunpowder Plot)[68] in terms that echo those of Protestant commentaries on both arts. Herod's response, "nay, 'tis so: she's unchaste, / Her mouth will ope to ev'ry stranger's ear" (4.7.433–34), similarly imagines Mariam as the painting harlot and the equivocating Jesuit, since equivocation is, as Edward Coke writes, "a kind of unchastity."[69] Salome's equivocating descriptions of Mariam's cheek as "A crimson bush, that ever limes / The soul whose foresight doth not much excel" (4.7.401–2) and, a few lines later, as "fair, but yet will never blush" (4.7.405) implicate language as a means of painting falsehood and link equivocation to the female face: Mariam's cheek contains at once an entrapping bush and a deceitful blush. Doris, too, censures Mariam by adopting the common terms of the cosmetic debate when she claims that, despite Mariam's deceptive beauty, her "soul is black and spotted, full of sin" (4.8.575–76).

As manifestations of the twin aspects of the early modern cosmetic culture, both Salome and Mariam are defined by the conventional terms of that culture. Although Bellini's and Titian's treatments of painting women stress different aspects of the cosmetic debate—painting as a token of wifely obedience, on the one hand, and painting's debased associations with transience and death, on the other—both approaches render the female form an object defined and fixed by the masculine gaze. These twin aspects of the debate are articulated in *The Tragedy of Mariam* by Herod, whose Petrarchan hyperbole oscillates with his hyperbolic invective. When Herod enters the play in act 4, painting Mariam with the flattering excesses of Petrarchan praise ("Muffle upon thy brow, / Thou dark day's taper. Mariam will appear, / And where she shines, we need not thy dim light" [4.1.7–9]), the placement of the genre in the tyrant's mouth suggests that Petrarchism's objectifying poetics may themselves be a form of tyranny. This is clearly the case in cosmetic manuals, in which Petrarchan standards of beauty are often and enthusiastically embraced to instill in women the ideal beauty toward which they are encouraged to strive. Titian's *Young Woman at Her Toilette*, too, illustrates how the defining gaze of the Petrarchan lover fixes the

beloved object, robbing her of subjectivity as effectively as do cosmetic invectives. The vehemence of Herod's castigation of Mariam's falsehood is proportionate to the violence of his Petrarchan passion. Salome points out the irrationality of Herod's Petrarchism in terms that predict the irrationality of the death sentence he imposes on Mariam:

> Your thoughts do rave with doting on the queen.
> Her eyes are ebon-hued, and you'll confess:
> A sable star hath been but seldom seen.
> Then speak of reason more, of Mariam less. (4.7.453–56)

Despite Herod's effort to contrast Salome's "paintings" with Mariam's "praise," (4.7.463), he ultimately condemns Mariam as a "painted devil" and "white enchantress" (4.4.175–76), claiming, "A beauteous body hides a loathsome soul" (4.4.178), and lamenting, too late (and erroneously), "I might have seen thy falsehood in thy face" (4.4.219).

It would be a mistake, however, to see Mariam as an innocent victim of an equivocation introduced into the play by Salome and exploited by her brother—the dangers of listening "with ears prejudicate" of which the Chorus of act 2 warns (2.401). On the contrary, from its first lines the play explores Mariam's own hypocrisy, her recognition of a division between her inward state and outward show that accounts for her "wavering mind" (Chorus 1.498) throughout the opening acts and underwrites her martyrdom in the final scene. Mariam's self-consciousness about her duplicity marks her effort to assert the integrity of a unified self, whose unwavering substance does not depend upon the vagaries of superficial appearance. Her indictment of Julius Caesar's "deceit" (l.1.2) condemns the same trait in herself and associates it specifically with women in the pregnant pun "Mistaking is with us but too too common" (1.1.7). As the play proceeds, Mariam expresses her growing unwillingness to engage in the dissembling that would allow her, or her marriage to Herod, to survive. Greeting Herod in mourning garments, Mariam asserts a correspondence between her inner state and outward appearance: "My lord, I suit my garments to my mind, / And there no cheerful colours can I find" (4.2.91–92). Her realization in act 3, "Oh, now I see I was an hypocrite" (3.3.152), prefaces a reassessment of the practice of painting that relocates the art from the face to the heart:

> But now the curtain's drawn from off my thought,
> Hate doth appear again with visage grim:

And paints the face of Herod in my heart
In horrid colours with detested look. (3.3.157–60)

This internalization of painting, whose subject is no longer the woman's painted face but her husband's detested visage, places cosmetic discourses in a direct and urgent relationship with Cary's efforts to construct feminine interiority in the figure of Mariam. The image, while similar to Lanyer's image of the internalized Susanna in *Salve Deus Rex Judeaorum* (see chap. 4), suggests the internalization of patriarchal authority with which both the cosmetic debate and discourses of conscience are concerned. Although the Chorus will insist that wives must surrender their bodies as well as their minds to their husbands—"No sure, their thoughts no more can be their own" (Chorus 3.237)—the play probes the circumstances in which a wife's thoughts might legitimately remain hidden from her husband's penetrating gaze and the disastrous consequences when a wife does reveal her mind to a husband's harsh judgment. Liébault's replacement of the painting woman's conscience by that of her husband anticipates Mariam's internalization of Herod's tyranny. Yet Mariam's expression of her state of mind, her description of a dialogue with Herod's internalized authority, gestures toward the construction of female subjectivity as a matter of conscience. As a Catholic wife of a Protestant husband, moreover, Cary would have had intimate knowledge of the contemporary debate on the degree to which the conscience of a recusant wife could be considered subject to her husband's.[70] If the play stages, in Ferguson's words, "a debate about the 'duty'—incipiently, a 'right'— to resist 'lawful authority' if it degenerated into tyranny,"[71] it does so in terms of the discourses of cosmetics that permeate Cary's characterizations of her female protagonists.

Cary makes use of the soliloquy to stage Salome's demonized painting and to demonstrate, and thereby censure, the abuses of casuistry's imagined interactions between the conscience and internalized authorities. In Mariam's voice the soliloquy becomes an occasion to explore the dialogic relationship of conscience to the conventional discourses and customary practices defining women. Poised on the threshold between private thought and public speech, Mariam's soliloquies (like Cary's closet drama) hope "to stand above or outside the realm of equivocation,"[72] both verbal and visual. Thus, Mariam admits, "I know I could enchain him with a smile, / And lead him captive with a gentle word," but immediately she rejects these wiles, longing to project more accurately her state of mind in her face: "I scorn my look should ever man beguile, / Or other speech

than meaning to afford" (3.3.163–66). Indeed, when Herod pleads, "Yet smile, my dearest Mariam, do but smile, / And I will all unkind conceits exile," Mariam insists, "I cannot frame disguise, nor never taught / My face a look dissenting from my thought" (4.3.143–46). Despite her husband's desire that she feign marital bliss, Mariam stubbornly claims the right to align her visage with her thoughts. It is this insistence, in fact, that leads to Mariam's death. Herod's preoccupation with the problem of "female divisibility,"[73] the difficulty in distinguishing between a woman's being and what she seems to be, is harshly literalized when, as Nuntio bluntly states, Mariam's "body is divided from her head" (5.1.89). With this definitive cut Mariam's effort to reconcile her countenance and her conscience is violently curtailed.

Cary's closet drama positions its female subjects in direct and difficult relationships with the customs attending women's painting and the discourses of conscience in the period and exploits the disjuncture between women's inner states and outward shows not merely to demonize women's painting in Salome but also to indict, in Mariam's martyrdom, the larger culture in which this diabolical practice passes current. Thus, Salome's success, despite her exposure, doubles and destabilizes the monarchical authority that silences the resistant Mariam. Her defiance of internal and external authorities, including conscience, mirrors Herod's own erratic, illicit government.[74] In Mariam, meanwhile, Cary explores the distinction between being and seeming to stage her heroine's growing awareness of the demands of conscience and her ill-fated attempt to realize a feminine subjectivity as a matter of the mind. In a world in which men are both convinced of and obsessed by the inscrutability of women's faces, Mariam's assertions of her right to self-determination and self-creation—like those of her author—can only prompt the disapproval of her male governors. As Mariam struggles toward a subjectivity based on the sovereignty of female conscience, Cary reveals, and thereby challenges, the gender constructions that would alienate a woman's body from her mind.

In Counter-Reformation Italy the creation of the female subject by means of her dialogic engagement with internalized authorities is illustrated in the conversion of Mary Magdalen, a woman imagined as an "example and . . . mirror" for penitent Christians of both sexes and for fallen women in particular.[75] Orazio Gentileschi's *Conversion of the Magdalen*, now in Munich (fig. 24),[76] dramatizes the New Testament episode in which, during Christ's visit to the home of Lazarus, Martha rebukes her sister for her neglect of housework and the Savior

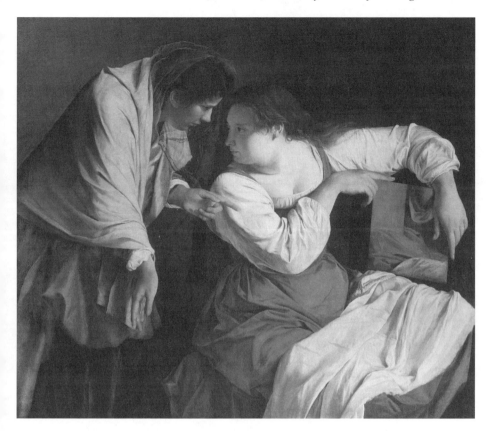

Fig. 24. Orazio Gentileschi, *Conversion of Mary Magdalen* (c. 1613–15). Bayerische Staats-gemäldesammlugen, Alte Pinakothek, Munich.

takes Mary's part: "Martha, thou art careful and troubled about many things: But one thing is needful: and Mary hath chosen that good part, which shall not be taken away from her" (Luke 10:41–42). Orazio follows convention in distilling the narrative into the concise moment of Mary's conversion,[77] her turn away from the vanity of her former life of sin and toward the perennial penance that will mark her retreat to the hermitage of Sainte Baume, where, according to medieval legend, she ends her days.[78] Early modern commentaries on the story cast Martha as emblematic of the active life and Mary as an allegory of contemplation; thus, Martha is associated with the outer person, while Mary symbolizes the inner self.[79] Accordingly, the mirror from which Mary turns her attention in Orazio's canvas carries traces of the object's traditional deployment as a

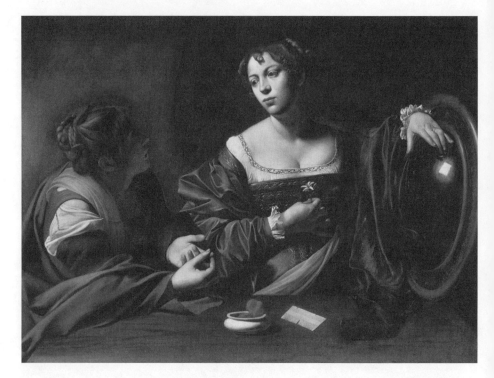

Fig. 25. Michelangelo Merisi da Caravaggio, *The Conversion of the Magdalen* (1597–98).
Gift of the Kresge Foundation and Mrs. Edsel B. Ford. Photograph © 1984 The Detroit Institute of Arts.

symbol of feminine vanity but also understands self-reflection as a spiritual and intellectual undertaking,[80] as do techniques for examining the conscience influenced by Saint Ignatius of Loyola's *Spiritual Exercises*.[81] The image seeks to effect in the spectator a spiritual response similar to that implied in the figure of Magdalen: the contrition that is the first step toward penance.[82]

Orazio's composition is indebted to Caravaggio's *Conversion of the Magdalen*, now in Detroit (fig. 25), in which the parallel between the art of painting and women's face painting, latent in Orazio's image, renders the mirror an over-determined symbol of artistic virtuosity, feminine vanity, and spiritual self-reflection. In Caravaggio's handling, a convex mirror such as that included in Titian's *Young Woman at Her Toilette* accompanies the painting woman, her toilette characterized by the *sponzarol* and ivory comb laid forth on the table. Martha's presence, however, qualifies the usual associations of the woman's toilette with vanity and merges the image's material and spiritual meanings. Is the

mirror from which Magdalen turns to address her reproving sister a symbol of vanity or of penitential contemplation? Has Mary been interrupted before or after the moment of her conversion? The conversion of Orazio's Magdalen, like that of Caravaggio's, is implied rather than performed—intimated by the surface of things but essentially an unseen occurrence. The dialogue between Martha and her sister externalizes and literalizes the conversation implied between Magdalen and her polysemous mirror.

Unlike Caravaggio, Orazio refuses the distortion of the convex mirror and represents his looking glass as a simple square pane, turned not toward Mary but toward the viewer. He locates the viewer in a precise relationship to the scene by depicting within the pane that parcel of mirrored reality visible only from this vantage point. Thus, the mirror comments on the art of painting, offering "a simile of Caravaggesque painting as the mirror of nature" and a tour de force that celebrates Orazio's virtuosity.[83] It is a triumph of artifice that, paradoxically, guarantees and valorizes the truth of appearances. Orazio's mirror argues that the surface of things—mere appearances—are in fact reliable indices of the hidden truths beyond. The image thereby vindicates the art of painting by emphasizing its function, like the mirror's, as a tool for spiritual self-examination, a *Biblia pauperum*. Orazio's Counter-Reformation painting promises a clear, accurate reflection of the physical world that serves as a metaphor for the undistorted spiritual truth attained in the sacrament of penance and in individual contemplation. Like John Brinsley's *Looking-Glasse for Good Women* (1645), Orazio depicts his Magdalen, and her mirror, as a "*Glasse*, which represent things as they are," insisting that his "*Intentions*, in holding forth this *Glasse*," are, like the object itself, "*sincere* and *candid*."[84]

Orazio's *Conversion of Mary Magdalen* dates from period in which the popularity of penitential saints bespeaks a new emphasis on the individual conscience in Counter-Reformation spirituality—one that parallels an analogous development in Protestantism.[85] This reorientation redeems and reimagines the painting woman, Mary Magdalen, as a symbol of contemplation and contrition. A similar reformation occurs within debates on cosmetics in the period. Gauden's *Discourse of Artificial Beauty* shares with Baroque depictions of Magdalen's conversion a faith in the power of dialogue to effect change:[86] thus, the text offers a dialogue between two women, one pro- and one anti-cosmetics, in which the latter becomes "a chearful Conformist" to "the exacter rules of Reason and Religion" revealed by the painting woman (262).[87] Gauden's pro-cosmetic interlocutor undertakes a revisionist exegesis to defend painting through biblical prece-

dent. Marshaling "Scripture-instances which mention *painting* or *colouring* the eyes, among other customary ornaments of those times and places, but with no token of God's dislike" (41), she counters the Old Testament commonplaces advanced by anti-cosmetic polemicists to legitimize painting for use by English-women. For example, in answering the claim that Jezebel's fate proves painting to be "flatly against the Word of God" (7), the speaker maintains (citing her guid-ance by an "excellent Bishop . . . of great judgment and sober piety" [9]—one imagines Gauden himself) that Jezebel's painting was an incidental "after-act." Thus, "it is an horrible wresting of Scripture, to make every recited circumstance in any place to bear the whole weight of the story and event" (14). She vindicates custom in general, and painting in particular, by insisting that "God would have explicitly forbid painting . . . if he'd wanted it to be presented as abominable to him as Idolatry, Theft, Murder, and Adultery, which some men have passion-ately, but very impotently pretended" (27). Echoing the Anglican position that images are indifferent, Gauden's speaker asserts that "Private mens opinions may not charge the Soule with sin in things of outward use and fashion, where Scrip-tures and Councils are silent" (154). Accordingly, "where there is "no *adulterous* intent or evil thought in the heart," she reasons, women may employ cosmetics with "a pure heart, faith unfeigned, and a good Conscience" (54).

Implicit in this referral of moral judgments on customary practices to the standard of individual conscience is a radical challenge to the assumed corre-spondence between internal state and external show on which anti-cosmetic invectives proceed. If a woman's conscience is the final arbiter in determining the morality of painting, the possibility of gauging her character on the basis of external evidence is entirely undone. Moreover, while common sense suggests that *some* painting women may, in fact, be morally suspect, they will necessarily be unidentifiable through outward appearance, which they may easily manipu-late. The speaker affirms this, with an allusion to the reformed rejection of rit-ual confession, when she states that men cannot know which women use cos-metics, "unles they were made womens Confessors, which I believe few are in this case" (4). Although the Scriptures occasionally mention painting as "the practice of wanton & imperious women," the speaker admits, we nevertheless must not conclude

> that only such women did then use those things, who are alwaies so cunning, as not
> to render themselves notorious by any such outward differences from grave and
> sober women (as they say the common curtizans of Rome are commanded to do,

for distinction sake:) But rather you must conclude that wanton women did cast themselves in the same outward mould or civil garb and fashion wherein persons of honour and good repute appeared . . . For sin is generally so apishly crafty, as to hide it self under the colours and masks of goodness and honesty. (20–21)

Rather than advertising her wantonness, the vicious painting woman mimics the chaste cosmetics common in her culture. The mask of painting, thus construed, is utterly impenetrable. All appearances, all customary practices, are ciphers inviting speculation but frustrating certain knowledge of the practitioner's mind and soul hidden within.

In granting sovereignty to the woman's conscience to determine what "conform[s] to the divine mind, or will; which must be the only touchstone of sinne and test of Conscience" (42), Gauden participates in the post-Reformation debate on the nature of conscience, which grew increasingly urgent around the Restoration in 1660.[88] His treatment of cosmetics as a case of conscience responds to a perceived need for a Protestant casuistry to counter and correct the vast body of Catholic casuistry whose guilt by association with probabilism and Jesuit practice rendered it suspect.[89] If Catholic casuistry appeared to Anglicans as a kind of fraudulent painting, the painting woman of Gauden's *Discourse* dares "to contend in a case of Conscience with . . . Reformed Divines" (232). Although she begins her defense of painting by calling forth the authority of a clergyman to support her views, this gesture occurs only once, in answering the first of the dialogue's thirteen objections. Quickly, the speaker relies upon her own discretion to demonstrate that "God hath given both Reason and Scripture"—the only grounds, she maintains, upon which cases of conscience can be decided—"to women as well as men; nor have we less liberty granted to traffick in all truths both humane and divine" (236).

Certainly, the traffic in truths is a problem at the heart of both Catholic and Protestant casuistry in the period. By mid-century, as Patricia Crawford has argued, "the dangers of using individual judgment as a guide to public duty were widely apparent. By the end of the seventeenth century, educated men were suspicious of conscience as a guiding principle."[90] Henry Hammond's *Of Conscience* (1656) defines "that specious venerable name of *Conscience*" as "Phansy, humour, passion, prepossession, the meanest worldly interest of the ambitious or covetous designer, like the Calves, the Cats, the Crocodiles, the Onions, the Leekes, of *Egypt*."[91] While Gauden's *Discourse of Artificial Beauty* seems to embrace an enthusiast rejection of external authority and elevation of the individual conscience, his

treatise on oaths condemns the Quakers' enthusiastic "idols." This intertextual dilemma is replicated within his *Discourse Concerning Publick Oaths* itself: although Gauden relies upon Right Reason and Scripture to qualify enthusiast claims, his editor offers the more pragmatic view that the "true Religion" is, in effect, the most convenient one, "established by publick consent and Law, as *best* and *fittest* for the Nation."[92] As for reason, as Jeremy Taylor puts it, "reason is such a box of quicksilver that it abides no where . . . it is like a dove's neck, or a changeable taffeta; it looks to me otherwise than it lookes to you, who do not stand in the same light that I do."[93] Reason and religion themselves may be mere custom.

Accordingly, *A Discourse of Artificial Beauty* conflates casuistry with custom: the speaker maintains that "no *Casuist* is sufficient to enumerate or resolve the many intricate niceties and endless scruples of Conscience which some mens and womens more plebian *Zelotry* makes, about Ladies *cheeks* and *faces*" (83). In this conflation Gauden anticipates John Locke's claim that one's innate awareness of truth is itself the product of custom and education.[94] Faced with radical relativism, Locke argues for a technique of "suspension and examination" by which the individual submits the variety of probable truths to the criterion of Reason.[95] Similarly, in submitting the case of cosmetics to the standard of Reason, Gauden offers his text as "an impartial glass" wherein the conscience weighs the reasonable evidence for and against painting (A3). Thus, the speaker dismisses the commonplace that makeup is the invention of the devil by showing that it is not proved "by reason or authority" but by "old fabulous fancy." "What sober person can dote so farre as to allow any such monstrous fictions," she asks (163–64). Guided by reason, she undertakes an all-out assault on the "outcries and clamors. . . lightnings and thunders . . . *Anathemas*, excommunications and condemnations . . . of many angry . . . preachers and others, who are commonly more quick-sighted and offended with the least mote they fancy as adding to a Ladies complexion, than with the many Camels of their own customary opinions and practices" (82). "Many women," she insists, "have been more scared then convinced, more distracted with scruples and terrours then satisfied with truth" by such invectives (5). To illustrate the follies of anti-cosmetic polemics, she cites "a witty and eloquent Preacher, whom we both heard at *Oxford*, who speaking against (not the absolute *use*, but) the wanton *abuse* of womens curiosities in dressing and *adornings*, instanced in *Jezebel's* being *eaten up of dogges*; as shewing, saith he, that *a woman so poluted and painted was not fit to be mans meat*" (87).

At issue, ultimately, in the painting woman's challenge to anti-cosmetic polemicists in Gauden's dialogue is a defense of a reformed understanding of con-

science, starkly contrasted with the illicit and unhelpful interventions of Catholic casuistry. Responding to the familiar warning "that no *painted face* shall see the face of God," Gauden's speaker claims that the "blind thunderbolts" of anti-cosmetic invectives emerge from "Papal authority or popular facility" (244): thus, the traditional claim that painting is a popish practice is overturned by Gauden's female speaker. She urges, "it is time for us at length to get beyond that servility and sequaciousness of Conscience, which is but the Pupilage, Minority, and Wardship of Religion, inquiring and heeding, not what saith the Lord, but what saith such a Father, such a godly man, such a Preacher or Writer." "Our Reformed Religion," she adds, "is redeemed from the slavery of mans private Traditions, and confined to the oracles of God; whose general rule [does] agree without any enterfearing with the holy Scriptures" (236–37). Not surprisingly, when the anonymous, but clearly Catholic, author of *Primitive Christian Discipline* publishes a critique of the *Discourse* in 1658, he attributes authorship to "*Doctor Patch the Devils Procuratour General*" and brands him a "*Libertine.*"[96] If we grant, as Dr. Patch does, "*the freedome of every one, whose vertuous or vitious minds best resolved the lawfullness or unlawfulness of them in particular Cases of Conscience,*" he laments, "then farewell all *Religion.*"[97] Against Gauden's "shuffling"— for this author a reformed brand of equivocation—he offers the fervent hope that "sufficient *Casuists* and more, as such eminent *Prelates*, and truly pious *Pastours of Soules*, with all prudent discretion, be not willing then to be deceived, either thus, or by the *Custom* of modest womens pretended use."[98] And he concludes, "this most divine and tender premonition [conscience] ties us to the Catholick Church, as infallible in all Cases; to this end, ever to bend our eyes upon her."[99]

Any measured discussion of *A Discourse of Artificial Beauty* must consider the possibility that the male-authored work may, in fact, have been written as a ventriloquized tour de force in which Gauden assumes the female voice engaged in a casuistic defense of the famously ostracized practice of painting in order to debunk casuistry itself as sophistical and self-serving. Rather than empowering the female voice, in other words, the treatise would capitalize on the unreliability of the female speaker in order to expose and censure casuistry's fallacious flexibility. This possibility would seem to be supported by the implications for women of the growing suspicion of claims of conscience by mid-century. This intellectual shift, as Crawford explains, "disadvantaged the ways in which the workings of female conscience were viewed. Since women's judgment and knowledge were widely thought to be weak, there was less tolerance of their pleas of conscience when it was no longer an innate, natural, and human quality. The

difficulty over allowing pleas of conscience to justify female insubordination were one reason why political thinkers modified their views."[100] *The Looking-Glasse for Good Women*, for example, reflects this growing sense of women's frailty when Brinsley imagines that his female readers "may here see more of *Satan*, and *your selves*, his *wiles*, your *weaknesse*, then before you were aware of . . . some *spots* and *blemishes* discovered, not becoming the *face of profession*."[101] Whether or not this antifeminist ventriloquy can be imagined to be Gauden's original motive, however, later cosmetic manuals vindicate the art on Gauden's terms, explicitly citing his authority.[102] Moreover, his publisher's address "to the Ingenious Reader" clearly displays his willingness, and by implication that of his readers, to take Gauden's female speaker at face value. The epistle begins by distinguishing between the "ornamental toyes" proper to women and the "gravity and sobriety" proper to men but quickly discounts this standard formula of the cosmetic culture to espouse a reliable correspondence between the countenance and the conscience. Thus, he claims that, although the subject appears "but skin-deep and superficial," the text nonetheless offers "a profound and notable case of Conscience" (A2v). This correspondence, however, must be taken on faith: it requires us to place our trust in an apparently unreliable witness, the painting woman—to rely upon her conscience to determine the matter and her rational capacity to apprehend the truth.

Yet Gauden stops short of licensing his female interlocutor to engage in any and all subjective interpretations of Scripture and customary practice. Although he constructs the woman's voice on the basis of a sovereign individual conscience, he nonetheless understands conscience to be at once an internal and an external force. His speaker offers a metaphor for this dialogic construction of subjectivity when she compares the conscience governed by "Fancy or Opinion" to "Puppets [moved] with gimmers," while that governed by "Reason and divine revelation" moves, she says, "as the Body doth by its living Soul" (43). Rather than creating the female subject as a puppet through which the voice of patriarchy is cast, *A Discourse of Artificial Beauty* suggests the complexity of a woman's negotiations with internalized authority and emphasizes discrimination as the demand made upon the subject. Thus, Gauden's speaker insists that painting, rather than staging "a rebellion of affections against judgement,"[103] reveals women's "prudence and discretion" (70). "In the ingenuous use of *colour* and *complexion* of the *face*," she affirms, "there may be the *wisdome of the serpent*, without the least of its poison" (65–66).

Regardless of Gauden's motives, then, his text is remarkable in the degree to which it displays strategies for feminine self-representation also adopted by women writers and artists in the period. The female subjectivity toward which Cary's Mariam struggles is realized in Gauden's painting woman. It is achieved through the dialogue's advancement of her discretion, grounded in conscience, as she reinterprets the exegetical tradition that condemns women's physical and moral frailties. Confronted with the objection that, as "the weaker vessel, of greater frailties and less capacity," she should not contradict "those many worthy and famous men" who condemn painting, the speaker insists, "I do not less willingly own my weakness then my Sex, being farre from any such Amazonian boldness," but nonetheless affirms her ability, "by answering specious fallacies and producing stronger arguments . . . [to redeem truth] from that long captivity wherein both it self and many worthy persons consciences were unjustly detained" (235). Like a sanctified Salome, the speaker shows her sex the way to freedom's door. Like Elisabetta Sirani, Artemisia Gentileschi, and Aemilia Lanyer, she deploys the examples of biblical heroines to authorize her challenge to masculine authorities.[104] And, like Marguerite de Navarre, she imagines outward appearance as a garment that does not alter the internal substance of the soul: thus, "a little quickness of *colour* upon the skin . . . alters not the substance, fashion, feature, proportions, temper or constitutions of nature" (56). Painting is "like the *feathers* and colours of the *Dove*, which adde nothing to its internal innocency, but something to its outward *decency*" (112–13). She returns, as does Marguerite, to Christ's dictum in Matthew 25, "we cannot make one hair of our head white or black," to defend the argument that "all *dyes* and *tinctures* do but alter the outward form of colour, by hiding what is native, for an internal and (by us) unchangeable principle, which is out of the reach of Art" (99). Voicing— in a unique moment in the history of the cosmetic debate—the point of view of women confronted with the paralyzing standards of beauty that they are expected to meet, the speaker states, "nor may the least suspicion of pride fall upon many women who while they modestly use *help* to their *complexions*, are the more humbled and dejected under the defects they find of native *beauty* or lively *colour*" (129). By constructing the female subject on the contested and shifting ground between inward state and outward show, Gauden's dialogue holds forth the potential for authorizing traditionally silenced female voices and echoes the voices of women writers engaged in the same project. Tellingly, early editions of the work identify its author not as a bishop but as a woman: the publisher thus

asserts that "a Woman was not onely the chief occasion" of the treatise "but the Author and Writer" (A2). It was not until thirty years later that the dialogue was attributed to "a Learned Bishop."[105]

This shift in attribution parallels a shift in addressee, from "the Ingenious Reader" in the original edition and the 1662 reprint (A2) to "All the Fair Sex" in 1692.[106] These changes between the editions suggest changing attitudes toward women's authorship and publication and toward their cosmetic self-creation in the second half of the century. The promise of the earlier editions to move from the superficial to the substantive (that is, from the "skin-deep" question of cosmetics to the "profound" case of conscience) asserts that, despite the assumed superficiality of the female speaker herself and the triviality of her subject, "Ingenious" readers of both sexes—readers who value wit and innovation, in all of its senses—will find both pragmatic advice and spiritual profit in the words of a woman. By 1692, however, the distinction between women interlocutors and their male author (a Learned Bishop) is clearly articulated, and the audience for the text is restricted to women only. In the place of the dialogic interplay between female speakers that reflects and parallels the sovereignty granted to the female conscience in the earlier edition, the later text emphasizes the artificiality of the dialogue form and exacerbates the division between women and their male advisors and governors. Accordingly, the Dedicatory Epistle reiterates the essentialist insistence that painting is an act of wifely obedience when the author, C.G., writes, "'Tis my Opinion that Painting the Face is not only lawful, but much to be commended; nay, absolutely necessary . . . Woman was made and designed by Heaven for the Pleasure of Man, and if so, certainly 'tis her business, and part of her duty to endeavor to contribute to that End, for which she was created."[107] As objects of admiration by men, women are exhorted to "Improve . . . the Beauties Heaven has bestowed upon you, and preserve them as long as you can; for I can see no Reason why the cultivating Outward Form should be a Crime, since the Improvement of Inward Grace is a Vertue, and a Duty."[108] The increasing social acceptance of women's (and men's) face painting by century's end isolates the voice of Gauden's female interlocutor, allowing her to address women only on a feminine subject of little importance, too trivial to be of interest to men. Relegated to the realm of women's entertainment (and with women themselves described as entertainment for men), the later edition forecloses on the powerful female speaker who reasons out and persuasively articulates Gauden's case of conscience. While Gauden authorizes his female speaker by undermining the discernible link between her conscience and behavior—that is, by granting

women the power to determine appropriate behavior on the basis of the unob-servable mandates of private thoughts—C.G. simply conflates Outward Form and Inward Grace: the female body, like the female mind, is decorative rather than functional.

Nonetheless, Gauden's original text enacts and displays the basis on which female subjectivity can be constructed through the dialogic engagement of the conscience with internalized authorities in ways that parallel those undertaken by female artists and writers in the period, both in Anglican England and Catholic Italy. Artemisia Gentileschi's *Mary Magdalen*, in the Pitti Palace, Flo-rence (fig. 26),[109] shares Gauden's deconstruction of the assumed connection between the painting woman's inward state and outward show and does so in terms that, similarly, valorize feminine discrimination, self-creation, and self-determination. With one hand Magdalen pushes away the mirror in which her distorted profile can be gleaned, while with her other she clutches her breast in a gesture of contrition. While Artemisia's Magdalen appears alone,[110] the paint-ing bears the trace of the absent interlocutor, Martha, in the gilt inscription on the mirror, "*Optimum partem elegit*," "she chooses the better part." On the back of the chair the artist's signature appears in the same gold lettering.[111] Beside the mirror a skull associates Mary's reflection in the mirror with the *vanitas* tradi-tion.[112] Her alabaster ointment jar appears at her feet, identifying this woman as the saint—who might otherwise be merely a Florentine noblewoman—but also suggesting her imminent disregard for the accoutrements of the lady's toilette, a forgotten token of (soon-to-be) rejected luxuries.

Like Caravaggio, Artemisia engages contemporary notions of women's paint-ing in the figure of Magdalen, who is simultaneously sinner and saint and who, like her signature attribute, the pyx, refers both to the indulgences of the flesh and their rejection in the moment of conversion. Like her father, Artemisia meditates upon the art of painting in the image of the mirror. Thus, she merges painting in both of its senses, with novel implications for the female artist and her work. Artemisia's mirror is neither a symbol of the Caravaggesque realism, nor is it an emblem of self-reflection. It remains the distorted glass of custom, even as her Magdalen is an emblem of contemporary custom, adorned, jeweled, coiffed, and painted according to the fashions of seventeenth-century Florence. The figure's opulence has led Mary Garrard to argue that the image "seems mired in an iconography that stigmatizes female sexuality . . . [through] the asso-ciation with Luxuria and Vanitas, linked types that merge female erotic beauty with transience and mortality."[113] The painting would thus share the point of

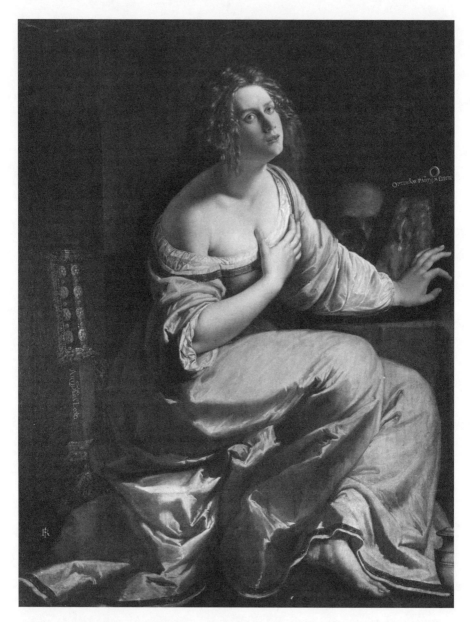

Fig. 26. Artemisia Gentileschi, *Mary Magdalen* (c. 1615–16). Galleria Palatina, Palazzo Pitti, Florence, inventory no. 142. Alinari/Art Resource, New York.

view of anti-cosmetic polemicists, who condemn women's painting as an index of feminine pride.

When read in light of works such as *A Discourse of Artificial Beauty*, however, a different meaning emerges. By casting Magdalen so thoroughly as a creature of custom, the painting valorizes an *internal* process and act of conversion—the subtle, almost imperceptible transformation wrought in Magdalen's soul as a result of gazing upon her *own* reflection in her mirror. With the mirror's inscription Artemisia relocates the drama of conversion within the individual soul: Christ's dictum now moralizes and decorates, without wholly revising, the conventional image of *vanitas* and stresses the radical division between inner state and outward show.[114] Like Marguerite de Navarre's allegorical glass (see fig. 15), Magdalen's inscribed mirror serves as a material emblem of the individual's complex negotiations with internalized authorities through which early modern subjectivity is constructed. The result is not to suggest a conversion that has already taken place but to imply a continual choice, an ongoing election, made by this woman on the basis of conscience alone. As in Gauden's *Discourse*, the body in this image is no longer the mirror of the soul. Despite the trappings of conventional beauty and customary luxury, Mary Magdalen here experiences a spiritual conversion—perhaps for the first time, perhaps as a daily occurrence—that renders the body's surface an interpretive crux. The act of observing Artemisia's Magdalen is an act of hermeneutic negotiation—a necessary step in the effort to read a woman's heart in her face. The painting thus instills in Magdalen a freedom of conscience and power of self-determination that licenses not only women's physical self-creation through the use of cosmetics but also women's creativity in the art of painting. Garrard's speculation that Artemisia's *Mary Magdalen* may have served as "a show-piece" to advertise her virtuosity stresses the continuity between the two areas of feminine self-authorship and underscores Artemisia's revision of conventional depictions of the subject,[115] away from the mere display of the female figure—whether as an allegory of penance or of vanity—toward an enriched subjectivity for her Magdalen. Her painting gives voice to the *experience of being* a painting woman, rather than the act of merely observing her, and describes the occult process by which her countenance may be reconciled with her conscience.

In 1630 Elizabeth Cary published a translation of Cardinal Jacques Davy du Perron's explication of the tenets of Catholicism in his reply to doctrinal challenges issued by James I some fifteen years earlier.[116] In dedicating this work (by

a cardinal who famously converted from Calvinism to Catholicism) to her country's most prominent Catholic, Queen Henrietta Maria, Cary maintains that it is "a plaine translation wherein there is nothing aimed at, but rightlie to expresse the Authors intention" (a2). Her address "To the Reader" further glosses the point: "To looke for glorie from Translation," she insists, "is beneath my intention." She concludes, insisting upon her anonymity, "I desire to have noe more guest at of me, but that I am a *Catholique*, and a Woman: the first serves for mine honour, and the second for my excuse, since the worke be but meanely done, it is not wonder, for my Sexe can raise noe great expectation of anie thing that shall come of me." Nonetheless, she states, "I think it [the work is] well done," and, despite her gesture toward a feminine modesty, she both eschews and mocks the pose of nonchalance that so often accompanies early modern editions into print:[117] "I will not make use of that worne-out forme of saying, I printed it against my will, mooved by the importunitie of Friends: I was mooved to it by my beleefe, that it might make those English that understand not French, whereof there are manie, even in our universities, reade *Perron:* And when this is done, I have my End, the rest I leave to Gods pleasure" (a2v).

Cary's positions toward readership and toward her text illuminate not only her self-representation as author in the work but also her constructions of femininity in *The Tragedy of Mariam* and suggest, more generally, strategies for engagement with male-authored works, genres, and conventions available for use by the female writer in the early modern period. Clearly, Cary strikes a tenuous balance between modesty and self-praise, not only in implicitly elevating her own linguistic skills beyond those of her countrymen (who, even in the universities, know no French) but also in her apparently pragmatic claim that "if [the translation] gaine noe applause, hee that write it faire, hath lost more labour than I have done, for I dare avouch, it hath bene fower times as long in transcribing, as it was in translating" (a2v). What appears at first as a trivialization of her role as mere translator of the text becomes, in the Latin and English poems included in the volume, "In Laudem Nobilissimae Heroinae, Quae Has Eminentissimi Cardinalis Disputationes Anglice Reddidit" (In Praise of the Most Noble Heroine Who Has Translated the Disputations of this Most Eminent Cardinal into English), the basis on which to advance Cary's skills and erudition even beyond those of her author. The first English sonnet claims:

> One woman, in one Month, so large a booke,
> In such a full emphatik stile to turne:

Is't not all one, as when a spacious brooke,
Flowes in a moment for a little Burne?
Or is't not rather to exceede the Moone
In swift performance of so long a race,
To end so great and hard a worke as soone,
As Cynthia doth her various galliard trace?
Or is she not that miracle of Arts
The true Elixir, that by onely touch
To any mettals, worth of gold imparts?
For me, I think she valewes thrice as much.
A wondrous Quintessence of woman kind,
In whome alone, what els in'all, we find. (e2)

As a Cynthia who surpasses Cynthia in running her course with miraculous celerity, as an elixir that transforms the metal of Perron's text into gold, Cary is cast as the quintessential woman, with *quintessence* defined as the feminine capacity to ingest, process, improve upon, the products of men. A blank verse encomium that follows also praises Cary's skill in presenting "this Mirrhor of French Eloquence" to English readers and her miraculous speed in completing the work:

But that a Woman's hand alone should raise
So vast a monument in thirty days
Breeds envie and amazement in our sex
Of which the most ore weening witts might vex.

Cary's translation improves upon Perron's text, the poet claims, "As hee who coppying a rare Picture, shall/Equall, if not exceede, the Originall." The encomium defends Cary against the charge that the translation was "done with too much haste" by comparing her to the consummate artist of the period:

For had it bene in Michel Angells power
To perfect his great judgement in one hower,
Hee who for that should valew it lesse,
His owne weake judgement would therein expresse. (e3)

What appears at first to be Cary's merely "Mechanicall" skill in translation, the poems argue, in fact qualifies her for the highest praise as a female artist who surpasses her male-authored original. The poems cast translation as an art rather than a craft and Cary herself as the Michelangelo of the medium. Similar terms

apply to Cary as author of *The Tragedy of Mariam* vis-à-vis her source for the play, Josephus' *Antiquities of the Jews*. In both instances the female writer, like an engraver copying and correcting her male-authored source, improves upon the original and, in doing so, expresses her own virtuosity. Although remaining faithful to the orthodox source, her works suggest a space for a feminine intervention, a place at which the mechanical, material practices of painting intersect with the occult processes of self-authorship. Thus, as does her heroine in her closet drama, Cary, the "most noble heroine" in her translation of Perron, presents her work and constructs her presence as author and subject under the rubric of conscience. "I was mooved to it by my beleefe," she states, "that it might make [the] English . . . reade *Perron*." Cary's conscience, her conviction that Perron's defense of Catholicism is inherently worthy of English readership, authorizes the translation and her appearance in the public realm of print. Accordingly, the second sonnet in praise of her authorship casts a critical eye toward the potential devaluation of women's works and abilities by men, their husbands included, that resonates with Herod's myopic estimation of Mariam in Cary's play:

> Beleeve me reader, they are much deluded
> Who think that learning's not for ladies fitt:
> For wisdome with their sexe as well doth sitt,
> As orient pearle in golden chace included.
> > T'will make their husbands, yf they have true eyes,
> > Wise beauty, beauteous wisdome deerly prize. (e2v)

The performances of painting women—Mariam and Cary, Magdalen and Artemisia—pose a challenge of interpretation to viewers and readers, female and particularly male. They insist upon being viewed with true eyes but at the same time trouble the possibility that accurate assessments of women's internal qualities can be made based upon their outward appearances. They cull from their male-authored sources the means by which to correct and redirect critical views, away from simple essentialist castings of the sexes toward productive constructions of subjectivity based on creative encounters with the commonplaces of their culture's discursive and material practices. Feminine beauty, they insist, is not a matter of outward show but a "beauteous wisdome" rooted in and sustained by the sovereignty of a woman's willing mind.

Conclusion

I end this study of early modern painting by returning to our own era through the haunting and heartbreaking refrain of Bruce Springsteen's "Atlantic City":

> Everything dies, baby, that's a fact,
> But maybe everything that dies someday comes back.
> Put your makeup on, fix your hair up pretty,
> And meet me tonight in Atlantic City.[1]

The lines reiterate the association, often noted in the preceding pages, between cosmetics and death—a connection vividly expressed, for example, when Margaret Cavendish compares women's "Preparatives" to "Masks of Sear-clothes, which are not only horrid to look upon, in that they seem as Dead Bodies embalmed; but the stink is offensive."[2] In "Atlantic City" the artificiality of the made-up face figures the fragility of the speaker's dream (the American Dream, we might say) of acquiring money, power, and love. His invitation, in the carpe diem tradition, invokes the pleasures of a night on the town in the shadow of an uncertain future. His lover's made-up face is an emblem of these projected pleasures, shared by the couple and financed—owned, as it were—by the male speaker.

Like painted queens, Atlantic City's casinos attempt to veil the corruption and decay consuming the city around them but symbolize that corruption in the attempt. The garish casinos are distorted mirrors reflecting disguised faces—fun house mirrors in which the speaker reinvents himself as he imagines crossing the line, once and for all, between losing and winning.

But, perhaps more important for the work at hand, the lines also intimate another connection—not between makeup and death but between makeup and redemption, re-creation, resurrection. If painting signifies the inevitability of death, it also signals the hope, however illusory, for rebirth. Women's cosmetic self-creation, like the more orthodox art of painting proper, gestures toward immortality, and, like the painted face of "Atlantic City," it is poised precariously between the beautiful and the grotesque. Across the chasm of centuries the productions of the women writers and artists studied in this book, their performances of femininity on the contested stage of painting, perennially come back. The identities of their creators are reinvented as new readers and viewers rediscover them in contexts unimaginable to early modern men and women but still, at least in part, defined by the cosmetic culture whose disciplinary strategies the works record. Too many contemporary women, I would venture to guess, have felt the dejection expressed by Gauden's female speaker before the censorious mirror or have turned away from the glass with a sorrow approximating that of Gentileschi's Magdalen, perhaps more often prompted by self-hatred than contrition. But many of us, too, have felt the exhilaration of self-definition, the defiant power in appropriating one's own image, that becomes possible as the mirror transforms into the canvas or the page. As the song "Atlantic City" is reinvented with each replay, each new encounter between the singer and the audience, so the performances of the painting women studied here, and active in our culture, argue that immortality lies in this process of re-creation and re-invention. To escape the ravages of time and those of the defining male gaze, the painting woman understands, the body itself must become her work of art. Through art, or, as Cavendish calls it, "Sluttishness"[3]—the mechanical, mundane craftsmanship that constitutes virtuosity—she can reclaim and redeem the flesh.

The afterlife of one notorious painting woman, Anne Turner, demonstrates the brand of redemption ordinarily required of women who undertake transgressive (and in this case lethal) acts of self-definition: repentance. Following Turner's execution in 1615 for her role in the poisoning death of Sir Thomas Overbury—which allegedly involved her preparation of "Tarts . . . poysoned

with *Mercury Sublimate*,"[4] a common ingredient in cosmetics—she was resurrected in a series of popular texts that showcase her penance. In Richard Niccols's *Sir Thomas Overbury's Vision*, Turner's ghost urges women:

> But be ye not so blinded, looke on me,
>
> And let my story in your clossets be
>
> As the true glasse, which there you looke upon,
>
> That by my life, ye may amend your owne.[5]

Niccols proposes that the renovation of the lady's closet can also ensure the renewal of her soul, as his own text renovates the disturbing details of Turner's arraignment. Thus, the penitent Mistress Turner, now a reformed mirror for ladies, displaces the heinous image of a "picture . . . of a naked woman, spreading and laying forth her hair in a Looking-glass," cited in her trial as evidence "that she had the seven deadly sins, viz. A Whore, a Bawd, a Sorcerer, a Murtherer, a Witch, a Papist, a Felone, the daughter of the Devil."[6] As Turner's (now defunct) body becomes both a dead object and a living exemplum, so Niccols's female addressee is figured in and as her closet: inanimate but intimate; at once a physical and an ethical site; the scene of self-fashioning and of surrender to moral authorities.[7]

By setting visual and textual mirrors for women, such as Niccols's, alongside the material practices of women engaged in the arts of painting, this study has argued that early modern women were able to complicate and challenge the essentialist assumptions governing and defining them through productive encounters with the objects, materials, and conventions of the cosmetic culture. The preceding pages have marshaled a series of material objects that serve as emblems for women's engagement with and treatment by the discourses of cosmetics: Portia's *coltello* and Elisabetta Sirani's *pennello;* Artemisia Gentileschi's salacious *scalpello* and the sword wielded by her Judith; Elizabeth I's phoenix jewel and Aemilia Lanyer's steel glass; Bellini's *sponzarol* and the water jug of Lavinia Fontana's Samaritan; Marguerite de Navarre's erudite looking glass and Jean Liébault's clouded mirror of Socrates. Invariably, women's deployments of the materials of painting trouble commonplace descriptions of feminine nature by stressing that the sometimes laborious effort involved in creating the body's appearance mirrors their culture's fastidious constructions of feminine essence. Thus, Mary Evelyn's painstaking inventory of the lady's dressing room, circa 1690, glosses and overwhelms Niccols's simple, allegorized image of the lady's "closset":

A new Scene to us next presents,
The Dressing-Room, and Implements
Of Toilet Plate Gilt, and Emboss'd,
And several other things of Cost:
The Table *Miroir,* one Glue Pot,
One for *Pomatum,* and what not?
Of *Washes, Unguents, and Cosmeticks,*
A pair of Silver Candlesticks;
Snuffers, and Snuff-dish, Boxes more,
For Powders, Patches, Waters store,
In silver Flasks, or Bottles, Cups
Cover'd, or open to wash Chaps.[8]

Our attention to the painting woman's tools of the trade—the literary, artistic, and cultural forms and genres available to her—enables us to move beyond the unfeatured representations of femininity, virtuous or vicious, advanced by early modern men. In the privacy of her closet (an enclosure, like the female body itself, that haunts male observers from Richard Niccols to Bruce Springsteen) her virtuoso performance of femininity anticipates, enables, and guides her provocative entry into the public worlds of literary and artistic exchange. And there, centuries later, we can retrieve her likeness and retrace her steps.

Notes

Introduction

1. Tuke, *Treatise Against Painting*, 57.

2. Ibid., 24–25.

3. The related genre on physiognomy also exemplifies this faith. See, e.g., Lemnius, *De habitu et constitutione corporis*; Lemnius, *Touchstone of Complexions*; Porta, *De humana physiognomia*; and, for discussion, Porter, "Making Faces," 385–96. On the relationship of these concerns to ontological and empirical forms of knowledge in the period, see Hillman, "Visceral Knowledge," 81–105.

4. Tuke, *Treatise Against Painting*, 17.

5. See Colish, "Cosmetic Theology," 3–15; and Whigham, *Ambition and Privilege*, 116–17.

6. These aesthetics are indebted to Petrarchan ideals of feminine beauty: see Cropper, "On Beautiful Women, Parmigianino, *Petrarchismo*, and the Vernacular Style," 374–94; and Kirkham, "Poetic Ideals of Love and Beauty," 50–61.

7. Buoni, *I problemi della belleza*, 33; *Problemes of Beautie*, 36.

8. Stubbes, *Anatomie of Abuses*, L5v. On the cosmetic debate and anti-theatricality, see Drew-Bear, *Painted Faces on the Renaissance Stage*, 34–36; and Barish, *Antitheatrical Prejudice*.

9. Downame, *Second Part of the Christian Warfare*, 1: 134.

10. Among the seminal works in feminist literary studies are Showalter, "Towards a Feminist Poetics," 21–44; Showalter, "Feminist Criticism in the Wilderness," 179–205; Gilbert and Gubar, *Madwoman in the Attic*; Greene and Kahn, *Making a Difference*; Ferguson, Quilligan, and Vickers, *Rewriting the Renaissance*; Ezell, *Writing Women's Literary History*; and Ferguson, "Moderation and Its Discontents," 349–66. Major works in feminist art historical criticism include Nochlin, "Why Have There Been No Great Women Artists?" 145–78; Broude and Garrard, intro., in *Expanding Discourse*, 1–25; Gouma-Peterson and Matthews, "Feminist Critique of Art History," 326–57; and the critique of this article in Pollock, "Politics of Theory," 3–24; Parker and Pollock, *Old Mistresses*; and Pollock, *Differencing the Canon*.

11. Gouma-Peterson and Matthews, "Feminist Critique," 347–48, characterize the shift from first- to second-generation feminist art history as a move from an essentialist interest in "the condition and experience of being female" to a constructionist emphasis on gender differences. See also Broude and Garrard, intro., in *Expanding Discourse*, 15–17. In literary criticism, see Fuss, *Essentially Speaking*; Butler, *Gender Trouble*; and Belsey, *Subject of Tragedy*.

12. See Spear, "Artemisia Gentileschi," 575, on the struggles between traditional connoisseurship and attributions based on "gendered expression" in recent approaches to Gentileschi; and see Garrard, *Artemisia Gentileschi;* Bissell, *Artemisia Gentileschi and the Authority of Art;* and Spear's review of Bissell, 571–75. Pollock, *Differencing the Canon,* 97–127, has offered a critique of Garrard's approach; and Garrard responds in *Artemisia Gentileschi around 1622,* xix–xxi.

13. See Nochlin, "Why Have There Been," 149. Descriptions of women's writing and artworks as forms of direct expression continue to appear. See, e.g., Stortoni, intro., in Stortoni and Lillie, *Gaspara Stampa,* xiv–xv, who describes Stampa's poems as "her love diary."

14. See the essays included in Johnson and Grieco, *Picturing Women in Renaissance and Baroque Italy;* Pollock's *Differencing the Canon;* and Hyde, "'Makeup' of the Marquise," 453–76. Exemplary literary studies include Dolan, *Whores of Babylon;* Wall, *Staging Domesticity;* and Ferguson, *Dido's Daughters.* My project is aligned with that of Melchoir-Bonnet, *Mirror,* insofar as we both address the development of early modern subjectivity in relation to specific cultural attitudes and material practices.

15. See Parker and Pollock, *Old Mistresses,* 25.

16. This assumption underlies the helpful anthology by Prescott and Travitsky, eds., *Female and Male Voices in Early Modern England.*

17. Despite the cultural and historical differences separating early modern women from twenty-first century critics, it is not anachronistic to attribute to these women's works a feminist sophistication when confronting questions of gender and subjectivity. For a different view, see Mueller, "Feminist Poetics of Aemilia Lanyer's *Salve Deus Rex Judaeorum,*" 208–36.

18. Melchoir-Bonnet, *Mirror,* 214 and 272. On classical Roman treatments of the mirror, see Wyke, "Woman in the Mirror," 134–51.

19. Bartky, "Foucault, Femininity, and the Modernization of Patriarchal Power," 64 and 71.

20. Berger, *Ways of Seeing,* 51.

21. Bartky, "Foucault," 79.

22. Many instructional manuals address women readers and/or include dedications to female patrons. At least three published texts were written by women: Cortese, *I secreti de la Signora Isabella Cortese;* Meurdrac, *La Chymie des dames;* and Evelyn, *Mundus Muliebris.* Other instructional manuals include Ruscelli, *Alexii Pedemontani De secretis libri sex,* trans. into Italian as *De' secreti* and into English as *The Secretes of the Reverende Maister Alexis of Piemount;* Piccolomini, *Raffaella,* extant in English as *Raffaella of Master Alexander Piccolomini;*, Le Fournier, *La Decoration d'humane nature* (Lyon: Claude Veycellier, 1532); Marinello, *Gli ornamenti delle donne;* Liébault, *Trois livres de l'embellissement et ornement du corps humaine,* based upon Liébault's Latin translation of Marinello, *De cosmetica seu ornatu et decoratione;* Plat, *Delightes for Ladies;* Wecker (or Culpeper), *Cosmeticks, or the Beautifying Part of Physick;* Shirley, *Accomplished Ladies Rich Closet of Rarities;* Fioravanti, *Dello specchio di scientia universale,* 305v–310v, trans. into French by Gabriel Chappuys as *Le Miroir universel des arts et sciences,* 512–20, and into English in Haydocke, *Tracte Containing the Artes of Curious Paintinge,* 129–33; Porta, *Io. Bapt. Portae magiae natvralis libri XX,* trans. into Italian as *Della magia naturale del Sign. Gio. Battista Della Porta Napolitano libri XX,* partially trans. into French as *La Magie naturelle: qui est, les secrets & miracles de nature, mise en quatre liures,* and into English as *Natural Magick.*

23. Evelyn, *Mundus Muliebris*, 22–23. While Evelyn's recipe may be in jest, earlier manuals include similar recipes: e.g., Bate, *Mysteries of Nature and Art*, 177, recommends, "Take Snailes, beat them shels and bodies together: steep them a night in new milke: then still them with the flowers of white Lillies," for a lotion to whiten the face.

24. Porta, *Della magia naturale*, 405–6; *Natural Magick*, 242.

25. See Cropper, "On Beautiful Women"; and Berdini, "Woman under the Gaze," 578–79.

26. Marinello, *Gli ornamenti delle donne*, 157–58. The sonnet is number 131 of the *Rime sparse*. Marinello also cites Petrarch's canzone 127, "In quella parte, dov'amor mi sprona." See Liébault, *Trois livres*, 63, for a similar treatment of Petrarchan colors.

27. Porta, *Della magia naturale*, 406; *Natural Magick*, 242.

28. Cavendish, "Of Painting," 86.

29. On the toxicity of early modern cosmetics, see DeGalan, "Lead White or Dead White?" 38–49. Invectives include: Tuke, *Treatise Against Painting*; Vives, *De institutione feminae Christianae*, 74–100; Alberti, *I primi tre libri della famiglia*, 352–62, trans. into English as *Family in Renaissance Florence*, 84–86; Day, *Mirror of Modestie*; Hall, *Appendix Containing Divers Reasons and Arguments Against Painting*; Smith, *Wonder of Wonders*; Niccholes, *Discourse of Marriage and Wiving*; Tasso, *Householders Philosophie*; Bansley, *Treatyse*; Laguna, *Annotationes in Dioscoridem*, partially translated by Tuke, with an English translation no longer extant attributed to a "Mistress Elizabeth Arnold," *Treatise Against Painting*, B4v; Taylor, *Glasse for Gentlewomen*; Rich, *My Ladies Looking Glasse*; Brinsley, *Looking-Glasse for Good Women*; T.H., *Looking-Glase for Women, or, A Spie for Pride*; and Richards, *Celestiall Publican*, esp. G2–H3v. Cavendish, "Of Painting," initially defends painting and then disallows it. A number of Elizabethan and Jacobean plays (particularly Webster's and Jonson's) deploy images of poisoned cosmetics in terms that could be construed as anti-cosmetic invectives: see Drew-Bear, *Painted Faces*; Garner, "Let Her Paint," 123–39; Finke, "Painting Women," 357–70; and Pollard, "Beauty's Poisonous Properties," 187–210.

30. Vives, *De institutione*, 76–77.

31. Ibid., 78–79.

32. Ibid., 80–81. Vives is quoting Cyprian. On classical invectives, see Richlin, "Making Up a Woman," 185–213. On the church fathers, see Colish, "Cosmetic Theology." The major patristic texts are Tertullian, *De Cultus Feminarum*, 111–52; Saint Cyprian, *Dress of Virgins*, 31–52; Saint Ambrose, *Hexameron*, 3–283; Saint Jerome, *Selected Letters of St. Jerome*, esp. Ep. 38 (158–65), Ep. 54 (228–63), Ep. 107 (338–69), and Ep. 138 (466–82).

33. Alberti, *Family*, 82; *Della famiglia*, 352.

34. Ibid. On the work, see Wyke, "Woman in the Mirror," 140; Hutson, *Usurer's Daughter*, 17–51; and Freccero, "Economy, Women, and Renaissance Discourse," 204–7.

35. Alberti, *Family*, 84; *Della famiglia*, 355–57.

36. Richlin, "Making Up," 200.

37. Tuke, *Treatise Against Painting*, 27–28.

38. Wyke, "Woman in the Mirror," 135.

39. Richlin, "Making Up," 205; Bartky, "Foucault," 71.

40. Quoted in Tuke, *Treatise Against Painting*, B1v. The idea of deformity is central to instructional manuals and invectives, since women use cosmetics, the former argue, to

veil physical deformities, while the latter claim that cosmetic use itself constitutes women's moral deformity.

41. Garner, "Let Her Paint," 134. Women writers, such as Cavendish, "Of Painting," offer this argument, but their voices are greatly outnumbered by male-authored invectives.

42. Hall, *Appendix*, 102.

43. Richlin, "Making Up," 193.

44. Bulwer, *Anthropometamorphosis*, 260. On Bulwer, see Campbell, "*Anthropometamorphosis*," 202–22.

45. See Richlin, "Making Up," 189–95.

46. The Victoria and Albert Museum owns several of these boxes. Museum no. box W.24-1953 (Italian, c. 1500) depicts the Judgment of Paris; no. W.23–1953 (Northern Italy, 1500) depicts the Rape of Lucretia; and no. W.21–1953 (Italian, c. 1500) (fig. 1) is decorated with a series of figures in chariots recalling Petrarch's *Trionfi*.

47. Niccholes, *Discourse of Marriage*, 21.

48. Gwilliam, "Cosmetic Poetics," 144.

49. Buoni, *I problemi della bellezza*, 30; *Problemes of Beautie*, 33–34.

50. Porter, "Making Faces," 389.

51. Richlin, "Making Up," 186.

52. Eilberg-Schwartz, "Introduction: The Spectacle of the Female Head," 2.

53. Garner, "Let Her Paint," 133.

54. Porta, *Della magia naturale*, 387–88; *Natural Magick*, 233.

55. Gwilliam, "Cosmetic Poetics," 148.

56. Schutte, "Per Speculum in Enigmate," 186.

57. Alberti, *Family*, 86–87; *Della famiglia*, 359–60.

58. I follow theorists such as Joan Riviere and Judith Butler, who view makeup as one of the many "masquerades" through which femininity is performed. See Riviere, "Womanliness as a Masquerade," 35–44. For discussion, see Heath "Joan Riviere and the Masquerade," 45–62; and Butler, *Gender Trouble*, 61–73.

59. See Melchoir-Bonnet, *Mirror,* 200–206.

60. Rich, *My Ladies Looking Glasse*, 40.

61. Wyke, "Woman in the Mirror," 134.

62. Rich, *My Ladies Looking Glasse*, 14.

63. Reilly, "Taming of the Blue," 135–36.

64. Jacobs, *Defining the Renaissance Virtuosa*, 27–63.

65. Armenini. *De veri precetti della pittura*, 190. For discussion, see Jacobs, *Defining the Renaissance Virtuosa*, 44.

66. Quoted in Sohm, "Gendered Style in Italian Art," 791. See also Cropper, *Ideal of Painting*, 252.

67. Reilly, "Taming of the Blue," 90.

68. Sohm, "Gendered Style," 800.

69. Woods-Marsden, *Renaissance Self-Portraiture*, 189, notes that Vasari's second edition (1568) includes thirteen women, suggesting increased opportunities for women artists in the interim.

70. Vasari, *Le Vite dei piu celebri pittori, scultori e architetti,* 4: 400–401; *Lives of the Artists,* 341. For discussion, see Jacobs, *Defining the Renaissance Virtuosa*, 64–84; "Construction of a Life," 122–32; and Bluestone, "Female Gaze," 38–66.

71. Jacobs, *Defining the Renaissance Virtuosa*, 76–82.

72. Ibid., 64–84.

73. See Lichtenstein, "Making Up Representation," 77–87; and *Eloquence of Color.*

74. I rely upon the period's frequent discussions of the "sister arts" of painting and poetry and the conflation of painting and rhetoric that pervades humanist theories of oratory to link the works of women writers and painters. Thus, one meaning of *painting*, in my usage, refers to poetic and rhetorical works that understand themselves as verbal painting. See Lichtenstein, "Making Up"; Lichtenstein, *Eloquence of Color;* Dolan, "Taking the Pencil Out of God's Hand," 224–39; and Gent, *Picture and Poetry.*

75. Bartky, "Foucault," 70.

76. Ibid., 72.

77. Comparison and interdisciplinarity have followed different trajectories in recent literary and art historical criticism. For discussions of interdisciplinary approaches in art history, see Gouma-Peterson and Matthews, "Feminist Critique," 340–42; and Johnson and Grieco, "Introduction: Women and the Visual Arts: Breaking Boundaries," esp. 8–10. See Cropper, "On Beautiful Women," for an exemplary methodological model. For a good treatment of the question in comparative literature, see Bernheimer, *Comparative Literature in the Age of Multiculturalism.* See also Barkan, "Making Pictures Speak," 326–51.

78. Koelb and Noakes, *Comparative Perspective on Literature*, 11. In that volume Ferguson, "Room Not Their Own," 93–116, provides an interdisciplinary model for this study.

79. Milton, *Paradise Lost*, bk. 4, l. 181.

80. Most notably, Pater, *Renaissance;* and Burckhardt, *Civilization of the Renaissance.*

81. For exemplary studies of Renaissance *imitatio*, to which my work is greatly indebted, see Greene, *Descent from Heaven; Light in Troy;* and *Vulnerable Text.*

82. See Traub, Kaplan, and Callaghan, intro., in *Feminist Readings*, 5–6; and Hunt, afterword, in *Queering the Renaissance*, 359–64.

83. See Traub, Kaplan, and Callaghan, intro., in *Feminist Readings*, 4–5; and Johnson and Grieco, intro., in *Picturing Women*, 1–13.

84. See Spencer, *Readings in Art History*, vol. 1.

85. Gauden, *Discourse of Artificial Beauty*, 6 and 141. See chap. 5.

86. See Tuke, *Treatise Against Painting*, B3–B4v and 42.

87. Traub, Kaplan, and Callaghan, intro., in *Feminist Readings*, 6.

88. Vickers, "This Heraldry in Lucrece's Face," 218.

ONE: Painting Women

1. See Williams, *Powder and Paint*, 42.

2. Richards, *Celestiall Publican*, H3. Richard's invective is typical in that it occurs within a poem, "The Vicious Courtier" (G2–H3v), but mainly censures the painted court lady.

3. Porta, *Della magia naturale*, 428–29; *Natural Magick*, 253.

4. Tuke, *Treatise Against Painting*, 57.

5. Cohen, "Trials of Artemisia Gentileschi," 65–66, argues that the period saw the female body as less bordered and less gendered than in current views.

6. Tuke, *Treatise Against Painting*, B3. Arnold's translation is not extant, but the fact of a female translator underscores the relevance of cosmetic texts to women.

7. Ibid., B4v.

8. Ibid., 11.

9. Dolan, "Taking the Pencil," 229.

10. Ibid., 230.

11. Puttenham, *Arte of English Poesie*, 150. The image resonates with Ben Jonson's claim that Elizabeth I's maids vermilioned the aged queen's nose. See chap. 4.

12. Fréart de Chambray, *Idée de la perfection*, a2v; *Idea of the Perfection of Painting*, A4–A4v. See also Lichtenstein, "Making Up," 80.

13. Cognet, *Politique Discourses*, 184. Cognet cites Clement of Alexandria.

14. Stubbes, *Anatomie of Abuses*, E8–E8v. See also Cognet, *Politique Discourse*, 185, which cites St. Jerome as the common source.

15. Vasari, *Vite*, 4:11.

16. Ibid., 5:429. *Diligenza* and its various forms appear in 5:427–29. For a qualification of this view, see Jacobs, *Defining the Renaissance Virtuosa*, 51–63; and Woods-Marsden, *Renaissance Self-Portraiture*, 196.

17. Dolon, "Taking the Pencil," 227, summarizing Lichtenstein's argument, "Making Up," 77–78.

18. Vickers, "This Heraldry in Lucrece's Face," 218.

19. Picinardi, *Il Pennello Lagrimato*, 4.

20. Heller, *Women Artists*, 32–34. On Sirani, see Bohn, "Antique Heroines of Elisabetta Sirani," 52–79; and Frisoni, "Elisabetta Sirani," 343–64. On Sirani's students and their works, see Bohn, "Antique Heroines," 53 nn. 4 and 5. Sirani's "Nota" records her works, patrons, and payments received, but she failed to record them all, omitting, for instance, her self-portraits. See Ragg, *Women Artists of Bologna*, 246–49; and Bohn, "Female Self-Portraiture in Early Modern Bologna," 258–59. For the "Nota," see Malvasia, *Felsina pittrice*, 2:393–401.

21. Picinardi, *Il Pennello Lagrimato*, n.p. See also Malvasia, *Felsina pittrice*, 2:465; and Ragg, *Women Artists*, 230.

22. Picinardi, *Il Pennello Lagrimato*, n.p.; and Malvasia, *Felsina pittrice*, 2:465.

23. Ibid.; and Malvasia, *Felsina pittrice*, 2:466.

24. Marnesi, *Il processo*, 8. See also 34–35; and see Moretti, *Il pennello lacrimato*.

25. Sirani's mother and aunt testify that they believe Tolomelli was employed by a jealous rival: see Marnesi, *Il processo*, 24 and 29. The perforations of the stomach found during Sirani's autopsy suggest a prolonged ulcerous inflammation, rather than poisoning, as the cause of death. See ibid., v; and Ragg, *Women Artists*, 287.

26. Malvasia, *Felsina pittrice*, 605.

27. My thanks to Lael Parish for her helpful gloss of Malvasia's title and its implications.

28. Picinardi, *Il Pennello Lagrimato*, 25, dedicates a sonnet "Alla Sign Barbara Sirani, che dipingeva in Rame dopo la morte della Famosa Sig. Elisabetta sua Germana il Ritratto della medesima." See also Malvasia, *Felsina pittrice*, 2:481. The image is catalogued as a self-portrait by Elisabetta Sirani, but critical opinion ascribes it to Barbara. See Bohn, "Female Self-Portraiture," 259 n. 55 and 265 n. 68; and Harris and Nochlin, *Women Artists*, 148 n. 9. For discussion of the image as Elisabetta's self-portrait, see Moretti, *Le Più belle del reale*, 103–8. Cheney, Faxon, and Russo, *Self-Portraits by Women Painters*, 77–78, attribute a portrait now in the Uffizi (inventory no. 5501) to Elisabetta.

Ghirardi, "Women Artists of Bologna," 43, attributes the portrait to Lucia Casolini Torelli. The latter attribution seems more likely.

29. See Bohn, "Female Self-Portraiture," 249–71, on the Bolognese tradition of depicting female artists at work.

30. On the composition of early modern cosmetics, see Williams, *Powder and Paint*, 14–16; Burton, *Pageant of Elizabethan England*, 236–38; Camden, *Elizabethan Woman*, 178–80; and Sagarin, *Cosmetics*, 31.

31. Lomazzo, *Trattato dell'arte de la pittura*, 191; Haydocke, *Tracte Containing the Artes of Curious Paintinge*, bk. 3, 99 and 130.

32. Haydocke, "Of the Painting of Women," in *Tracte*, bk. 3, 129.

33. See Harley, *Artists' Pigments*, esp. 8–9 and 17.

34. Fialetti, *Whole Art of Drawing*, 21. On procedures for making lead white, see Harley, *Artists' Pigments*, 166–72.

35. Porta, *Della magia naturale*, 407; *Natural Magick*, 242–43.

36. See Woods-Marden, *Renaissance Self-Portraiture*, 17, for a similar interpretation of the performance of gender in early modern self-portraits.

37. On the portrait, see Rossi, *Jacopo Tintoretto*, 154; and Bereman, *Italian Pictures of the Renaissance*, 1:189.

38. Franco, *Lettere*, 69, 72, and 76; *Poems and Selected Letters*, 37, 38, and 40. I am indebted to Bianca F. C. Calabresi for calling my attention to Franco's comments on painting.

39. Franco is not alone in condemning the arts by which her career flourishes. Gaspara Stampa's canzone "Felice in questa e più ne l'altra vita" (no. 298 in Salza's edition and those following his reordering of the poems) complains, "quella con acque forti il viso offende,/ de la salute sua propria nimica" ("One spoils her face with acids and bleaches,/ Injuring in this way her own good health"). See Stampa, *Gaspara Stampa–Veronica Franco*, 173; and Stampa, *Selected Poems*, 208–9. The poem was not published in first edition of the *Rime* (1554) but in Christoforo Zabata, *Nuova scelta di rime di diversi begli ingegni* (1573), 196; it was reprinted in subsequent editions of Stampa's work. The poem's recantatory language must have appealed to readers such as Salza, who insisted upon and largely invented Stampa's penance.

40. Alberti, *Della pittura*, 55 and 77–78; *On Painting*, 43 and 64. On Alberti's use of the myth, see Baskins, "Echoing Narcissus in Alberti's *Della pittura*," 25–33.

41. See Pallucchini and Rossi, *Jacopo Tintoretto*, 1:43–44 and 2:418–20; Bereman, *Italian Pictures*, 1:177 and 182; and Vecchi, *Tout l'ouvre peint de Tintoret*, 99. Pallucchini dates both paintings from 1555–56. The dimensions of the two canvases suggest that they were conceived as a pair: *Susanna* measures 146.6 x 193.6 cm; and *Narcissus* 147 x 190 cm.

42. Franco, *Lettere*, 73; *Poems and Selected Letters*, 39.

43. Smith, *Wonder of Wonders*, A2v.

44. Finke, "Painting Women," 360.

45. Stubbes, *Anatomie*, E8.

46. Tuke, *Treatise Against Painting*, A4v.

47. Fioravanti, *Dello specchio*, 306v–309; Haydocke, "Of the Painting of Women." See also Tuke, *Treatise Against Painting*, A3v.

48. Tuke, *Treatise Against Painting*, B3 and A1.

49. The equation between moral and physical poisoning is spectacularly displayed in Barnes, *Divels Charter*, when Lucretia Borgia is poisoned by makeup which she ap-

plies onstage. For discussion, see Drew-Bear, *Painted Faces*, 22 and 51–53, and Pollard, "Beauty's Poisonous Properties," 187–89. Tuke, *Treatise Against Painting*, 51–52, responds to the 1615 trial and execution of Mistress Anne Turner for the poisoning death of Sir Thomas Overbury. The conflation of painting and poisoning is ubiquitous in commentaries on the case: see Niccols, *Sir Thomas Overbury's Vision;* anon., *Bloody Downfall of Adultery, Murder and Ambition;* and anon., "Mistress Turners Farewell to All Women." See also Lindley, *Trials of Frances Howard*, 164–92; and Traister, *Notorious Astrological Physician of London*, 181–90.

50. Finke, "Painting Women," 364.

51. Marchese Ferdinando Cospi, in a letter dated September 1, 1665; quoted in Marnesi, *Il processo*, xi.

52. Anguissola's and Sirani's extant works demonstrate that neither was limited to portraiture. On the former, see Ferino-Padgen and Kusche, *Sofonisba Anguissola;* Perlingieri, *Sofonisba Anguissola;* Garrard, "Here's Looking at Me," 556–621; and Woods-Marsden, *Renaissance Self-Portraiture*, 191–213.

53. Alberti, *Della pittura*, 65; *On Painting*, 51; and Reilly, "Taming of the Blue," 88.

54. Overbury, *A Wife*, B2 and C2–C2v.

55. Bohn, "Antique Heroines," 79, notes that Picinardi's *Poesie* compares Sirani with the masculine *sole*. On the gendering of the paintbrush, see Sohm, "Gendered Style," 798–99; Jacobs, *Defining the Renaissance Virtuosa*, 141–42; and Woods-Marsden, *Renaissance Self-Portraiture*, 188.

56. Malvasia, *Felsina pittrice*, 2:385.

57. For a similar view of Lavinia Fontana, see Murphy, *Lavinia Fontana*, 85–116.

58. Jacobs, *Defining the Renaissance Virtuosa*, 86.

59. Finke, "Painting Women," 358.

60. Ragg, *Women Artists*, 234.

61. Picinardi, *Il Pennello Lagrimato*, n.p.; and Malvasia, *Felsina pittrice*, 2:465.

62. Tuke, *Treatise Against Painting*, 57.

63. Picinardi, *Il Pennello Lagrimato*, n.p.; and Malvasia, *Felsina pittrice*, 2:465, identify the creator of the catafalque as "Sig. Matteo Borboni Pittore de più Celebrì della Città" (Signore Matteo Borboni, one of the most Celebrated Painters of the City).

64. Lomazzo, *Trattato*, 187; Haydocke, *Tracte*, bk. 3, 93–94.

65. Lichtenstein, "Making Up," 77–78. See also Lichtenstein, *Eloquence*, 37–54 and 185–95.

66. Junius, *Painting of the Ancients*, 288–89; *De pictura veterum libri tres*, 176–77. Castiglione, in *Il libro del cortegiano*, 64–65 (*Book of the Courtier*, 46–47), describes *sprezzatura* as a similar aesthetic construction of the self.

67. See Lichtenstein, *Eloquence*, 197–226. See also Reilly, "Taming"; and Sohm, "Gendered Style."

68. Lomazzo, *Trattato*, 188; Haydocke, *Tracte*, bk. 3, 95.

69. Vickers, "This Heraldry in Lucrece's Face," 218.

70. Ibid., 213.

71. Ibid., 214. See also Fineman, "Shakespeare's Will," 35–36.

72. Vickers, "This Heraldry in Lucrece's Face," 219.

73. Shakespeare, "Rape of Lucrece," l.1367. All subsequent citations appear parenthetically.

74. Vickers, "This Heraldry in Lucrece's Face," 217, notes that the word *color* is more frequent in "The Rape of Lucrece" than in any other Shakespearean work.

75. Shakespeare, *Sonnets*, no. 20. For discussion, see Garner, "Let Her Paint," 135–36 and Hutson, "Why the Lady's Eyes," 154–75.

76. Fineman, "Shakespeare's Will," 36–37 and 44.

77. Lomazzo, *Trattato*, 188; Haydocke, *Tracte*, bk. 3, 94.

78. Jeamson, *Artificiall Embellishments*, 1–3. On the text, see Heyl, "Deformity's Filthy Fingers," 137–51.

79. Ibid., 2.

80. Ibid., 3.

81. Ibid., A3v.

82. Lomazzo, *Trattato*, 191; Haydocke, *Tracte*, bk. 3, 101.

83. Jacobs, *Defining the Renaissance Virtuosa*, 133–34, notes that the myth of Zeuxis was often used to describe the female artist by enumerating her body parts, creating a blazon within which male intellect gave shape to female matter.

84. On the *ekphrasis*, see Fineman, "Shakespeare's Will," 55–60. On the sister arts in Elizabethan England, see Barkan, "Making Pictures Speak"; and Gent, *Painting and Poetry*. On the *ekphrasis* and iconoclasm, see Siemon, *Shakespearean Iconoclasm*, 76–100.

85. Berdini, "Women under the Gaze," 575.

86. Alberti, *Della pittura*, 91; Alberti, *On Painting*, 75.

87. Camden, *Elizabethan Woman*, 176.

88. Bartas, *La Judit*, 65; *Historie of Judith*, 73.

89. Jeamson, *Artificiall Embellishments*, A4–A4v.

90. Ibid., 3.

91. Quoted in Tuke, *Treatise Against Painting*, A3v.

92. Quoted in ibid., B2v–B3.

93. Quoted in ibid., A3v.

94. Stubbes, *Anatomie*, F2. See also Cognet, *Politique Discourses*, 183.

95. Edward Tylman, quoted in Tuke, *Treatise Against Painting*, A3.

96. Ziegler, "My Lady's Chamber," 78–82.

97. Jed, *Chaste Thinking*, 16.

98. Malvasia, *Felsina pittrice*, 2:474. The painting is signed "Elisa. Sirani 1664" in gold lettering on the front of the chair.

99. Chadwick, *Women, Art and Society*, 102. See also Bohn, "Antique Heroines," 66–70. Images of Portia's wounding were relatively rare in the period: see Bohn, "Antique Heroines," 63; and Harris and Nochlin, *Women Artists*, 150.

100. Morselli and Sones, in *Collezioni e quadrerie nella Bologna*, report that the library included "le *Vite* de Plutarco in due tomi" (414). See also Bohn, "Antique Heroines," 68. I include passages in Italian from Plutarch, *Vite*, 2:177–201, probably the edition in question. The other contender is Plutarch, *Le Vite gli huomini*, published in the same year as Fioravanti's *Dello specchio*, by the same publisher. English translations are from Plutarch, *Lives of the Noble Grecians and Romanes*, 1053–1078, the source for Shakespeare's *Julius Caesar*, 2.1.234–308.

101. Plutarch, *Vite*, 2:177; *Lives*, 1058.

102. Plutarch, *Vite*, 2:177–78; *Lives*, 1059.

103. The conflation of the chamber and the female body, both violated by the rapist

in Shakespeare's poem (Ziegler, "My Lady's Chamber," 78–79), exposes Sirani's Portia to a similar violation by the viewer.

104. Wyke, "Woman in the Mirror," 139, notes the classical view (expressed by Livy's Cato, e.g.) that cosmetics symbolize the submission of the state to luxury and require women's submission to men's rule. Thus, the feminine adornment of Sirani's Portia and her masculine act may challenge masculine domestic and aesthetic hegemony.

105. Bohn, "Antique Heroines," 78.

106. Shakespeare, *Julius Caesar,* 2.4.40.

107. Chadwick, *Women, Art and Society,* 103–4.

108. From British Galleries web site, www.vam.ac.uk/collections/british_galls/, October 27, 2002.

109. Parker and Pollock, *Old Mistresses,* 27.

110. Ibid.

111. Jed, *Chaste Thinking,* 68, describes a similar feminist intervention in which the material text of *Lucretia* is an analogy for the female body.

112. Bohn, "Antique Heroines," 67–68, compares Sirani's image to Reni's *Portia* (c. 1625–26), now in Genoa, arguing that Sirani "eschew[s] the sensuality and emotionality typically assigned to women by male artists" (78).

113. See Gwilliam, "Cosmetic Poetics," 151.

114. Plutarch, *Vite,* 2:182; *Lives,* 1063.

115. Plutarch, *Vite,* 2:182–83; *Lives,* 1063.

116. Shakespeare, *Julius Caesar,* 2.4.8–9.

117. Jeamson, *Artificiall Embellishments,* A3.

118. Ibid., A4.

TWO: Public Women

1. "Testimony of the Rape Trial of 1612," in Garrard, *Artemisia Gentileschi,* 447. All further citations in English are to this source and appear parenthetically. Italian from Menzio, *Atti di un processo per stupro,* 91; and from app. 1 in Christiansen and Mann, *Orazio and Artemisia Gentileschi,* 432–45, each of which provides only partial transcripts. Citations to these two sources appear parenthetically, identified as *Atti* or "Appendix."

2. Cohen, "Trials of Artemisia," 56–57.

3. The image occurs six times in the transcript; see "Testimony," 450, 455, 457, 480, and 485; *Atti,* 95–96, 106; and "Appendix," 434 and 435.

4. See Cavazzini, "Artemisia in Her Father's House," 283–95.

5. Cohen, "'Courtesans' and 'Whores,'" 205.

6. On Artemisia's career, see Cropper, "Life on the Edge," 263–80; and Cohen, "Trials of Artemisia," 51–53, who argues that she was not permanently marred by the rape. Cavazzini, "Artemisia Gentileschi," 283, disagrees.

7. Quoted in Garrard, *Artemisia Gentileschi,* 519 n. 240.

8. This polarization marks the *querelle des femmes,* which typically presents pro- and antifeminist arguments in extremes. See, e.g., Castiglione, *Il libro del cortegiano,* 207–82; *Book of the Courtier,* 87–198.

9. McKluskie, "Patriarchal Bard," 97.

10. Knoppers, "(En)gendering Shame," 451.

11. See Matchinske, "Legislating 'Middle Class' Morality," 154–55, for a helpful gloss of this phrase.

12. Shakespeare, *Measure for Measure*, 2.4.123–28. All subsequent references appear parenthetically.

13. I see the play as more feminist and less restrictive than much contemporary criticism holds it to be. See, in particular, Matchinske, "Legislating 'Middle Class' Morality"; Carlson, "'Fond Fathers' and Sweet Sisters," 13–31; and Adelman, "Bed Tricks," 151–74.

14. See Malvasia, *Felsina pittrice*, 1:214–24; Pietrantonio, "L'immaginario degli artisti bolognesi," 97–111; Murphy, *Lavinia Fontana*, 16–20; and Fortunati, *Lavinia Fontana*, 187–88.

15. Berdini, "Women under the Gaze," esp. 573.

16. Woods-Marsden, "Portrait of the Lady," in 64–87, notes that brides' gifts (*donore*), containing items for women's adornment, were regulated by sumptuary laws for six years following the marriage; thus, portraits recording them would ordinarily fall within this time frame. Because sumptuary laws governed wives' adornment in public, the portrait records the penetration of public codes into the domestic space. On the probable distinction between what women wore in public and in private, see Woods-Marsden, "Portrait of the Lady," 65; and, on women's clothing, see Landini and Bulgarella, "Costume in Fifteenth-Century Florentine Portraits of Women," 90–97; and Frick, *Dressing Renaissance Florence*.

17. It has been suggested to me that this is an oeil-de-boeuf window. The oeil-de-boeuf, however, which becomes current in seventeenth-century French architecture, is by definition circular or oval.

18. Cropper, "Life on the Edge," 264. See also Cohen, "Honor and Gender in the Streets of Early Modern Rome," 597–625; and Cohen, "Trials of Artemisia."

19. Woods-Marsden, "Portrait of the Lady," 71.

20. Alberti, *Della pittura*, 70; *On Painting*, 56; and Woods-Marden, "Portrait of the Lady," 71. See also Alberti, *Della pittura*, 65; Alberti, *On Painting*, 51; and Brown, *Virtue and Beauty*, 106–8 and 172–75.

21. Tuke, *Treatise Against Painting*, 57.

22. Margherita from Milan, Orazio's laundrywoman for twenty years, testified at Tassi's trial for the Gentileschi, and Fausta Cicacconi, Agostino's landrywoman, appeared on his behalf. See "Testimony," 480, 483, and 485; and "Appendix," 434, 436, and 439.

23. Maidservants in Italian paintings of the period do not always function in this manner: consider, e.g., Titian's *Venus of Urbino*. The imagery and implications of the window in Prospero's painting, however, make the issue of surveillance central to the portrait's meaning and its subject's identity.

24. Fortunati, *Lavinia Fontana*, 187, calls Prospero's portrait "a fundamental model for Lavinia."

25. See Murphy, *Lavinia Fontana*, 38–47. On the portrait, see Cantaro, *Lavinia Fontana*, 72–74; King, "Looking a Sight," 392–93; Cheney, Faxon, and Russo, *Self-Portraits*, 58–60; Woods-Marsden, *Renaissance Self-Portraiture*, 216–17; McIver, "Lavinia Fontana's Self-Portrait Making Music," 3–8; and Bohn, "Female Self-Portraiture," 251–54.

26. Woods-Marsden, *Renaissance Self-Portraiture*, 216. Murphy, *Lavinia Fontana*, 41, notes that red was the traditional color of wedding dresses in sixteenth-century Bologna.

27. On Fontana's impressive education, see McIver, "Lavinia Fontana's Self-Portrait," 3; and Cantaro, *Lavinia Fontana*, 5–6.

28. The easel has been interpreted alternatively as figuring Lavinia's ambivalence toward her art and as showcasing her virtuosity. For the former view, see Woods-Marsden, *Renaissance Self-Portraiture*, 217; for the latter, see McIver, "Lavinia Fontana's Self-Portrait," 4–5.

29. The painting is now in Althorpe House. On the two works, see Ghirardi, "Lavinia Fontana allo specchio," 37–52; and Garrard, "Here's Looking at Me," 556–621.

30. As Murphy, *Lavinia Fontana*, 43–44, points out, the marriage contract indicates that both families intended for Lavinia to continue to paint. She did so through eleven pregnancies.

31. See, e.g., Anguissola, *Self-Portrait in Miniature*. See also Ferino-Padgen and Musche, *Sofonisba Anguissola*, 22–23; King, "Looking a Sight," 387–90; and Ghirardi, "Lavinia Fontana," 38–39.

32. See Alberti, *Della pittura*, 100; *On Painting*, 83. See also Cheney, "Lavinia Fontana," 39, for a similar reading of Fontana's Uffizi *Self-Portrait in the Studio*.

33. See Brown, intro., in Brown, *Virtue and Beauty*, 12, on Renaissance portraiture's adoption of Petrarchan ideals.

34. On light, see Alberti, *Della pittura*, 62–65; *On Painting*, 48–51.

35. On the virginal as a symbol of women's virginity, see Garrard, "Here's Looking at Me," 588–89; and, on the *cassone* as an emblem of marriage, see Murphy, *Lavinia Fontana*, 43.

36. Murphy, *Lavinia Fontana*, 45; see also McIver, "Lavinia Fontana's Self-Portrait," 3.

37. McIver, "Lavinia Fontana's Self-Portrait," 5 and 8 n. 24, notes that one copy is now in the Uffizi and the other is known only through a photograph. See also Cantaro, *Lavinia Fontana*, 74. I disagree that the first version was also conceived as a public relations tool, as McIver argues.

38. On the different career options available to Lavinia and Artemisia, resulting from Prospero's relative wealth and Orazio's relative penury, see Cavazzini, "Artemisia Gentileschi," 283–84.

39. Cohen, "Trials of Artemisia," 74.

40. Dean, "Fathers and Daughters," 87–88.

41. A witness recalls having chastised the thief in terms that echo the etymology of *raptus:* "You should also be ashamed of taking a painting . . . from this girl, just as if she were obliged to pay you for [not] having given you a copy of her *naturale*" ("doveresti vergognarvi di pigliare da questa fanciulla una quadro di quella sorte come proprio ella sia anco obbligato pagarvi per haver. data copia del suo naturale") (437; *Atti* 76). Christiansen and Mann, *Orazio and Artemisia*, 85, identify the painting in question as *Judith and Her Maidservant*, now in a private collection.

42. See Cohen, "Trials of Artemisia," 59–60; and Spear, "Artemisia Gentileschi," 570.

43. Cavallo and Cerutti, "Female Honor," 76.

44. Ruggiero, *Boundaries of Eros*, 31. See also Cohen, "No Longer Virgins," 169–91, for testimony relevant to Artemisia's; and see Cohn, *Women in the Street*, esp. 98–136.

45. See Ruggiero, *Boundaries of Eros*, 31 and 97.

46. Cavallo and Cerutti, "Female Honor," 74. See also Cohen, "Trials of Artemisia," 58.

47. Hayne, "Performing Social Practice," 5. See also Amussen, *Ordered Society*, 103–4, on early modern confusion on marriage; Matchinske, "Legislating 'Middle Class' Morality," 162–63, on English marriage law and *Measure for Measure;* and Lever's introduction to *Measure for Measure*, liii–liv, for the implications of this confusion in the play.

48. Cavallo and Cerutti, "Female Honor," 89.

49. See Brucker, *Giovanni and Lusanna*, esp. 26–33, 35–36, and 72–74.

50. Tassi claims that a "desperate" ("disperatissimo") Orazio "had brought the said Tuzia to live in the same house" as "a remedy for the many troubles his daughter was causing him by being wild and leading a bad life" ("ch'haveva messa a stare la detta Tutia in sua compagnia nell'istessa casa . . . di posser riparare a molti disguisti, che detta sua figliola gi dava con essere sfrenata e tenere cattiva vita") ("Testimony," 446; *Atti* 90).

51. On Tuzia's testimony, see Cohen, "Trials of Artemisia," 62–63.

52. Cohen, "Trials of Artemisia," 72. See also Garrard, *Artemisia Gentileschi*, 21.

53. Artemisia's "open marriage" to Pierantonio Stiattesi may imply a similarly troubled relationship to the patriarchal household. Although few domestic scenes are included in the Gentileschi's oeuvre, with the exceptions of Orazio's *Annunciation* (1623; Galleria Sabauda, Turin) and Artemisia's *Birth of Saint John* (c. 1633–35, Museo Nacional del Prado, Madrid), this fact reflects the drama of their Caravaggesque style rather than a position on domesticity per se.

54. Cohen, "No Longer Virgins," speculates that Artemisia's testimony may have been prepared in advance, given its conformity to the standard patterns of trials for *stupro violente*. See also Spear, "Artemisia Gentileschi," 570.

55. Alberti, *Della pittura*, 59; *On Painting*, 55.

56. ffolliott, "Learning to Be Looked At," 111, argues that the *velo* utilized by Artemisia in Merlet's film renders the female artist a spectacle.

57. On the logic governing the torture of victims in rape trials, see Cohen, "Trials of Artemisia," 58–59.

58. Ibid., 52. See also Cropper, "Life on the Edge," 264.

59. See, e.g., Lapierre, *Artemisia*; Banti, *Artemisia*; and, most recently, Vreeland, *Passion of Artemisia*. Agnès Merlet's *Artemisia* (1997) was met with vigorous criticism by feminists and art historians for historical inaccuracies and its romanticized portrayal of the relationship with Tassi. See Spear, "Artemisia Gentileschi;" 570–71; ffolliott, "Learning to Be Looked At"; and Pollock, "Hungry Eye," 26–28.

60. Garrard, *Artemisia Gentileschi*, 208 and 311.

61. Bissell, *Artemisia Gentileschi*, exemplifies the former; Pollock, *Differencing the Canon*, 97–127, the latter. For a measured review of Bissell's book, see Spear, "Artemisia Gentileschi," 571–75; and see Garrard's response to Pollock in *Artemisia Gentileschi around 1622*, xix–xxi.

62. For Garrard's negative assessment of the Metropolitan exhibit, see Garrard, "Painting with Crude Strokes," 56.

63. See Ciletti, "Patriarchal Ideology," 35–70.

64. On the painting, see Garrard, *Artemisia Gentileschi*, 38–39, 51–53, 326, and 337–38; Christiansen and Mann, *Orazio and Artemisia*, 347–50; Spear, "Artemisia Gentileschi," 569–71; Pollock, *Differencing the Canon*, 115–24; Bissell, *Artemisia Gentileschi*, 43–44 and 104–5; and Cropper, "Artemisia Gentileschi," 204–9.

65. This is more clearly the case in Artemisia's earlier version of the scene, painted around the time of the trial, now in Naples. On the two versions, see Garrard, *Artemisia Gentileschi*, 307–13 and 321–27; Christiansen and Mann, *Orazio and Artemisia*, 308–11 and 347–49; and Wagstaff, "Weltering in Blood," 194–97.

66. Pollock, "Hungry Eye," 28. The position is elaborated in *Differencing the Canon*, 122–24, and critiqued by Spear, "Artemisia Gentileschi," 570–71.

67. *Book of Judith*, 10:3–4.
68. Levine, "Sacrifice and Salvation," 7:217.
69. Greer, *Obstacle Race*, 189.
70. Quoted in Ciletti, "Patriarchal Ideology," 68.
71. Bartas, *La Judit*, 49; *Historie of Judith*, 51. Early modern versions of Judith's story emphasize her role as an artist and orator: Bartas, *La Judit*, 52–53 (*Histoire of Judith*, 56–57), includes an *ekphrasis* of Judith's tapestries, while the anonymous *La Rappresentatione di Judith Hebrea*, A5–A5v, presents Judith's speeches to the Israelites. See also Bohn, "Antique Heroines," 66. Judith's associations with the colors of cosmetics and rhetoric and with the art of painting made her an attractive model for female artists.
72. Bartas, *La Judit*, 57; *Historie of Judith*, 63.
73. Bartas, *La Judit*, 65; *Historie of Judith*, 73. Holofernes names Semiramis and Helen as painted counterfeits of Judith's beauty.
74. Bartas, *La Judit*, 50; *Historie of Judith*, 52.
75. Stocker, *Judith, Sexual Warrior*, 29. For discussion of these genres, see 28–35.
76. Ibid., 9.
77. Lichtenstein, "Making Up," 85.
78. Stocker, *Judith*, 17–18.
79. On the painting, see Garrard, *Artemisia Gentileschi*, 8–9, 39–41, 200, and 313–19; Christiansen and Mann, *Orazio and Artemisia*, 330–33; Bissell, *Artemisia Gentileschi*, 198–203; Greer, *Obstacle Race*, 189–91; and LaPierre, *Artemisia*, 144–47 and 445–48.
80. Garrard, *Artemisia Gentileschi*, 320.
81. See Simons, "Women in Frames," 39–57.
82. On the painting, see Christiansen and Mann, *Orazio and Artemisia*, 82–86; Bissell, *Artemisia Gentileschi*, 12–13 and 198–201; and Spike, "Review of Florence 1991," 733.
83. Christiansen and Mann, *Orazio and Artemisia*, 85–86.
84. See Garrard, *Artemisia Gentileschi*, 317–19. On the jewelry in the Uffizi *Judith*, see 325–27.
85. Stocker, *Judith*, 18. On the painting, see Garrard, *Artemisia Gentileschi*, 67–72 and 328–35; Christiansen and Mann, *Orazio and Artemisia*, 368–70; and Bissell, *Artemisia Gentileschi*, 219–20.
86. Garrard, *Artemisia Gentileschi*, 330–31.
87. Berdini, "Woman under the Gaze," 585–86, argues that the Detroit *Judith* destabilizes the humanist regime of vision and displaces the male gaze, effects he describes as typically Baroque.
88. Pollock, *Differencing the Canon*, 112–13.
89. On the work, see Garrard, *Artemisia Gentileschi*, 15–18 and 182–209; Christiansen and Mann, *Orazio and Artemisia*, 297–99; Pollock, *Differencing the Canon*, 111–14; Greer, *Obstacle Race*, 191; Bissell, *Artemisia Gentileschi*, 187–89; Cropper, "Artemisia Gentileschi," 195–202; Cropper, "Life on the Edge," 276–78; and Spike, "Review," 723.
90. Aylet, *Susanna*, 16–18, typifies literary treatments of Susanna, which usually anatomize her in lengthy blazons. Like Bartas's Judith, Aylet's Susanna is an artist; thus, he includes an *ekphrasis* of her needlework (13–14).
91. Pollock, *Differencing the Canon*, 114.
92. See Diehl, "Infinite Space," 393–410; and Jankowski, "Pure Resistance," 218–55.
93. See Matchinske, "Legislating 'Middle-Class' Morality," 174, for a similar argument about Sowernam's *Ester Hath Hang'd Haman*.

94. Whetstone, *Promos and Cassandra*, A4. All subsequent references appear parenthetically.

95. See Friedman, "O let him marry her!" 454–64.

96. See, e.g., Whetstone, *Promos and Cassandra*, E2, F1, F4v, and H2.

97. Bartas, *La Judith*, 50; *Historie of Judith*, 52.

98. See Phillippy, *Women, Death and Literature*, 109–38.

99. See Herbert, *History of the Twelve Great Livery Companies*.

100. On Fontana, see McIver, "Lavinia Fontana's Self-Portrait," 3; and Murphy, *Lavinia Fontana*, 45; and, on Artemisia, see Cropper, "Life on the Edge," 268. See also Barzman, *Florentine Academy*. Levina Teerlinc may have offered Shakespeare a local example of a female painter, but she was regularly identified as a "gentlewoman" rather than as a member of the London Painter-Stainers Company. On Teerlinc, see Auerbach, *Tudor Artists*, 75–77 and 104; McManus. "Queen Elizabeth," 43–66; and Cheney, Faxon, and Russo, *Self-Portraits*, 35–36.

101. Smith, *Wonder of Wonders*, A2.

102. Jankowski, "Pure Resistance," 223.

103. Tuzia testifies that Orazio "warned me not to speak to his daughter about husbands, rather that I should persuade her to become a nun" ("avvertita e non dir alla sua figliola nè parlarli di mariti, ma che li persuadessi il farse monaca"), a suggestion that Artemisia refused ("Testimony," 421; *Atti* 59).

104. Thus, Aylet, *Susanna*, B4v, describes women's face painting.

105. See Adelman, "Bed Tricks," 151–74.

106. Carlson, "Fond Fathers," 17 and 22.

107. McKluskie, "Patriarchal Bard," 95–96.

108. The boy's presence in the grange plays upon what Jankowski, "Pure Resistance," 232, calls "the Protestant imagination of the Catholic nunnery as place of woman's erotic autonomy."

109. Critics have often seen Angelo's problematic justice as a critique of Puritanism: see, e.g., Diehl, "Infinite Space," 395; and Hayne, "Performing Social Practice," 18–20. The law's unfortunate impact on other informal networks is also clear: Mistress Overdone reports that "Mistress Kate Keep-down was with child by [Lucio] in the Duke's time, he promised her marriage. His child is a year and a quarter old come Philip and Jacob. I have kept it myself" (*MM* 3.2.192–97). Her arrest deprives the child of the support provided by this informal alliance, and, when the Duke seeks to repair the damage by replacing that alliance with marriage, Lucio complains, "I beseech your lord, do not marry me to a whore . . . Marrying a punk, my lord, is a pressing to death, / Whipping and hanging" (5.1.511–21).

110. Amussen, *Ordered Society*, 109–12, suggests that the decrease in legal marriage disputes from the sixteenth to the seventeenth century reflects the ubiquity and success of informal controls on marriage in England. The law's remoteness is implied by the Duke's disguise and Isabella's query, "To whom should I complain? Did I tell this, / Who would believe me?" (*MM* 2.4.170–71), which revises Cassandra's resolve to appeal for justice to the king, "I wyll recount my wretched state, / Lewde Promos rape, my Brothers death, and all" (Whetstone, *Promos and Cassandra* 1.5.6, F4v). By contrast, the Duke himself must encourage Isabella to appeal to him for remedy (*MM* 4.3.125ff.).

111. See Hayne, "Performing Social Practice," 27–29, for this persuasive argument.

112. Ibid., 12.

113. Knoppers, "(En)gendering Shame," 455.
114. Hayne, "Performing Social Practice," 13.
115. See Carlson, "Fond Fathers," 22.
116. See Cavallo and Cerutti, "Female Honor," 79–81.
117. Agrippa, *Glory of Women*, 22.
118. See Diehl, "Infinite Space," 406.
119. See also *MM* 2.2.64–67; and see Lupton, *Afterlives of the Saints*, esp. 135–36, on the play's understanding of mercy as an empathetic internalization of the law.
120. Quoted in Hayne, "Performing Social Practice," 15.
121. See Knoppers, "(En)gendering Shame," 464.
122. See DiGrangi, "Pleasure and Danger," 589–609.
123. See Cavazzini, "Artemisia Gentileschi," 287–88; and Bissell, *Artemisia Gentileschi*, 16.
124. Cropper, "Life on the Edge," 279.
125. Gentileschi's *Lucretia* (1623–25), now in Milan, illustrates this resistance and resonates with Artemisia's testimony that, following the rape, she threatened Tassi with a knife and drew blood ("Testimony," 416; *Atti*, 49). On the painting, see Garrard, *Artemisia Gentileschi*, 216–39; Christiansen and Mann, *Orazio and Artemisia*, 361–64; Pollock, *Differencing the Canon*, 158–64; Lapierre, *Artemisia Gentileschi*, 471–72; Cropper, "Artemisia Gentileschi," 209; and Bissell, *Artemisia Gentileschi*, 36–37 and 189–91.

THREE: The Mirror of Socrates

1. Lemnius, *Les Occultes merveilles*, 324; *Secret Miracles of Nature in Four Books*, 144.
2. The anecdote originates in Laertius, *Lives, Opinions and Remarkable Sayings*, 120. See also Corrozet, *Hecatomgraphie*, n.p.; Rich, *My Ladies Looking Glasse*, 1; Buoni, *I problemi*, 46–47; and *Problems of Beautie*, 53–54.
3. Lemnius, *Les Occultes mervilles*, 327; *Secret Miracles*, 145. Lemnius also compares this to "les caracteres d'Imprimerie" (printing presses).
4. Melchoir-Bonnet, *Mirror*, 187.
5. Ibid., 192.
6. Ripa, *Della novissima iconologia*, 310.
7. Day, *Mirror of Modestie*, 33–34.
8. Lessius, *Widdowes Glasse*, 280–81.
9. Tuke, *Treatise Against Painting*, 42.
10. Calvin, *Institutes of the Christian Religion*, 1:96; *Institutionum Christianae Religionis*, 20.
11. Aston, *England's Iconoclasts*, 1:7–8, notes that reformers considered the Eucharist, and thus the High Mass, the most idolatrous of Catholic forms.
12. Calvin, *Quatre sermons de M. Jean Calvin*, 829–30.
13. Calvin, *Foure godlye sermons*, B2–B2v.
14. Quoted in Tuke, *Treatise Against Painting*, B2.
15. Calvin, *Quatre Sermons*, 830; *Foure godlye sermons*, B2v.
16. Barasch, *Icon*, 118. See also Martin, *History of the Iconoclastic Controversy*.
17. Tuke, *Treatise Against Painting*, 3. See also Cognet, *Politique Discourses*, 185.
18. Downame, *Second Part of the Christian Warfare*, 1:134–35.
19. O'Connell, *Idolatrous Eye*, 56–58, argues that iconoclasm results from the decline

of the incarnational structure of late medieval worship toward Reformation logocentrism.

20. Liébault (1535–96) was a physician in Dijon and Paris and son-in-law of the printer Charles Estienne. He is best known for his edition of Estienne's *L'Agriculture et maison rustique* (1564). He translated three of Marinello's cosmetic and gynecological works; his Latin translation of *Gli ornamenti delle donne, De cosmetica seu ornatu et decoratione,* is the model for the *Trois livres.* In 1570 Liébault became the first person to grow tobacco in France, which he named *nicotine* in honor of Jean Nicot.

21. Navarre, *Le Miroir de Jhesus Christe crucifié,* ed. Fontanella, l. 2. All subsequent citations are to this edition and appear parenthetically, indicated by the abbreviation *MJCC.* The poem first appeared as *Le Miroeur de Jesus-Christe crucifié* and was reissued by Pierre Olivier as *L'Art et usage du soverain miroeur du chrestien, composé par excellent princesse madame Marguerite de France, royne de Navarre,* in 1556. On the editions, see Clive, *Marguerite de Navarre,* 38–39; Ferguson, "Now in a Glass Darkly," 400–402; and LeBègue, "Le Second *Miroir* de Marguerite de Navarre," 46–56.

22. Liébault, *Trois livres,* a5. All subsequent citations appear parenthetically.

23. Even the most entrenched anti-cosmetic polemicists occasionally allow the remedial use of cosmetics: see, e.g., Taylor's *Glasse for Gentlewomen,* 19. Obviously, the repair of defects is a ubiquitous defense of painting in cosmetic manuals.

24. The condition was controversial: Hall, *Appendix,* 104–5, argues that wives are not compelled to obey husbands' immoral commands, including demands that they paint; and anon., *Primitive Christian Discipline Not to be Slighted,* 97, calls the argument a rationalization. Liébault alludes to Esther, a wife who resists her husband's unethical commands (a5), acknowledging the difficult status of his claim. See chap. 5.

25. See also Porta, *Della magia naturale,* 378–78; *Naturale Magick,* 233.

26. See Agrippa, *Sur la noblesse,* 33–34; *Of the Nobilitie,* A3v–A4.

27. For Agrippa's blazon, see *Sur la noblesse,* 44–47; and *Of the Nobilitie,* B2v–B3v. Liébault's blazon continues for nearly two pages.

28. Agrippa, *Sur la noblesse,* 33; and *Of the Nobilitie,* A2v–A3.

29. Agrippa, *Sur la noblesse,* 44; and *Of the Nobilitie,* B2.

30. Since he writes on women's beauty, Liébault admits the superficiality of his text: "Celle est la beauté, de laquelle avons deliberé de discourir en ce traitté en la faveur des femmes (deliassant la contemplation de l'autre beauté pour une plus grande & serieuse etude)" (a4v) (This is the beauty which we have decided to discuss in this treatise in favor of women [leaving aside the contemplation of the other beauty for a more grand and serious study]).

31. It is unclear whether cosmetics' poisonous effects were understood in the sixteenth century, even by doctors such as Liébault. See DeGalan, "Lead White or Dead White?"

32. Fioravanti, *Le Miroir universel,* 518–20; *Dello specchio,* 310–10v. The passage is partially translated into English by Haydocke, *Tracte,* 133.

33. Smith, *Wonder of Wonders,* A2.

34. Bucer, *Treatyse,* B3. On the work, see Aston, *England's Iconoclasts,* 203–10.

35. Fox, *Iconoclastes,* 3–5.

36. See Melchoir-Bonnet, *Mirror,* 200–205.

37. See Eire, *War against the Idols,* 19–20 and 36; and Barasch, *Icon,* 185–253.

38. Paleotti, *Discorso,* "Proemio" and 8. See also *Discorso,* 75 and 77v on the *Biblia pau-*

perum; and Boschloo, *Annibale Caracci in Bologna,* 1:10–13 and 121–55, on Paleotti's biography and his influence.

39. Paleotti, *Discorso,* 8.

40. Sander, *Treatise,* 15. The treatise was first published in 1567. On natural and artificial images, see 94–97.

41. Ibid., 11.

42. Calvin, "On Shunning the Unlawful Rites," 3:393; *Epistulae duae,* 58. Beza's French translation is found in Calvin, *Comment il faut eviter et fuir les ceremonies,* 82.

43. Bucer, *Treatyse,* B5–B6.

44. See Eire, *War against the Idols,* esp. 31–41; Miles, *Image as Insight,* 113–18; and O'Connell, *Idolatrous Eye.*

45. Calvin, *Institutes,* 1:94; *Institiuionum,* 20.

46. Calvin, *Institutes,* 1:104–7 and 89; *Institiuionum,* 23–24 and 18. Bucer, *Treatyse,* B8v, offers the same argument. Erasmus also supports the Bible's primacy over visual icons and private readership of the Word: see O'Connell, *Idolatrous Eye,* 36; and see 51–56, on the increasing iconoclasm among reformers influenced by Erasmian humanism.

47. Paleotti, *Discorso,* 7 and 83v.

48. Fox, *Iconoclastes,* 4–5.

49. Paleotti, *Discorso,* 66.

50. Bucer, *Treatyse,* E3–E3v.

51. See Aston, *England's Iconoclasts,* 466–72, on the common conflation of idolatry and adultery.

52. Calvin, *Quatre sermons,* 832–33; *Four godlye sermons,* B8v–C1.

53. Calvin, *Quatre sermons,* 833; *Four godlye sermons,* C2.

54. Calvin, *De fugiendis impiorum,* 51; "On Shunning the Unlawful Rites," 3:389.

55. Navarre, *Le Miroir de l'âme pécheresse,* ed. Salminen, ll. 833–34. All subsequent citations by line are to this edition and appear parenthetically, indicated by the abbreviation *MAP.* English translation is from the facsimile of Elizabeth's manuscript "The Glasse of the Synnefull Soule," in Shell, *Elizabeth's Glass,* 39. All subsequent citations are to this edition, unless otherwise noted. See Prescott, "Pearl of the Valois and Elizabeth I," 61–76, on Elizabeth's translation.

56. For a similar view, see Cottrell, *Grammar of Silence,* 105–6.

57. Snyder, "Guilty Sisters," 450.

58. Cottrell, *Grammar of Silence,* 129, argues that the 1552 edition of *MJCC* contains thirty-three pages, rendering it an "icon" of the *corpus Christi.*

59. See Ferguson, *Mirroring Belief;* and Salminen, *Le Miroir de l'âme pécheresse,* 70–84. See also Ferguson, *Dido's Daughters,* 225–26, on Marguerite's indebtedness to Marguerite Porete's fourteenth-century book *Le Miroeur des simples ame;* and see Porete, *Le Miroeur des simples ames,* 501–636.

60. The first *Miroir* was reprinted seven times before 1539; see Ferguson, *Dido's Daughters,* 227; and Salminen, *Le Miroir de l'âme pécheresse,* 1–21. On the Sorbonne's censure, see Salminen, 22–30; Ferguson, "Now in a Glass Darkly," 398–40; and Prescott, "Pearl of the Valois," 63.

61. Salminen, *MAP,* 22.

62. See ibid., 23–24; and Eire, *War against the Idols,* 190–91.

63. Snyder, "Guilty Sisters," 445 n. 4, suggests that Marguerite's "Pauline emphasis

on primacy of faith" and her reliance on Lefèvres's unsanctioned translations may explain the Sorbonne's censure. See also Salminen, *MAP*, 73.

64. On the influence of Briçonnet's ideas on the first *Miroir*, see Salminen, *MAP*, 40–62; Ferguson, *Mirroring Belief*, 181–200; and Cotrell, *Grammar of Silence*, 10–12 and 19–33. See also Martineau, Veissière, and Heller, *Guillaume Briçonnet–Marguerite d'Angoulême*.

65. On the Lefèvres circle and its influence on Calvin's iconoclasm, see Eire, *War against the Idols*, 168–81. On Marguerite's relationship with the reformers at Nérac, see Kinney, *Continental Humanist Poetics*, 135–40.

66. See Cottrell, *Grammar of Silence*, 105.

67. This image may be based upon Astolfo, transformed by Alcina into a myrtle in Ariosto's epic poem *Orlando Furioso*, 1:6:26–53.

68. See Jourda, *Marguerite d'Angoulême*, 380, for a reading of the mirror as "moins un poème qu'une longue effusion, une confession" (less a poem than a long effusion, a confession). For discussion, see Sommers, *"Le Miroir de l'âme pécheresse* Revisited," 101.

69. Lukach, "Reflecting Images," argues that *MAP* employs the symbolism of baptism, *MJCC* of the Eucharist, suggesting Marguerite's reformed view of the sacraments. See also Cottrell, *Grammar of Silence*, 128.

70. For moments of Eucharistic imagery in *MJCC*, see 80, 117, 640, 660, 677–78, 803–5, 938, 958, 993, 1305–6, 1325–30, 1338–40, and 1349.

71. The passage alludes to Matthew 5:36, "we cannot make one hair of our head white or black," commonly cited to condemn women's painting. See chap. 5.

72. Lessius, *Widdowes Glasse*, 280–81.

73. Anon., *Primitive Christian Discipline*, 31.

74. Grabes, *Mutable Glass*, 107.

75. The image of washing in or drinking the blood of Christ is frequent in the poem: see also 80, 640, 660, 677–78, 938, 958, and 978–79.

76. The curators suggest that the elephant illustrates the Latin proverb "the Indian elephant is not afraid of flies"; the goose carrying a pin symbolizes the ability to break down large things with small but sharp objects; braided hair represents profane love; and the ermine is a symbol of purity.

77. On the tendency to reprint stock images in early modern title pages, see Pollard, *Last Words on the History of the Title-Page*; Laufer, "L'Espace visuel du livre ancien," 1:483–92; and Chatelain, "L'Esthétique du frontispice," 354–63. I am grateful to Craig Kallendorf for bibliography on this question.

78. Agrippa, *Sur la noblesse*, 45; *Of the Nobilitie*, E2v.

79. E.g., Agrippa, *Sur la noblesse* 41–42; *Of the Nobilitie*, D7–D7v; and Castiglione, *Il libro del cortegiano*, 227–39; *Book of the Courtier*, 223–36.

80. On Paleotti's influence on Fontana, see Murphy, *Lavinia Fontana*, 2–4 and 31–36; and Fortunati, "Lavinia Fontana," 13–31.

81. Caterina Spada, in Fortunati, *Lavinia Fontana*, 106.

82. A similar visual rhetoric marks Fontana's Uffizi *Noli me tangere* (1581), which embodies Magdalen's viewpoint by depicting Christ as a gardener: see Granziani, in Fortunati, *Lavinia Fontana*, 66; Murphy, *Lavinia Fontana*, 31–34; and Cantaro, *Lavinia Fontana*, 102–3 and 215. Fontana's emphasis on women's intimacy with Christ is also evident in *Christ and the Canaanite Woman* (1576–77), in a private collection in Venice: see Murphy, *Lavinia Fontana*, 35–38; and Cantaro, *Lavinia Fontana*, 68–69.

83. Fontana was influenced in several paintings by Tasso's *Discorso della virtù feminile e donnesca.* See Fortunati, "Lavinia Fontana," 27 and 29–30. Fontana's painting *The Visit of the Queen of Sheba to Solomon* (Dublin, National Gallery of Ireland), in particular, has been associated with Tasso's text: see Tufts, "Successful 16th Century Portrait," 60–64.

84. Cantaro, *Lavinia Fontana*, 215.

85. See Mâle, *Religious Art*, 167–99; and Jones and Worcester, *From Rome to Eternity*, on Counter-Reformation approaches to images; and see Miles, *Image as Insight*, 95–125, on Protestant and Post-Tridentine views on imagery and personal devotion.

86. Calvin, *De fugiendis impiorum*, 57–58; "On Shunning the Unlawful Rites," 3:393. Erasmus uses the Samaritan in a similar argument: see Eire, *War against the Idols*, 36.

87. Alberti, *On Painting*, 64; *Della pittura*, 77–78.

88. Paleotti, *Discorso*, 71.

89. Ibid., 69–69v.

90. Paleotti, *Discorso*, 47v–48.

91. As transcribed by Spada, in Fortunati, *Lavinia Fontana*, 106. On the date and signature, see Cantaro, *Lavinia Fontana*, 215. Until her marriage Fontana signed her paintings as "Lavinia Fontana Prosperi Fontanae Filia." Her inclusion of both names in *Christ and the Samaritan Woman* emphasizes her roles as daughter and wife of painters. See Fortunati, "Lavinia Fontana," 14–15.

92. Murphy, *Lavinia Fontana*, 20.

F O U R : Colors and Essence

1. Gallery label, Victoria and Albert Museum, London, Museum no. M.78-1910. On similar bottles, see Doran, *Elizabeth*, 104–5.

2. See Richlin, "Making Up," 189–95.

3. Sander, *Treatise*, 31–32.

4. See Strong, *Portraits of Queen Elizabeth I; Elizabethan Image;* and *Cult of Elizabeth.*

5. On the records of Elizabeth's apothecary, see LaWall, *Four Thousand Years of Pharmacy*, 233. Loomis, "Brittle Gloriana," discusses inventories of Elizabeth's mirrors. I am grateful to Dr. Loomis for sharing her work with me. The Victoria and Albert Museum owns a pestle and mortar with a Tudor Rose design from Elizabeth's court (c. 1600; Museum no. M991–1926), used for grinding cosmetics: see Doran, *Elizabeth*, 116.

6. Quoted in Foley, *Records of the English Province of the Society of Jesuits*, 1:8. See Strong, *Portraits*, 18–19; and Mullaney, "Mourning and Misogyny," 139–49, for similar accounts. I am indebted to Anna Riehl for her commentary on this passage.

7. Gunn, *Artificial Face*, 185.

8. Platter, *Thomas Platter's Travels*, 192.

9. Smith, *Wonder of Wonders*, 21.

10. Taylor, *Glasse for Gentlewomen*, 41–44. The King James Bible translates Taylor's *inward comeliness* as *discretion.*

11. I refer to Stubbes, *Crystall Glasse for Christian Women* (1591), which went through thirty-four editions before 1700.

12. I am indebted to Frick, "Crimson, Feathers, and Pearls." See also Frick, *Dressing Renaissance Florence.*

13. Cooper, "Queen's Visual Presence," 179.

14. See Strong, *Portraits*, 9. See also Cooper, "Queen's Visual Presence," 192.

15. Cooper, "Queen's Visual Presence," 179. On the gown in the *Phoenix Portrait* and Elizabeth's wardrobe generally, see Arnold, *Queen Elizabeth's Wardrobe Unlock'd*, esp. 22–25.

16. Hilliard's training as a goldsmith supports viewing the jewel as a synecdoche of the queen and suggests a similar function for his miniatures of Elizabeth. See Strong, *Nicholas Hilliard*, 4; Auerbach, *Nicholas Hilliard*, 1–16; and Thornton and Cain, intro., in Hilliard, *Treatise*, 26–28.

17. On Anglican iconoclasm, see Aston, *England's Iconoclasts*, 220–342; Phillips, *Reformation of Images*; O'Connell, *Idolatrous Eye*; Siemon, *Shakespearean Iconoclasm*, esp. 1–44; and Duffy, *Stripping of the Altars*. On Elizabethan portraiture's response to iconoclasm, see Strong, *Portraits*, 33–40; Gent, *Painting and Poetry*; and Pomeroy, *Reading the Portraits of Queen Elizabeth*.

18. Tuke, *Treatise of Painting*, 2–3.

19. Hammond, *Idolatry*, 2.

20. Jewel, *Defence*, 497. Sander, *Treatise*, 121–22, replies to Jewel. Zurich reformer Ulrich Zwingli also defines *idolatry* as "raising of the creature over God through the deception of the devil" (qtd. in Eire, *War against the Idols*, 76). Eire notes that this is a standard definition of idolatry among reformers. On Zwingli's reforms in Zurich, see ibid., 73–83; and Miles, *Image as Insight*, 98–108.

21. Tuke, *Treatise Against Painting*, 2.

22. Bucer, *Treatyse*, B2v–B3.

23. Ainsworth, *An Arrow Against Idolatrie*, 3 and 126–27.

24. Elizabeth I, *Elizabeth I: Collected Works*, 326.

25. Bale, *Godly Medytacyon*, A7v–A8. All subsequent citations are to this edition, unless otherwise noted, and are included parenthetically. Shell, *Elizabeth's Glass*, 77–103, reprints Bale's framing materials.

26. Hilliard, *Treatise*, 86.

27. Gent, *Painting and Poetry*, 6.

28. See Gent, *Painting and Poetry*, 9–17; and Barkan, "Making Pictures Speak."

29. The work has been identified as a miniature in the National Portrait Gallery, London (no. 108), dated 1572. See Thornton and Cain, intro., in Hilliard, *Treatise*, 26; Auerbach, *Nicholas Hilliard*, 63–64; and Cooper, "Queen's Visual Presence," 176.

30. Quoted in Gent, *Painting and Poetry*, 19.

31. Hilliard, *Treatise*, 70.

32. Haydocke, *Treatise*, 185; Lomazzo, *Trattato*, 251.

33. Hilliard, *Treatise*, 72. See also 62–70.

34. Haydocke, *Treatise*, 3–4. On Haydocke's censorship of Lomazzo, see Phillips, *Reformation of Images*, 119–20. Gent, *Painting and Poetry*, 31, notes that painting's affiliation with the *Biblia pauperum* contributed to its low status, as a plebeian undertaking, in Elizabethan England.

35. Haydocke, *Treatise*, 207; Lomazzo, *Trattato*, 270.

36. Gent, *Painting and Poetry*, 18.

37. Hilliard, *Treatise*, 90. While the editors suggest that Hilliard's allusion to "women painters" refers to Levinia Teerlinc (133 n. 57), the plural implies a reference to women's cosmetic practices. On the English literature on pigments, see Harley, *Artists' Pigments*, 1–14.

38. Tuke, *Treatise Against Painting*, 61.

39. Haydocke, *Treatise*, 14; Lomazzo, *Trattato*, 19.

40. Day, *Mirror of Modestie*, 33–34.

41. See Strong, *Elizabethan Image*, n.p.; Phillips, *Reformation of Images*, 114; and Aston, *England's Iconoclasts*, 314–15. The view of images as indifferent and rejection of "abused images" returns to Henry VIII's position on idolatry. The official Anglican position on images is also moderate: see Jewel, *Apologie*, esp. 46–46v.

42. PRO S.P. 12/31, no. 25. See Strong, *Portraits*, 5–6; and Englefield, *History of the Painter-Stainers Company*, 53–55. Elizabeth took similar steps throughout the 1570s and 1580s to control the sale and quality of her portraits: see Strong, *Portraits*, 6–7. Hilliard seems to have provided the pattern for Elizabethan portraits, although he was never given an official post. A draft patent (never approved) was drawn up by George Gower (appointed Sergeant Painter in 1581) and Nicholas Hilliard proposing that they share a monopoly on the production of Elizabeth's portraits. See Madden, "Portrait Painters of Queen Elizabeth," ser. 1, vi, 1852, 238, for full transcript.

43. Evelyn, *Scupltura*, 25.

44. PRO S.P. 12/31, no. 25, in Englefield, *History*, 53.

45. This discussion is indebted to Loomis, "Brittle Gloriana."

46. Jonson, "Conversations with William Drummond," 1:141–42.

47. Bucer, *Treatise*, B3v. For a treatment of Elizabeth's legacy that discounts the notion of a Stuart era nostalgia for the queen, see Watkins, *Representing Elizabeth in Stuart England*, esp. 33–34.

48. The conclusion of the film *Elizabeth*, dir. Kapur, illustrates this transformation of Elizabeth's body into a canvas. See also Mullaney, "Mourning and Misogyny," 147.

49. Rich, *My Ladies Looking Glasse*, 1–2. See also Scot, *Discoverie of Witchcraft*, 316, on false mirrors; and, for discussion, see Loomis, "Brittle Gloriana," 6.

50. Southwell, "True Relation of what succeeded at the sickness and death of Queen Elizabeth," transcribed in Loomis, "Elizabeth Southwell's Manuscript Account," 492–509. Persons, *Discussion of the Answere of M. William Barlow*, 218, reprints Southwell's account.

51. Klein, "Your Humble Handmaid," 477.

52. Ibid., 481. In 1544 Elizabeth had angered her father and was sent away from the royal household, but later, perhaps through Katherine's mediation, she was recognized as legitimate and restored to the royal succession. On Elizabeth's tumultuous childhood and the question of her illegitimacy, see Doran, *Elizabeth*, 9–24; and Shell, *Elizabeth's Glass*, 3–22.

53. Klein, "Your Humble Handmaid," 480.

54. Quilligan, "Incest and Agency," 216 and 231. See also Ferguson, *Dido's Daughters*, 227.

55. On *The Coronation Portrait* (c. 1600), now in the National Portrait Gallery, London (NPG 5175), see Doran, *Elizabeth*, 43; and Strong, *Portraits*, 89.

56. Quilligan, "Incest and Agency."

57. John Donne deploys the *noli me tangere* topos to support the Anglican position that images are indifferent: "When Christ devested, or supprest the Majesty of his outward appearance at his Resurrection, Mary Magdalen took him but for a Gardiner." Quoted in Phillips, *Reformation of Images*, 149. Bentley's 1582 reprinting of Elizabeth's *Glasse* in *Monument of Matrones* also equates Elizabeth with Magdalen when she addresses Christ as "Rabonni." See Quilligan, "Incest and Agency," 227–29.

58. On Bale's religious dramas, which show affinities with the woodcut's logocentrism, see O'Connell, *Idolatrous Eye*, 92–97. Elizabeth also elevates text over image in a letter prefacing her gift to Katherine Parr of her translation of Calvin's *Institutes*, a year after the *Glasse:* "Donq est l'art de paindre graveur, ou tailler l'ymage, et effigie des choses corporelles, visibles, et palpables; et au contraire, lescriture est l'ymage, et effigie des choses spirituelles, invisibles, et inpalpables." See Mueller and Marcus, *Elizabeth I: Autograph Compositions*, 11 ("Thus the art of painting, engraving, or sculpting is the image and effigy of bodily, visible, and palpable things; and by contrast, the Scripture is the image and effigy of spiritual, invisible, and impalpable things" [*Elizabeth I: Collected Works*, 12]).

59. Quilligan, "Incest and Agency," 218.

60. On the specters of incest and illegitimacy surrounding the poem, see Shell, *Elizabeth's Glass*, 8–12; and Snyder, "Guilty Sisters."

61. Prescott, "Pearl of the Valois," 76.

62. See Frye, *Elizabeth I*, esp. 7.

63. Sander, *Treatise*, 88.

64. Strong, *Portraits*, 37–38.

65. See, e.g., Bilson, *True Difference*, esp. 547–80.

66. Siemon, *Shakespearean Iconoclasm*, 55. See also Strong, *Portraits*, 40.

67. Quoted in Neale, *Queen Elizabeth I*, 76.

68. Quoted in Rye, *England as Seen by Foreigners*, 4:103–4.

69. Clapham, *Certain Observations*, 97. Clapham also reports Elizabeth's deathbed invective against flattery after seeing her face "reflected truly in a glass" (96).

70. Tuke, *Treatise*, 3.

71. Lanyer, *Poems of Aemilia Lanyer*, 51. All subsequent citations appear parenthetically.

72. See Lewalski, *Writing*, 212–41; and McBride, "Sacred Celebration," 60–82.

73. *Le Miroeur de Jesus-Christe crucifié* may have been in England at this time, perhaps through the Seymour sister's associations with members of Marguerite's household. See Seymour, *Annae, Margaritae, Janae*; facsimile ed., Hosington, *Anne, Margaret and Jane Seymour*, ser. 1, vol. 6. On the work, see Demers, "Seymour Sisters," 343–65; Hosington, "England's First Female-Authored Encomium," 117–63; and Beilin, *Redeeming Eve*, 179. On Marguerite's reputation in England, see Bedouelle, "L'Image de Marguerite de Navarre," 95–106; and Prescott, "And Then She Fell on a Great Laughter," 41–65.

74. Lanyer shares Marguerite's imagery of the mirror and the Eucharist: see McGrath, "Metaphoric Subversions," 101–13; and see McBride, "Sacred Celebration."

75. Fioravanti, *Dello specchio*, 310–10v; Haydocke, *Treatise*, 133.

76. Bowen, "Aemilia Lanyer," 286. For a similar argument about Cary's *Tragedy of Mariam*, see Ferguson, *Dido's Daughters*, 323.

77. See Mueller, "Feminist Poetics," 214–15.

78. See Hutson, "Why the Lady's Eyes," 167–75, for a similar argument.

79. Marguerite also addresses the Daughters of Jerusalem, casting herself as Mary Magdalen seeking the lost body of Christ:

O heureuses filles
ames tressainctes,
En la cité de Hierusalem joinctes . . .
Dire à mon DIEU

mon Amy

et mon Roy

. . . Que je languiz pour luy de son amour. (*MAP* 1091–92 and 1096–98)

["O hapy daughters, right holy soules, joyned in to the citie of iherusalem . . . tell unto my god my frende, and kinge . . . i do languishe for hys love" (*Glass*, 49v–50).]

80. In Shakespeare's "Rape of Lucrece" Tarquin repeatedly merges colors and excuse: see, e.g., ll. 225 and 267. Lanyer paraphrases l. 238, "the shame and fault finds no excuse nor end," in her "Apologie for Eve": "This sinne of yours, hath no excuse, nor end" (87). For discussion, see Bowen, "Aemilia Lanyer," 278–79.

81. Agrippa, *Of the Nobilitie*, C5v.

82. Ibid., C7v.

83. Ibid., G1v.

84. Ibid., C7.

85. Agrippa's similar argument appears in ibid., C7, and continues with a catalogue of exemplary women that underlies Lanyer's community of women in her poem.

86. Agrippa, *Glory of Women*, 9.

87. Agrippa, *Of the Nobilitie*, G2.

88. Ibid., B2.

89. The image, derived from Isaiah 1:18, also appears in Bale's conclusion to Elizabeth's *Glasse:* "If thy synnese be so redde as scarlet, I shall maketh them whyter than snowe. And though thy factes be as the purple, yet shall they apere so whyte as the wolle" (E7).

90. Bucer, *Treatise*, B5–B6.

91. Tintoretto's *Bathing Susanna* is a good example of Susanna's objectification as a painting woman; see chap. 1.

92. Hutson, "Why the Lady's Eyes," 171–72, reads Sheba as an "analogue for Margaret Clifford's interpretative virtue." I supplement this view by referring the episode to Elizabethan self-fashioning and by reading it through Lanyer's engagement with painting and idolatry.

F I V E : Custom, Conscience, and the Reformation of Painting

1. Taylor, *Glasse for Gentlewomen*, 19–20.

2. Rich, *My Ladies Looking Glass*, A2v.

3. Ibid., 42. Rich plagiarizes Buoni, *Problemes of Beautie*, 36.

4. Downame, *Second Part of the Christian Warfare*, 1:132. The passage is quoted approvingly by Smith, *Wonder of Wonders*, 24–25; and challenged by Gauden, *Discourse of Artificial Beauty*, 161–62. All subsequent citations to Gauden are to the 1662 edition, unless otherwise noted, and appear parenthetically.

5. Jonson, *Fountaine of Self-Love*, C4v.

6. Several mid-century texts, including Smith's *Wonder of Wonders*, wrestle with the defense of painting on the basis of custom. See Bulwer, *Anthropometamorphosis*, for a comparative ethnography of painting in cultures throughout the known world. Despite the challenge of custom to absolute estimations of moral behavior, Bulwer condemns painting by Christian women. Among mid-century works defending painting are Jeamson, *Artificiall Embellishments*, and Wecker, *Cosmeticks*.

7. The work first appeared under the title *A Discourse of Auxiliary Beauty, or Artificial Handsomeness* (1656). The new title in 1662 stresses the text's casuistic aspect, reflecting the heightened emphasis on questions of conscience around the Restoration. Authorship is alternatively attributed to John Gauden, Jeremy Taylor, and Obidiah Walker. Williams, *Powder and Paint*, 172 n. 36, notes that "the work was ascribed in his lifetime to [Jeremy] Taylor, who did not deny authorship." Later editions, however, attribute the work only to "a Learned Bishop": see Gauden, *Discourse of Artificial Beauty* (1692), A3v; and Taylor [?], *Several Letters between Two Ladies*, A3v. Royston's publication of Taylor's compendious casuistic work, *Ductor dubitantium*, bolster's Taylor's claim, but the style of the *Discourse* aligns it more closely to Gauden's works than to Taylor's.

8. Perkins, *Whole Treatise of the Cases of Conscience*, 45.

9. Taylor, *Ductor dubitantium*, 1:2. Taylor also claims that divine law "was written in the tables of our hearts with the finger of God" (x). Largely due to this belief, discrimination practiced by the individual conscience became, by the end of the seventeenth century, a defining feature of subjectivity, signaling the demise of casuistry. See Leites, "Casuistry and Character," 120–25.

10. For a similar view, see Slights, "Notaries, Sponges, and Looking-Glasses," 243.

11. On the two paintings, see Cummings, "Meaning of Caravaggio's 'Conversion of Mary Magdalen,'" 572–78; Goffen, "Bellini's Nude with Mirror," 185–99; Goffen, *Giovanni Bellini*, 252–57; Goffen, *Titian's Women*, 66–72; Bialostocki, "Man and Mirror in Painting," 1:61–72; Panofsky, *Problems in Titian, Mostly Iconographic*, 91–93; and Schwarz, "Mirror in Art," 97–118.

12. The *reticella* leads Goffen, "Bellini's Nude," 187–91, to argue that this is a marriage portrait.

13. See Cummings, "Meaning," 572. For discussion of the *sponzarol* in Caravaggio's Detroit *Conversion of the Magdalen* (see fig. 25), see ibid., 571–72; and Bassani and Bellini, *Caravaggio assassino*, 106.

14. Goffen, *Giovanni Bellini*, 257, identifies the object as "a clear glass vase, partially filled with water" containing "flowers, too indistinct to name." She does not repeat the claim in the later "Bellini's Nude." Although Cummings's interpretation seems more likely (a visual comparison of the sponge with that in Caravaggio's *Conversion*, e.g., confirms this), I agree with Goffen that the object comments upon the relationship between art and nature.

15. Goffen, "Bellini's Nude," 194.

16. The distinction is implicit in Vasari's *Vite*, 6:164, *Lives*, 500–501, when Michelangelo praises Titian's coloring but condemns his design. See also Hollanda, *Four Dialogues on Painting;* and see Sohm, "Gendered Style," 778–80 and intro.

17. Alberti, *Della pittura*, 55; *On Painting;* 43. See also Schwarz, "Mirror in Art," 101–11; and Melchoir-Bonnet, *Mirror*, 126–29.

18. Goffen, "Bellini's Nude," 194–96; and Goffen, *Giovanni Bellini*, 253–54.

19. Melchoir-Bonnet, *Mirror*, 214.

20. Goffen, "Bellini's Nude," 186.

21. Goffen, *Titian's Women*, 66.

22. Rigolot, "Magdalen's Skull," 68–73. See also Bialostocki, "Man and Mirror," 70. On the conflation of Maries, see Haskins, *Mary Magdalen*, 3–32.

23. Panofsky, *Problems in Titian*, 93.

24. Bialostocki, "Man and Mirror," 71–72; and Cummings, "Meaning," 576, associ-

ate the picture with the *vanitas* tradition, while Egon Verheyen, according to Cummings, 572, argues that the subject registers her awareness of temporality.

25. Goffen, "Bellini's Nude," 193; and Goffen, *Titian's Women,* 67.

26. Sohm, "Gendered Style," 787–90, discusses the gendering of oil painting in similar terms.

27. Ibid., 67.

28. Panofsky, *Problems in Titian,* 92; Goffen, *Titian's Women,* 67.

29. Thus, I disagree with Goffen's argument that the painting "gives the woman the upper hand" and "subverts the expected balance of power" between the sexes (*Titian's Women,* 67).

30. Tuke, *Treatise Against Painting,* B3–B3v.

31. See Drew-Bear, *Painted Faces,* 17–21. Bosch's painting *Seven Deadly Sins* (c. 1480), now in the Prado, includes an allegory of Pride in which a demon offers a woman a mirror.

32. On Cagnacci, see Benati, *Guido Cagnacci.*

33. Melchoir-Bonnet, *Mirror,* 156–57.

34. Goffen, "Bellini's Nude," 196. The signature reads, "Joannes bellinus faciebat MDXV."

35. Anon., *Life of Lady Falkland,* in Cary, *Tragedy of Mariam,* 194.

36. See Ferguson, *Dido's Daughters,* 265–332; Iwanisziw, "Conscience and the Disobedient Female Consort," 109; Bennett, "Female Performativity," 298; and Raber, "Gender and the Political Subject," 324.

37. Cary, *Tragedy of Mariam,* ed. Weller and Ferguson, 5.1.125 and 1.4.309. All subsequent citations are to this edition and appear parenthetically.

38. Ferguson, *Dido's Daughters,* 301.

39. See ibid., 283–84.

40. Rich, *My Ladies Looking Glass,* 14. See chap. 3 for Marguerite de Navarre's use of this passage in *Le Miroir de l'âme pécheresse.*

41. Gwilliam, "Cosmetic Poetics," 146.

42. Tuke, *Treatise Against Painting,* 9–10.

43. For discussion, see Bennett, "Written on My Tainted Brow," 15.

44. Constabarus' image of the painted sepulchre, borrowed from Christ's censure of the Pharisees in Matthew 23:27, casts Salome as Pilate to Mariam's Christ. Lanyer, *Poems,* confirms the association between the Pharisees and Pilate when she calls Pilate "a painted wall,/A golden Sepulcher" (91).

45. Raber, "Gender," 315.

46. Quoted in Tuke, *Treatise Against Painting,* B2.

47. Hammond, *Idolatry,* 3.

48. Sanders, *Treatyse,* 19.

49. For an application of casuistry to Cary's play, see Ferguson, *Dido's Daughters,* 281–83.

50. Stubbes, *Motive,* 166.

51. See Tully, "Governing Conduct," 16–22.

52. Perkins, *Whole Treatise,* 45.

53. Ibid., 45 and 47–48. For discussion, see Slights, "Notaries," 232–33.

54. Gauden, *Discourse Concerning Publick Oaths,* A1 and 11. Gauden's treatise was an-

swered by Samuel Fisher ("a Prisoner in *Newgate* for the *Truth* of *Jesus*" [A1]) in *The Bishop Busied Beside the Business* (1662).

55. Ibid., 8.

56. Taylor, *Ductor dubitantium* (bk. 1, chap. 2, rule 7), 1:80.

57. See Tully, "Governing Conduct," 28.

58. See Weller and Ferguson, intro., in Cary, *Tragedy of Mariam*, 5; and Ferguson, *Dido's Daughters*, 273–81.

59. Sommerville, "New Art of Lying," 160. On equivocation and mental reservation, see 160–69.

60. Mason, *New Art of Lying*.

61. See, e.g., Coke, *True and Perfect Relation*; Blackwell, *Mr. George Blackwel*; Leigh, *Great Britaines*; Cooper, *Romish Spider*; and Cecil, *Answere to Certaine Scandalous Papers*. The pro-Catholic point of view was represented by Persons, *Treatise*. On the establishment of the Oath of Allegiance and its context in the Gunpowder Plot, see James I, *Triplici nodo*.

62. Mason, *New Art of Lying*, B4v. For the charge as directed toward women's painting, see Gauden, *Discourse of Artificial Beauty*, 211–12.

63. Morton, *Full satisfaction*, A3v. The period's pervasive association of painting with poisoning may account for Salome's charge that Mariam intends to poison Herod (3.2.91–92) and his easy acceptance of the claim: "I cannot think she meant to poison me;/But certain 'tis she liv'd too wantonly" (4.4.256–57).

64. Tuke, *Treatise Against Painting*, 41.

65. Morton, *Full satisfaction*, A4.

66. See Sommerville, "New Art of Lying," 177–78. Reports of Garnet's trial seventy-five years earlier were reprinted when equivocation was banned: see, e.g., Preston, *Tryal and Execution*.

67. Ferguson, *Dido's Daughters*, 279.

68. Ibid., 300–301.

69. Coke, *True and Perfect Relation*, T3v. For discussion, see Ferguson, *Dido's Daughters*, 292–99.

70. See Crawford, "Public Duty," 57–76.

71. Ferguson, *Dido's Daughters*, 266. See also 282–83.

72. Ibid., 295.

73. Iwanisziw, "Conscience," 116.

74. For a similar view, see Bennett, "Female Performativity," 306.

75. Cornelio Musso, from a 1541 sermon to Venetian courtesans, quoted in Aikema, "Titian's Mary Magdalene," 52.

76. On the painting, see Christiansen and Mann, *Orazio and Artemisia*, 430–31; Cummings, "Meaning," 578; Bissell, *Orazio Gentileschi*, 172–73; and Garrard, *Artemisia Gentileschi*, 46 and 499 n. 69.

77. See Christiansen and Mann, *Orazio and Artemisia*, 430, for similar visual and dramatic types.

78. See Haskins, *Mary Magdalen*, 120–27 and 232–33; and Rigolot, "Magdalen's Skull," 68–73.

79. See Cummings, "Meaning," 572; Garrard, *Artemisia Gentileschi around 1622*, 35 and 45; and Schwarz, "Mirror in Art," 103.

80. See Schwarz, "Mirror in Art," 106; Cummings, "Meaning," 572.

81. Ignatius of Loyola, *Spiritual Exercises of St. Ignatius*. Wharton, *Enthusiasm of the Church of Rome*, describes Ignatian meditation as the exemplary form of enthusiasm.

82. Smith, *Wonder of Wonders*, A4, also enlists Magdalen to correct the painting woman's pride with penitential tears.

83. Christiansen and Mann, *Orazio and Artemisia*, 431.

84. Brinsley, *Looking-Glasse*, A2.

85. See Aikema, "Titian's Mary Magdalen," 50; Slights, "Notaries," 232–33; and Melchoir-Bonnet, *Mirror*, 101–84.

86. Christiansen and Mann, *Orazio and Artemisia*, 430, note that the dialogic portrayal of Magdalen's conversion as occurring in Martha's presence "achieved popularity only in the seventeenth century," despite a literary tradition dating back three hundred years.

87. The frontispiece of the 1662 edition depicts the interlocutors as a Puritan woman resting her hand upon the Bible, instructing a fashionably clad, painted woman who holds a fan. Gunn, *Artificial Face*, 94, describes the interlocutors, somewhat misleadingly, as a Royalist and a Puritan. Moreover, the same image was used by Royston in the same year to illustrate Smith's anti-cosmetic *Wonder of Wonders*.

88. Taylor's dedication of his *Ductor dubitantium* to Charles II (A3–A4v) locates the need for the "Reformed Churches" to develop "the Rules of Conscience and Casuistical Theology" within the context of the Restoration (A4), when the Oath of Allegiance prompted widespread debate on the legitimacy or illegitimacy of conscientious objection.

89. On Protestant casuistry, see Sampson, "Laxity and Liberty," 98–102. Taylor, *Ductor dubitantium*, i–xxi, discusses the shortcomings of Catholic casuistry, but his Protestant art falls victim to the same problems he describes as plaguing Catholic casuistry. See, e.g., "Whether it be lawfull to equivocate . . . and in what cases it is so" (bk. 2, chap. 2, rule 3, question 3), 2:100–3. See Sommerville, "New Art of Lying," 159–84, for discussion.

90. Crawford, "Public Duty," 70.

91. Hammond, *Conscience*, in *Several Tractes*, 1.

92. Exon, "Epistle Dedicatory," in Gauden, *Discourse Concerning Publick Oaths*, A2v–A3. Exon's pragmatism is reflected in Charles II's *Declaration of Breda*, which granted "a liberty to tender consciences, and that no man shall be disquieted or called in question for differences of opinion in matters of religion, which do not disturb the peace of the kingdom." See Charles II, England and Wales, *His declaration*.

93. Taylor, *Ductor dubitantium* (bk. 2, chap. 1), 1:231.

94. See Crawford, "Public Duty," 70.

95. See Tully, "Governing Conduct," 23–28.

96. Anon., *Primitive Christian Discipline*, 182.

97. Ibid., 225–26.

98. Ibid., 203–4.

99. Ibid., 239.

100. Crawford, "Public Duty," 70.

101. Brinsley, *Looking-Glasse*, A2.

102. See, e.g., Anon., *Beauties Treasury*, A3v–A4.

103. Ibid., 11.

104. See Lanyer, *Poems*, 49. Gauden's heroines are Jael (Judg. 10), the woman who "dashes out the brains of King *Abimelech*" (Judg. 9:53), and another who "saves by her loyal prudence the city *Abel* from the miseries of a long siege" (2 Sam. 20:16) (235–36).

Gauden's speaker compares her discourse to the widow's mite, "our *two mites* may not be despised which we offer to God's Temple," an image also employed by Lanyer, *Poems*, 64.

105. Gauden, *Discourse of Artificial Beauty* (1692), A3v. See also *Beauties Treasury*, which attributes the book to "a very eminent Divine" (A3v).

106. Gauden, *Discourse of Artificial Beauty* (1692), A3.

107. Ibid., A5.

108. Ibid., A12–A12v.

109. On the painting, see Christiansen and Mann, *Orazio and Artemisia*, 325–28; Garrard, *Artemisia Gentileschi*, 40–41 and 45–48; Garrard, *Artemisia Gentileschi around 1622*, 35–42; Bissell, *Artemisia Gentileschi*, 209–11; and Mann, "Caravaggio and Artemisia," 161–85.

110. Artemisia's immediate model was Caravaggio's *Repentant Magdalen* (c. 1596–97), now in the Galleria Doria-Pamphilj, Rome. See Garrard, *Artemisia Gentileschi around 1622*, 42–48.

111. The signature bears Artemisia's paternal surname, "Lomi," which she employed frequently during her Florentine period: see Christiansen and Mann, *Orazio and Artemisia*, 326 and 355. It is possible that the signature and inscription on the mirror are not by Artemisia (particularly given that she testified during Tassi's trial that she could not write), but their prominence suggests that they were included under her direction. See Bissell, *Artemisia Gentileschi*, 209–11; Mann, "Caravaggio and Artemisia," 179 and 185 n. 41; and Spike, "Review of Florence," 732–34; and, for Artemisia's testimony, see "Testimony," 463.

112. Rigolot, "Magdalen's Skull," 10.

113. Garrard, *Artemisia Gentileschi around 1622*, 38. See also Garrard, *Artemisia Gentileschi*, 40.

114. Mirrors were often decorated with images and mottos encouraging moral speculation as a remedy for vanity. Four allegorical panels by Giovanni Bellini representing Perseverance, Fortune, Prudence, and Falsehood, now in the Accademia in Venice, originally formed part of a small mirrored dressing table. See Cummings, "Meaning," 576.

115. Garrard, *Artemisia Gentileschi around 1622*, 38–39.

116. The work to which Perron responds is James I, *Remonstrance*. Perron died in 1618, and his collected works were published in three volumes in Paris (1620–22); the second volume contains the reply to James. Cary's translation appeared in 1630 as Perron, *Reply of the Most Illustrious Cardinal of Perron, to the Answere of the Most Excellent King of Great Britaine, The First Tome Translated into English*. All subsequent references appear parenthetically.

117. The locus classicus for this strategy is Castiglione, *Il libro del cortegiano*, 23–25; *Book of the Courtier*, 1–3.

Conclusion

1. Springsteen, "Atlantic City."
2. Cavendish, "Of Painting," 86.
3. Ibid.
4. Bacon, *True and Historical Relation*, 25.
5. Niccols, *Sir Thomas Overbury's Vision*, 30.
6. Bacon, *True and Historical Relation*, 50 and 54.

7. On early modern closets, see Orlin, "Gertrude's Closet," 44–67; Ziegler, "My Lady's Chamber"; Jed, *Chaste Thinking*, 80; Jardine, *Reading Shakespeare Historically*, 148–57; and Stewart, "Early Modern Closet Discovered," 76–100.

8. Evelyn, *Mundus Mulierbris*, 9.

Bibliography

PRIMARY TEXTS

Agrippa von Nettesheim, Heinrich Cornelius. *The Glory of Women: or A Looking-Glasse for Ladies*. Trans. H.C. London: T.H. for Frances Coles, 1652.

———. *Of the Nobilitie and Excellencie of Womankynde*. Trans. David Clapham. London: Thomas Berthelet, 1542.

———. *Sur la noblesse et l'excellence du sexe feminin, de sa preeminence sur l'autre sexe (1537)*. Paris: côté-femmes, 1990.

Ainsworth, Henry. *An Arrow Against Idolatrie, Taken out of the quiver of the Lord of hosts*. Amsterdam: Giles Thorp, 1611.

Alberti, Leon Battista. *Della pittura*. Ed. Luigi Mallé. Florence: Sansoni, 1950.

———. *The Family in Renaissance Florence*. Trans. Renee Neu Watkins. Prospect Heights, Ill.: Waveland Press, 1969.

———. *I primi tre libri della famiglia*. Ed. F. C. Pellegrini. Florence: Sansoni, 1946.

———. *On Painting*. Ed. John R. Spencer. New Haven: Yale University Press, 1956.

Ambrose, Bishop of Milan. *Hexameron*. Trans. John J. Savage. New York: Fathers of the Church, 1961.

Anonymous. *Beauties Treasury, or The Ladies Vademecum*. London: S. Malthus, 1705.

———. *The Bloody Downfall of Adultery, Murder and Ambition, presented in a black seane of Gods just Judgments in revenge of the Inocent blood lately shed in this Kingdome*. London: G. Eld for Richard Higgerton, 1616.

———. *La Rappresentatione di Judith Hebrea, nuovamente ristampata*. Florence: Badia, 1568.

———. *The Life of Lady Falkland*. In *The Tragedy of Mariam with The Lady Falkland Her Life by One of Her Daughters*. Ed. Barry Weller and Margaret W. Ferguson. Berkeley: University of California Press, 1994.

———. "Mistress Turners Farewell to All Women." London: John Trundle, 1615.

———. *Primitive Christian Discipline Not to be Slighted: or, Man, Look home, and know thy self*. London, 1658.

"Appendix 1." In *Orazio and Artemisia Gentileschi*, ed. Christiansen and Mann, 432–44. New Haven: Yale University Press, 2001.

Ariosto, Ludovico. *Orlando Furioso*. Ed. Marcello Turchi. 2 vols. Milan: Garzanti, 1974.

Armenini, Giovanni Battista. *De veri precetti della pittura*. Ravenna: Francesco Tebaldini, 1586.

Atti di un processo per stupro. Ed. Eva Menzio. Milan: Edizioni delle donne, 1981.

Aylet, Robert. *Susanna: or, The Arraignment of the Two Unjust Elders*. London: John Teague, 1622.

Bacon, Francis. *A True and Historical Relation of the Poysoning of Sir Thomas Overbury.* London: T.M. and A.C. for John Benson and John Playford, 1651.

Bale, John. *A Godly Medytacyon of the christen sowle concerning a love towardes God and hys Christe, compyled in frenche by lady Margarete quene of Naverre, and aptely translated into Englysh by the ryght vertuouse lady Elyzabeth doughter to our late souverayne Kyng Henrie the viii.* Marburg: Dirik van der Straten, 1548.

Bansley, Charles. *A Treatyse Shewing and Declaring The Pryde and Abuse of Women Now a Dayes.* London: Thomas Raynalde, 1550[?].

Barnes, Barnabe. *The Divels Charter.* London: G.E. for John Wright, 1607.

Bartas, Guillaume du. *The Historie of Judith in Forme of a Poem. Penned in French by the Noble Poet G. Salust. Lord of Bartas. Englished by Tho. Hudson.* Edinburgh: Thomas Vautroullier, 1584.

———. *La Judit.* Ed. Andrè Baïche. Toulouse: Maurice Espic, 1971.

Bate, John. *The Mysteries of Nature and Art.* London: Ralph Mab, 1634.

Bentley, Thomas. *A Monument of Matrones.* London: H. Denham, 1582.

Bilson, Thomas. *The True Difference Betweene Christian Subjection and Unchristian Rebellion.* London, 1585.

Blackwell, George. *Mr. George Blackwel, (made by Pope Clement 8. Arch-priest of England) His Answeres Upon Sundry His Examinations.* London: Robert Barker, 1607.

The Book of Judith. Trans. Morton S. Enslin. Ed. Solomon Zeitlin. Leiden: Brill, 1972.

Brinsley, John. *A Looking-Glasse for Good Women.* London: John Field for Ralph Smith, 1645.

Bucer, Martin. *A Treatyse declaryng & shewyng dyvers causes taken out of the holy scriptur, of the sentences of holy faders . . . that pyctures & other ymages which were wont to be worshypped, ar in no wise to be suffered in the temples and churches.* London: Thomas Godfrey for W. Marshall, 1535.

Bulwer, John. *Anthropometamorphosis: Man Transform'd, Or The Artificiall Changling.* London: William Hunt, 1653.

Buoni, Tommasso. *I problemi della belleza.* Venice: Gio. Ciotti, 1605.

———. *Problemes of Beautie.* Trans. Samuel Lennard. London: G. Eld for Edward Blont and William Aspley, 1606.

Calvin, Jean. *Comment il faut eviter et fuir les ceremonies et superstitions Papales, & de la pure observation de la religion Chrestienne.* In *Recueil des Opuscules, C'est à dire Petits traictez de M. Jean Calvin,* 58–96. Trans. Theodore Beza. Geneva: Baptiste Pinereul, 1566.

———. *Epistulae duae. De fugiendis impiorum illicitis sacris & puritate Christianae religionis observanda. Altera De Christiani hominis officio in sacerdotis Popolis Ecclesia vel administrandis, vel abiiciendis.* Geneva[?], 1550.

———. *Foure godlye sermons agaynst the polution of idolatries, comforting men in persecutions, and teaching them what comodities thei shal finde in Christs church which were preached in French by the most famous clarke Ihon Caluine; and translated firste into Latin, and afterward into Englyshe by diuers godly learned men.* London: Rouland Hall, 1561.

———. *Institutes of the Christian Religion.* Trans. Henry Beveridge. 2 vols. Grand Rapids, Mich.: Eerdmans, 1957.

———. *Institutionum Christianae Religionis.* Amsterdam: Joannem Jacobi Shipper, 1686.

———. "On Shunning the Unlawful Rites of the Ungodly, and Preserving the Purity of the Christian Religion." In *Tracts and Treatises In Defense of the Reformed Faith,* 3:360–411. Trans. Henry Beveridge. 3 vols. Grand Rapids, Mich.: Eerdmans, 1958.

————. *Quatre sermons de M. Jean Calvin, traittans de matieres fort utiles pour nostre temps, comme on pourra voir par la preface. Avec breve exposition du Pseaume LXXXVII.* In *Recueil des opuscules*, 824–79.

Cary, Elizabeth. *The Tragedy of Mariam, the Fair Queen of Jewry, With, The Lady Falkland: Her Life, by One of Her Daughters.* Ed. Barry Weller and Margaret W. Ferguson. Berkeley: University of California Press, 1994.

Castiglione, Baldassare. *The Book of the Courtier.* Trans. Charles Singleton. New York: Doubleday, 1959.

————. *Il libro del cortegiano.* Ed. Ettore Bonora. Milan: Mursia, 1972.

Cavendish, Margaret. "Of Painting." In *Worlds Olio*, 84–87. London: J. Martin and J. Allestrye, 1655.

Cecil, Robert, Earl of Salisbury. *An Answere to Certaine Scandalous Papers, Scattered Abroad Under Color of a Catholicke Admonition.* London: Robert Barker, 1606.

Charles II, England and Wales, Sovereign. *His declaration to all his loving subjects of the kingdome of England. Dated from his court at Breda in Holland the 14 of Aprill 1660.* London: W. Godbid for John Playford, 1660.

Cognet, Martin. *Politique Discourses Upon Trueth and Lying.* Trans. Edward Hoby. London: Ralfe Newberie, 1586.

Coke, Edward. *A True and Perfect Relation of the Whole Proceedings against the Late Most Barbrous Traitors, Garnet a Jesuite, and his Confederats.* London: Robert Barker, 1606.

Colse, Peter. *Penelopes Complaint; or A Mirrour for Wanton Minions.* London: H. Jackson, 1596.

Cooper, Thomas. *The Romish Spider, With his Web of Treason, Woven and Broken.* London: G. Eld for John Hodgets, 1606.

Corrozet, Giles. *Hecatomgraphie.* 1540. Ed. John Horden. London: Scolar Press, 1974.

Cortese, Isabella. *I secreti de la Signora Isabella Cortese.* Venice: Giovanni Bariletto, 1561.

Cyprian, Bishop of Carthage. *The Dress of Virgins.* Trans. Angela Elizabeth Keenan. In *Treatises.* Trans. Roy J. Deferrar, 31–52. New York: Fathers of the Church, 1958.

Day, Martin. *A Mirror of Modestie.* London: Samuel Man, 1630.

Diogenes Laertius, *The Lives, Opinions and Remarkable Sayings of the Most Famous Ancient Philosophers.* Trans. by Several Hands. London: Edward Brewster, 1688.

Downame, John. *The Second Part of the Christian Warfare.* 2 vols. London: Thomas Snodham, 1619.

Elizabeth I, Queen of England. *Elizabeth I: Autograph Compositions and Foreign Language Originals.* Ed. Janel Mueller and Leah S. Marcus. Chicago: University of Chicago Press, 2003.

————. *Elizabeth I: Collected Works.* Ed. Leah S. Marcus, Janel Mueller, and Mary Beth Rose. Chicago: University of Chicago Press, 2000.

Evelyn, John. *Sculptura, or the History and Art of Chalcography and Engraving with Copper.* London: J.C. for G. Beedle and T. Collins, 1662.

Evelyn, Mary. *Mundus Muliebris: Or, The Ladies Dressing-Room unlock'd And her Toilette Spread.* London: R. Bentley, 1690.

Fialetti, Odoardo. *The Whole Art of Drawing, Painting, Limning and Etching.* Trans. Alexander Browne. London: Peter Stint, 1660.

Fioravanti, Leonard. *Dello specchio di scientia universale.* Venice: Vincenzo Valgrissi, 1564.

————. *Le Miroir universel des arts et sciences.* Trans. Gabriel Chappuys. Paris: Pierre Cavellat, 1586.

Fisher, Samuel. *The Bishop Busied Beside the Business, or, That Eminent Overseer, Dr. John Gauden, Bishop of Exeter, so Eminently Overseen as to Wound his own Cause Well Nigh to Death With his own Weapon.* London, 1662.

Fox, George. *Iconoclastes, or, A hammer to break down all invented images, image-makers and image-worshippers.* London, 1671.

Franco, Veronica. *Lettere.* Trans. Stephano Bianchi. Rome: Salerno Editrice, 1998.

———. *Poems and Selected Letters.* Ed. Ann Rosalind Jones and Margaret Rosenthal. Chicago: University of Chicago Press, 1998.

Fréart de Chambray, Roland. *An Idea of the Perfection of Painting.* Trans. J.E. London: Henry Herrington, 1668.

———. *Idée de la perfection de la peintre.* Le Mans: Jacques Ysambart, 1662.

Gauden, John. *A Discourse Concerning Publick Oaths, and the Lawfulness of Swearing in Judicial Proceedings.* London: Richard Royston, 1662.

———. *A Discourse of Artificial Beauty, in Point of Conscience, Between Two Ladies* London: Richard Royston, 1662.

———. *A Discourse of Artificial Beauty in Point of Conscience Between Two Ladies.* London: J. L. for Luke Meredith, 1692.

———. *A Discourse of Auxiliary Beauty, or Artificial Handsomeness.* London: Richard Royston, 1656.

H.T. *A Looking-Glase for Women, or, A Spie for Pride.* London: R.W., 1644.

Hall, Thomas. *An Appendix Containing Divers Reasons and Arguments Against Painting, Spots, Naked Backs, Breasts, Arms, &c.* London: J.G. for Nathanael Webb and William Gratham, 1654.

Hammond, Henry. *Conscience.* In *Several Tracts Of 1. Conscience. 2. Scandall. 3. Will-worship. 4. Superstition. 5. Idolatry. 9 [sic]. Sinnes of Weaknesse. Wilfullnesse. 7. A Late, or a Death-bed repentance.* London: Richard Royston, 1646.

———. *Idolatry.* In *Several Tracts Of 1. Conscience. 2. Scandall. 3. Will-worship. 4. Superstition. 5. Idolatry. 9 [sic]. Sinnes of Weaknesse. Wilfullnesse. 7. A Late, or a Death-bed repentance.* London: Richard Royston, 1646.

Haydocke, Richard, trans. "Of the Painting of Women." In *A Tracte Containing the Artes of Curious Paintinge,* bk. 3, 130–33.

———. *A Tracte Containing the Artes of Curious Paintinge.* Oxford: Joseph Barnes, 1598.

Hilliard, Nicholas. *A Treatise Concerning the Arte of Limning.* Ed. R.K.R. Thornton and T.G.S. Cain. Northumberland: Mid Northumberland Arts Group, 1981.

Hollanda, Francisco de. *Four Dialogues on Painting.* Trans. Aubrey F. G. Bell. Oxford: Oxford University Press, 1928.

Ignatius of Loyola. *The Spiritual Exercises of St. Ignatius.* Trans. Anthony Mottola. Garden City, N.Y.: Image Books 1964.

James I, King of England. *A Remonstrance of the Most Gratious King James I. King of Great Britaine, France, and Ireland, Defender of the Faith, &c. For the Right of Kings, and the Independence of their Crownes. Against an Oration of the Most Illustrious Card. of Perron, Pronounced in the Chamber of the Third Estate. Jan. 15. 1615,* trans. Richard Betts. Cambridge: Cantrell Legge, 1616.

———. *Triplici nodo, triplex cuneus. Or An Apologie for the Oath of Allegiance.* London: Robert Barker, 1607.

Jeamson, Thomas. *Artificiall Embellishments, or Arts Best Directions How to Preserve Beauty or Procure It.* Oxford: William Hall, 1665.

Jerome, Saint. *Select Letters of St. Jerome.* Trans. F. A. Wright. London: William Hinemann, 1933.

Jewel, John. *An Apologie or aunser in defence of the Church of England; Concerninge the State of Religion used in the same.* London: Reginald Wolfe, 1562.

———. *A Defence of the Apologie of the Churche of Englande, Conteining an Answeare to a certain Booke lately set foorthe by M. Hardinge, Entitled A Confutation of &c.* London: Henry Wykes, 1567.

Jonson, Ben. "Conversations with William Drummond." In *The Works of Ben Jonson,* ed. C. H. Hereford and Percy Simpson, 1:128–177. 11 vols. Oxford: Clarendon Press, 1925.

———. *The Fountaine of Self-Love, or Cynthias Revels.* London: Walter Burre, 1601.

Junius, Franciscus. *De pictura veterum libri tres.* Amsterdam: Johannes Blaeu, 1637.

Kapur, Shekhar, dir. *Elizabeth.* New York: PolyGram Video, 1999.

Laguna, Andres de. *Annotationes in dioscoridem.* Lugduni: G. Rouillium,1554.

Lanyer, Aemilia. *The Poems of Aemilia Lanyer: Salve Deus Rex Judaeorum.* Ed. Susanne Woods. Oxford: Oxford University Press, 1993.

Le Fournier, Andre. *La Decoration d'humane nature.* Lyon: Claude Veycellier, 1532.

Leigh, William. *Great Britaines, Great Deliverance, From the Great Danger of Popish Powder.* London: T. Creede for Arthur Johnson,1606.

Lemnius, Levinus. *De habitu et constitutione corporis.* Antwerp, 1561.

———. *Les Occultes merveilles et secretz de nature.* Trans. J.G.P. Paris: Pierre du Pre, 1567.

———. *The Secret Miracles of Nature in Four Books.* London: Jo. Streater, 1658.

———. *The Touchstone of the Complexions.* Trans. Thomas Newton. London: Thomas Marsh, 1581.

Lessius, Leonardo. *The Widdowes Glasse.* Trans. I.W.P. St. Omer, 1621.

Liébault, Jean. *Trois livres de l'embellissement et ornement du corps humaine.* Paris: Jacques du Puys, 1582.

Lomazzo, Giovanni Paolo. *Trattato dell'arte de la pittura.* Milan: Paolo Gottardo Pontio, 1584.

Malvasia, Carlo Cesare. *Felsina pittrice. Vite de pittori Bolognesi.* 2 vols. Bologna: Domenica Barbieri, 1678.

———. *Felsina pittrice: Vite dei pittori Bolognesi.* Ed. Marcella Brascaglia. Bologna: ALFA, 1971.

Marguerite, Queen Consort of Henry II of Navarre. *L'Art et usage du soverain miroeur du chrestien, composé par excellent princesse madame Marguerite de France, royne de Navarre.* Paris: Guillaume le Noir, 1556.

———. *Le Miroir de l'âme pécheresse.* Ed. Renja Salminen. Helsinki: Suomalainen Tiedeakatemia, 1979.

———. *Le Miroir de Jhesus Christe crucifié.* Ed. Lucia Fontanella. Alessandria: Editioni dell'Orso, 1984.

———. *Le Miroeur de Jesus-Christe crucifié, composé par feu tresillustre princess Marguerite de Valois, reine de Navarre.* Toulouse: Guyon Boudeville, 1552.

Marinello, Giovanni. *Gli ornamenti delle donne.* Venice: Francesco de Franchesci Senese, 1562.

Mason, Henry. *The New Art of Lying Covered by Jesuits Under the Vaile of Equivocation.* London: Miles Flesher for John Clark, 1634.

Merlet, Agnès, dir. *Artemisia.* New York: Miramax, 1997.

Meurdrac, Marie. *La Chymie des dames*. Paris: Laurent d'Houry, 1687.

Morton, Thomas. *A full satisfaction concerning a double Romish iniquitie; hainous rebellion, and more then heathenish aequivocation*. London: Richard Field for Edmond Weaver, 1606.

Niccholes, Alexander. *A Discourse of Marraige and Wiving*. London: N.O. for Leonard Becket, 1615.

Niccols, Richard. *Sir Thomas Overbury's Vision, With the Ghosts of Weston, Mistris Turner, the late Lieftenant of the Tower, and Franklin*. London: R.M. for T.I., 1616.

Overbury, Thomas. *A Wife, Now The Widdow of Sir Thomas Overburye*. London: Lawrence Lisle, 1614.

Paleotti, Gabriele. *Discorso intorno alle immagini sacre et profane (1582)*. Ed. Paolo Prodi. Bologna: Arnaldo Forni, 1990.

Perkins, William. *The Whole Treatise of the Cases of Conscience, Distinguished into Three Books*. London: John Legat, 1606.

Perron, Jacques Davy du. *The Reply of the Most Illustrious Cardinall of Perron, to the Answere of the Most Excellent King of Great Britaine, The First Tome Translated into English*. Trans. Elizabeth Cary. Douay: Martin Bogart, 1630.

Persons, Robert. *A Discussion of the Answere of M. William Barlow*. St. Omer, 1612.

———. *A Treatise Tending to Mitigation Towardes Catholike-subjectes in England*. St. Omer: F. Bellet, 1607.

Piccolomini, Alessandro. *Raffaella of Master Alexander Piccolomini*. Trans. John Nevinson. Glasgow: Robert MacLehose and Co., 1968.

Picinardi, Giovanni Luigi. *Il Pennello Lagrimato Orazione Del Signore Luigi Picinardi, Di ognissimo Priore de' Signori Leggisti nello Studio di Bologna, con Varie Poesie In Morte della Signora Elisabetta Sirani Pittrice famosissima*. Bologna: Giacomo Monti, 1665.

Plat, Hugh. *Delightes for Ladies*. London: H.L., 1608.

Platter, Thomas. *Thomas Platter's Travels in England 1599*. Trans. Clare Williams. London: Jonathan Cape, 1937.

Plutarch. *Le Vite gli huomini illustri Greci et Romani de Plutarco Cheroneo*. Trans. Francesco Sansovino. 2 vols. Venice: Vincenzo Valgrisi, 1564.

———. *The Lives of the Noble Grecians and Romanes*. Trans. Thomas North. London: Richard Field for Bonham Norton, 1595.

———. *Vite*. Trans. Lodovico Domenichi et al. 2 vols. Vinegia: Gabriel Giolito de' Ferrari, 1568.

Porete, Marguerite. *Le Miroeur des simples ames anienties et qui seulement demourent en vouloir et desir d'amour*. Ed. Romana Guarnieri. *Archivio italiano per la storia della pietà* 4 (1965): 501–636.

Porta, Giovanni Battista della. *De humana physiognomia libri IIII*. J. Cacchium: Vici Aequenais, 1586.

———. *Della magia naturale del Sign. Gio. Battista Della Porta Napolitano libri XX*. Naples: Giovanni Jacomo Carlino e Constantino Vitale, 1611.

———. *Io. Bapt. Portae magiae natvralis libri XX*. Naples: Horatium Salvianum, 1589.

———. *La Magie naturelle: qui est, les secrets & miracles de nature, mise en quatre liures*. Lyon: Jean Martin, 1565.

———. *Natural Magick*. London: Thomas Young and Samuel Speed, 1658.

———. *Physiognomie coelestis*. Rotterdam, 1650.

Preston, Thomas. *The Tryal and Execution of Father Henry Garnet, Superior Provincial of the Jesuits in England for the Powder-treason.* London: Jonathan Robinson, 1679.

Puttenham, George. *The Arte of English Poesie.* Kent, Ohio: Kent State University Press, 1970.

Rich, Barnaby. *My Ladies Looking Glasse.* London: Thomas Adams, 1616.

Richards, Nathaniel. *The Celestiall Publican.* London: Felix Kyngston for Roger Michell, 1630.

Ripa, Cesare. *Della novissima iconologia di Cesare Ripa Perugino.* Padua: Pietro Paolo Tozzi, 1625.

Ruscelli, Girolamo. *Alexii Pedemontani De secretis libri sex.* Lugduni: Gulielmum Rovillium, 1561.

———. *De' secreti.* Venice, 1580.

———. *The Secretes of the Reverende Maister Alexis of Piemount.* London: John Kingston for Nicolas Ingland, 1558.

Sander, Nicholas. *A Treatise of the Images of Christ, and of his Saints: And that it is unlawfull to breake them, and lawfull to honour them.* St. Omer, for John Heigham, 1624.

Scot, Reginald. *A Discoverie of Witchcraft.* London: R. C., 1651.

Seymour, Lady Anne. *Annae, Margaritae, Janae, Sororum virginum heroidum anglarum, in mortem Divae Margaritae Valesiae navarrorum Regina, Hecatodistichon. Accessit Petri Mirarii ad easdem virgines Epistola: una cum doctorum aliquot virorum Carminbus.* Paris: Reginald and Claude Calderius, 1550.

———. *Le Tombeau de Marguerite de Valois, Royne de Navarre. Faict premierement en Distichtiques Latins par les trois Seours Princesses en Angleterre. Depuis traduictz en Grece, Italien, & Francois par plusieres des excellentz Poetes de la France.* Paris: Michel Fezandat and Robert Granion, 1551.

Shakespeare, William. *Julius Caesar.* In *The Riverside Shakespeare.* Ed. G. Blakemore Evans. 2nd ed. Boston: Houghton Mifflin, 1996.

———. *Measure for Measure,* ed. J. W. Lever. New York: Routledge, 1987.

———. "The Rape of Lucrece." In *Riverside Shakespeare.*

———. *Sonnets.* Ed. Stephen Booth. New Haven: Yale University Press, 1977.

Shirley, John. *The Accomplished Ladies Rich Closet of Rarities, Or the Ingenious Gentlewoman and Servant-Maids Delightfull Companion.* London: W.W. for Nicholas Boddington, 1687.

Smith, R. *A Wonder of Wonders.* London: J.G., for Richard Royston, 1662.

Springsteen, Bruce. "Atlantic City." *Nebraska.* Columbia Records, 1982.

Stampa, Gaspara. *Gaspara Stampa–Veronica Franco. Rime.* Ed. Abdelkader Salza. Bari: Giuseppe Laterza and Figli, 1913; and *Selected Poems,* 208–9.

———. *Rime.* Venice: Plinio Pietrasanta, 1554.

———. *Selected Poems.* Ed. Laura Anna Stortoni and Mary Prentice Lillie. New York: Italica Press, 1994.

Stubbes, Philip. *The Anatomie of Abuses.* London: Richard Jones, 1583.

———. *A Crystall Glasse for Christian Women.* London: Richard Jones, 1591.

———. *A Motive to good workes.* London: Thomas Man, 1593.

Tasso, Torquato. *Discorso della virtù feminile e donnesca.* Ed. M. L. Doglio. Palermo: Sellerio, 1997.

———. *The Householders Philosophie,* Trans. Thomas Kyd. London: J.C. for Thomas Hacket, 1588.

Taylor, Jeremy. *Ductor dubitantium, or, The rule of conscience in all her generall measures.* 2 vols. London: James Flesher for Richard Royston, 1660.

――― [?]. *Several Letters between Two Ladies Wherein the Lawfulness or Unlawfulness of Artificial Beauty in Point of Conscience are Nicely Debated. Published For the Satisfaction of the Fair Sex.* London: Thomas Ballard, 1701.

Taylor, Thomas. *A Glasse for Gentlewomen to dresse themselves by.* London: J.H. for John Bartlet, 1624.

Tertullian. *De cultus feminarum.* In *Tertullian: Disciplinary, Moral and Ascetical Works,* 111–52. Trans. Rudolph Arbesmann, Emily Joseph Daly, and Edwin A. Quain. *Fathers of the Church.* Washington, D.C.: Catholic University Press, 1959.

"Testimony of the Rape Trial of 1612." In Garrard, *Artemisia Gentileschi,* 407–87.

Tuke, Thomas. *A Treatise Against Painting and Tincturing of Men and Women.* London: Thomas Creed and Barnaby Allsope for Edward Merchant, 1616.

Vasari, Giorgio. *Le Vite dei piu celebri pittori, scultori e architetti.* Ed. Rosanna Bettarini. 6 vols. Florence: Sansoni, 1966.

―――. *Lives of the Artists.* Trans. Julia Conaway Bondanella and Peter Bondanella. Oxford: Oxford University Press, 1991.

Vives, Juan Luis. *De institutione feminae Christianae.* Trans. Charles Fantazzi. Leiden: Brill, 1996.

Wecker, John (or Nicholas Culpeper). *Cosmeticks, or the Beautifying Part of Physick.* London: Thomas Johnson, 1660.

Wharton, Henry. *The Enthusiasm of the Church of Rome Demonstrated in Some Observations Upon the Life of Ignatius Loyola.* London: Richard Chiswell, 1688.

Whetstone, George. *Promos and Cassandra.* London: John Charlewood for Richard Jones, 1578.

Zabata, Christoforo. *Nuova scelta di Rime di diversi begli ingegni.* Genoa: Christoforo Belloni, 1573.

SECONDARY TEXTS

Adelman, Janet. "Bed Tricks: On Marriage and the End of Comedy in *All's Well that Ends Well* and *Measure for Measure.*" In *Shakespeare's Personality,* ed. Norman N. Holland, Sidney Homan, and Bernard J. Parks, 151–74. Berkeley: University of California Press, 1989.

Aikema, Bernard. "Titian's Mary Magdalene in the Palazzo Pitti: An Ambiguous Painting and Its Critics." *Journal of the Warburg and Courtauld Institutes* 57 (1994): 48–59.

Amussen, Susan Dwyer. *An Ordered Society: Gender and Class in Early Modern England.* Oxford: Oxford University Press, 1988.

Arnold, Janet. *Queen Elizabeth's Wardrobe Unlock'd: Inventories of the Wardrobe of Robes prepared in July, 1600, edited from Stowe MS 557 in the British Library, MS LR 2/121 in the Public Record Office, London, and MS V.b.72 in the Folger Shakespeare Library, Washington DC.* Leeds: W. S. Maney and Sons, 1998.

Aston, Margaret. *England's Iconoclasts.* Vol. 1: *Laws against Images.* Oxford: Clarendon Press, 1988.

Auerbach, Erna. *Nicholas Hilliard.* London: Routledge, 1961.

―――. *Tudor Artists: A Study of Painters in the Royal Service and of Portraiture on Illumi-*

nated Documents from the Accession of Henry VIII to the Death of Elizabeth I. London: Athlone Press, 1954.

Banti, Anna. *Artemisia.* Trans. Shirley D'Ardia Caracciolo. Lincoln: University of Nebraska Press, 1988.

Barasch, Mosche. *Icon: Studies in the History of an Idea.* New York: New York University Press, 1995.

Barish, Jonas A. *The Antitheatrical Prejudice.* Berkeley: University of California Press, 1981.

Barkan, Leonard. "Making Pictures Speak: Renaissance Art, Elizabethan Literature, Modern Scholarship." *Renaissance Quarterly* 48 (1995): 326–51.

Bartky, Saundra Lee. "Foucault, Femininity and the Modernization of Patriarchal Power." In *Feminism and Foucault: Reflections on Resistance,* ed. Irene Diamond and Lee Quinby, 61–86. Boston: Northeastern University Press, 1988.

Barzman, Karen-Edis. *The Florentine Academy and the Early Modern State: The Discipline of Disegno.* Cambridge: Cambridge University Press, 2000.

Bassani, Riccardo, and Fiora Bellini. *Caravaggio assassino: la carriera di un "valenthuomo" fazioso nella Roma della Contrariforma.* Rome: Donzelli, 1994.

Bedouelle, Guy. "L'Image de Marguerite de Navarre dans l'Angleterre du XVIe siècle." In *La Femme lettrée à la Renaisssance,* ed. Michel Bastiaensen, 95–106. Brussels: Peeters, 1997.

Beilin, Elaine. *Redeeming Eve: Women Writers of the Renaissance.* Princeton: Princeton University Press, 1987.

Belsey, Catherine. *The Subject of Tragedy: Identity and Difference in Renaissance Drama.* London: Methuen, 1985.

Benati, Daniela, ed. *Guido Cagnacci.* Milan: Electa, 1993.

Bennett, Alexandra G. "Female Performativity in *The Tragedy of Mariam.*" *SEL: Studies in English Literature 1500–1900* 40 (2000): 293–309.

Bennett, Lyn. "'Written on my Tainted Brow': Women and the Exegetical Tradition in *The Tragedy of Mariam.*" *Christianity and Literature* 51 (2001): 5–28.

Berdini, Paolo. "Woman under the Gaze: A Renaissance Genealogy." *Art History* 21 (1998): 565–90.

Bereman, Bernard. *Italian Pictures of the Renaissance: The Venetian School.* 2 vols. London: Phaidon, 1957.

Berger, John. *Ways of Seeing.* London: Penguin Books, 1972.

Bernheimer, Charles, ed. *Comparative Literature in the Age of Multiculturalism.* Baltimore: Johns Hopkins University Press, 1995.

Bialostocki, Jan. "Man and Mirror in Painting: Reality and Transience." In *Studies in Late Medieval and Renaissance Painting in Honor of Millard Meiss,* ed. Irving Lavin and John Plummer, 1:61–72. 2 vols. New York: New York University Press, 1977.

Bissell, R. Ward. *Artemisia Gentileschi and the Authority of Art.* State College: Pennsylvania State University Press, 1998.

———. *Orazio Gentileschi and the Poetic Tradition in Caravaggesque Painting.* State College: Pennsylvania State University Press, 1981.

Bluestone, Natalie Harris. "The Female Gaze: Women's Interpretations of the Life and Work of Propezia de' Rossi, Renaissance Sculptor." In *Double Vision: Perspectives on Gender and the Visual Arts,* ed. Bluestone, 38–66. Cranbury, N.J.: Associated University Presses, 1995.

Bohn, Babette. "The Antique Heroines of Elisabetta Sirani." *Renaissance Studies* 16 (2002): 52–79.

———. "Female Self-Portraiture in Early Modern Bologna." *Renaissance Studies* 18 (2004): 239–86.

Boschloo, A.W.A. *Annibale Caracci in Bologna: Visible Reality in Art After the Council of Trent.* Trans. R. R. Symonds. 2 vols. The Hague: Government Publishing Office, 1974.

Bowen, Barbara. "Aemilia Lanyer and the Invention of White Womanhood." In *Maids and Mistresses, Cousins and Queens: Women's Alliances in Early Modern England*, ed. Susan Frye and Karen Robertson, 274–303. Oxford: Oxford University Press, 1999.

Broude, Norma, and Mary D. Garrard. Introduction. In Broude and Garrard, *Expanding Discourse.*

———, eds. *The Expanding Discourse: Feminism and Art History.* New York: Harper-Collins, 1992.

Brown, David Alan, ed. *Virtue and Beauty: Leonardo's Ginevra de' Benci and Renaissance Portraits of Women.* Princeton: Princeton University Press, 2001.

Brucker, Gene. *Giovanni and Lusanna: Love and Marriage in Renaissance Florence.* Berkeley: University of California Press, 1986.

Burckhardt, Jacob. *The Civilization of the Renaissance in Italy.* Trans. S.G.C. Middlemore. London: Penguin Books, 1990.

Burton, Elizabeth. *The Pageant of Elizabethan England.* New York: Charles Scribner's Sons, 1958.

Butler, Judith. *Gender Trouble: Feminism and the Subversion of Identity* . New York: Routledge, 1990.

Camden, Carroll. *The Elizabethan Woman.* London: Elsevier Press, 1952.

Campbell, Mary Baine. "*Anthropometamorphosis:* John Bulwer's Monsters of Cosmetology and the Science of Culture." In *Monster Theory: Reading Culture*, ed. Jeffrey Jerome Cohen, 202–22. Minneapolis: University of Minnesota Press, 1996.

Cantaro, Maria Teresa. *Lavinia Fontana bolognese "pittore singolare."* Milan: Jandi Sapi, 1989.

Carlson, Susan. "'Fond Fathers' and Sweet Sisters: Alternative Sexualities in *Measure for Measure.*" *Essays in Literature* 16 (1989): 13–31.

Cavallo, Sandro, and Simona Cerutti. "Female Honor and Social Control of Reproduction in Piedmont between 1600 and 1800." Trans. Mary M. Gallucci. In *Sex and Gender in Historical Perspective*, ed. Edward Muir and Guido Ruggiero, 73–109. Baltimore: Johns Hopkins University Press, 1990.

Cavazzini, Patrizia. "Artemisia in Her Father's House." In Christiansen and Mann, *Orazio and Artemisia*, 283–95.

Chadwick, Whitney. *Women, Art and Society.* 2nd ed. London: Thames and Hudson, 1996.

Chatelain, Jean-Marc. "L'Esthétique du frontispiece." In *La Naissance du livre moderne: mise en page et mise en texte du livre française (XIVe–XVIIe siècles)*, ed. Henri-Jean Martin, 354–63. Paris: Editions du Cercle de la Librairie, 2000.

Cheney, Liana De Girolamo. "Lavinia Fontana: A Woman Collector of Antiquity." *Aurora* 2 (2001): 22–42.

Cheney, Liana De Girolamo, Alicia Craig Faxon, and Kathleen Lucey Russo. *Self-Portraits by Women Painters.* Aldershot: Ashgate Press, 2000.

Christiansen, Keith, and Judith Mann, eds. *Orazio and Artemisia Gentileschi*. New York: Yale University Press, 2002.

Clapham, John. *Certain Observations on the Life and Reign of Queen Elizabeth*. Ed. Evelyn Plummer Read and Conyers Read. Philadelphia: University of Pennsylvania Press, 1951.

Clive, H. P. *Marguerite de Navarre: An Annotated Bibliography*. London: Grant and Cutler, 1983.

Cohen, Elizabeth S. "'Courtesans' and 'Whores': Words and Behavior in Roman Streets." *Women's Studies* 19 (1991): 201–8.

———. "Honor and Gender in the Streets of Early Modern Rome." *Journal of Interdisciplinary History* 22 (1992): 597–625.

———. "No Longer Virgins: Self-Presentation by Young Women in Late Renaissance Rome." In *Refiguring Woman: Perspectives on Gender and the Italian Renaissance*, ed. Marilyn Migiel and Juliana Schiesari, 169–208. Ithaca: Cornell University Press, 1991.

———. "The Trials of Artemisia Gentileschi: A Rape as History." *Sixteenth-Century Journal* 31 (2000): 47–75.

Cohn, Samuel K. *Women in the Street: Essays on Sex and Power in Renaissance Italy*. Baltimore: Johns Hopkins University Press, 1996.

Colish, Marcia. "Cosmetic Theology: The Transformation of a Stoic Theme." *Assays* 1 (1981): 3–15.

Cooper, Tanya. "The Queen's Visual Presence." In *Elizabeth: The Exhibition at the National Maritime Museum*, ed. Susan Doran, 172–96. London: Chatto and Windus, 2003.

Cottrell, Robert B. *The Grammar of Silence: A Reading of Marguerite de Navarre's Poetry*. Washington, D.C.: Catholic University of America Press, 1986.

Crawford, Patricia. "Public Duty, Conscience and Women in Early Modern England." In *Public Duty and Private Conscience in Seventeenth-Century England*, ed. John Morrill, Paul Slack, and Daniel Woolf, 57–76. Oxford: Oxford University Press, 1993.

Cropper, Elizabeth. "Artemisia Gentileschi, la '*pittora*.'" In *Barocca al femminile*, ed. Giulia Calvi, 191–218. Rome: Laterza, 1992.

———. *The Ideal of Painting: Pietro Testa's Dusseldorf Notebook*. Princeton: Princeton University Press, 1984.

———. "Life on the Edge: Artemisia Gentileschi, Famous Woman Painter." In Christiansen and Mann, *Orazio and Artemisia*, 263–80.

———. "On Beautiful Women, Parmigianino, *Petrarchismo*, and the Vernacular Style." *Art Bulletin* 58 (1976): 374–94.

Cummings, Frederick. "The Meaning of Caravaggio's 'Conversion of Mary Magdalen.'" *Burlington Magazine* 116 (1974): 572–78.

Dean, Trevor. "Fathers and Daughters: Marriage Laws and Marriage Disputes in Bologna and Italy, 1200–1500." In *Marriage in Italy, 1300–1650*, ed. Trevor Dean and K.J.P. Lowe, 85–106. Cambridge: Cambridge University Press, 1998.

DeGalan, Aimee. "Lead White or Dead White?" *Bulletin of the Detroit Institute of the Arts* 76 (2002): 38–49.

Demers, Patricia. "The Seymour Sisters: Elegizing Female Attachment." *Sixteenth Century Journal* 30 (1999): 343–65.

Diehl, Houston. "Infinite Space: Representation and Reformation in *Measure for Measure*." *Shakespeare Quarterly* 49 (1998): 393–410.

DiGrangi, Mario. "Pleasure and Danger: Measuring Female Sexuality in *Measure for Measure*." *ELH* 60 (1993): 589–609.

Dolan, Frances. "Taking the Pencil Out of God's Hand: Art, Nature and the Face-Painting Debate in Early Modern England." *PMLA* 108 (1993): 224–39.

———. *Whores of Babylon: Catholicism, Gender, and Seventeenth-Century Print Culture.* Ithaca: Cornell University Press, 1999.

Doran, Susan, ed. *Elizabeth: The Exhibition at the National Maritime Museum.* London: Chatto and Windus, 2003.

Drew-Bear, Annette. *Painted Faces on the Renaissance Stage: The Moral Significance of Face-Painting Conventions.* Lewisburg: Bucknell University Press, 1994.

Duffy, Eamon. *Stripping of the Altars: Traditional Religion in England, c. 1400–c. 1580.* New Haven: Yale University Press, 1992.

Eilberg-Schwartz, Howard, and Wendy Doniger, eds. *Off with Her Head! The Denial of Women's Identity in Myth, Religion, and Culture.* Berkeley: University of California Press, 1995.

Eire, Carlos M. N. *War against the Idols: The Reformation of Worship from Erasmus to Calvin.* Cambridge: Cambridge University Press, 1986.

Englefield, W.A.D. *History of the Painter-Stainers Company of London.* London: Chapman and Dodd, 1923.

Ezell, Margaret J. M. *Writing Women's Literary History.* Baltimore: Johns Hopkins University Press, 1993.

Ferguson, Gary. *Mirroring Belief: Marguerite de Navarre's Devotional Poetry.* Edinburgh: Edinburgh University Press, 1992.

———. "Now in a Glass Darkly: The Status of *je parlant* in the *Miroirs* of Marguerite de Navarre." *Renaissance Studies* 5 (1991): 398–411.

Ferguson, Margaret W. *Dido's Daughters: Literacy, Gender, and Empire in Early Modern England and France.* University of Chicago Press, 2003.

———. "Moderation and Its Discontents: Recent Work on Renaissance Women." *Feminist Studies* 20 (1994): 349–66.

———. "A Room Not Their Own: Women as Readers and Writers." In Koelb and Noakes, *Comparative Perspective on Literature,* 93–116.

Ferguson, Margaret W., Maureen Quilligan, and Nancy J. Vickers, eds. *Rewriting the Renaissance: The Discourses of Sexual Difference in Early Modern Europe.* Chicago: University of Chicago Press, 1986.

Ferino-Padgen, Sylvia, and Maria Kusche. *Sofonisba Anguissola: A Renaissance Woman.* Washington, D.C.: National Museum of Women in the Arts, 1995.

ffolliott, Sheila. "Learning to Be Looked At: The Portrait of [The Artist as] a Young Woman in Agnès Merlet's *Artemisia*." *Quidditas: A Journal of the Rocky Mountain Medieval and Renaissance Association* 20 (1999): 95–116.

Fineman, Joel. "Shakespeare's Will: The Temporality of Rape." *Representations* 20 (1987): 25–76.

Finke, Laurie A. "Painting Women: Images of Femininity in Jacobean Tragedy." *Theatre Journal* 36 (1984): 357–70.

Foley, Henry. *Records of the English Province of the Society of Jesuits.* 7 vols. London: Burns and Oates, 1877–83.

Fortunati, Vera, ed. *Lavinia Fontana.* Milan: Electa, 1998.

———. *Lavinia Fontana, 1552–1614.* Milan: Electa, 1994.

Freccero, Carla. "Economy, Women and Renaissance Discourse." In *Refiguring Women: Perspectives on Gender and the Italian Renaissance*, ed. Marilyn Migiel and Juliana Schiesari, 192–208. Ithaca: Cornell University Press, 1991.

Frick, Carole Collier. "Crimson, Feathers, and Pearls: Performing the Feminine in the Early Modern City." Paper presented at Attending to Early Modern Women, University of Maryland, November 2003.

———. *Dressing Renaissance Florence: Families, Fortunes, and Fine Clothing*. Baltimore: Johns Hopkins University Press, 2002.

Friedman, Michael D. "'O let him marry her!': Matrimony and Recompense in *Measure for Measure*." *Shakespeare Quarterly* 46 (1995): 454–64.

Frisoni, Fiorella. "Elisabetta Sirani." In *La Scuola di Guido Reni*, ed. Emilio Negro and Massimo Pirondini, 343–64. Modena: Artioli, 1992.

Frye, Susan. *Elizabeth I: The Competition for Representation*. Oxford: Oxford University Press, 1993.

Fuss, Diana. *Essentially Speaking: Feminism, Nature and Difference*. New York: Routledge, 1989.

Gamba, Bartolommeo. *Lettere di donne del secolo decimosesto*. Venice: Alvisopoli, 1832.

Garner, Shirley Nelson. "'Let Her Paint an Inch Thick': Painted Ladies in Renaissance Drama and Society." *Renaissance Drama*, n.s. 20 (1989): 123–39.

Garrard, Mary D. *Artemisia Gentileschi around 1622: The Shaping and Reshaping of an Artistic Identity*. Berkeley: University of California Press, 2001.

———. *Artemisia Gentileschi: The Image of the Female Hero in Italian Baroque Art*. Princeton: Princeton University Press, 1989.

———. "Here's Looking at Me: Sofonisba Anguissola and the Problem of the Female Artist." *Renaissance Quarterly* 47 (1994): 556–621.

———. "Painting with Crude Strokes." *Woman's Art Journal* 24 (2004): 56.

Gent, Lucy. *Picture and Poetry, 1560–1620: Relations between Literature and the Visual Arts in the English Renaissance*. Leamington Spa: James Hall, 1981.

Ghirardi, Angela. "Women Artists of Bologna: The Self-Portrait and the Legend from Catherine Vigri to Anna Morandi Manzolini." In *Lavinia Fontana of Bologna, 1552–1614*, ed. Vera Fortunati, 32–48. Trans. Iselle Fiale O'Roarke, Lucia Gunella, and T. Barton Thurber. Milan: Electa, 1998.

Gilbert, Sandra M., and Susan Gubar. *The Madwoman in the Attic: The Woman Writer and the Nineteenth-Century Literary Imagination*. New Haven: Yale University Press, 1979.

Goffen, Rona. "Bellini's Nude with Mirror." *Venezia Cinquecento* 2 (1991): 185–99.

———. *Giovanni Bellini*. New Haven: Yale University Press, 1989.

———. *Titian's Women*. New Haven: Yale University Press, 1997.

Gouma-Peterson, Thalia, and Patricia Matthews. "The Feminist Critique of Art History." *Art Bulletin* 69 (1987): 326–57.

Grabes, Herbert. *The Mutable Glass*. Cambridge: Cambridge University Press, 1982.

Greene, Gayle, and Coppelia Kahn, eds. *Making a Difference: Feminist Literary Criticism*. New York: Methuen, 1985.

Greene, Thomas M. *The Descent from Heaven: A Study in Epic Continuity*. New Haven: Yale University Press, 1963.

———. *The Light in Troy: Imitation and Discovery in Renaissance Literature*. New Haven: Yale University Press, 1982.

————. *The Vulnerable Text: Essays in Renaissance Literature.* New Haven: Yale University Press, 1986.

Greer, Germaine. *The Obstacle Race: The Fortunes of Women Painters and Their Works.* New York: Farrar, Straus, Giroux, 1979.

Grossman, Marshall, ed. *Aemilia Lanyer: Gender, Genre, and the Canon.* Lexington: University Press of Kentucky, 1998.

Gunn, Fenja. *The Artificial Face: A History of Cosmetics.* Devon: David and Charles, 1973.

Gwilliam, Tassie. "Cosmetic Poetics: Coloring Faces in the Eighteenth Century." In *Body and Text in the Eighteenth Century,* ed. Veronica Kelly and Dorethea von Mucke, 144–59. Stanford: Stanford University Press, 1994.

Harley, R. D. *Artists' Pigments, c. 1600–1835.* 2nd ed. London: Butterworth, 1982.

Harris, Anne Sutherland, and Linda Nochlin. *Women Artists, 1550–1950.* Los Angeles: Los Angeles County Museum of Art, 1976.

Haskins, Susan. *Mary Magdalen: Myth and Metaphor.* New York: Harcourt, Brace, 1993.

Hayne, Victoria. "Performing Social Practice: The Example of *Measure for Measure.*" *Shakespeare Quarterly* 44 (1993): 1–29.

Heller, Nancy G. *Women Artists: An Illustrated History.* New York: Abbeville Press, 1987.

Herbert, William. *The History of the Twelve Great Livery Companies of London.* 2 vols. 1834–37. Reprint. New York: A. M. Kelley, 1968.

Heyl, Christoph. "Deformity's Filthy Fingers: Cosmetics and the Plague in *Artificiall Embellishments, or Arts best Directions how to preserve Beauty or procure it* (Oxford, 1665)." In *Didactic Literature in England, 1500–1800: Expertise Constructed,* ed. Natasha Glaisyer and Sara Pennell, 137–51. Aldershot: Ashgate Press, 2003.

Hillman, David. "Visceral Knowledge: Shakespeare, Skepticism, and the Interior of the Early Modern Body." In *The Body in Parts: Fantasies of Corporeality in Early Modern Europe,* 81–105. Ed. David Hillman and Carla Mazzio. New York: Routledge, 1997.

Hosington, Brenda M. "England's First Female-Authored Encomium: The Seymour Sisters' *Hecatodistichon* (1550) to Marguerite de Navarre. Text, Translation, Notes, and Commentary." *Studies in Philology* 93 (1996): 117–63.

————, ed. *Anne, Margaret and Jane Seymour.* In *The Early Modern Englishwoman: A Facsimile Library of Essential Works,* ed. Betty Travitsky and Patrick Cullen, ser. 1, vol. 6. Aldershot: Ashgate Press, 2000.

Hunt, Margaret. Afterword. In *Queering the Renaissance,* ed. Jonathan Goldberg, 359–64. Durham: Duke University Press, 1994.

Hutson, Lorna. *The Usurer's Daughter: Male Friendship and Fictions of Women in Sixteenth-Century England.* New York: Routledge, 1994.

————. "Why the Lady's Eyes Are Nothing like the Sun." In *New Feminist Discourses: Critical Essays on Theories and Texts,* ed. Isobel Armstrong, 154–75. New York: Routledge, 1992.

Hyde, Melissa. "The 'Makeup' of the Marquise: Boucher's Portrait of Pompadour at Her Toilette." *Art Bulletin* 83 (2000): 453–76.

Iwanisziw, Susan B. "Conscience and the Disobedient Female Consort in the Closet Dramas of John Milton and Elizabeth Cary." *Milton Studies* (1998): 109–22.

Jacobs, Fredrika H. "The Construction of a Life: Madonna Properzia De' Rossi '*Schultrice*' Bolognese." *Word and Image* 9 (1985): 122–32.

Jankowski, Theodora. A. "Pure Resistance: Queer(y)ing Virginity in William Shake-

speare's *Measure for Measure* and Margaret Cavendish's *The Convent of Pleasure.*" *Shakespeare Studies* 26 (1998): 218–55.

Jardine, Lisa. *Reading Shakespeare Historically.* London: Routledge, 1996.

Jed, Stephanie H. *Chaste Thinking: The Rape of Lucretia and the Birth of Humanism.* Bloomington: Indiana University Press, 1989.

Johnson, Geraldine A., and Sara F. Matthews Grieco, eds. *Picturing Women in Renaissance and Baroque Italy.* Cambridge: Cambridge University Press, 1997.

Jones, Pamela M., and Thomas Worcester, eds. *From Rome to Eternity: Catholicism and the Arts in Italy, ca. 1550–1650.* Boston: Brill, 2002.

Jourda, Pierre. *Marguerite d'Angoulême, duchesse d'Alençon, reine de Navarre (1942–1549): Etude biographique et littéraire.* Paris: Champion, 1930.

King, Catherine. "Looking a Sight: Sixteenth-Century Portraits of Women Artists." *Zeitschrift fur Kunstgeschichte* 3 (1995): 381–406.

Kinney, Arthur F. *Continental Humanist Poetics: Studies in Erasmus, Castiglione, Marguerite de Navarre, Rabelais and Cervantes.* Amherst: University of Massachusetts Press, 1989.

Kirkham, Victoria. "Poetic Ideals of Love and Beauty." In Brown, *Virtue and Beauty,* 50–61.

Klein, Lisa M. "Your Humble Handmaid: Elizabethan Gifts of Needlework." *Renaissance Quarterly* 50 (1997): 459–93.

Knoppers, Laura Lunger. "(En)gendering Shame: *Measure for Measure* and the Spectacles of Power." *English Literary Renaissance* 23 (1993): 450–71.

Koelb, Clayton, and Susan Noakes, eds. *The Comparative Perspective on Literature: Approaches to Theory and Practice.* Ithaca: Cornell University Press, 1988.

Landini, Roberta Orsi, and Mary Westerman Bulgarella. "Costume in Fifteenth-Century Florentine Portraits of Women." In Brown, *Virtue and Beauty,* 90–97.

Lapierre, Alexandra. *Artemisia: un duel pour l'immortalité.* Paris: Editions Robert Laffont, 1998.

Laufer, Roger. "L'Espace visuel du livre ancien." In *Histoire de l'édition française,* ed. Hénri-Jean Martin and Roger Chartier, 1:483–92. Paris: Promodis, 1982.

LaWall, Charles. *Four Thousand Years of Pharmacy.* Philadelphia: Lippincott, 1927.

Leites, Edmund. "Casuistry and Character." In Leites, *Conscience,* 119–33.

———, ed. *Conscience and Casuistry in Early Modern Europe.* Cambridge: Cambridge University Press, 2002.

Levine, Amy-Jill. "Sacrifice and Salvation: Otherness and Domestication in the Book of Judith." In *The Feminist Companion to the Bible.* Vol. 7: *A Feminist Companion to Esther, Judith and Susanna,* ed. Athalya Brenner. Sheffield: Sheffield Academic Press, 1995.

Lewalski, Barbara. *Writing Women in Jacobean England.* Cambridge: Harvard University Press, 1993.

Lichtenstein, Jacqueline. *The Eloquence of Color: Rhetoric and Painting in the French Classical Age.* Trans. Emily McVarish. Berkeley: University of California Press, 1993.

———. "Making Up Representation: The Risks of Femininity." Trans. Katharine Streip. *Representations* 20 (1987): 77–87.

Lindley, David. *The Trials of Frances Howard: Fact and Fiction at the Court of King James.* New York: Routledge, 1993.

Loomis, Catherine. "'A Brittle Gloriana': Staging the Deposition of Queen Elizabeth I." Paper presented at the Shakespeare Association of American conference, April 2000.

————. "Elizabeth Southwell's Manuscript Account of the Death of Queen Elizabeth." *English Literary Renaissance* 26 (1996): 492–509.

Lukach, Barbro Suzanne. "Reflecting Images: A Study of Marguerite de Navarre's *Le Miroir de l'âme pécheresse* and *Le Miroir de Jhesus Christe crucifié.*" Master's thesis, University of Virginia, 1994.

Lupton, Julia Reinhard. *Afterlives of the Saints: Hagiography, Typology, and Renaissance Literature.* Stanford: Stanford University Press, 1996.

Madden, F. "Portrait Painters of Queen Elizabeth." *Notes and Queries*, ser. 1, 6 (1852): 238.

Mâle, Emile. *Religious Art from the Twelfth Century to the Eighteenth Century.* New York: Pantheon, 1949.

Mann, Judith. "Caravaggio and Artemisia: Testing the Limits of Caravaggism." *Studies in Iconography* 18 (1997): 161–85.

Marnesi, Antonio. *Il Processo di avvelenamento fatto nel 1665–66 in Bologna contro Lucia Tolomelli per la morte di Elisasbetta Sirani.* Bologna: Arnaldo Forni, 1975.

Martin, Edward James. *A History of the Iconoclastic Controversy.* New York: AMS Press, 1978.

Martineau, Christine, Michel Veissière, and Henry Heller, eds. *Guillaume Briçonnet–Marguerite d'Angoulême Correspondence (1521–1524).* 2 vols. Geneva: Droz, 1975–79.

Matchinske, Megan. "Legislating 'Middle Class' Morality in the Marriage Market: Ester Sowernam's *Ester Hath Hang'd Haman.*" *English Literary Renaissance* 24 (1994): 154–83.

McBride, Kari Boyd. "Sacred Celebration: The Patronage Poems." In Grossman, *Aemilia Lanyer,* 60–82.

McGrath, Lynette. "Metaphoric Subversions: Feasts and Mirrors in Aemilia Lanyer's *Salve Deus Rex Judaeorum.*" *Literature, Interpretation, Theory: LIT* 3 (1991): 101–13.

McIver, Katherine A. "Lavinia Fontana's Self-Portrait Making Music." *Woman's Art Journal* 19 (1998): 3–8.

McKluskie, Kathleen. "The Patriarchal Bard: Feminist Criticism and Shakespeare: *King Lear* and *Measure for Measure.*" In *Political Shakespeare: New Essays in Cultural Materialism,* ed. Jonathan Dollimore and Alan Sinfield, 88–108. Manchester: Manchester University Press, 1985.

McManus, Caroline. "Queen Elizabeth, Dol Common, and the Performance of the Royal Maundy." In *The Mysteries of Elizabeth I: Selections from English Literary Renaissance,* ed. Kirby Farrell and Kathleen Swaim, 43–66. Amherst: University of Massachusetts Press, 2003.

Melchoir-Bonnet, Sabine. *The Mirror: A History.* Trans. Katherine H. Jewett. New York: Routledge, 2001.

Miles, Margaret R. *Image as Insight: Visual Understanding in Western Christianity and Secular Culture.* Boston: Beacon Press, 1985.

Moretti, Valeria. *Il pennello lacrimato.* Bologna: Il Lavoro editoriale, 1990.

————. *Le Più belle del reale: pittrici in autoritratto dal cinquecento all'ottocento.* Roma: Spada, 1983.

Morselli, Rafaella, and Anna Cera Sones. *Collezioni e quadrerie nella Bologna del Seicento, Inventario 1640–1707.* Getty Documents for the History of Collecting, Italian Inventories, 3. J. Paul Getty Trust, 1997.

Mueller, Janel. "The Feminist Poetics of Aemilia Lanyer's *Salve Deus Rex Judaeorum.*" In

Feminist Measures: Soundings in Poetry and Theory, ed. Lynn Keller and Cristanne Miller, 208–36. Ann Arbor: University of Michigan Press, 1994.

Mullaney, Steven. "Mourning and Misogyny: *Hamlet, The Revenger's Tragedy* and the Final Progress of Elizabeth I, 1600–1607." *Shakespeare Quarterly* 45 (1994): 139–62.

Murphy, Caroline P. *Lavinia Fontana: A Painter and Her Patrons in Sixteenth-Century Bologna.* New Haven: Yale University Press, 2003.

Neale, J. E. *Queen Elizabeth I: A Biography.* New York: Doubleday, 1957.

Nochlin, Linda. "Why Have There Been No Great Women Artists?" In *Women, Art and Power and Other Essays*, 145–78. New York: Harper and Row, 1988.

O'Connell, Michael. *The Idolatrous Eye: Iconoclasm and Theater in Early Modern England.* Oxford: Oxford University Press, 2000.

Orlin, Lena Cowen. "Gertrude's Closet." *Shakespeare-Jahrbuch* 134 (1998): 44–67.

Pallucchini, Rodolfo, and Paola Rossi, eds. *Jacopo Tintoretto: opera completa.* 2 vols. Venice: Alfieri, 1974–82.

Panofsky, Erwin. *Problems in Titian, Mostly Iconographic.* New York: New York University Press, 1969.

Parker, Rosika, and Griselda Pollock. *Old Mistresses: Women, Art and Ideology.* New York: Pantheon Books, 1981.

Pater, Walter. *The Renaissance: Studies in Art and Poetry.* Ed. Donald L. Hill. Berkeley: University of California Press, 1980.

Perlingieri, Ilya Sandra. *Sofonisba Anguissola: The First Great Woman Artist of the Renaissance.* New York: Rizzoli, 1992.

Phillippy, Patricia. *Women, Death and Literature in Post-Reformation England.* Cambridge: Cambridge University Press, 2002.

Phillips, John. *The Reformation of Images: Destruction of Art in England, 1535–1660.* Berkeley: University of California Press, 1973.

Pietrantonio, Vera Fortunati. "L'immaginario degli artisti bolognesi tra maniera e controriforma: Prospero Fontana (1512–1586)." In *Le Arti a Bologna e in Emilia dal XVI al XVII secolo*, ed. A. Emiliani, 97–111. *Atti CIHA*, no. 4. Bologna, 1982.

Pollard, Alfred W. *Last Words on the History of the Title-Page with Notes on Some Colophons and Twenty-Seven Fac-Similes of Title Pages.* New York: Burt Franklin, 1971.

Pollard, Tanya. "Beauty's Poisonous Properties." *Shakespeare Studies* 27 (1999): 187–210.

Pollock, Griselda. *Differencing the Canon: Feminist Desire and the Writing of Art's Histories.* New York: Routledge, 1999.

———. "A Hungry Eye." *Sight and Sound* 11 (1998): 26–28.

———. "The Politics of Theory: Generations and Geographies in Feminist Theory and the Histories of Art History." In *Generations and Geographies in the Visual Arts: Feminist Readings*, ed. Pollock, 3–24. New York: Routledge, 1996.

Pomeroy, Elizabeth. *Reading the Portraits of Queen Elizabeth.* New York: Archon Books, 1989.

Porter, Roy. "Making Faces: Physiognomy and Fashion in Eighteenth-Century England." *Etudes Anglaises* 38 (1985): 385–96.

Prescott, Anne Lake. "'And Then She Fell on a Great Laughter': Tudor Diplomats Read Marguerite de Navarre." In *Culture and Change: Attending to Early Modern Women*, ed. Margaret Mikesell and Adele Seef, 41–65. Newark: University of Delaware Press, 2003.

———. "The Pearl of the Valois and Elizabeth I: Marguerite de Navarre's *Miroir* and

Tudor England." In *Silent But for the Word: Tudor Women as Patrons, Translators, and Writers of Religious Works*, ed. Margaret Hannay, 61–76. Kent, Ohio: Kent State University Press, 1985.

Prescott, Anne Lake, and Betty Travitsky, eds. *Female and Male Voices in Early Modern England*. New York: Columbia University Press, 2000.

Quilligan, Maureen. "Incest and Agency: The Case of Elizabeth I." In *Generation and Degeneration: Tropes of Reproduction in Literature and History from Antiquity through Early Modern Europe*, ed. Valeria Finucci and Kevin Brownlee, 209–34. Durham: Duke University Press, 2001.

Raber, Karen. "Gender and the Political Subject in *The Tragedy of Mariam*." *SEL: Studies in English Literature, 1500–1900* 35 (1995): 321–43.

Ragg, Laura M. *Women Artists of Bologna*. London: Methuen, 1907.

Richlin, Amy. "Making Up a Woman: The Face of Roman Gender." In Eilberg-Schwartz and Doniger, *Off with Her Head*, 185–213.

Rigolot, François. "Magdalen's Skull: Allegory and Iconography in *Heptameron* 32." *Renaissance Quarterly* 47 (1994): 57–73.

Riviere, Joan. "Womanliness as a Masquerade." In *Formations of Fantasy*, ed. Victor Burgin, James Donald, and Cora Kaplan, 35–44. London: Methuen, 1986.

Rossi, Paola, ed. *Jacopo Tintoretto: I Ritratti*. Venice: Alfieri, 1974–82.

Ruggiero, Guido. *The Boundaries of Eros: Sex Crimes and Sexuality in Renaissance Venice*. Oxford University Press, 1985.

Rye, William Brenchley. *England as Seen by Foreigners in the Days of Elizabeth and James I.* 4 vols. London: J. Russell Smith, 1865.

Sagarin, Edward, ed. *Cosmetics: Science and Technology*. New York: Interscience Publishers, 1957.

Sampson, Margaret. "Laxity and Liberty in Seventeenth-Century English Political Thought." In Leites, *Conscience*, 72–118.

Schutte, Anne Jacobson. "Per Speculum in Enigmate: Failed Saints, Artists and Self-Construction of the Female Body in Early Modern Italy." In *Creative Women in Medieval and Early Modern Italy*, ed. E. Ann Matter and John Coakley, 185–200. Philadelphia: University of Pennsylvania Press, 1994.

Schwarz, Heinrich. "The Mirror in Art." *Art Quarterly* 15 (1952): 97–118.

Shell, Marc, ed. *Elizabeth's Glass*. Lincoln: University of Nebraska Press, 1993.

Showalter, Elaine. "Feminist Criticism in the Wilderness." *Critical Inquiry* 8 (1981): 179–205.

———. "Towards a Feminist Poetics." In *Women Writing and Writing about Women*, ed. Mary Jacobus, 21–44. New York: Barnes and Noble, 1979.

Siemon, James R. *Shakespearean Iconoclasm*. Berkeley: University of California Press, 1985.

Slights, Camille Wells. "Notaries, Sponges, and Looking-Glasses: Conscience in Early Modern England." *English Literary Renaissance* 28 (1998): 231–46.

Snyder, Susan. "Guilty Sisters: Marguerite de Navarre, Elizabeth of England, and the *Miroir de l'âme pécheresse*." *Renaissance Quarterly* 50 (1997): 443–58.

Sommers, Paula. *"Le Miroir de l'âme pécheresse* Revisited: Ordered Reflections in a Biblical Mirror." *Modern Language Studies* 16 (1986): 101–8.

Sommerville, Johann P. "The 'New Art of Lying': Equivocation, Mental Reservation, and Casuistry." In Leites, *Conscience*, 160–69.

Spear, Richard. "Artemisia Gentileschi: Ten Years of Fact and Fiction." *Art Bulletin* 82 (2000): 568–79.

Spencer, Harold, ed., *Readings in Art History*, vol. 1: *Ancient Egypt through the Middle Ages*. New York: Scribner's Sons, 1969.

Spike, John T. "Review of Florence 1991." *Burlington Magazine* 133 (1991): 732–34.

Springsteen, Bruce. "Atlantic City." *Nebraska*. Columbia Records, 1982.

Stewart, Alan. "The Early Modern Closet Discovered." *Representations* 50 (1995): 76–100.

Stocker, Margarita. *Judith, Sexual Warrior: Women and Power in Western Culture*. New Haven: Yale University Press, 1998.

Strong, Roy C. *The Cult of Elizabeth: Elizabethan Portraiture and Pageantry*. London: Thames and Hudson, 1977.

———. *The Elizabethan Image: Painting in England, 1540–1620*. London: Trustees of Tate Gallery, 1969.

———. *Nicholas Hilliard*. London: Michael Joseph, 1973.

———. *Portraits of Queen Elizabeth I*. Oxford: Clarendon Press, 1963.

Traister, Barbara Howard. *The Notorious Astrological Physician of London: Works and Days of Simon Forman*. Chicago: University of Chicago Press, 2001.

Traub, Valerie, Lindsay Kaplan, and Dympna Callaghan, eds. *Feminist Readings of Early Modern Culture: Emerging Subjects*. Cambridge: Cambridge University Press, 1996.

Tufts, Eleanor A. "A Successful 16th Century Portrait: Ms. Lavinia Fontana from Bologna." *Art News* 77 (1974): 60–64.

Tully, James. "Governing Conduct." In Leites, *Conscience*, 12–71.

Vecchi, Pierluigi de. *Tout l'ouvre peint de Tintoret*. Trans. Simone Darses. Paris: Flammarion, 1971.

Vickers, Nancy J. "This Heraldry in Lucrece's Face." In *The Female Body in Western Culture: Contemporary Perspectives*, ed. Susan Rubin Suleiman, 209–22. Cambridge: Harvard University Press, 1986.

Vreeland, Susan. *The Passion of Artemisia*. London: Review, 2002.

Wagstaff, Sheena. "Weltering in Blood: Artemisia Gentileschi." *Parkett* 65 (2002): 194–97.

Wall, Wendy. *Staging Domesticity: Household Work and English Identity in Early Modern Drama*. Cambridge: Cambridge University Press, 2002.

Watkins, John. *Representing Elizabeth in Stuart England: Literature, History Sovereignty*. Cambridge: Cambridge University Press, 2002.

Whigham, Frank. *Ambition and Privilege: The Social Tropes of Elizabethan Courtesy Theory*. Berkeley: University of California Press, 1984.

Williams, Neville. *Powder and Paint: A History of the Englishwoman's Toilet, Elizabeth I to Elizabeth II*. London: Longmans, Green, 1957.

Woods-Marsden, Joanna. *Renaissance Self-Portraiture: The Visual Construction of Identity and Social Status of the Artist*. New Haven: Yale University Press, 1998.

Wyke, Maria. "Woman in the Mirror: The Rhetoric of Adornment in the Roman World." In *Women in Ancient Societies: An Illusion of the Night*, ed. Léonie J. Archer, Susan Fischler, and Maria Wyke, 134–51. New York: Routledge, 1994.

Ziegler, Georgianna. "My Lady's Chamber: Female Space, Female Chastity in Shakespeare." *Textual Practice* 4 (1990): 73–100.

Index

Page numbers in *italics* indicate illustrations.